Feasts of Light

Celebrations
for the Seasons of Life
based on the
Egyptian Goddess
Mysteries

Feasts of Light

Lamenting the ruined state in which she'd found the Temple of Hathor at Cusae, Hatshepsut said, "The ground had swallowed up its august sanctuary. . . ." To return the city to prosperity, she rebuilt Hathor's temple, overlaid the images of the goddess with gold, and reestablished the temple services. The offerings she conducted in the temple she called Feast of Light.

For Hathor

and for All of Hathor's Daughters
whether Clothed in Light or in Flesh

Hymn to Hathor the Beautiful

Thou art the mistress of jubilation, the queen of the dance,
The mistress of music, the queen of the harp playing,
The lady of the choral dance, the queen of wreath weaving,
The mistress of inebriety without end.

Feasts of Light

Celebrations
for the Seasons of Life
based on the
Egyptian Goddess Mysteries

Normandi Ellis

A publication supported by
THE KERN FOUNDATION

Quest Books
Theosophical Publishing House
Wheaton, Illinois ♦ Chennai (Madras), India

The Theosophical Publishing House
P.O. Box 270
Wheaton, IL 60189-0270

A publication of the Theosophical Publishing House,
a department of the Theosophical Society in America

Cover and book design by Kimberly Oakley

Library of Congress Cataloging-in-Publication Data

Ellis, Normandi.
 Feasts of light: celebrations for the seasons of life based on the Egyptian goddess mysteries /
Normandi Ellis. — 1st Quest ed.
 p. cm.
 Includes bibliographical references.
 ISBN 0-8356-0744-5
 1. Fasts and feasts — Egyptian religion. 2. Goddesses, Egyptian.
 3. Egypt — Religious life and customs. I. Title.
BL2450.F28E44 1999
299'.31 — dc21 98-37366
 CIP

Original illustrations by John Squadra: xix, 8, 13, 37, 45, 55, 57, 61, 70, 78, 83, 89,
90, 101, 104, 109, 117, 136, 137, 141.

Cover image: *Musicians in the Tomb of Priest Nakht at Thebes*, 18th Dynasty,
courtesy Uni-Dia-Verlag.

Every effort has been made to secure permission to reproduce the images in this book. Any
additional copyright holders are invited to contact the publisher so that proper credit can be
given in future editions.

5 4 3 2 1 * 99 00 01 02 03 04 05

Printed in the United States of America

ACKNOWLEDGMENTS

Each time I write a new book I am reminded of the Old Kingdom tale of Ruddedet who births three great kings with the assistance of the goddesses and gods of Egypt. My friends are my divine birthing coaches and this book would not have been born without their loving assistance.

Many thanks to my friends and editors at Quest, especially Sharron Dorr, Kim Oakley, and Ray Grasse, and to Brenda Rosen who presented me with the opportunity to write this book. A special thanks to Jean Houston, Peggy Rubin, Pat Monaghan, and John West who are always a part of every book I write on Egypt. Thanks to Carol Dunbar, Rich Adams, and particularly Harold Moss who read the manuscript and indefatigably assisted me with my many astrological questions.

To those editorial assistants who helped me compile and research the material, proof and transcribe, I owe a debt of gratitude. I couldn't have done it without you, Roxanne Hurt, Cara Fedders, Deborah Chenault, and Tiffany Pruett.

I appreciate the selfless and good-spirited assistance of John Squadra, who provided much of the original art in this book. To all those friends inside the landscape of my computer who helped me track down footnotes and hymns, goddess bless you.

And a special thanks to my daughter Alaina for just being an all-around joy and help. She typed, she proofed, she answered telephones, and she grew from a child to a teen during the process of writing this book. David Hurt, I thank you for being my soul mate and for uplifting me through the entire process when it felt as if I would never finish the book.

Contents

The Season of Harvest

The Epagomenal Days

INTRODUCTION TO THE MYSTERIES
OF THE EGYPTIAN GODDESSES

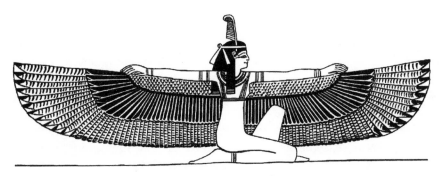

The winged Isis appears as Ma'at, goddess of truth.

When I was a child I had a secret place at the edge of the woods amid a circle of hackberry and elm trees. In the spring a rivulet of water flowed through it, disappearing down a nearby storm drainage pipe. My mother warned me never to go in there—I might get caught by a rainstorm and swept away or bitten by a snake. As a result, it was my favorite spot in which to hang out and stay cool on a summer's day. I journeyed to the woods with regularity, pulling behind me a wagon full of brooms, old two-by-fours, an army blanket, a journal, empty canning jars, old bricks, broken concrete lawn ornaments—deer, or angels, or headless Saint Francises, whatever I could find.

I'd sweep the dirt in my circle of trees until the ground was hard packed. In the crook of the trees I'd pound down the broken boards until they sat level. Then I'd pick wildflowers—dandelions, bluebells, violets, Johnny-jump-ups, or mayflowers—to put in the glass jars on my tree altars. I scoured the little stream for shiny rocks to add to the altar, sometimes catching tadpoles or just bathing my feet and watching the cold water and dappled light play over my skin.

On long, sweet afternoons I spread out the army blanket and lay down, staring up through the leaves of the trees toward the infinite blue sky. The sunlight wavered over me, warming me. The wind tickled my face. I felt just like one of those wildflowers, so alive in the world I could burst wide open. Sometimes when I was depressed, I crawled inside the long, black tunnel of the storm sewer and just sat. Occasionally I'd take in a piece of broken brick for chalk and a flashlight so that I could draw or write poems on the concrete walls.

All the world felt alive to me—every grampus in the stream, every caterpillar egg on every elm leaf, all the white clouds like puffs of breath from the angels, the lady bugs disappearing into the leaf mulch. It all seemed holy. I remember lying there on my army blanket chatting with God's Wife, as I called her. I remember thinking that I had built the most wonderful cathedral in the world, and I wanted everyone to see it.

The spiritual impulse must be innate in children, the desire to commune with the Divine through prayer as natural as breathing. I didn't know I was having a spiritual experience then, however. At eight years of age I knew that "God's house" was where we went on Sunday morning in cramped, shiny, black shoes with my ponytail pulled so tight it narrowed my eyes and blurred the world. The cathedral in the woods was someplace else, someplace comfortable, more home than home; it didn't belong to God, it belonged to his Wife. It was a place where hours passed with only the voice of the wind, where secrets revealed themselves in the dark storm sewer, in the rustling leaves, in the murmuring water.

When I was a child I didn't know that in ancient Egypt many scribes and artists spent the better part of their lives at the bottom of a long tunnel, writing and illustrating the texts hidden within the dark, mysterious tombs of the pharaohs. I didn't know the stories of how the goddess Hathor appeared as a sycamore tree; how Isis appeared as the fructifying water; how the sky was the body of the goddess Nut; or how the gentle warmth of the sun was a goddess named Bast. I only knew as a child that the world was loving and good and that I belonged to it, as much its child as I was my mother's. The

natural world loved me and I loved it in return. Later, my Sunday school teacher told me that deifying the natural world was a pagan idea that broke the laws of God the Father. When I tried to explain that I thought God the Mother liked my cathedral in the woods, he threw me out of Sunday School.

As I grew older, I rekindled that childhood dream of trying to show others the holiness of the world through my studies of Egyptian myth. I believed that if people came to see every tree as holy, they would not be so quick to cut them down; if they saw the water as holy, they would not throw garbage and poison into it; and if they saw themselves, and their children, and even their enemies as holy, they would be less cruel, less thoughtless, and less self-centered. Really, I've just been trying for years to get everyone to lie down on the blanket inside that cathedral in the woods and look up.

Some people give me a hard time about what I believe. Knowing that I still go to a Christian church but resonate deeply with Egyptian mythology, they ask: So, what religion are you? I laugh and tell them I'm an Episcopagan, and I go to Sunday-Monday-Tuesday school. In truth, I believe the Divine calls us to have a deeply personal, emotional, intellectual, and spiritual relationship with it. You may call it God or Goddess, or Yahweh, or Buddha, or Mohammed, or Kwan Yin, or Pachamama. I don't imagine each religion is the same; but I imagine each religion reflects an aspect of the Divine. The lessons may differ, but they are all aspects of divine truth.

Whether a particular day honors Christ or Mary, Horus or Isis (or occurs on Saturday, Sunday, or Tuesday), the observance of a religious feast day offers us all an opportunity to transcend mundane existence and move beyond the petty struggle of our daily lives. For a moment, temporal life is suspended, allowing us time to contemplate the greater mysteries. To gaze upon the form of Christ or to gaze into the beautiful face of the Goddess is to gaze into the awesome nature of eternal time and glimpse one's own eternal nature. In such a way, we enter into the larger story so that we actually feel the passion of Christ carrying his cross or the grief of Isis mourning her lost Beloved. For the devout, for the mystic, for the initiate, this is not simply remembering a story. It is rather a complete immersion into the mysterious heart of the sacred, an infusion into the mortal experience of the divine Eternal that creates anew in the participant an ecstatic entrance into the holy mystery itself.

What we gain by deepening into the myths and stories of a given spiritual tradition is an immersion into the means and principles of cosmic creation and an understanding of our own lives in relationship to that pattern. By entering into myth, we reach a kind of ecstatic fusion of ourselves and the universe. This unification divinely reveals and powerfully unveils our own unique participation in the creation of cosmic pattern and design.

"Why would anyone care about these old stories anyway?" I've been asked. "They are not history, after all."

"Ah, but they are truer than history," I respond.

Mythologist Mircea Eliade assures us that the essential question of cultures and individuals throughout time has been, "Where did we come from, and why are we here?" In trying to answer that question, myths teach us the primordial stories that have constituted humankind existentially; and, of course, as Eliade says, everything connected with one's search for the meaning of life, for the whys and wherefores of the cosmos, concerns every individual directly.[1]

To put it another way: There is no event manifest in heaven or on earth in which some myth is not also manifest and in which some spiritual principle is not being activated. If you exist at all, you exist within the realm of the Divine. On the physical level, every dawn is the birth of the sun, and the image of that sun on the horizon—like a golden head parting the realm of heaven and earth—relates to the shared birth myths of the sun god Ra by the sky goddess Nut and of the sun god Horus (Harakhty) by the goddess Isis. On a psychological level, every woman who gestates and gives birth to a child finds a deeper purpose and meaning to the stories of Nut and Isis. On a mythic level, anyone who has ever struggled to birth an idea, a dream, or a work of art undergoes the same process of magical, divine birthing. On a cosmic level, we begin to experience the power of the Goddess to birth the sun as the creation of all life in the universe, a celebration of the joy and pain of the Big Bang.

Nor is there one correct interpretation of myth. When I talk about the birth of Ra on December 25 as the winter solstice, I am also talking about the birth of Horus through the goddess Isis and the birth of Jesus through the Virgin Mary. I can talk about an abstract astrological phenomenon at the same time that I am talking about a dawning awareness of your own inner child being born. Or your heroic self coming into being. Or a science lesson in particle wave theory. Or the story of single mothers who raise their children alone. Or the idea that it is always darkest before the dawn. . . . Any one of these levels of interpretation, or a different one, may occur to you at any given moment, not necessarily only on December 25. The festivals are cyclical to allow us time to contemplate them again and again, but they are simultaneously eternal, always happening whether we are aware of them or not.

Therefore, the equinox, the new year, the birth of a child, the birth of an idea, the everyday rise of the sun—are all celebrations of Isis birthing Horus. The pattern is an eternal

constant. The Goddess (or the God) becomes then a mediator between the human and the transcendent realms, inserting the seed of a truth that grows within us a higher awareness of ourselves in the world. This longing, this yearning to move beyond the local, personal consciousness of time into an eternal, divine time is what provides the means to contact the Divine within the self.

Simply put, the Goddess is everywhere. We've lived too long under our misguided conceptions of a God who resembles the absent father, laying down rules, leaving, and then coming home unannounced to hand out punishments for wrongs we've done. The Goddess is always home, omnipresent, and nurturing. She encourages us to learn from her. She sees our flaws and errors and knows that they are how we learn. Many women who are sensitive to the spiritual have a hard time with the religious. Our culture has defined Father God as the law-giver and ruler who wields the power of discrimination. Women often have found themselves relating to their spiritual natures differently and therefore feel discriminated against. They long for the Great Mother, the welcoming arms that embrace their intuitive, feeling side. We define the Goddess as Love, the Unbounded, the Unity.

She accepts us and understands us as we come to accept and understand her, little by little, moving us from a profane human condition into rebirth into a sanctified state. Slowly, slowly do the veils of the Goddess loosen themselves before the eyes of the Beloved. Slowly, slowly do we come to understand that we have entered into the sacred mystery that now utterly changes the way we will ever after view the world and even ourselves.

There are two kinds of mysteries in the Egyptian tradition: the *akhut* (glorious mysteries) and the *sesheta* (sacred mysteries). The akhut, or glorious mysteries, were performed by the priestesses and priests for the entire population. They often involved a great deal of pageantry, masking, and storytelling in the form of ritual drama, feasting, song, and dance. Certainly not everyone understood the larger importance of these rituals, but mass festivals and worship unified the people in their spiritual longing. The drama of the recent death of a child, spouse, or parent might find its spiritual mirror in the transformative experience reenacting the death of Osiris and the grief of Isis. As much as the participants grieved with Isis the loss of Osiris, as much as they cried, tore their clothes, and threw dust upon their heads, perhaps on one level remembering their similar loss, their ritual grief was enacted on an archetypal level as well.

Whereas the mass worship of the akhut mysteries satisfied the longings of the group consciousness, the sacred sesheta mysteries spoke to the individual relationship to the Divine. On a spiritual level, the same dramatic, public rituals enacted within the temple before the *adytum* (shrine) of the Divine provided an opportunity to contemplate the cosmic mystery of death in a transpersonal way. By contemplating one's future death, one learned to die to old ways of life, to become reborn, and to approach life in a renewed way. The implications of such rituals were so life altering that they were not spoken because they could not be spoken. They could only be understood in the human heart. On a larger level, the grief of the newly "dead" initiate mirrored the grief of all human-kind in its loss of the sacred wisdom, without which all were condemned to live their lives in fragmentation and ignorance.

Of the celebrations of the glorious akhut mysteries we know a little, for they were enacted in public for cathartic benefit. Of the sacred sesheta mysteries we know for certain very little, for they were shrouded in the mystery that accompanies divine transformation. The sesheta mysteries can only be understood after long, deep relationship with the Divine, when one has become a priestess to the Divine, a vessel of the Goddess, and has completely entered into a new sacred life. At this moment, the mystery is no longer about us: the drama, the awe, the power, and the wonder are about the Goddess. As Naomi Ozaniec warns us:

> Sacred drama has a long and universal history. We underestimate its potency if we cheapen the concept with twentieth-century usage. Sacred drama was never theater to be observed, it was the enactment and conscious realisation of the group's sacred myth by the participants. Its key players were those who impersonated the gods, priests, and priestesses.
>
> Impersonating the gods [or Goddess] is both awesome and dangerous, fraught with liability unless contained by a code of conduct. . . . Unlike the mystery plays of medieval Europe which functioned to both entertain and educate, . . . the sacred rites of the ancients served to empower and initiate. [2]

Nothing short of death to an old understanding of the world is required. Unless we are willing to make such a sacrifice, the spiritual riches of the Divine will always remain an elusive mystery, a power, and a truth beyond our pale intellectual understanding. If we incarcerate ourselves in habits of filling time with business, then our divine, spiritual selves find neither the time nor the space to enter in. Since few of us continue to live within the festival calendar of feast and saint days, we have to create some practice of inserting sacred time

into our everyday lives so that we can have the opportunity to recommit ourselves to the gestation and birth of the great forces within us.

An hour a day, a day a week, a weekend a month, and yes, a month a year, would do wonders for most of us! We might even—as in the myth of Isis searching for and finding the body of Osiris—rediscover some holy part of ourselves that has been too long confined and which can now be released, renewed, and incorporated. We might find that we are suddenly engaged in a new marriage between our masculine and feminine selves, as well as a reunification of the body and the spirit.

As you read this book, it is important that you make your own connections to the Goddess in your own way, not simply according to my interpretations and suggested activities. Then will she nourish you. Then will she become alive in you. Then will she take up residence in your heart, in your cathedral in the woods, in your own world. In building your own unique relationship to Isis through her myths and festivals, you will begin to see your life reflected in hers. Listen initially to the stories that seem to speak directly to your heart and life. The important thing to remember is that all the *neters* (gods and goddesses alike) are aspects of the great divine Light. They are the brilliant multiform petals of a single lotus.

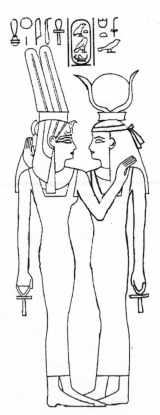

The goddesses Mut and Hathor embrace.

A Brief History of the Egyptian Calendar

Plato believed that the ideal society would have a festival calendar of 365 days, each day celebrating a different aspect or character of the Divine. In that way, he felt, all of human nature could be acknowledged at the proper time. Festivals would commemorate the notable spiritual events in one's life—marriage, the birth of a child, the onset of menopause, or the death of a loved one. Some festivals might be more occasional, as in laying the foundation of a new building, the day of papyrus plucking and flower gathering, or the return of the sailing ships. Other festivals might include feasts of ecstatic drunkenness or ecstatic remembrance, of innocence, of sensuality, of chastity, or of forgiveness. With the proper channel for the personality's natural drives, Plato believed, obsessions might be avoided.[3]

During the Twentieth Dynasty, Egypt's festival calendar came close to Plato's ideal. No less than 120 festivals a year occurred during the reign of Ramses III, or approximately one festival every third day![4] That did not include lunar feasts of heaven regularly held at the new and full moons each month. Egyptologist C. J. Bleeker believes the many feast days eventually crippled the community and marred the original sacred significance of the festivals.[5] Bleeker seems to judge a feast's efficaciousness with its austerity and soberness.

Between Plato's ideal and Bleeker's vision of hedonism lies a deeper truth. Rather than focus on the amount of days devoted to rejoicing and celebrating, we must look inward. True spirituality comes from the heart. Indeed, a heart that sees the hand of the Divine at work in one's daily affairs is a heart capable of jubilation every day. Left to our own devices, however, we might fail to make time to honor the Divine; thus, the regularity of a worship calendar assures that at least part of the time we will focus our desires outside ourselves and reach toward the Divine. That is the very least we can do, since the Creator never fails to reach toward us. The established religious festival takes us out of our rigid notion of the passing present and places us into the realm of the eternal moment. It is the difference between being trapped in living and dying and racing against the clock and being alive to life's full potentiality, every moment, every day, all the time.

The neters of old were the gods and goddesses of nature. The coming of the annual flood, the blossoming of the lotus, the rising of the brightest star in the sky, the disappearance of the moon, the eclipsing of the sun, the cutting of the wheat—all were occasions in which the Divine manifested on earth. The Egyptian New Year festival, for example, reenacted the drama of earth's creation, the moment all life began when the primordial mound of earth rose above the waters of chaos.

Such a festival embodied themes both sacred and secular. Foremost, it provided people with an opportunity to witness renewal of the dying year and to experience within their own psyches a spiritual renewal. It marked a time in the agricultural cycle that initiated the growing season. Finally, it allowed the pharaoh, as king and high priest, to enact a rite demonstrating human power bringing order from chaos. Thus, the festival celebrated renewal on all levels, temporal and eternal, astronomical and agricultural, individual and communal, psychospiritual and political.

The religious life of the ancient Egyptian was marked by the celebration of the following kinds of sacred events:

— festivals dedicated to a particular god or goddess which honored them through the public remembrance of their mythic lives;

— festivals which honored the dead, bringing together a sense of the tribal community and the ancestral history and marking the cycles of time;

— festivals which initiated the agrarian work cycles of preparing, sowing, and harvesting, as well as lying fallow.

In all probability these seasonal festivals were determined by astronomical markers, such as the equinoxes, the solstices, and the rise of particular stars and constellations. These were sacred events to which the Great Goddess provided her blessing, for she was the manifestation of the cosmic cycle of nature. Her will was made known through the great pattern laid out in the sky by celestial phenomena.[6] As we have seen, the earliest festivals were those celebrating the mysteries of the Goddess in her appearance as the day and night sky, as both sun and moon. Most of the original ancient Egyptian feast days were celebrated at the new or the full moon. The ancient hieroglyph for "month" was the image of the moon itself. Apparently, the original festival calendar was lunar.[7]

We do know that by the time writing first appeared (around 3100 B.C.E.) ancient Egyptian life centered around no less than three calendars. The lunar calendar, the civil calendar, and the Sothic calendar were based on the celestial patterns of the moon, the sun, and the star Sirius, respectively. The moon with its regular thirty-day cycles became the oldest timekeeper. Coinciding with a woman's menstrual cycles, it was the perfect instrument to keep track of her and the animals' fertile times and to record the pattern of life. No wonder the goddesses Isis and Hathor were associated with the moon.

The civil calendars were solar based and used the movement of the sun across the sky to signal the approaching seasons. When roaming the countryside, chasing game, and gathering food gave way to the practice of agriculture, it became more important for our ancestors to master the signs of the growing seasons than to follow the animals' migration patterns. Early agriculturalists began to look up at the sky in an effort to learn when to prepare the ground, when to plant, and when to reap. Unlike lunar calendars, solar calendars marked the solstices (the longest and shortest days of the year), as well as the equinoxes (when the days and nights were of equal length).

In addition, seasonal changes that affected the growing seasons were predicted by observing the rise of certain constellations, particularly those constellations that followed the ecliptic (the apparent path of the sun through the heavens). Thus, the appearance of the twelve zodiacal constellations formed an important part of the civil and solar calendar.

Because the moon cycles didn't exactly match the sun cycles, five intercalary days, called Epagomenal Days, were eventually added to the calendar year. In Egypt those five days honored the births of the great neters Osiris, Horus, Seth, Isis, and Nephthys. Even after the Epagomenal Days were added to the solar calendar, it was still inexact because the true year is actually a few hours longer than 365 days.

To determine exactly when the seasons would change and when to sow or harvest, the Egyptians began to track and observe all of the heavenly bodies, including the moon, the sun, the constellations, and the brightest, most visible stars. By watching the sky over the years, people began to notice that just before dawn near the summer solstice, the rising of the Dog Star Sirius, the brightest star in the heavens, was a better, more reliable predictor of the coming of the flood season than the solar calendar alone. When the star appeared, the flood waters flowing from the southern mountains and highlands appeared soon after. By observing Sirius, preparations for planting and sowing could be made well in advance. In addition, the regularity of the rise of Sirius most closely resembled the true length of the year.

This brilliant star Sirius, appearing in the constellation we know as Canis Major, was ancient Egypt's most important star. The Egyptians called the star Sopdet and equated it with Isis, the powerful goddess of regeneration. The Greeks called the star Sothis, later developing a so-called Sothic calendar that kept even more regular track of the years and seasons, being most nearly 365.25 days. Even then the calendar still wasn't perfect. Incremental changes were occurring due to the rotation of the earth, the tilt of the earth, and the procession of the equinoxes.

By divine decree laid down in the mists of prehistory, the Egyptian priest-king swore never to alter the civil calendar, even though its solar-based calculations were not keeping up with the changing seasons. The reason for this seemingly irrational adherence lay in the fact that the year had been divinely established by the god of wisdom and time, Thoth. Thoth's laws were the laws of the gods, and divine laws were considered unalterable. The real reason may have been that astrologer priests were tracking an even larger arc of time—a procession not of the sun and moon, but of the equinoxes—that resulted in a kind of calendar of the ages.

When the Greeks arrived in Egypt, however, they saw little value in maintaining such a cosmic calendar when the civil (solar) calendar was so woefully out of alignment. Once they established themselves as kings, the Ptolemaic Greeks believed the time had come to alter Thoth's divine law. They coerced the priests into adding an extra day every four years to even out the true calendar. The result created the leap year, which we use even to this day. [8]

At first Egypt's calendar seems hard to understand because we are conditioned to our own notions of month and season derived from the Romans. Really, the ancient Egyptian calendar is fairly simple. The year has twelve months, the months have three weeks, and each week has ten days. This represented the basic system of the lunar year. Tacked onto the end of these 360 days were the five Epagomenal Days, added to create the 365 days of the solar year. The Epagomenal Days signaled the end of the year and were followed by the new year's celebration, just as New Year's Day follows New Year's Eve in our calendar. But, whereas we begin counting in the winter month of January, the ancient Egyptians began counting at the rise of the star Sirius, which occurs in the middle of our summer.

The system makes perfect sense because the new year signaled the beginning of a new agricultural cycle. When the star rose, the Nile flooded, and the parched earth was refertilized. The sacred actions of the Nile River—its flooding, its retreat into its banks leaving fertile soil, and its eventual low flow creating drought conditions—determined not only the major festivals of the pharaoh and his people, but the three seasons of the year. The ancient Egyptians did not celebrate four seasons of spring, summer, fall, and winter as we do. Rather, their three seasons were uniquely timed to the particular agricultural requirements in their geographic region. The three seasons were:

AKHET (Inundation) From mid-July to mid-November, when most of the river valley and Delta were underwater. Also called the Red Season;

PERT (Sowing) From mid-November to mid-March, the equivalent to our spring, which the Egyptians called the Coming Forth. Also called the Black Season;

SHEMU (Harvest) From mid-March to mid-July, when crops were harvested. By the season's end, everything was dry and the fields were scorched. Also called the White Season.

The festival calendar, as it appears to us now, spans three thousand years of Egyptian history and probably was being recorded, observed, and manipulated many thousands of years before that. In those three millennia a great many political and religious changes affected the designated feast days. Some feasts fell out of favor, others were renamed, a few were entirely forgotten.

Among those casualties were many of the early goddess-based festivals celebrated with great fervor during the Old Kingdom. [9] By the time of their revival during the Graeco-Roman period, their meaning, rituals, and importance, even the names and realms of the Goddess, in all probability had completely changed. The festival dates of King Hor-Aha around 3000 B.C.E. were not the same as the festival dates given for King Seti I in 1320 B.C.E. Many of the festival names were not even the same. They certainly were not the same as those recorded by Herodotus during his travels to Egypt around 450 B.C.E.

Of course, many Egyptian feast days are moveable feasts; that is, they are lunar festivals timed to phases of the moon. Thus, their occurrence might slip around from one year to the next. Imagine how hard it is for us to determine when Easter will occur next year without consulting a calendar. Easter Sunday, as you may have noticed, slides back and forth on any day between March 22 and April 25. It takes a little astronomical calculation to find its correct date, which will be the first Sunday following the first full moon after the spring equinox. Likewise, Egyptian festival dates were set by the motion of the stars, the planets, the phases of the moon, and the actions of the sun.

In any true sense it would be impossible for us to know the actual recurring dates of many of the festivals. We can, however, approximate the ancient dates, which is what most Egyptologists do. During the season of Inundation more major public festivals occurred than at any other time of the year, most of them related to fertility rites and abundance rituals. The feasts tended to occupy the general public during this time because the land was so flooded that little real work could be done. By comparison, the Sowing season had fewer

festivals. Once the waters receded and work in the fields began, the Sowing season was the busiest time of year. The growing season was quickly followed by the Harvest season. But during the final months of the year, when the harvest had ended and the land was dry, the festivals began again, mostly in anticipation of the coming Inundation.[10]

For your own feast days, celebrate when the appropriate time occurs in your own life. Your harvest festival might occur in September around Labor Day or in November at Thanksgiving, rather than in late March. Your New Year's Day festival might take place in January, but you may also celebrate the Chinese New Year, or Rosh Hashanah, or Kwanza. Obviously, any celebration of the birth of your child will occur on whatever day your child chooses for you, not just December 25 or the spring equinox. As my friend Harold Moss, a priest in the Egyptian-based Church of the Eternal Source, points out, "It is more important to cultivate an Egyptian frame of mind and schedule celebrations according to the magic of your own locality."[11]

In Herodotus's day the three most important goddess festivals were The Festival of Bast (Hathor) at Bubastis, The Festival at the Temple of Isis for the Mourning of Osiris at Bubastis (also celebrated at Abydos), and The Festival of Lights of Neith at Sais. Other major festivals might have been The Birth of Ra at Heliopolis and The Opet Festival held in Thebes. In addition, smaller, regular festivals were held at Philae every ten days to celebrate the weekly visit of Isis to the tomb of Osiris located on the nearby island of Bigeh.[12]

One way or another the feast day always uses one of the myths of the gods and goddesses as its focal point. The ancient Cairo Calendar uses those myths as a means of divining whether the day is auspicious or dangerous. For example, Koiak 13 (the thirteenth day of the fourth month in the season of Inundation) was said to be The Day of the Going Forth of Hathor, Her Heart Pleased in the Presence of Ra. The calendar's advice was to make a holiday in one's house. I find it most enriching to revisit a particular myth on its day as a means of studying the aspects of the Goddess, attempting to learn how consciously to heal an old wound or manifest a new possibility based on the inherent wisdom of the myth.

The festival inscriptions that I've used to reconstruct the festivals of the goddesses span three thousand years of history from the predynastic kings to the Greek rulers of Egypt who continued to celebrate many of the feast days. The calendar inscriptions come from a variety of sources, those found on stelas; on temple walls at Medinet Habu, Dendera, Esna, and Edfu; at the Temple of Mut at Karnak; and on several papyri, including the Papyrus Harris, the Cairo Calendar, and others.

The reader should note that Gregorian Calendar dates in parentheses following the Egyptian festival dates are only approximate. They are as close as I can get, given that the Egyptian calendar was lunar, each month ideally beginning with the new moon. The feast days are moveable, however, given the changing phases of the moon and the other astronomical data that the ancients used to determine the festival calendar.

The neters of old were the gods and goddesses of nature.

THE FESTIVAL CALENDAR OF THE ANCIENT EGYPTIANS

Egyptian Calendar	Gregorian Calendar	Festival Day	Life Cycles and Celebrations
		Akhet (Winter) Season: Inundation	
THUTHI			
1	July 19	The Rise of Sothis as Isis	Renewal, Beginnings, Creativity
		The Opening of the New Year	Renewal, Beginnings, Creativity
7	July 25	The Feast of Anket	Renewal, Abundance, Fertility
20	Aug 7	The Inebriety of Hathor	Love, Ecstacy, High Emotion
PAOPI			
5	Aug 22	The Feast of Hathor and Min	Love, Marriage, Fertility
15	Sept 1	The Opet Festival	Love, Marriage, Abundance, Childbirth, Renewal
21	Sept 7	Neith Goes Forth to Atum	Loss, Constraint, Wisdom, Sacrifice
HETHARA			
1	Sept 17	Hathor's Birthday Feast	Love, Joy, Renewal, Ecstacy
17	Oct 3	The Lamentations of Isis	Loss, Mourning, Sacrifice, Death
21	Oct 8	The Feast Day of Ma'at	Balance, Healing, Fall Equinox
30	Oct 16	Opening the Bosom of Women	Fertility, Motherhood
		The Feast of Isis in Busiris	Fertility, Motherhood
KOIAK			
17	Nov 2	The Plucking of the Papyrus for Hathor	Joy, Friendship, Love
27	Nov 12	The Osirian Mysteries: Isis Seeks the Body of Osiris	Loss, Mourning, Sacrifice, Death
28	Nov 13	Isis Grieves the Loss of Osiris	Loss, Mourning, Sacrifice, Death
29	Nov 14	Isis Rejoices as She Finds Osiris	Loss, Mourning, Sacrifice, Renewal
		Pert (Spring) Season: Sowing	
TYBI			
19-20	Dec 4-5	The Voyage of Hathor to Nubia	Separation, Travel, Independence
20	Dec 5	Bast Goes Forth from Bubastis	Love, Motherhood, Healing, Magic
28-30	Dec 13-15	The Voyage of Hathor to Egypt and Her Father	Travel, Reconcilation
MECHIR			
1-3	Dec 16-18	The Voyage of Hathor to Egypt and Her Father (continued)	(See Tybi 28-30)
6	Dec 21	The Feast of Isis the Black Cow	Mourning, Regeneration, Motherhood
		The Festival of Raising the Djed of Osiris	Resurrection, Winter Solstice
10	Dec 25	The Birth of Ra, Child of Nut	Fertility, Motherhood
		The Birth of Horus, Child of Isis	Fertility, Motherhood, Winter Solstice
19	Jan 3	Isis Returns from Phoenicia with Osiris	Mourning, Reunion
21	Jan 5	The Voyage of Hathor to See Her Seven Sisters	Gifting, Sisterhood, Childbirth
24	Jan 8	Isis Greets Min in Coptos	Fertility, Creativity

Egyptian Calendar	Gregorian Calendar	Festival Day	Life Cycles and Celebrations

Pert (Spring) Season: Sowing

PAMENOT

5	Jan 19	The Brilliant Festival of the Lights of Neith	Crone Wisdom, Feminine Power

PARMUTI

20	Mar 5	The Blessing of the Fleets by Isis	Travel, Protection
28	Mar 13	Isis Births Horus the Younger Hathor Births Ihy	Motherhood, Fertility, Family, Beginnings, Spring Equinox

Shemu (Summer) Season: Harvest

PACHONS

1	Mar 16	The Feast of the Hand of the God	Fertility, Sexuality, Abundance, Marriage
6	Mar 21	The Pregnancy of Isis/Nut	Motherhood, Protection, Family, Growth, Abundance, Spring Equinox
15	Mar 30	The Festival of Renenutet	Harvest, Thanksgiving, Abundance, Protection
19	Apr 3	Isis Finds Osiris	Mourning, Loss, Reunion

PAYNI

1	Apr 15	The Great Festival of Bast at Bubastis	Love, Marriage, Motherhood, Joy Ecstacy
26	May 10	The Going Forth of Neith along the Water	Completion, Magic, Protection, Rebirth

EPIPHI

1	May 15	The Hierogamos of Hathor and Horus	Love, Marriage, Family, Joy, Reunion
4	May 18	The Conception of Horus	Fertility, Abundance, Beginnings, Renewal
5	May 19	Hathor Returns to Punt	Crone Power, Parting, Reconciliation
7	May 21	The Sailing of the Gods after the Goddess	Travel, Reconcilation
30	June 13	The Festival of Mut: Feeding of the Gods	Thanksgiving, Abundance, Sacrifice

MESORE

3	June 16	The Feast of Raet (Pakhet)	Crone Power, Protection
		The Feast of Hathor as Sothis	Renewal, Beginnings, Creativity, Summer Solstice

The Epagomenal Days

1	July 14	The Birthday of Osiris	Births, Renewals, Beginnings, Endings
2	July 15	The Birthday of Horus the Elder	Births, Renewals, Beginnings, Endings
3	July 16	The Birthday of Seth	Births, Renewals, Beginnings, Endings
4	July 17	The Birthday of Isis (The Night of the Cradle)	Births, Renewals, Beginnings, Endings
5	July 18	The Birthday of Nephthys	Births, Renewals, Beginnings, Endings

The Season of Inundation

Goddess of scribes, Seshat records the deeds and years
of life in the akashic records.

THE RISE OF SOTHIS AS ISIS AND THE OPENING OF THE NEW YEAR

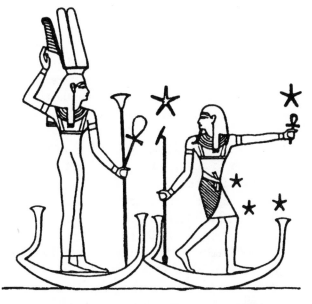

Isis (the star Sirius) and Osiris (the constellation Orion) appear together on the horizon at the New Year.

Appropriate for Days that Celebrate

- Abundance
- Fertility and Creative Endeavors
- A New Business
- A New Home
- Spring/Renewal
- Any New Year Celebration
- The New Moon in Leo
- The Rise of the Dog Star

How does the world begin? Storytellers in all cultures throughout time devote themselves to answering that question by recalling the acts of divine creation. It may feel odd to us to celebrate the new year at the end of summer, as the Egyptians did. Those of us accustomed to the Roman calendar begin our year in January. We've grown used to thinking that as days lengthen after the winter solstice, so the new year grows. Even Porphyry found the Egyptian summer New Year Festival unusual: "not in Aquarius, as for the Romans, but Cancer."[1] Nevertheless, Porphyry understood that the celebration could only occur when a natural phenomenon signaled *Zep Tepi* and the beginning of the regeneration of the world.

Historically, the new year in ancient Egypt began on summer solstice. In the Pyramid Age, the festival celebrated the birth of Ra, the sun god; the new year; the rising of the star Sirius; and the coming Nile flood.[2] The river, indeed, was the lifeblood of Egypt. Without its rise, life would have been impossible. Living in a desert landscape, the Egyptians depended upon the annual flood to fertilize the soil and water their crops.

One of the most amazing rivers on the planet and the longest, the Nile runs south to north (unlike most rivers, which run north to south). It travels over four thousand miles, cutting through the Sahara Desert and carrying enormous volumes of water. On either side of the river between the mountains narrow bands of green fields appear, until the river fans out into swampland near the Delta. As the river runs through this parched land, it restores to the people living on its banks the fertile soil necessary to survive agriculturally for another year.

The Inundation that annually rejuvenated Egypt was a complex chain reaction that began in the mountainous regions of central Africa. When the summer heat melted the snow on the mountaintops, these waters overflowed into two lakes, Lake Albert and Lake Victoria. These two sources merged in Uganda into a stream called River of the Mountain, then entered onto the plains of Sudan, creating one of the main tributaries of the Nile. This overflow combined with flood waters caused by the torrential rains elsewhere in the Ethiopian highlands. Thus, two burgeoning tributaries, the Blue Nile and the White Nile, simultaneously overflowing, merged in the Sudanese city of Khartoum.

The ancient Egyptian new year arrived after a long, hot, dry period, a seasonal dead zone that we would equate with our winters. When the floods arrived, all agricultural work stopped because everything—the fields and sometimes even the houses—were underwater. Not only did the flooding Nile signal a new agricultural year, but it also signaled new construction on the plateau as well. Extensive building projects—the building of pyramids, tombs, and temples on the plateaus—were enacted during the season of Inundation, primarily because the heavy blocks of stone could be floated easily downstream from their quarries during the flood season. Besides, there was plenty of labor for the projects, since the farmers could not access their fields and needed work to support their families.

Curiosity over the source of the Nile gave rise to many legends in the ancient world and has sparked a number of explorations in the last two to three hundred years. Herodotus, the Greek historian writing about his travels in Egypt around 446 B.C.E., set out three possible reasons for the Nile flood. One legend asserted that the Nile rose as a result of a prevailing summer wind that blew the river water toward the sea. Another suggested that the waters came from the ocean, which was imagined to be a stream of water encircling the entire world. Yet another allowed that the water was the result of melting snow in Africa. Herodotus rejected all three explanations as preposterous, deciding that the flood was caused by rain further south in Africa.[3]

The Egyptians, of course, had their own theories. Prominently carved on a rock on Seheil Island overlooking the first cataract of the river resides a monument called the Famine Stela. It recalls the legend of how widespread drought and starvation caused the Third Dynasty pharaoh Djoser to send his emissary on a quest to find the source of the Nile. (Djoser and his very learned high priest and architect, Imhotep, built the famed Step Pyramid on the Saqqara Plateau during the Third Dynasty.)

Apparently for many years the floods had been insufficient, resulting in a seven-year famine throughout Egypt. Foods were scarce, children were hungry and crying, and people were robbing their neighbors simply to survive. Eager to remedy the situation and bring peace to his kingdom, Djoser decided that perhaps he'd been praying to the wrong god or goddess. When the king asked his high priest to whom he should pray, Imhotep did not know. Djoser suggested that Imhotep sail south to the river's source until he discovered the answer. Imhotep rowed all the way to Elephantine Island and the first cataract. There he discovered that the Nile emerged from an underground double cavern, called *Qerty*. Inside this cavern lived Hapi, the river god, who was an old man with pendulous breasts. From these breasts flowed all the goodness and sweetness of life. When the time of Inundation came, Hapi rose up and rushed forth like a vigorous young man, extending his might throughout the country.

The guardian of Qerty, Imhotep discovered, was a ram god named Khnum who had the power to open or close the doors through which the waters came. On the Island of Elephantine, Imhotep found a ruined temple dedicated to Khnum and to his three consorts, the goddesses Anket, Satis, and Sopdet (who is a form of Isis as Sothis). Knowing now that the floodgates of the Nile were controlled by three goddesses and a god, Imhotep scouted about the environs of Elephantine, noting which flora and fauna in the area might provide suitable offerings for the divine guardians of the river.

After Djoser prayed and sacrificed as Imhotep had instructed him to do, Khnum appeared to the king in a vision, saying, "I am Khnum, the Creator. My hands protect and make sound every body. I mold men from the clay and make their hearts to beat. I am he who created himself. I am the primeval watery abyss, and I am the Nile that rises. I am the guide and director of all men, the Almighty, the father of the gods and the possessor of the earth." Khnum then complained that the Egyptian people had forgotten him and that none offered sacrifices to him any more. To appease the god, Djoser reopened the temple, devoted tracts of land to Khnum and the goddesses, and levied taxes on the products of the region, all of which would be used to support a new priesthood of Khnum and the southern goddesses.[4]

The oldest festival in ancient Egyptian history, the celebration of The Opening of the New Year began with the rising of Sirius who appeared as the goddess Isis cloaked in robes of brilliant light. Sirius forms a part of the constellation Canis Major, sometimes referred to as the Dog Star. Of all the stars in the sky throughout the year, Sirius shines the brightest. The Greeks called the star *Sothis*, meaning "The Soul of Isis." The Egyptians called her *Sept* or *Sopdet*, referring to the concept of preparing for the future. The ancient feast day name *Per Sopdet* may be translated as "The Coming Forth of the Goddess."

When King Khufu of the Fourth Dynasty built the Great Pyramid around 2460 B.C.E., he aligned its energies with the fecundating light of Sirius. Recently, scientists have learned that the narrow shafts in the Great Pyramid, which we once considered simply air vents, are actually precisely aligned byways intended to channel the starlight of Sirius (Isis) and Orion (Osiris) through the dense walls into the sarcophagus chambers. In this way the ancient priests used this directed starlight for the purpose of the soul's renewal.[5]

This connection between the star Sirius and the renewal of the dead occurs throughout every pyramid tomb in Egypt. The first inscribed tomb of any pharaoh was that of the pharaoh Unas, last king of the Fifth Dynasty. His Pyramid Text (Utterance 302) makes clear the ways in which Isis is responsible for resurrecting the soul and bringing the king to his heavenly eternal life:

> The sky is serene. Sothis lives. She shines,
> a peaceful flame.
> Unas lives eternal as the son of Sothis,
> As the child of Isis, as a child of Light,
> As Earth is child of the Cosmos.
> Unas is pure. She is pure,
> As are all the gods whoever lived since
> the beginning of time
> In the worlds above and in the worlds below.
> They have been born the Imperishable Stars
> Living within the *Meshetiu*, which shall never die.[6]

The goddess who appears robed in brilliant starlight possesses immense magical power as the Great Awakener. Bronze statuettes of Isis as Sothis found in the Late Period depict her as a young woman wearing the crown of Upper Egypt surrounded by a pair of horns. Her curved horns are made to resemble extended arms uplifting a five-pointed star, the ancient symbol of the mortal soul elevated to divine being. By the power of her enduring love Isis awakened her beloved husband/brother Osiris from death and elevated him to life with the "Imperishable Stars," those circumpolar stars that never set and never fade. Perhaps the tears the grieving goddess cried over the lifeless corpse of her husband were the magical potion that restored him to life.

On the Island of Philae, where Isis grieved the death of Osiris, the Egyptians dedicated a beautiful, spacious temple. Here, men and women gathered to mourn with Isis, to learn the myths and stories carved on the temple walls, and to sing her praises. Legends spread stating that the magical source of the river was the Island of Philae itself. Some said that the Nile began to flow on the "Night of the Drop," when the tears that streamed down the cheeks of the grieving Isis fell into the river, causing it to overflow. Others declared that the river arose from an underground source beneath the cult statue of Isis, flowing out of the temple and into the Nile from a spot located between the goddess's feet.

So prevalent are the Isis myths that her stories link, touch, incorporate, and illuminate the stories of nearly every other Egyptian goddess until Isis comes to embody the divine Feminine in all aspects, wherever she may appear. In Elephantine she was associated with the goddess Satis, a flood goddess who accompanies Khnum. At Saqqara in the Pyramid Text (Utterance 965) found in the tomb of Pepi, it is said: "Sothis is your beloved daughter who prepares yearly sustenance for you in this her name of 'New Year.'"[7]

Linked with the cow goddess Hathor at Crocodilopolis, Isis appears as Renpet, goddess of the year. On her head she wears a palm shoot indicative of her powers of rejuvenation.[8] Renpet exhibits a talent for precise calculation and accounting, taking care of tracking the precise growth and progress of all forms in time. Thus, Isis becomes both the goddess of the calendar and a goddess of eternity who provides a long life of many, many years. At the Temple of Osiris in Abydos, the pharaoh Seti I depicted Isis as Renpet, goddess of eternity, who accompanies Ma'at goddess of truth.[9] At Dendera, priestesses likewise praised Isis as Renpet by saying, "Years are reckoned from her shining forth."[10]

A small ivory tablet inscribed by Hor-Aha, second king of the First Dynasty, established the age-old connection between Isis and Sirius. The inscription calls her simply "Sothis, Opener of the Year, Inundation 1."[11] The tablet depicts a seated cow-woman (the ancient sign of the goddess) as Sirius with the symbol of the year between her cow horns. This same hieroglyph appears nearly three thousand years later in the ceiling zodiac at the temple of Dendera where the festival calendars and the horoscopes are kept. Here she is called by her triune name: Hathor/Isis/Sothis. The inscription is dedicated to "She who shines into her temple on New Year's Day."

When Sirius reappeared as the morning star, the altars at the Isis temples of Philae, Karnak, and Dendera opened early. The portals and sanctuaries were aligned so precisely with the heavenly bodies that the predawn starlight of Sirius was projected onto the cult statue of the goddess.[12] Thus began a season of preparation for the coming agricultural year and a celebration of the flood and fecundity of earth.

A major part of the renewal festivities included rites enacted at the tombs of the ancestors to assure their continued eternal life. Records from the Middle Kingdom show pharaoh Khnumhotep II following the statues of his ancestors into the temple and providing them with offerings of bread, beer, wine, incense, and joints of beef.[13] New Year's Day in every temple of every neter across the land began with the lighting of the wicks for the temple fires. The glowing lamplight symbolized the eternal life of the spirit world and the flame's earthly burning became a mirrored image of the glittering light of Sothis in the sky. The lighting of the fires was usually followed by a sacred eucharist, an offering of bread and prayers glorifying the dead, enacted in the northern corner of the temple —the northern region being linked

with the souls of the ancestors, the Imperishable Ones who were the circumpolar stars.[14]

When at the beginning of each new year Isis showed herself as the brilliant star Sirius emerging from the shadowy realm of night below the horizon, the ancients said that the goddess had come to announce the rejuvenation of the world and the resurrection of the god on earth. In all the heavens, in any season or in any hemisphere, Sirius is the brightest star in the sky other than our own sun. It is an amazingly accurate marker of yearly time on earth. It appears to rise helically nearly every 365.25 days (actually 365.242392 days), which is a more accurate celestial indicator of the true passage of time than simply depending on either a lunar cycle of thirteen, thirty-day months per year, or on a solar cycle of 365 days per year. In fact, it was the observation of Sirius that gave the Egyptian astrologers of the Greek-born Ptolemaic kings the idea of creating a leap year to account for the extra day created every four years. On New Year's Day Sirius always appeared as the morning star seen just above the horizon at dawn. The Egyptian priests likewise noted that the Nile floods seemed to coincide with the reappearance of Sirius. Thus, it was believed that Isis as Sothis and the rise of the river were related.

Even reliable Sirius is a little bit off—just enough so that in 120 years its rise would still lag behind by a day. In 7000 B.C.E. the star probably rose near Aswan around May 16. By 3500 B.C.E. it rose around June 12; and probably it rose on July 19 around 300 B.C.E. during the period of time just after Alexander the Great conquered Egypt. Thus, this "official" date of New Year's Day in Egypt is a remnant of the Alexandrian festival calendar.

When priests celebrated the *Wept Renpet* (Opening of the Year), they also celebrated the traditional birthday of the king. No matter the true date of his birth, the king's birthday in predynastic times nearly always coincided with the birthday of Ra.[15] Because the pharaoh was equated with the sun, he embodied the Divine on earth. It was more important that the spiritual and mythical implications of his rejuvenation be emphasized than that his actual birthday be observed.

Because of the time-honored association of the birthday with renewal, the New Year's Feast became an important festival in the king's life. It involved his ritually hoeing the ground and breaking the dirt clods in preparation for the sowing that would follow the receding waters. Linking this feast day with the god Osiris who taught the Egyptians the art of agriculture, the pharaoh was addressed as the Savior of the People. As part of the ritual, both the ground and the king were ritually sprinkled with holy water.

When Queen Hatshepsut assumed the throne in the Eighteenth Dynasty, her scribes wrote a proclamation of her ascension, indicating that her father, Thutmose I, had recognized the auspiciousness of crowning his daughter as pharaoh. During a New Year's Day festival, he had a vision that Hatshepsut's reign would mark many peaceful years in his kingdom—and so it was. After his death, his heir apparent celebrated The Feast of Shed on her New Year's Day. Identified with the predynastic god Shed, lord of the deserts and paradise, Hatshepsut called herself Savior of the People. Then purified with holy water, she entered the house of the gods and stood in their presence. At last, she made her circuit of the North Wall of the capital city, led by the god Horus himself.

Probably the flood festival retained some of its associations with Ra because of a myth of how the sun god arose from the watery abyss at the dawn of creation. It was said that the world lay in darkness, and forms remained invisible. Then Atum, the divinity of being and nonbeing, called out into the darkness. A thousand-petaled lotus began to rise from the murky, watery depths of the primordial soup. As the lotus rose, the petals slowly unfurled, and the golden light of the sun emerged from the flower. This sun child is called Ra, or Horus, or Nefertum. The child's mother, Nut, the sky, is that fragrant opening flower arising from the watery cosmic world.

In addition to its associations with the birth of the sun, the flood festival likewise recalled the myth of the great world Flood that carried to Egypt the civilizing divine beings Isis and Osiris. Scattered throughout ancient texts one finds allusions to a tale of apocalypse and regenesis called *Zep Tepi* (the First Time) that was followed by the arrival of the major gods and goddesses in a fleet of boats. Among these occupants arriving in Egypt from a mythical land across the waters called *Ta-Neteru* (Land of the Divine Beings) were not only Isis and Osiris, but also Ra, Thoth, Seth, and Nephthys.

While the world was still flooded, these divine boats moored upon rocky shores in the eastern hills surrounding Abydos. When Osiris first set foot upon dry land, a cypress tree sprang up. When the flood waters receded, the boats were left upon dry land in what is now essentially the Eastern Desert. The earliest prehistoric temples to Isis and Osiris can be found here in Abydos, the birthplace of the neters who were the gods and goddesses of Egypt. Far out in the desert lie remnants of what were purported to be the seafaring vessels in which the divine ones arrived. Symbolically moored to rocks, they have been discovered only in recent years, having been covered over by five millennia of obscuring sands.[16]

During the Egyptian new year the pharaoh, priests, and priestesses—indeed, the entire civilization of Egypt—reenact-

ed the intermingled sacred stories of how the world arose from the Great Flood, of how Osiris was magically resurrected from death, of how the holy child was born to avenge his father, and of how Isis became the *Salve Regina* of all peoples.

Similar festivals had other names as well, depending on how much influence another divinity had at that place in time. During the New Kingdom, Seti I celebrated the new year by building a beautiful divine resting place for the god Amun at Karnak.[17] At Aswan, Seostris III made new year's offerings of grain and cattle to the god Khnum and to his consorts, Satis and Anket.[18] Since every temple in the land celebrated the day in one way or another, the feast day became known as The Festival of All the Gods and Goddesses.

Throughout time, however, Isis and Sirius remained the pivotal images on which initiation into a new year depended. When Isis as Sothis appeared to evoke all new beginnings, abundance, joy, peace, and resurrected life, the priestesses celebrated by reciting this prayer from the Sallier Papyrus:

> The water stands and fails not, and the Nile carries a high flood. The days are long, the nights have hours, and the months come aright. The Gods are content and happy of heart, and life is spent in laughter and wonder.[19]

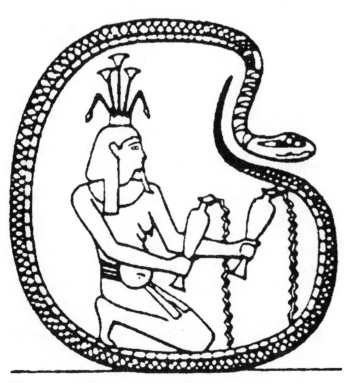

The river god Hapi rests within the cosmic serpent, awaiting the time of his appearance as the Flood.

Activities

1. Recall a time in your life when you were starting anew, perhaps after a divorce or when moving into a new home. Perhaps your new life followed the birth of a child or a change in career. Investigate what had to die in your old life in order for the new life to emerge. How did that feel as you stood poised on the brink of change?

2. Explore what it means to be creative. Think about the most creative times in your life. Where did you live? How different did life seem then from the way it seems now? How was your time structured? What were you thinking, desiring, telling yourself on a daily basis? Can you duplicate any of that in your life now?

3. Make a list right now of ten things you want to manifest in the next six months. Be specific. Plant three seeds for each thing you want to manifest, then tend to them. Mark each seed with a popsicle stick to indicate what goal you are germinating, so that when you water the plant, you stay focused on what you are nurturing within yourself. Write a brief prayer to one of the abundance goddesses—Isis, Hathor, or Anket—asking her to guide you and to oversee your fecundity. Say your prayer each time you tend your plants.

THE FEAST OF ANKET

Anket, goddess of the flood, wears the feathered crown of Nubia.

Appropriate for Days that Celebrate

- Abundance
- A New Relationship
- Thanksgiving
- Sharing the Wealth

Herald of the floods and bringer of abundance, the fertility goddess Anket was sometimes called the Clasper or the Enveloper. The two tributaries that fed flood waters to the Nile were thought to be her arms. During Inundation these arms reached out to embrace all Egypt's fields. Anket's nurturance extended to all people as well as to the land, empowering and fructifying all with which she came into contact.

In her hand Anket held the *ankh*, which resembles a cross surmounted by a circle. The cross and circle signified male and female sexual unity. Joined together as the ankh, they became one unified symbol of life and rebirth. Because Anket was a goddess of fertility and abundance on earth, her capacity to evoke the sensual and sexual nature of all humans and animals was heightened. Another of her sacred symbols was the cowrie shell because it bore the shape of the vagina. Self-generated, Anket gave virgin birth to the sun. She was also linked with a number of creation gods, including Min, the ithyphallic god of Coptos. On the Island of Elephantine two other gods, Khnum, the ram-headed god, and a semetic god named Yehebu proclaimed her as their consort in their island temples.

Her priestesses sang her praises as they made their temple offerings by reciting the following Hymn to Anket:

Thou art the bringer of food.
Thou art the mighty one of meat and drink.
Thou art the creator of all good things.
Thou fillest the storehouses.
Thou heapest high with corn the granaries.
Thou hast care for the poor and needy.[20]

Because the goddess is connected with the flood's fertility, Nile water was the main ingredient in ancient aphrodisiacs, love potions, fertility charms, and a vivifying tonics. When at Philae on the day of Inundation the priests of Isis first perceived that the Nile was rising, they ceremoniously cast coins, gold, jewelry, and precious gifts into the waters.[21] Thus the riches that the Nile had given the Egyptians were ritually returned to their source, assuring another year of abundance and prosperity. The reciprocal offering intimated that renewal could only be brought about through some significant sacrifice. The gold and jewelry reminded the people of the sacrifice of Osiris, who was cast into the Nile in a jeweled coffin and whose mysteries were celebrated later during the season of Inundation.

Even in the mid-1800s A.C.E., a Coptic Christian new year festival recalled this occasion with religious rites that included a burlesque carnival wherein a mock king was symbolically condemned to death by burning. Amid great pageantry, the king later emerged phoenix-like from the ashes.[22] In a similar Greek Orthodox ritual, priests throw a silver cross into the sea. Likewise, an Islamic version of the feast day called Arousat-el Nil involves throwing into the waters a clay statue of the Goddess called the Bride of the Nile. While some mythologists see this rite related to the sacrifice of a young girl in more ancient times,[23] it is more likely connected to Christ through Osirian tradition and to the goddess of the flood, Anket.

Rather than sacrificing a young girl, the ancient Egyptians offered more appropriate offerings to Anket. The pharaoh Amenhotep II so loved the goddess that he extended her festival in Nubia to three or four days. The supplies reserved for the sacrifice and temple feast included beer, bread, oxen, geese, wine, incense, fruit, and "every food and pure thing."[24]

Less elaborate Anket rituals were celebrated by the common man, however. The ancient Greek historian Herodotus reported observing the Egyptian peasants celebrating the Feast of Anket by sitting in the doorway of their houses eating fried fish.[25] Eating fish in most regions of Egypt was a religious taboo because myth recalled that the phallus of Osiris was eaten by the oxyrhynchus fish; however, on certain days the eating of fish was sanctioned. This was probably one of those occasions. In the mythic tradition, Isis was the fish who ate the phallus, impregnating herself with the son of Osiris. In the Greek language, *delphos* signifies both "fish" and "womb." According to certain Greek superstitions, fish were considered an aphrodisiac and commonly eaten on Friday, the day considered sacred to the goddess of love, Aphrodite.

The Feast of Anket originated in southern Egypt and was probably celebrated as early as 4500-5000 B.C.E.[26] Anket's feathered headdress has been seen as similar to those worn by central African tribesmen, and she was most deeply revered in the land of Nubia. Excavations on the Island of Elephantine suggest that in predynastic times a temple to Anket was erected there and was originally oriented toward Sirius, the star that heralded the flood.[27]

Throughout history, Egyptian kings attributed the source of the Nile to a cleft in the rocks below this temple. As the Nile tumbled between the rocks of the cataracts and through the falls, the forceful jets of water perhaps resembled flying arrows. Thus, Anket, who holds in her hand a quiver of arrows, was also called She who Shoots Forth.

While the predictable rise of Sirius heralded the coming flood and new year on Thuthi I, the actual day celebrating the arrival of the flood waters was less predictable. The Feast of Anket was a moveable feast that usually followed The Opening of the New Year by a week or so. Two reasons account for this. First, the Nile flood was dependent on the weather in central Africa, and we all know how variable even predictable weather patterns can be. Second, once the flood began, it took several days for the water first observed in Southern Egypt to arrive in Memphis, the old capital city in Northern Egypt.

One can imagine, then, that if the civil calendar relied on the first appearance of the water, the various cities en route would all be celebrating their new year on different days. If that happened, chaos would erupt. The true start date of the calendar mattered a great deal to the Egyptians, since the new year also marked the state-sanctioned birthday and inauguration of the pharaoh, as well as the anniversary of his reign.[28] Remember that Egyptian years were not counted forward or backward from the birth of Christ. They were counted forward from the reign of the pharaoh; for example, a particular year in Egypt might be nunbered Year 14 in the reign of Ramses II.

On the other hand, for thousands of years people were accustomed to celebrating the new year with the arrival of the flood in their city. An agrarian people, they craved the manifestation of their neters in the natural cycle of the world. In true Egyptian style, the solution was to celebrate two flood festivals—as Amenhotep II did: one standard and predictable day heralding the flood and opening the year, and the other celebrating the actual arrival of the flood. It seems fitting that the result was two celebrations: one aimed at the manifestation of the pharaoh as Horus, son of Osiris, on earth, and the other aimed at the manifestation of the flood waters as the gift of the goddess.

Activities

1. Perhaps you have not honored the goddess within for some time. Perhaps she has been forgotten like Anket. Now is the time to celebrate her. Buy some flowers for her window or garden. Find out what kinds of food she likes and cook a good meal. Buy some perfumed bath salts and bathe in them. Toast your powerful, fecund, creative power.

2. Imagine yourself as the flood about to burst forth. What have you been longing to do? What has been holding you back? Break forth and flow toward your future destiny. Write this journey toward your deepest self in your journal.

3. Turn your thoughts to a new goddess, one you may not know. Find some books in the library and read up on her myth. As you read, make notes of key words and phrases that leap out at you. Ask yourself in what ways your life reflects the goddess's heroic journey. Compile a list and sculpt a poem about her as if she inhabited your body.

THE INEBRIETY OF HATHOR

Appropriate for Days that Celebrate

- Lovers
- Motherhood
- Ecstatic Visions
- Wine-Tasting Party
- Eradicating Bad Habits
- Menstruation
- Divination
- Trickster Energy
- Days of Rage and Anger

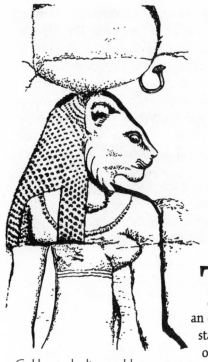

Sekhmet, the lion goddess, wears the sun disk encircled by a cobra, emblematic of the warrior power.

The sacred drunkenness of ancient Egyptians provided an entrance into the altered state of a shaman where one might experience high forms of ecstatic union and feelings of love. It offered humanity a means of approaching the Divine and of experiencing an intoxication of the Goddess and the God. For the most part, drink and song served a religious purpose, as they do in a number of modern religious practices. Drink allowed the devotee an opportunity to participate in the mystery of life, to understand the nature of offering and sacrifice, and to focus on the abundant love readily offered to humankind from the hand of the Divine.

As in any culture, drink also offered the chance to relax and cast off worldly cares. It signaled a communion of friends, a circle of people enjoying each other's company. Many, many ancient tombs depict scenes of feasting, drinking, dancing, and music. As it was in this world, so the ancient Egyptian hoped that the party of friends, gods, and goddesses would continue in the world beyond.

No one loved a good party more than an ancient Egyptian. Even though the wisdom texts of sages and philosophers throughout time warned against excessive drink, the common man, then as now, occasionally had a few too many cups of the fruit of the vine. Egyptian literature is filled with banquet poems, such as the following translated by Noel Stock:

> My girlfriend's house is rowdy.
> That is the only way to describe it.
> Crammed all night with song and dance
> Overflowing with beer and wine.
> I consider how melodies entwine,
> And finally, after my love has forced the issue
> With a request for active cooperation,
> I conclude that the night has been worth it, after all.
> And tomorrow?
> The same old song.[29]

Beer was a staple of the Egyptian diet. Because the brewing and fermentation processes made it more potable and healthful than water, beer was offered at breakfast, lunch, and dinner. Wine, however, was the favored drink of great celebrations. During this particular festival to Hathor, goddess of wine, alcoholic beverages were in plentiful supply, as were a number of psychotropic plant ingredients. Certainly the wine served at this festival was not the same as that which creates an ordinary down-home kind of inebriation. The wine of Hathor produced an ecstasy of the Goddess, a sacred and enthusiastic kind of drunkenness that both excited and soothed at the same time.[30]

While beer was the main drink of choice, Robert Masters, who has intensively studied the myths and rituals of

Sekhmet—the lioness goddess linked to Hathor—believes the drink served here contained opium and plants from the solanaceae family, among which might be belladonna, jimson weed, or wormwood.[31] He believes this festival to Hathor actually celebrated Sekhmet, and he calls it The Day of Sekhmet's Repulsion of Seth, giving the date as Thuthi 25, which is close enough for us to consider it the same celebration.

According to legend, the feast day was established by the sun god Ra to celebrate the new year, to commemorate the saving of Egypt from the ravaging power of Sekhmet, and to honor the priestesses who served Ra and Hathor. Here's how the story goes:

Ra, who created heaven and earth as well as himself and humankind, ruled all earth in peace for many thousands of years; but as he grew old, his human subjects began to make fun of him and no longer offered him their adoration. Outraged and disgusted, the old god summoned to him all the gods and goddesses of heaven, soliciting their advice. Nun, god of the cosmic abyss, suggested sending forth Ra's fiery eye—his daughter Hathor-Sekhmet, the lioness—to deal with them. The idea delighted Ra, who imagined his quaking, irreverent human creatures fleeing into the mountains and deserts, trying to hide for fear of Sekhmet.

Now, Sekhmet went forth to do her father's bidding, devouring every man, woman, and child that crossed her path. She killed the wicked and the good. She ravaged all the land in both Upper and Lower Egypt, through the mountains and savannahs east and west of the river. She started in Nubia and ate her way north toward the Delta. The river ran red with the blood of those she had slain. As the fierce goddess waded through the carnage, her feet became tainted red with the blood of her victims.

I suspect this legend refers to an actual destruction of the world by heat and fire. Certainly the Egypt of 10,000 B.C.E. was a different place—a beautiful, lush savannah, teeming with life. Some geological disaster, created by either global crustal displacement or the worldwide floods and famines that were a consequence of the Ice Age, caused the Sahara savannah to turn to desert. Thus, all life in Egypt shrank to occupy only the delta lands and the narrow strip of green earth on either side of the Nile. To continue our story:

Ra looked down upon the havoc Sekhmet had created, and he was shocked and remorseful. His daughter was a great warrior, but her blood thirst knew no bounds. Gently he tried to reign her in, saying, "Thou has done what I asked thee to do." But Sekhmet replied, "By my life, I love the taste of blood. My heart rejoices and I will work my will upon humankind!" She would not be

deterred. Ra, realizing he had made a grave mistake, felt pity for all life and for his human creations, but no god nor human could stop Sekhmet, for her will had to be turned.

Ra turned to Thoth, god of wisdom. Thoth collected his messengers and said, "Go swiftly as the blast of a storm to Elephantine, where the river rages among the rocks. Bring me from there the fruit that causes sleep, the fruit that is scarlet and its juice crimson as human blood." The messengers flew off fast as the wind and returned with the poppies Thoth had requested. Then Ra commanded the women of his sacred city of Heliopolis to crush barley to make beer and mix it with the juice of the poppies, henna, and other magical ingredients, according to the recipe of Thoth. The women of Heliopolis made seven thousand measures of this beer the color of blood.

At dawn, this soothingly sweet red brew was laid down in a pool in a field outside the city, where Sekhmet might find it. And find it, she did. Thinking it was the blood of her victims, the lioness lapped up the mixture until it was gone. When the potion took effect at last, the heart of the fierce Sekhmet was soothed. She lay down, laughed aloud, and purred, no longer wanting to seek revenge. At last, stretched out in the field for a sweet sleep, she transformed herself into the gentle, nurturing, loving cat goddess Bast.

This feast day linked to the myth of Sekhmet falls in the first month of Inundation as a promise of renewed life to come, but also as a reminder of the deadly hot, dry, parched life along the Nile banks during the recently passed dog days of summer. On some midsummer days the sun's intense heat in the mountains around Thebes causes temperatures to soar, reaching 120 degrees before noon. Thus, the first indication of the cooling season is just cause for celebration. The Nile's cooling flood waters, which arise during summer's thaw of the snowcaps in central Africa's mountains, are reminiscent of the sweet concoction that tempered Sekhmet and promises all the land a time of renewal and coming fertility.

On the other hand, this myth dispels any notion of Hathor as some eternally sweet, kind-hearted fairy godmother. It was no secret that the great goddess could become wrathful. In times of war, she was especially honored for doing so. All of us need outlets for our stress, our frustration, and our anger, and the festival of The Inebriety of Hathor provided just that for ancient Egypt's general populace. During the festival, men and women "freed themselves of all unpleasant feelings, resentment, and repressed, angry passion."[32] Similar festivals were celebrated at the end of battle, in order to pacify the goddess of war, so that there would be no more destruction. On such occasions, the people danced and played music to soothe the wildness of the goddess.[33]

Hathor's dual personality is quite intriguing. Her volatile temperament vacillates between extremes of military fervor and religious ecstasy. It doesn't surprise me that Richard the Lion-Hearted carried the emblem of Sekhmet throughout Europe and Asia during his Crusades. Sometimes, like the Red Queen in *Alice in Wonderland*, Hathor-Sekhmet gives the battle cry: "Off with their heads!"; while a moment later, as Hathor-Bast she becomes the sleepy-eyed Mistress of Inebriety, calling out like the caterpillar with his hookah, "Feed your head!"

It's important to remember that Hathor's drunkenness was a state, not of forgetfulness, but of learning to open the heart and mind. This was the kind of dizzying spiritual height to which a true goddess (and a high priestess embodying a goddess) might soar. Says Egyptologist C. J. Bleeker: "The intoxicant had a sacred significance, not so much because it provided pleasure, but particularly because it was the medium through which contact could be effectuated with the world of the gods."[34] Probably on this day divination was possible, as well as trance channeling and mediumship.

Transforming Anger

Goddess of the blood, Sekhmet wears the crimson robe. Her name means "The Power." Fiery, fecund, and magical—the energy of life itself—she is the scarlet woman the Hebrews warned about. As she is highly protective and a great spiritual warrior, it's not surprising that Big Daddy Ra sent her to do his work, and when it didn't turn out exactly as he'd planned, let her take the rap for it. (That ever happen to you?)

In the Egyptian tradition, Sekhmet is the crone aspect of the Goddess, the mother aspect being embodied by Bast and the maiden aspect ruled by Hathor. The three goddesses represent the stages of the blood mysteries ruling a woman's life as she moves from being lover, wife, and mother to being an elder woman of the tribe. Sekhmet rules that menopausal phase wherein the blood, no longer shed, was thought to be held within. It was believed that if a woman was not using her blood to create children, then the fecund fluid turned inward, marking a powerful time of self-creation and self-government that could produce visions and create magic. According to ancient beliefs, post-menopausal women were said to be carrying "the wise blood."

The power of woman to use her potent will and creativity for her own benefit, rather than for the benefit of a mate or child as she might have done in her Bast or Hathor phases, gave certain nonEgyptian members of the community the willies. The Greeks called her Medusa. The Powerful One, Sekhmet, now became the Feared One, the Gorgon, with her wild hair of snakes and fiery gaze that turned men to stone.

The blood mysteries are linked to the moon, as a woman cycles through the triple goddess phases every month. During ovulation she may feel like Bast with her gentle purring and luxuriating, but prior to and during menstruation she might feel more like the fiery Sekhmet. Highly potent in her magical knowledge, Sekhmet guards the gates of life and death. Monthly she allows a little death to happen; an ovum slips away and is gone. Just as quickly she regenerates the body, opening the way for a new cycle of potentiality. On the other hand, she may allow the egg to be fertilized, thus creating life but simultaneously marking another kind of death. Motherhood ends the maiden phase of a woman's life and moves her from focusing on self-expression in the outer world to a more inner focus wherein her energies are used to gestate the life she is now creating. If you get the idea that every birth creates a death, then you see how important is the domain of Sekhmet. In her crone phase, the goddess within very wisely chooses what to create and what to destroy. She uses her energies for posterity, coming to a phase where she passes on the wisdom she has learned to younger women in the community.

The important thing to remember about Sekhmet is that her rage is a manifestation of thwarted energy. We may have been told that nice girls don't rage, so we turn the anger inward. After a time, the anger festers, still growing and causing us pain. Unacknowledged anger creates illness. The truth is that energy in all forms is a blessing. As Yoko Ono put it: "Bless you for your anger. It's a sign of rising energy. Direct not on your family. Waste not on your enemy." Of course, one has to do something with all that rising energy. Using it creatively for your own benefit is one way to break the cycle that generated the anger in the first place.

Sekhmet can be a cure for depression, that dark cloak for repressed anger. That energy, that rage, needs an outlet. We feel it when our emotions overwhelm us. Then is a good time to reduce our responsibilities to others and go inward. Often I find that my own anger is created by somebody else's agenda and comes from coded messages that play on guilt. Usually the message is that I am not being as Bast- or Hathor-like as someone else wants me to be. I'm learning to stop and withdraw before becoming either enraged or despairing.

Often I pour my Sekhmet energy into divinations, either reading cards or considering astrological influences. At various times I've compiled a list of worries that plague me and put them inside a box with the shed skin of a snake. I ask the serpent power of Sekhmet to use her transformative energy to change the situation. Amazingly, when I come back to the box two or three months later, many of the issues have resolved themselves, or I have gained clearer insights into them.

In her book Amulets of the Goddess, Nancy Blair has a wonderful exercise for creating "Angry Dolls," which are similar to the poppets or voodoo dolls sometimes used in sorcerer's magic.[35] Rather than piercing my angry doll with needles and cursing my enemy, I make her face wild, energetic, and beautiful, then fill her with magical taming herbs or scents. Then the two of us dance in a creative process. I tell her how I feel and ask her to show me the best use of my energy in the situation. The point is that you are the vehicle for the transformation of Sekhmet's energy. Sekhmet makes no distinction. Her energy is neutral, a universal force that can be used to curse or to heal; but what you put into the universe is what you get back. Don't let your Sekhmet energy devour you in the process.

When I feel like tearing and shredding something, I use the energy to clean house, both physically and emotionally. I toss out things and obligations that no longer serve any purpose, so that I make an empty place where new life can enter. I've been known to rearrange furniture twice a month using my anger to create possibilities or alternate points of view. I go about cleaning all the mirrors and windows so that I can see more clearly what is being reflected and what is being shown.

Anything you can do for your body and yourself during times of tension, anger, and deep transformation will have a soothing effect on your nerves. Hot baths in hops are especially sedative, just like the soothing potion of beer that Thoth laid down for Sekhmet. (I don't recommend drinking alcohol as a way of dealing with anger, but I must admit my Grandmama's hot toddy was perfect for the cramps.) Massages with relaxing aromatherapy oils are wonderful means of turning Sekhmet into Bast. Learning one of the martial arts as a spiritual practice is a great way to build your sense of self-worth and store your Sekhmet energy at the same time. Sometimes kicking and shouting in a large group of other people who are also kicking and shouting is just what is called for!

What you do with your Sekhmet energy is a direct message to yourself about what and who you value. If you give yourself the message that you are taking care of and nurturing yourself, your own dreams, your own vision, your own wisdom, then you understand that you have less to be angry and resentful about. When all else fails, turn off the phone, quit answering the door, and curl up with a magical book. Tell yourself you are "wholing" up.

Sometimes Sekhmet energy is directed toward us from other people. Certain folks, even people we love—our parents, spouses, children, and friends—can wear us out simply by being present. People in the extremes of emotional conditions, in anger or depression, create fatigue and hopelessness in those with whom they are in contact. Because they generate large electrical fields of emotion around themselves, they require more and more energy to sustain their operating condition. Thus, they unconsciously pull in the energy of others. It is imperative that we remain conscious of our own energy flow, observe when our energy wanes, and retreat, if necessary, to protect ourselves. Psychologists may call this pattern codependence, but we are all susceptible to psychic vampirism. We are especially vulnerable when the "vampire" is someone we love.

If we monitor our own energy outflow, exercise restraint and control our emotions, we find that *sekhem*, or "powerful emotion," is a good thing. Strongly felt emotions are but another name for energy, which may be used for purposes either good or ill. Use your energy to envision and manifest a better situation for yourself and the world.

THE FEAST OF HATHOR AND MIN

Appropriate for Days that Celebrate

- Love and Marriage
- Fertility and Creativity
- Gardening
- The Birth of Animals
- Initiation of Any Activity
- Trickster Energy

Hathor holds the emblems of fertility and transformation.

The actual name of the celebration is "The Offering of the Phallus Which Makes All that Exists Fertile." During the Ptolemaic era, the phallus that was presented to Hathor was the phallus of Ra-Atum, the divine creative light that arises out of the watery depths of chaos at the dawn of time.[36] The day is no doubt linked with The Feast of the Hand of God on Pachons 1. This ritual seems to be a very ancient southern Egyptian traditional feast day, Hathor being the oldest goddess in Egypt and Min being the oldest god, predating even Ra.[37] The two divine beings, Hathor and Min, likewise predate the more popular goddess and god, Isis and Osiris, whose myths merge with theirs. The fertility rites associated with Hathor and Min on this date may have been the pattern for the later rites of Isis at Dendera held during the month of Hethara. The day evokes the powerful first creative union of male and female which prompts the recreation of the world, the people, the animals, and the crops.

The fecundity of the entire Egyptian nation was the main issue at stake, and the rite invoked the power of the goddess and god to bestow their fertility and blessings upon the reigning pharaoh and his wife or consort. Through the fertility of the king, the fertility of the entire land was assured. Such similar legends are the stuff of the romantic tales of King Arthur and Guinevere; if the land is dying it is because something (lost love) ails the king. At Medinet Habu, one can find the ritual depiction of pharaoh Thutmose III and his favored consort Merytre[38] celebrating the rites of Hathor and Min. The king is depicted as the ithyphallic god who presents himself to the horned goddess portrayed by Merytre. If not the queen herself, the high priestess of these rites during the Old Kingdom era was a priestess of Hathor called the Wife of Min.[39]

As with any festival in Egypt, statues of the ithyphallic god Min and his consort Hathor, the goddess of love, were paraded through their temples carried on the shoulders of priests and priestesses. The cult centers of Min (Coptos) and Hathor (Dendera) are separated by a mere twenty-three miles, and in all probability the feast day included back and forth conjugal visitations between the god and goddess. The statues of Hathor and Min were carried through the streets of Coptos for the benefit of those who wanted to have children and for the propagation of animals and crops in the coming year. In riotous procession the priests of Min at Coptos carried the ithyphallic statue of the god on their shoulders, preceded by a white bull and followed by bundles of lettuce, which was the god's sacred fertility plant.[40]

Geraldine Pinch doubts that the rites were strictly agricultural. The sacred dances performed for the divine couple by both men and women were blatantly sexual in nature. One can imagine the orgiastic festivities among the general populace that followed in their wake and, nine months later, the appearance of a brood of healthy, strong-willed, pleasure-loving children born under the sign of Taurus and thus belonging to the herd of the cow goddess Hathor. In the temple of Horus at Edfu, in the temples of Hathor at Deir el-Bahri and at Mirgissa, and even in the surrounding desert communities of Timna and Gebel Zeit, archaeologists have unearthed a number of wooden phalli, presented by men either seeking cures of impotence or offering gratitude for a healing or fertility.[41]

Perhaps it is no coincidence that the city Coptos and the words *copulate* and *couple* sound so similar. It may have been that the sacred union of the marriage couple was named after this festival. In Latin the word *coaptus* means "to join" or "to fit together" and carries explicit sexual connotations. E. O. James speculates that the festival involved a ritual sexual intercourse between the king and queen in some secluded portion of the temple while the priests elsewhere called out their prayers: "Hail to thee, Min, who impregnates his mother! How mysterious is that which thou hast done to her in the darkness." Because Min was intimately linked with the kingship in ancient times, it was important that an heir to the throne be conceived at this festival. At the end of the ceremonies, perhaps when the king and queen reappeared, it was said that four birds, the emblems of spirit, were released into the air to carry into the four cardinal points of the earth the proclamation: "Horus, son of Min and Osiris, has assumed the Great Crown of Upper and Lower Egypt."[42]

Min is an archetypally masculine god: sexy, cunning, energetic. Around his forehead he wears a red ribbon that trails to the ground, which represents the rising power of the kundalini, or sexual energy. At Luxor, he wears upon his head two high plumes that reach upward to penetrate the sky and draw down the celestial energy of the sky goddess. At Medinet Habu, he is likewise called Opener of the Clouds and is the sacred lover of the Great Mother.[43]

Min, always popular among the common folk, seemed to have been most popular with the pharaohs during the Old Kingdom. In predynastic times, the domain of Min stretched 270 miles from Oxyrhynchus (the city of the sacred fish) to Coptos. Like the later Osiris, he was not only Lord of Life, but Lord of the Dead. His cult following was so strong that it prevailed even in later dynasties when more state-sanctioned gods were given the honors due to him. During the Middle and New Kingdoms of Egypt in nearly every sacred city, Min became attached to the local creator gods in their capacities as the Great Inseminator, including Amun, Horus, Osiris, and Ptah.

Isis appears as the *abtu* fish that tows the boat of the sun through the underworld.

Originally a sky god, Min manifested as a bolt of lightning and, as such, embodied the inseminating principle in the womb at the moment sperm meets egg. Greek writers of the day identified him with the god Pan, for his sexual appetite was his greatest attribute. His name meant both "To Establish" and "To be Firm," and so he appeared with a very large, erect phallus that signified his sexual power and his promise of renewal, abundance, and procreation. Whatever lasted into perpetuity was within the domain of Min, whether dynasties, cities, or children.

At Coptos, he was identified with the legendary first pharaoh of Egypt, King Menes. Here's how the story goes:

An oracle warned the citizens of Coptos that an enormous army was poised to descend upon the city and raze it. Menes gathered all of the available men from their houses, their fields, and their families and organized them into a vast army to march far beyond the city limits and meet the invaders head on. He told them that while they were away, he would stay in the city and organize "the greatest army in all of Egypt." While the men were away, however, Menes stayed behind and made love to all their wives. His sexual prowess became legendary among the women. They flocked to the palace in droves, for he was said to be a tireless lover, and every woman he slept with became pregnant. When the husbands returned from the war and found all their women pregnant, they were enraged. Determined to kill Menes, they only managed to tear off his arm before he escaped.

Nevertheless, fate proved Menes right. When, some twenty years later, the invaders again attempted to descend upon Coptos, they were met by a large and powerful army indeed. The "greatest army in all of Egypt" turned out to be the sons of Menes, who went bravely to war and defeated the enemy once and for all. His progeny became the first pharaohs of Egypt, and Menes himself was buried amid great ceremony in Abydos.

No doubt the first pharaoh of Egypt Menes was named after the god Min, and Min's myth was attached to his biography. The connection between Min and Osiris appears to be as close as the connection between Hathor and Isis. Both gods appear in their effigies wrapped in mummy cloths, and both gods were rent to pieces—Min by a tribe of enraged husbands, and Osiris by Seth because the "good" brother had impregnated Seth's wife, Nephthys. Later, when Isis and Nephthys gathered the fourteen body parts of Osiris to bury them, they could not find one important missing piece: the phallus. When it was thrown into the Nile, the sacred part apparently was eaten by an oxyrhynchus fish. Thus, the connection between Osiris and Min in the locale of Oxyrhynchus becomes clear.

Isis herself appears in Egyptian myth as the sacred *abtu* fish. *Abtu* was the ancient Egyptian name of the city of Abydos, where Osiris and the early kings of Egypt were buried. *Abtu* was also the ancient word denoting "the west," that region where the sun god died and entered the underworld, or the womb of his dark mother, the night sky. *Abtu* may be the word origin of our word "abyss," indicating a

yawning gap or the void. When Isis appears as the fish, she leads the boat of the sun god through the watery abyss of the underworld. But the fish throughout myth has also been the sign of the *vesica piscis*; that is, of the vulva of the Goddess. Isis swallows the phallus in a magical act that merges male and female; thus, when woman ingests the spirit of man she creates new life.[44] Kali, the Hindu goddess of creation and destruction who likewise swallowed the penis of Shiva, was known as the Fish-Eyed One.

This combination of sacred eating and sacred copulation is the sign of a continuous chain of existence, what the ancient Egyptians termed "endless, ceaseless becoming." Out of death comes life, and all life begets death, and so on. The erect phallus of Min is the sign of the life to come, but the flail he holds in his other hand is the emblem of the harvest of souls. Thus, in the myths of Osiris and Min, as in some Woody Allen movie, sex and death go strolling hand in hand.

The only true difference between the gods is that while the phallus of Osiris remains invisible, the phallus of the god Min always appears erect. In fact, when new temples were built during the New Kingdom, the builders always inserted a "seed stone" as a cornerstone or keystone to the new structure.[45] That magical, creative stone, taken from an older pre-existing temple, was usually the stone on which the phallus of the god Min, or Amun-Min, had been carved.

Hathor, in her own right, had the same sexual prowess as the god Min. One of her epithets was used to describe Inanna, the Sumerian goddess of love. Both were called Mistress of the Vulva. From as early as 5000 B.C.E., images of her appear as a naked dancing woman, her graceful arms above her head, her vulva marked with a cross, her belly swollen, and her hips wide and full as would befit the body of child-bearing women. Her face has a distinct birdlike appearance, indicating that her domain is celestial as well as terrestrial. She is spirit creating matter. As the goddess of love, sensuality, and sexuality, she has been connected with all the major gods throughout Egyptian history. She is the consort, not only of Min, but of Horus, Sobek, Ra, Khnum and Ptah.

Even when The Feast of Hathor and Min fell out of favor with the pharaohs, it was still honored by the community at large. By and large, state religions, which by their nature are patriarchal and honor the gods embodied in the pharaoh, tended to ignore the women's festivals, but the Goddess continued to find a way into the hearts of those who loved her. Because she was a goddess of fate as well as love, when two lovers were brought together it was through the will of Hathor. One popular ancient Egyptian love song says, "Brother, oh, I am among the women destined for you by the Goddess."

In addition to the wooden phalli found at various sites, at both the Hathor chapel in Deir el-Bahri and the Temple of Min at Coptos archaeologists have unearthed a collection of baked clay fertility charms representing both the male and female sexual organs. Additional statuettes of broad-hipped women lying on a bed were found, as well as a number of offering jars that depict arms with hands cupping full breasts. [46] Clearly, these sacred sites dedicated to Hathor and Min were honored for their fecund powers. They are reminiscent of the fertility festivals of the Greeks at Haloa, where women ate phallus-shaped loaves, and of the Roman practice of having the bride touch the phallus of Priapus, the equivalent of the Egyptian god Min.[47]

After the glory of pharaonic Egypt was eclipsed, The Feast of Hathor and Min still maintained a following among the local people. Even in modern-day Egypt, under the shroud of Christian and Moslem religions, the so-called superstitions of the women of Egypt still reflect remnant traces of these rituals. Within the old temples to Min and Hathor one can find shards of broken pottery, given as offerings by modern women in a magical prayer to secure a fruitful womb, a fruitful harvest, and all the blessings of the Goddess.

Although the rites of Hathor and Min probably originated in southern Egypt and had their strongest following among the common folk located near the Temple of Hathor, Min eventually began to travel alone to Buto in the Delta region during the New Kingdom and Ptolemaic eras. Here he appeared dressed all in red, wearing a shining breastplate, merging with the god Mars and exhibiting a masculine prowess in the areas of love and war. No longer eroticized by his former connection to the goddess of love, Min by this time had become an image that struck terror in the hearts of those who saw him, not riding in his golden sacred barque, but being driven around in a chariot drawn by horses.[48] Without the tender influence of the goddess Hathor, the Coming Forth of Min was followed, not by lovemaking, but by reenactments of war and physical violence among the crowds and the priests.

Nevertheless, whenever he appeared as the lover of Hathor, his power was softened under the loving gaze of the goddess. In that capacity, the influence of Hathor and Min survived the Greek, the Christian, and the Moslem influences and continued underground into the present day. Winifred Blackman, an anthropologist in Egypt during the 1920s, not only observed some of these local women's mysteries, but apparently assisted in them. She reports that the woman in search of the Goddess's aid would step over and back across the threshold of one of the tomb chapels seven

times. In the temples they likely would have stepped across the opening into one of the subterranean chambers that ran beneath the temple. The mysterious, dark opening in the ground was symbolic of the womb of the Mother. Within the tomb chapel, four fertility charms were brought forth—a mummified god representing Min; the scarab beetle representing the power of "becoming" and transformation; a cat charm signifying Bast, the gentle mothering aspect of Isis; and, lastly, either the red carnelian Buckle of Isis, signifying the Goddess's womb, or a blue faience image of Isis herself. Lifting her skirt, the woman stepped across each charm seven times. Afterward, the woman dropped her charms into a glass of water and drank it. Then the remaining water was sprinkled over her and the fertility charms rubbed across her body. Ms. Blackman reports that at least two of the women who performed these rites became pregnant soon after.[49]

To be sure, in ancient times, the true festival date depended upon the phases of the lunar cycle. Hathor, with her crown of crescent horns and full moon disk, was the patron goddess of festivals, as well as of the cycles of the moon. The last day of any month was always named in honor of the god Min, with the last waning crescent of the moon representing the horn of his phallus. In the Middle Kingdom dynasties, the festival apparently occurred somewhat earlier in the summer, which may have to do with the slippage between lunar dates and the Sothic calendar that kept track of the Inundation.

According to the Medinet Habu calendars, the festival seemed less orgiastic and instead required that the king cut a sheaf of grain.[50] This custom made state-sanctioned connection between the old fertility rites and the harvest rites at which the king always made an appearance. Hathor's appearance as the goddess of love and fertility goes hand in hand with her appearance as the goddess of abundance. In Chapter 82 of The Egyptian Book of the Dead she provides bread and drink, not only in this world, but in the next:

> Let me eat my food beneath the sycamore of my
> lady Hathor
> And spend my hours beneath the tree
> On which the souls of divine beings have alighted.
> In a clean place I sit on the ground
> Reading divine words and writings in the Book of
> Thoth
> Under the leaves under the date palm belonging
> to Hathor
> Who dwells in the spacious globe of sun
> As it advances toward Heliopolis.
> Let me call for my cakes and eat them

> Under the leaves under this tree of Hathor, my
> divine lady.[51]

Activities

1. Think about the story of the severed phallus of Osiris. Imagine it as some portion of yourself that has been cut off, separated, or disowned. Perhaps you were told that it wasn't necessary for your well-being, or that it was inappropriate. What part of your own creativity has been lost? Who told you it wasn't important? Become like Isis the fish. Dive into the deep subconscious waters. Go and find that lost creativity. Swallow it. Take it into yourself again, and begin to let it feed your spirit.

2. The love poems of the ancient Egyptians are some of the most beautiful, sensual, and tender in all of literature. Buy or make a beautiful journal in which to keep a collection of love poems. Spend some time looking through the poetry of Kahlil Gibran, Jalaluddin Rumi, Rainer Maria Rilke, or other poets both ancient and modern. Copy them into your book. Write a few yourself. You may wish to give the journal to your Beloved or keep it for yourself. You may wish to give it to some dear friends as a wedding present.

3. The seed stone is a powerful talisman that reminds us that for everything that has passed away, something new is created. Meditate on the places and people in your life which have meant the most to you. Perhaps a grandparent's home, a distant place to which you traveled, a garden you enjoyed as a child. Determine how this piece of your personal past can be incorporated into the future you are building for yourself. Name that future fully and specifically. If possible, return to the source spot and find a piece that you can take away with you. It may be the brick from an old house, a shoot from a yellow rose bush, or a pebble from a beach. Find a place in your own home where you can honor and tend it, letting it remind you of its magical legacy.

THE OPET FESTIVAL

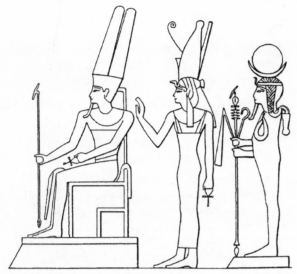

Amun, Mut, and their son Khonsu celebrate the Opet Festival at Karnak.

Appropriate for Days that Celebrate
- Fertility and Creativity
- Abundance
- Family Gatherings
- Community Events
- Marriage
- Travel
- Thanksgiving
- Renewal
- The Birth of a Child
- The Full Moon in Pisces

More outlandish than the New Year Festival, the feast of Opet was the biggest, most extravagant festival of the year. The river was flowing freely and the Nile water probably reached all the way up to the edge of the Luxor Temple located on its bank. It was here that most of the public festivities took place, and the festival engaged the royal couple, the priests, and the common people alike. It was a favorite of the people, with much dancing, music, incense burning, and general eating and drinking.

The stars of The Opet Festival were the great creator god Amun, his goddess wife Mut, and their child Khonsu, the god who embodied the moon. On this day Amun, sometimes called Amun-Ra, and his family were carried in gilded barques on the shoulders of their priests. Procession of the shrines was most important for it allowed the people an opportunity to see the Divine face to face. The heavy statues in their shrines were carried over land in arks supported by two poles. Between twelve and sixteen strong men shouldered each divine being's statue and shrine.[52] Sometimes only a single neter went about in procession, but during The Opet Festival, it was the entire divine family of Amun, Mut, and Khonsu who left their sanctuaries at Karnak to journey in enormous gilded boats to the Temple of Luxor. There Amun would spend the next twenty-four to twenty-seven days feasting and making merry, ensconced with his consort Mut in their holy temple beside the Nile.

Luxor Temple was known as the Southern Harem where the goddess Mut lived.[53] Amun's conjugal visit was part of the original fertility rites related to the marriage of the divine parents of the falcon god and to the rising of the Nile waters that refertilized the plain. In later versions of the myth, we come to know the divine parents of the falcon god Horus as Isis and Osiris. Yet the same festival was celebrated even in predynastic times just slightly upstream and across the river in the ancient city of Nekhen. (*Nekhen* means "the child.")

The falcon god was born of his mother Hathor, who was sometimes called simply Mut, meaning "Mother." Mut, like Nekhebet, another goddess of the South, took the form of a vulture. Vultures, according to Egyptian legend, were said to turn their tails to the wind, thus impregnating themselves. They represented the supreme feminine mystery of conception and birth, a miracle that perhaps early in human history might have been considered a spontaneous generation. In this case, the wind becomes linked with Amun (sometimes spelled *Amen*, like the end of a prayer). The ancient word *amun* represents all that is as "mysterious, hidden, and secret" as the god.

What The Opet Festival originally celebrated was the deep mystery of all life itself: how from apparent nothingness sprang new life; how into the barren desert one day, at the rising of a star, the waters of the Nile suddenly flooded the land; and how, when those waters receded, the fields were sprout-

ing green with new barley and wheat, the river was again teeming with fish and fowl, and the herds of animals came to the edge of the water to drink. Through the mystery of a predatory bird that takes into its body dead flesh and then spins out new life when she lays her eggs, the vulture became a symbol, not only of bountiful life on earth, but of life in the afterworld, as this Hymn to Nekhebet (Mut) from the Tomb of Paheri exemplifies:

> Homage to thee, Lady of the Mouth of the Valley,
> Lady of Heaven, Mistress of the gods, beautiful
> tiller for him that hath no rudder,
> Judge in Heaven and on Earth,
> Beautiful Star Unseen
> Save in time of good. I have come to thee.
> Grant me my mouth to speak, my feet to walk,
> My eyes to see thy radiant light every day,
> That I may enjoy the good things life
> presents to me.
> Grant then that I may pass through
> the beautiful Amentet [the hidden world of
> the gods] day by day.[54]

What we now identify as the Opet or Ipet festival was called by the ancient Egyptians Apet-Aset. *Apet* is a word that signifies any type of "gathering together," and *Aset* means "seat or throne." Irmgaard Woldering says the name means "counter of the places" or the assembly hall for all Egyptian deities with chapels for visiting gods like a national temple.[55] I suggest the name is actually related to two great goddesses, Apet and Isis, the pregnant goddess and the suckling mother.

Apet is the pregnant mother figure linked with the old fertility goddess Tauret, who often appears as a hippopotamus with a burgeoning belly, her tongue pressed between her teeth. Some symbolists believe the gesture to be a fierce one, and of course it is; but, as any Lamaze instructor can attest, it is a symbolic gesture linked with the fierce determination and will of a mother about to give birth. She pants and presses her tongue between her teeth. *Aset* indeed does mean "throne," but it is the holy ancient Egyptian name of the goddess we call Isis. Her lap is the throne, the seat, the place upon which the child Horus sits, and a pharaoh is only a pharaoh if he is the embodiment of Horus, the child of Isis. Even though the festival in the New Kingdom is called Amun's Feast of Opet and is dedicated to the god, it actually celebrates the life-giving

The hippo goddess called either Tauret or Apet is one of the predynastic images of the Great Mother.

power of the mother. Remember, great god that he may be, Amun leaves his home at Karnak and journeys to Luxor, the Great Mother's home. Here the hidden, mysterious god of the world returns to the womb, to the possibilities of his manifestation and to his multitude of forms.

The hippo form of the Great Mother appears in the earliest funerary text, the Pyramid Text of the Fifth Dynasty pharaoh Unas. Apet, or Ipy as he calls her, lives in the celestial ocean, a goddess of the night sky swimming in its starry ocean. In this Hymn to Apet the king begs the goddess to give him sustenance in the next life he will lead in heaven:

> O my mother, Ipy, give me this breast of yours
> That I may take it in my mouth
> And suck your white, gleaming sweet milk.
> As for that eternal land yonder where I shall walk,
> I neither thirst nor hunger in it.[56]

As astronomical references, the two goddesses Apet and Aset remind us of the eternally beautiful rhythm of the universe. Isis, or Aset, as we have seen, is identified with the rising star Sirius and the goddess Sothis. Tauret, or Apet, is identified as the constellation we now know as Draco, which was then the ancient Egyptian North Star. Apet as Tauret can be seen as the central figure in all the later astrological ceilings of Egypt, the divine creative matrix around which all the other stars spin. Those stars closest to the pole were eternal gods, called the Imperishable Ones, epitomized by those stars which circumambulate, but never rise and never set.

Although some of the pharaohs may have forgotten whose festival day this originally was, the pharaoh Seti I never forgot his goddesses. He, more than any other pharaoh, always gave Isis, Hathor, and their sister goddesses his full respect. On the walls of Karnak is his Nineteenth Dynasty depiction of Isis during The Opet Festival appearing in her role as supreme mother Mut. She introduces her son, Seti I, to his "father," the god Amun. The artistic rendering of this portrait is particularly touching. The goddess Isis gently holds the hand of the noble but modest and humble pharaoh, leading him forward. Despite the fact that Seti carries the whip and crook, emblems of his divine authority to rule all of Egypt, he appears slightly bowing before Amun and smiling shyly. Isis wears the vulture headdress of Mut, as well as the crown of the horns of Hathor. There is no mistake that she is

Queen Mother and divine being in this portrait. In her hand she uplifts the lotus to the nose of Amun and shows him the sacred sistrum of Hathor.

Back in the Eighteenth Dynasty, however, the "divine emergence" of Amun, Mut, and Khonsu sent the crowd of awaiting devotees outside the temple walls into swells of cheers and cries of joy. The procession moved through the hypostyle hall with its beautifully painted, towering lotus bud and papyrus columns. Carried on the shoulders of their priests, the triad must have looked as if they were sailing upon the waters on the first day of the world. Before them danced sleek, strong-bodied young women, accompanied by their sister musicians playing lyres, sistra, banjos, and tambourines. Those who had no instruments kept the rhythm by clapping their hands. The singers filled the resonant halls with the sound of their voices intoning the sacred name of the divine Amun. The temple of Karnak from which they emerged was a massive, sprawling temple filled with dazzling monuments.

Each pharaoh tried to surpass the marvelous monuments of the last. Amenhotep II commissioned his artisans to erect for Amun an adytum of gold, the floor of which was made of silver. He built enormous columns in the festival hall and tipped them with electrum, an amalgam of both gold and silver. He said, "It was more beautiful than that which had been: I increased that which was before: I surpassed that of the ancestors."[57] There stood the twin obelisks of Queen Hatshepsut, over ninety-seven feet tall carved of single blocks of rosy granite hauled all the way from Aswan, their gleaming points tipped in electrum. The later monuments of Thutmose IV were sculpted "of gold, lapis lazuli, malachite, [and] every splendid, costly stone. . . ."[58]

So impressive was the pageant that the famed Tutankhamun had the phases of The Opet Festival inscribed on the walls of the Colonnade at the Temple of Luxor.[59] Never mind that he was only a nine-year-old boy coerced into announcing the glory of Amun by the priests. (They had even insisted that he change his name from *Tutankhaten* to *Tutankhamun*.) They certainly didn't want to promote any further allegiance to that lunatic king Akhenaten and his one god who had ignored the festivals of Amun and contributed nothing to the temple coffers. By then the priests had acquired a taste for the opulence and status they had received over the last two centuries from pharaohs like Thutmose I, Thutmose III, and Amenhotep III. They craved the riches that came from the hands of these conquering pharaohs who plundered the wealth of foreign lands.

When Akhenaten abandoned Karnak and Luxor, moving his religious community into the desert at Tell el-

Armana, the former capital city residents missed The Opet Festival. No doubt the gods and goddesses missed all the attention, too. Amun's return to power marked a time of renewed interest in the old festivals once more. Amenhotep III especially adorned Amun and his family with lavish gifts, making for him the largest and widest of any of the sacred barques ever given to Karnak, carved of Lebanese cedar, which he named "Beginning of the River." The boat was ornamented with silver and covered in gold inside and out. The shrine in which the statue of the god stood was sculpted from pure electrum, as were the bows of the ship bearing the great crown of Egypt protected by entwined cobra images and the two obelisks sitting in the boat before the god. It was said that the great shrine "filled the land with its brightness." Even two obelisks were built to sit in the boat before the god and they, too, were wrought with electrum. Said Amenhotep III of his gift, "The two Nile gods of the South and the North, they embrace its beauty, its bows make Nun [the celestial waters of heaven] shine as when the sun rises in heaven, to make his beautiful voyage at his feast of Opet. . . ."[60] The reflection of that glittering boat upon the water must have been quite a sight.

Before the journey to Luxor began, however, certain matters needed to be attended to at Karnak. The pharaoh made his offerings and prayers before the statues of the god and goddess in their vestibules. In the time of Ramses III these offerings included nearly 3 million loaves of various breads and cakes, 219 thousand jars of beer, and nearly 40 thousand jars of wine, as well as various kinds of oils, unguents, wax incense, spices and salt. Linen garments, leather sandals, and woven papyrus were among the offerings. The food menu gives us a wonderful sense of the divine palette with its pomegranates, figs, grapes, cabbage, olives, corn, emmer, and barley. Divine fragrances for the gods included cinnamon, myrrh, frankincense, and lotus and papyrus flowers. All kinds of flowers were woven into garlands and ropes or set in standing bouquets. Led by servants to stand before the god and goddess were the temple's divine livestock, including nearly 3,000 cattle, oryxes, and gazelles; 126,250 fowl, including geese, ducks, cranes, pigeons, doves, and other birds; and nearly half a million fish of different varieties. Then came the white, yellow, and red gold of Egypt and the silver, copper, lead, and tin, as well as "costly stone"— perhaps basalt and rosy quartzite for statues, lapis lazuli and carnelian for jewelry making, and malachite to beautify the divine eyes. Trees were rare in ancient Egypt, and thus offerings of cedar, ebony, and other wood were highly prized as building or sculpting materials.

After the pharaoh made his offerings, his priests per-

formed for him the sacred rites of renewal, by which they secured his protection. The gods made the king to flourish and "be youthful daily . . . his every limb being whole, in prosperity and health."[61] Pharaoh was given his royal crowns of the North and South. From the hand of the Divine he received the emblems of his authority: his uraeus—"the serpent goddess alighting on his forehead"—which was a headdress adorned with a representation of the sacred asp, symbolizing supreme power; his crook and flail; and his mace head for smiting enemies. Holy contracts between human and god were often made at Opet festivals. In a text called the Papyrus Harris, Ramses III reminds the neters that the oracle of Amun had promised him a reign of two hundred years to repay him for his kind offerings to the divine ka's (spirit doubles) of the gods.[62] Indeed, there were two hundred years of pharaohs named Ramses ruling Egypt, including Ramses the Great before him and all the pharaohs of the Twentieth Dynasty who followed in Ramses III's footsteps. But Ramses III himself was murdered in his twenty-first year of reign, his lavish offerings at the Temple of Amun having virtually impoverished the Egyptian people and made the priests vastly wealthy and thirsty for power.

In 1154 B.C.E., however, the party was still ongoing. The pharaoh attended the sacrifices of the sacred bulls made in propitiation to the god and goddess. All the sacred locales of the vast Karnak temple had to be visited, sprinkled with holy water, and fumigated with sweet aromatic incense. The ground had to be kissed, the rites performed, and the prayers intoned. Elsewhere in the temple the pharaoh poured holy oils and waters over the statues of an ithyphallic god Amun, who transferred his power as the Divine Progenitor to the king, who nearly always served and always was considered the god's high priest.

Among the halls, temples, rooms, and kiosks through which the pharaoh, the priests and priestesses, and the statues passed in grand procession, there were many sites dedicated to the fecundity and beauty of the divine Feminine. Directly behind the granite chapel containing the holy of holies sanctuary and the Hall of Records lay a courtyard ringed with statues of the seated lion goddess Sekhmet. These statues functioned as guardians of the temple.

Immediately south of the main gateway to Karnak lies a temple to Mut, also built by Amenhotep III around 1450 B.C.E. Part of the Karnak temple complex and south of the larger temple to Amun, it is reached by procession along an avenue of sphinxes. It sits near the Sacred Lake of Asher. Part of the Opet festivities no doubt included a regalia of boats sailing along the lake.[63] Local natives say that on a full-moon night one can occasionally still see the ghostly shape of the golden barque of Amun sailing on the sacred lake, glittering beneath the moonlight.[64]

The procession then emerged from the temple and proceeded along the avenue of rams that linked Karnak with the Temple of Luxor. A cry of joy emerged from the crowd who had waited all this time outside the precinct, smelling the incense, hearing the prayers, but unable to witness the sacred rites. They occupied themselves with the carnival atmosphere that surrounded the temple outside—with dancing and eyeing the beautiful women dressed in their jewels and fine linen, with jostling other party-goers, and with buying trinkets and eating tidbits from the merchant booths set all along the parade route of the gods.

As the statues and sacred barques passed, the crowd must have gone wild to see at last the brilliant flashing light of gold and to witness the high priests—their heads shaven and gleaming—dressed in their panther skins. Then followed the priests who carried the barges of Amun, Mut, and Khonsu dressed in their sacred masks of gold, obsidian, and carnelian. The identities of the priests remained mysterious and hidden: the priests of Horus in their falcon masks walked ahead, while the priests of Anubis in their jackal masks walked behind.

At last the entourage made its way to the river. There the sacred boats containing the cult statues were towed upstream by smaller boats. No doubt spectators crowded both sides of the banks, and those who could afford it launched their own or rented boats to join the procession. The divine cedar barges were rowed by a hand-picked crew of the finest, most upstanding men of the community, while gangs of workmen tugged tow ropes along the bank. High-ranking officials fought for the honor of manning the royal flagship that towed the boats carrying the divine family. The boats were adorned with carvings of divine images—the prow of Amun with the ram, the prow of Mut with the vulture and the horns of Isis. They were filled with singers and priestesses and decorated with beautiful textiles and garlands of flowers.

Author Barbara Mertz describes the fervor of the crowd surrounding The Opet Festival. "When, amid shouts of rejoicing, the divine boat reached the Luxor temple, the god was carried in procession, led by the king, into his Luxor shrine. The crowd of followers stopped at the gates to the courtyard. There they could jostle and gape and point out important personages in the procession, like the crowds at the first night performances of plays and films. Sooner or later free food would be distributed, with plenty of bread and beer, and perhaps even a cup of wine."[65]

We might bemoan the fact that the grand pageantry of those ages has disappeared, but in truth the impulse to cele-

brate the Divine never completely disappears; it simply changes form. Even now in modern-day Luxor, there remains a faint echo of this grand occasion. In Luxor Temple there is a mosque which, like many mosques and churches around the world, was built on the preexisting sacred ground of the ancients. Once a year a boat belonging to the Sheikh Abu'l Haggag, a local Moslem saint, is solemnly and ceremoniously carried out of that mosque and hauled through Luxor in a horse-drawn cart.[66]

Herbs and Flowers of the Magician's Garden

The Leyden Papyrus lists many spells, mixtures, and ingredients for the ancient magician. The manuscript offers cures for gout, watery eyes, and snake bites as well as recipes for dreams, love spells, and divinations. Because they are being used in a magical way, many of the plants and flowers mentioned here are associated with sorcery, which is probably not the extent of their use in Egypt. Here are a few of the herbs, flowers, shrubs, and trees that grew in the magician's garden:

Trees

ACACIA—Acacia flowers infused in oil were used in Egyptian love potions. Sacred to Isis, the tree also attracted money and psychic visions, while keeping misfortune at bay. Modern Egyptians tuck acacia sprigs into their turbans to ward off evil.

APPLE—Though rare, apple trees were known in Egypt. The tree of love fell under the rulership of Isis but was associated with all goddesses of love, healing, and magic. For a love divination, cut the apple in half and count one seed per year to find how soon a marriage will occur. If a seed is cut, the relationship will be stormy. If two seeds are cut, one may be widowed. If an uneven number of seeds appears, one will not marry soon.

AVOCADO—Sacred to Hathor, the avocado (persea) was one of the most beloved trees of Egypt. Beneath it, the lion goddess Raet killed Apep, the serpent of darkness; thus, magic wands carved from persea wood were quite potent. Avocado grown from seed brings love into your home. Carrying the seed in your pocket attracts a mate.

CEDAR—The god Osiris was ensnared in the cedar tree of Lebanon; thus it was called the Tree of Life. The scent of cedar increases one's memory, even

as Isis assisted in the re-membrance of Osiris. Keeping cedar in one's pocket draws money and love. It is the tree of abundance.

CYPRESS—Called the Tree of Death, the cypress was equated with the chest in which Seth trapped and murdered Osiris. Thereafter, cypress was used for making coffins. Since it had held the body of a god, it was thought to bring comfort, healing, protection, and longevity. A sprig of cypress on the grave of a loved one brought him or her love and luck in the land of the gods. The roots, cones, and dried leaves were burned in the fireplace as an aromatic, healing incense.

FIG TREES—Fig sycamores grew in every garden to assure that life was joyful and one never hungered. The love fruit of Hathor's favorite tree was an aphrodisiac. Sharing figs with a lover assured that the beloved would stay entranced. Women carried wooden phalli carved from the tree to conceive easily; men carried the same amulets to overcome impotence. Placing a fig branch in front of the door before leaving on a trip assured a safe return.

MYRRH—Hathor loved the scent of myrrh, so Queen Hatshepsut planted rows of myrrh trees outside her temple to Hathor. Used in mummification, myrrh also had healing, restorative properties for the living. As an incense it was used to reduce stress, elevate spiritual thought, and purify all temples of Isis and Hathor. In conjunction with frankincense, it was believed to increase one's mystical and psychic power. Amulets, talismans, magic wands, and sacred texts were held above the rising smoke of myrrh to sanctify them.

Flowers

CROCUS—Dedicated to Isis, crocus ensures happiness, strength, and healing. Dried and powdered crocuses result in the spice saffron, used in drink and food to cure depression and evoke feelings of love. Saffron in the ancient world was baked into crescent cakes and eaten in honor of the moon goddesses.

CHRYSANTHEMUM—Chrysanthemums in the garden offered protection, if for some reason one had offended the gods. Drinking infusions of chrysanthemum cured drunkenness.

LOTUS—Lotus in a garden pool brought serenity,

fecundity, and spirituality, since the center of the universe lay at the core of the flower. Carrying or wearing lotuses brought good fortune and the blessings of the Goddess. Placing lotus root under the tongue and saying "Sign, Arggis" was said to open tomb and initiation chamber doors.

PAPYRUS—Papyrus was beloved by all Egyptian goddesses. Boats made of papyrus kept crocodiles away, and the rustling of the stalks drew the attention of Hathor to one's prayers.

PEONY—Wearing peonies protected the body, spirit, and soul. Children wore peony seeds in amulet bags to protect them from unsettled spirits. The root cured lunacy and sometimes substituted for mandrake root. Peonies in one's garden dispersed storms, bad weather, evil, and all kinds of negative energies.

ROSE—Wild roses dedicated to Hathor and Isis were essential ingredients in love magic. Rosehips were strung as beads and used as necklaces. Rosehip tea sipped at bedtime induced prophetic dreams.

Herbs and Botanicals

CHAMOMILE—Chamomile attracted money, if one washed one's hands in it. Bathing in it attracted love, and drinking it brought sleep. Growing it in a border around the house removed curses.

FLAX—Blue flax flowers protected the wearer from sorcery. Fresh flax seeds daily kept in one's purse with a few coins increased one's money. To ensure the future beauty of one's child, mothers took their children into the fields and let them dance among the flowers.

FLEABANE—Fleabane exorcised evil spirits and kept away intruders. Planted around one's property, it banished thieves, unwanted company, and ghosts.

GARLIC—Garlic contained protective powers for both the physical and spiritual bodies. Said to absorb disease, it was common in remedies for gout and rheumatism in ancient Egypt.

HENNA—Worn on the head, Henna chased away headaches; if worn as a necklace over the breast, it chased away heartaches. Held to be the blood of the Great Mother, it protected against the evil eye.

HOREHOUND—Named after Horus, son of Isis, as a tea it cleared and quickened the mind. Mixed with ash in a bowl of water, it sent healing energies throughout the sickroom. Hung about the house, it protected one from sorcerers and ghosts.

LETTUCE—Lettuce was the fertility crop of Min and Seth. Lettuce seeds were planted to form the name of one's lover. If it sprouted well, so would love. If it sprouted in spotty patches, your lover wasn't good for you.

ONION—Onion increased prophetic dreams and brought abundance. Ancient Egyptians wore onions while swearing oaths of honesty. Onion flower garlands protected the living and the dead from evil and poisonous creatures. Halved and placed around the house, onions banished disease.

RUE—Mixed with morning dew, rue established a magical circle. It promoted healing, health, and love. Fresh rue, sniffed, increased one's mental powers. Rue baths removed curses, while fresh leaves hung in the doorway or rubbed on the floor broke streaks of bad luck.

SESAME SEEDS—These were used to find treasure, reveal secrets, and open the doorways between realms. An opened jar of sesame seeds kept on a shelf and changed every month drew money to the household.

SPURGE PLANTS—Ruled by the fiery, lion goddesses, they exude a sticky, milky liquid that burns the skin on contact. The plant was used to ward off one's enemies. The fruits and leaves of spurge are usually toxic, unless refined as the castor-oil plant is.

WORMWOOD—Wormwood was the main ingredient in absinthe. Used in the rituals and mysteries of Isis, wormwood became associated with witches who brewed it to produce visions or burned it to summon the dead. Though addictive and poisonous, its ancient reputation was as a protection against bewitchment and as an antidote to hemlock and toadstool poisoning.

NEITH GOES FORTH TO ATUM

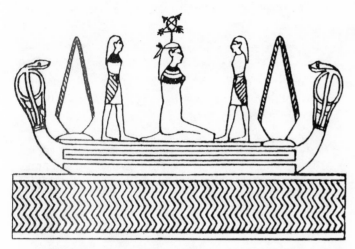

Neith sails through the neterworld in her cobra image.

Appropriate for Days that Celebrate

- Wisdom
- Croning
- Fathers and Daughters
- Regeneration after Loss
- Arbitration
- Regaining Balance
- Saturn Square or Saturn Return
- The Fall Equinox

Neith appears as the primary cobra goddess of the Delta, but her influence probably came from the western regions of Libya.[67] Most ancient of all the gods and goddesses, her magic was said to be as great as that of Isis. In times of trouble, the other gods and goddesses turned to her to settle their grievances. Not only could she fight darkness with the best of them, but as the goddess of the loom and shuttle, she was responsible for the whole cloth of life and the weaving of the fates. In one myth after another, she appears as mother to nearly every divine being. Her true name *Net* meant simply "The Great Goddess."

Respected and feared for her quick, cobra-like striking power, the fiery, creative warrior goddess Neith was one whom the newly dead soul wanted on his side in the underworld. She who struck fear in the hearts of enemies struck awe in the hearts of those who loved her. This Hymn to Neith from the Pyramid Text illustrates her power as the Great Goddess in control of the eastern and western horizons and of the power of death and rebirth:

Open the gates of the horizon.
Withdraw the bolts [of heaven] for he has come to
 thee, O Neith.
He has come to thee, O Flame.
He has come to thee, O Great One.
He has come to thee, O Great One of Spells.

He is pure for thee, for he fears thee. Yet art thou
 satisfied with him.
Thou art satisfied with his purity. Thou art
 satisfied with the words he speaks unto thee:
"How beautiful is thy face, happy, renewed,
 refreshed as when God, the father of gods,
 first fashioned thee."
He has come to thee, Great Lady of Spells.[68]

In a myth called "The Contendings between Horus and Seth," Neith plays a prominent role in deciding the fate of the contestants, as well as the fate of all of Egypt:

For eighty years the battle waged between Horus and Seth to determine which god was the rightful heir to the throne of Osiris. Should the throne be given to Seth, the brother of the slain king, or to Osiris's son Horus? Certainly Isis, the widow, wanted her son to rule in his father's place; but through several manipulations, Ra, the sun god, finally favored the older warrior god, Seth. Several tribunals met, but the matter could never be clearly decided, and the war raged on. The gods and goddesses grew embittered and disgusted, sick of the whole miserable affair. All of Egypt and heaven remained in chaos.

Finally, Ra became so angry that he locked himself in his room and refused to come out. The quirkiness and age of the sun god now threatened the order of the universe itself. Thoth, god of

knowledge, decided that the council should take the matter to Neith, the oldest and therefore the wisest. As mother of both the light and the darkness at the beginning of time, she could see the value of both contenders and thus the validity of their positions.

Neith awarded the throne to Horus but insisted that Seth be given double his existing property, plus two more wives, the Syrian goddesses of war and love, Anat and Astarte. That was her final word on the subject. She told the gods that if they did not obey her wishes and stop their brawling, she'd destroy the world and kill them all, putting everyone out of their misery.[69]

In her ancient wisdom, Neith knew the importance of duality, even the duality of good and evil, as it were. She would not deny Seth his power to destroy, but rather provided the god with doubly creative powers in the form of the two great goddesses Anat and Astarte, who balanced his destructive energies with the power of love, sexuality, and procreation.

Near the fall equinox the ancient Egyptians held a second, related festival called The Nativity of the Staves of the Sun. This festival recalled the story of how Ra, the sun god, grows older and weaker as time goes on until he must walk with a staff to support himself. The god Atum, whom Neith visits during her festival, was equated with Ra's setting sun aspect. As such, he also appeared as an old man leaning upon his walking stick. When the sun god died in the west at sunset, he transformed into Atum, lord of the dead and ruler of the mortuary complexes scattered throughout the western hills.

In her crone aspect, the goddess appears to offer succor and support to the western solar gods, as well as to the newly dead. On the west bank of the Nile in the vast tomb complex of the Valley of the Kings, she is known as Lady of the Peak. There, the Great Lady suckles the dead and brings the spirit eternal life. On the east bank of the river in her temples, she functions as the fecund wife of the god and the mother of the god incarnate.

Across the globe, prehistoric ceremonies intended to support the sun in the sky and to keep it from falling formed a fairly common equinoctial motif.[70] Both the festivals of Neith Goes Forth to Atum and The Nativity of the Staves portray a weakened solar king figure who approaches the divine, eternal Feminine for help. As part of the cycle of early solar calendar feast days, this festival of Neith at the autumn equinox complements the spring equinox festival of Sekhmet, daughter of Ra. She likewise saves the failing sun and returns it to the sky. It is the goddess who equalizes extremes, stabilizing the sun due east on the horizon during the equinox so that it does not fall too far north or south on the horizon, as it would during the summer or winter solstices. Originally, it appears that the rising constellations of Pisces (early March) and Virgo (early September) marked these equinoctial festival dates. During Graeco-Roman times, the city of Sais held its Neith festival in the month of Hethara, falling in the more familiar autumnal equinox sign of Libra.[71]

Linked with this feast day of Neith is the intriguing image of a ritual wedding depicted as mourning that shows a woman—carried in a cage, head covered with a veil and body tightly bound—being presented to her new husband. In this image from the mace head of the predynastic King Scorpion, the shrouded queen appears almost to have died (at least symbolically) and been wrapped in mummy cloths. Below her we find sorrowful, long-haired women, arms upraised and swaying in the gesture of mourning typically found in the portraits of keening women seen in later mortuary reliefs. Their bare breasts give the impression of their garments having been rent during the wild abandon of grief.

This image is a portrait of a young woman dying to one phase of life as she enters another. Early historians detailing the festival of Neith described it as Osirian in nature, having to do with the rituals of death, sacrifice, and rebirth. During the festival at Sais, the statue of a divine cow was paraded about the streets and publicly honored. The animal sacred to Hathor was said to bear the soul of Neith, commemorating the misfortunes of the sacrificed divine. More than that, it was believed that the shrine also contained the body of a sacrificed woman, if not the goddess herself.[72]

Yet another image of the sacrifical quality of this Neith festival was its link to the *heb sed* festival of the pharaoh, which was said to occur either twenty-eight to thirty years after his inauguration, or every seven years during his reign. The heb sed or "jubilee" festival was traditionally known as the festival of renewal. In this dramatic, somber ritual, the king underwent a public symbolic sacrifice and death, then was magically reborn to assure the fertility of the land.

I link the timing of the heb sed festival and the imagery of this festival of Neith with the astrological timing of the Saturn return. Astrologers believe the Saturn square and Saturn return are times of spiritual, emotional, and sometimes physical trial and test. Being the planet of restriction and limitation, Saturn was associated with the god Seth by the Graeco-Roman Egyptians. The Saturn cycle obviously reflects the mythic age of Osiris when Seth murdered him. The Saturn return occurs every twenty-eight years or so, and its influence lasts approximately two years.

Hence, the pharaoh's thirty-year heb sed festival really celebrates his having survived this most treacherous period (twenty-eight plus two years) without a waning of physical or

personal power; thus, his safety was ensured for at least another seven years, at which time he might become susceptible to another debilitating Saturn influence, such as the square, or fourteen years later, the opposition.

Certainly any autumn equinox festival will have all of these components marking its rituals; that is, remembrance of the battles between light and dark, succor and support for the dying sun, and remembrance of the dead.

The Saturn Cycles:
The Sorrowful Mysteries of the Goddess

As much I dislike the idea, there are times when fruitful progress in the outer world is denied us. There are occasions when we are not always in control of events, even though we remain in control of our responses to life. These are usually deep times of inner transformation calling us to investigate to the core what it is we want, what our deepest longings are, what directions our future will take. These are times equivalent to the entrapment of Isis in the prison of Seth. These are times of death in life likened to the mysteries of Neith who journeyed in her serpent form to visit the hidden world of the gods in the western lands. In these times of dying that precede rebirth, the hand of the Divine is actively at work. As the Norse rune Nauthiz reminds us, "Let the constraints of the time serve you in righting your relationship to your Self. Be mindful that rectification comes before progress. And once again, consider the uses of adversity." (See Ralph Blum, The Book of Runes.)[73]

I equate these times with the progression of Saturn, whom the Greeks related to the Egyptian god Seth. Saturn is the planet of testing, of restriction, of limitation, and of death. Depression, sadness, and feelings of loss accompany Saturn transits. Wherever it appears in our charts, Saturn indicates a point of tension that requires us to examine how we view our experience in the world. At times it feels as if we are utterly out of control, but I am reminded that "life is ten percent what happens to us, and ninety percent how we interpret the experience." Besides being the old devil whom we feel we must fight, Saturn is also considered by astrologers to be a teacher.

A full Saturn cycle through one's zodiacal chart takes between twenty-eight and thirty years. By the time we reach age 29, we have completed one full cycle of initiation. Thereafter, every time Saturn contacts a particular planet or travels through a particular house in our charts, we revisit the occasion years ago in which we were dealing with similar issues. Occurrences of progressed Saturn transiting natal Saturn are quite predictable. They happen to everyone at about the same time.

Horus was probably born to Isis when she was 29, since she and Osiris were twin souls who incarnated together and she did not become pregnant with Horus until Osiris, at age 28, had died. In essence, the birth of Horus represents a new phase in the story of Isis, wherein she moves from Maiden to Mother. I recently realized that I was born on my mother's Saturn return, when she was 29, and my daughter was born on my Saturn return, when I was 29. That means that every time I experience Saturn's limiting energies aspecting my natal Saturn, so do my mother and daughter experience similar Saturn aspects. In our equidistant cycles, my daughter experiences her Maiden phase, while I experience my Mother phase, and my mother experiences her Crone phase. Because we're all usually in an uproar at the same time in predictable seven-year patterns, we're not exactly good company for each other at those times, but at least we have the empathy that comes from undergoing similar life-altering experiences.

Saturn Conjunct Saturn Ages 29 and 58

The Saturn Return is the moment of endings and the preparation for new beginnings. One major phase of life has drawn to a close. At 29, your maidenhood lies behind you and you are entering your adult life. At 58, the majority of your life's work now lies behind. You are at a point of evaluating what you have nurtured and built up and how you feel about your experiences. At either age, you are likely to feel that a substantial part of your life has ended, and you may be unsure of what comes next. There is a feeling of urgency, a feeling that this might be your last chance to live your truth, to do that thing you've always wanted to do.

The Saturn return often disguises itself as loss. One may change jobs or careers or residences. Relationships may fall apart or transform

in radical ways. Some people experience the Saturn return as having control of their lives wrested out of their hands. Others find themselves going about pruning, weeding, excising the old and useless.

Many more feel the tug between doing what they have been expected to do, or think they should do, and doing what their hearts tell them to do. If at 29, you roll with the punches and let go of the struggle, you'll have an easier transit when you hit 58. If you don't, you may find yourself in extreme discomfort on the other side when you are required to make radical changes. If you've been living true, the impact will be felt as a more solidifying aspect. If you've been holding onto inappropriate ways of being, you'll encounter crisis.

Accompanying all the tension, one will soon feel the seeds of new growth ready to sprout. The Saturn return creates an empty space that will soon be abundantly filled. It is up to you what you will plant and what will come to fruition. In whatever guise, the Saturn return marks a time of maturation, of movement from Maiden to Mother, or Mother to Crone. The runes sometimes refer to this time as "opportunity disguised as a loss."

Saturn Square Saturn Ages 36, 50, and 65

The decisions you made seven years ago, at the time of your Saturn return, have come up for review. As you enter this phase of reevaluation, you may find yourself withdrawing, sometimes canceling relationships and breaking old habits and patterns that no longer work. Call it a seven-year itch, but allow yourself to do it. What you initiated seven years ago may be what is most valuable for you to continue pursuing. If your decisions and plans haven't passed the tests of seven years' time, you'll be better off without them.

At times the Saturn square Saturn creates conflicts at work, feelings of competition, or the stress of other people taking advantage of your lapse in confidence. This period often marks a kind of identity crisis or a period of insecurity. We fear we have made the wrong decision, taken the wrong track, gone off half-cocked. It's good to think over and question the long-term effect your decisions will have on your life. In fact, it's time to do a little soul-searching. But there is no reason to quiver in doubt. Simply examine your life and make any nec-

essary changes. You will soon enter a stable and fruitful time in two-and-one-half years in which you will see your work paying off handsomely and your spirits uplifted.

Saturn Opposed Saturn Ages 14, 42, and 78

For young girls, the tension and anxiety often centers around their bodies and emotions. By age 14, they have grown from infants into young women, and the demands of adulthood are being placed on them, but previously they have experienced the world only through the eyes of a child. Poised on the brink of their new lives, they face a time of changing relationships and new beginnings, accompanied by feelings of loss.

Older women may experience difficult Saturn oppositions if their past failures have been improperly handled. Whatever you shoved under the covers and refused to look at during any of the other Saturn transits will come back to haunt you, like a snake rearing its head, making life difficult indeed. If, however, you have handled your failures and losses well in the past, then you may find this to be a more fruitful time than you have previously experienced.

At 43, you could be reaching the peak of success and acquiring with it new responsibilities. The Saturn opposition indicates very hard work ahead, but also tremendous success. If you are not experiencing the positive aspect, it is abundant evidence that you have been moving in the wrong direction. In that case, your energies and efforts will seem blocked or disapproved at every turn. Rather than seeing these disappointments as a sign of failure, see them as a sign that you now have abundant permission to change direction and do something more suitable to your inner nature.

At 78, the Saturn opposition may be a sign of preparation for the end of life. It may indicate a time of turning inward, of developing a more spiritual way of thinking and living, especially if one has not done so in the past. At this stage, losses of friends, spouses, and loved ones are natural. Here Saturn crowns you now with a long life full of experience and the opportunity to become in spirit the Teacher of the Wise Blood.

HATHOR'S BIRTHDAY FEAST

Hathor presents the queen with the ankh and breath of life.

Appropriate for Days that Celebrate
- Your Birthday
- A Belly-Dancing Party
- The New Moon in Virgo
- Planting a Tree
- A Coming-of-Age Party
- The Celebration of a Healing
- Any Other Kind of Party

In ancient Egypt, Hathor was the most popular goddess among the common folk, her worship being older than that of Isis and many of the gods. Her image as the dancing, horned goddess was carved on the canyon walls of the savannah as early as 6000 B.C.E. There one can see images of the beasts of the field and the wild animals that were brought for her blessing. Although she was unnamed at that time before writing was invented, her image remained the same throughout history. She was the goddess who appeared on the Palette of Narmer, the first inscribed document of the first Egyptian king. He proclaimed his unification of Upper and Lower Egypt under the domain of the cow goddess, mother of the falcon god, Horus. Her name, which alluded to her celestial domain, was *Het-hor*, literally translated as "The House of the Exalted One," i.e., the sky as home of the falcon Horus. The Greeks especially loved her and equated her with Aphrodite, their own goddess of love and beauty. Even after six thousand years, Hathor remained as popular as ever. Especially in the later dynasties, there was often little distinction between the image of Isis and the image of Hathor.

No one loved a party better than Hathor, the goddess of music, dance, love, and jubilation. One day was simply not enough to celebrate her birthday; in fact, the whole month was devoted to the goddess and her festivities. The temple calendar of Esna, inscribed during the Graeco-Roman period, proclaims the whole month of Hethara (or Athyr) as "The

Feast of the Lady of Dendera."[74] Festivals in Hathor's honor were conducted in nearly every month of the year, but by far her most active season at the temple of Dendera was during that of Inundation, filling the months of Thuthi, Paopi, Hethara, and Koiak with over forty celebrations.[75]

Her influence pervaded Egypt and even stretched into the Arabian and Sinai deserts, where she was patron goddess of miners and mistress of the malachite. Since the time of the Old Kingdom, Hathor had her own temple north of the great white wall in the old capital city of Memphis. Near the embalming house, outside the temple precinct of the Memphite god Ptah, sit the remains of a small temple built by Ramses the Great where Hathor was worshipped as Goddess of the Tree of Life. Her sacred sycamore was often drawn with images of breasts being offered to the pharaoh. In the hot desert climate, her shade was a welcome relief. Also in Thebes, she was goddess of the necropolis.[76] Her portrait appears in several pharaonic tombs, sometimes as the suckling cow, the sycamore, the Lady of the Peak, or simply as a beautiful goddess holding the hand of the dead.

The mortuary temple of Queen Hatshepsut at Deir el-Bahri exhibits a beautiful chapel with columns bearing Hathor-headed capitals and images of the cow goddess suckling Hatshepsut, or licking her hand. Hathor's face and form appear throughout in perfected grace and hypnotic repetition. Her full, fluted lips hold a simple smile. The ends of her

long hair fall into swooping curls, curving upward in artistic repetition of the graceful curve of the cow horns. Peeping out from the sides of her head are the goddess's characteristic tiny cow ears. Her pupil-less, almond-shaped eyes seem to stare right through the viewer at some ecstatic vision that we cannot see taking place in the cloudless sky.

Not only did Hathor represent the sensual joy of the good life on earth, she also promised joy and beauty in the life after death. Like Isis, she provided succor for the dead, respite for the weary, and beauty for the eyes of all beholders. Her temples could be found at Memphis, Thebes, the Sinai, and Cusae, where she was connected with the Greek goddess Aphrodite Urania. The two- and sometimes three-day festivals honoring her at Edfu and Esna indicate that her power, beauty, and grace were celebrated even in temples devoted primarily to the heroic, warrior gods Horus and Sobek.

The most important and well-known of her temples is the Temple of Hathor at Dendera. The present Ptolemaic temple was built around 332 B.C.E., but its inscription says it was built upon the previous site where the Fourth Dynasty King Cheops erected his temple to the goddess.[77] Its most famous attribute is its dramatic astronomical ceiling with symbols of the ram, the bull, the crab, and so on that we recognize today as representatives of the zodiac. It may seem at first blush that the ceiling is purely a Greek representation of the zodiac in Egyptian dress. We must remember that the all-important polar star is represented by the very Egyptian hippo goddess Tauret holding the Leg of the Ox, which represents Draco as the polar star *as it would have appeared in 4500 B.C.E.* Clearly, the astrologers of Dendera based their astronomical ceiling on the observation of stars dating further back than the origin of writing, and the ceiling represents the priestesses of Hathor as having been engaged in astronomical observation from the dawn of Egyptian civilization.

Behind the vestibule lies the hall of the appearance, a small room with six pillars in which the goddess appeared in her boat and from which she was carried forth during her many festival processions. Adjacent rooms provided space for the mixing of perfumes, oils, salves, and other sacred offerings for the goddess. In its treasury were kept the precious stones, gold, silver, and jewelry of Hathor. Other more mysterious rooms were connected to the sanctuary—a room called the "place of birth"; the "room of rebirth"; rooms dedicated to the sistrum and the *menat*, or necklace, which were her sacred emblems; and rooms dedicated for water and for fire. On the roof was a smaller Hathor chapel and one dedicated to Osiris, as well as twelve crypts and a storeroom that was hermetically sealed. In it more divine effigies and cult objects were kept. What lay behind them is ineffable, for it was said that no stranger knew the contents of this room and that its entrances were hidden.[78]

But the most sacred room of all, the holy of holies chapel, contained the statue of Hathor in a niche near the rear wall. Within this sacred room within a room within a room, Hathor and her priestesses celebrated the goddess's festivals. Dark staircases on either side of the chamber led up to the roof, and processions of priests and priestesses moved up one staircase and down the other, carrying the cult image of the goddess. In fact, amazingly, where one staircase has nearly fallen away, one can see clearly the carved images of the gods and goddesses proceeding up a now vanished flight of steps to celebrate the ceremony of the goddess's appearance on the roof.

On her birthday in Dendera, the cult statue of Hathor was paraded onto the terrace of her temple to bask in the brilliant rays of the sun and in the appreciative love of her people. The citizens of Dendera and surrounding villages, breathless with excitement, waited outside the temple precinct for a glimpse of their goddess, whom they called the Golden One. Much of the birthday celebration was spent eating and drinking. There was music from dawn until dusk, the clatter of sistra, the rattle of menat beads being shaken, the lilting song of the flute, the beat of drums. . . . The Dendera texts themselves describe the sight:

> The gods of heaven exclaim 'Ah' in satisfaction, the inhabitants of the earth are full of gladness, the Hathors beat their tabors, the great ladies wave their mystic whips, all those who are gathered together in the town are drunk with wine and crowned with flowers; the tradespeople of the palace walk joyously about, their heads scented with perfumed oils, all the children rejoice in honor of the Goddess, from the rising to the setting of the sun.[79]

Dendera must have seemed a veritable carnival from morning until night. Dance was especially associated with the worship of Hathor, and her priestess dancers were agile, beautiful, and well trained. Some of the dances were erotic, rather like belly dancing. The focus was not strictly on the gyrations imitating the sexual act, however, but on the dancer's belly and navel as the sacred, fecund domain of the Mother. The belly dancer's well-developed muscles were considered an asset for a childbearing woman. The appearance of the dancing goddesses, the Seven Hathors, in the birth temples allude to the dance as assisting women during labor by demonstrating which muscles to use during the birth process.

Those people permitted to take part in the festivals as dancers, singers, or fan bearers were ecstatic, especially when they beheld the image of the Golden Goddess carried in procession. Ancient scribes proclaimed: "Fortunate are those who have taken part in the festival of Hathor" and "How happy is he who contemplates Hathor."[80] To see the image of the goddess was the same as seeing her in the flesh, for the ancient texts insist that Hathor was literally united with her effigy. Egyptologist C. J. Bleeker explains the phenomenon:

> Her image was not an arbitrary or fanciful representation of her personality, but was part of her being. In a procession she therefore, in a certain sense, appeared in person. The procession itself, the so-called pr-t or exodus, also possessed a deeper significance than the mere display of the divine image. It was an epiphany, an appearance of the deity who revealed her being to her adherents. The realization of this deeper significance of the procession of Hathor's effigy is necessary to comprehend fully the pronouncements . . . in which people express their great joy at having been privileged to behold Hathor. [81]

In her ancient temple Hathor's statue was venerated and venerable, adored and adorned for thousands of years. Thus, the statue acquired the power to heal, to speak, and to bring dreams to her worshippers. Pure Nile water poured over the base inscriptions of her statue could heal diseased bodies, minds, and spirits. Countless ancient seekers bathed in these holy waters. Whether their cures were brought about by fervent prayer, by some mineral in the water or within the stone, or by the powers of the goddess, the pilgrims wrote stories of their miraculous healing in prayers, poems, and inscriptions throughout the Dendera temple.

The office of high priest to Hathor was passed father to son, but many more women priestesses and royal princesses were engaged in her service than men, a custom unlike that of any other temple in Egypt. Dendera was predominantly a women's temple. Its walls depict the pharaoh engaged in the daybreak ritual service of Hathor. He climbs the three steps to the naos, breaks the clay seal on the door, and gazes upon the image of the goddess in adoration. To the Mistress of Heaven he offers her favorite gifts—incense, the menat, the sistrum, naturalia, and Ma'at, the image of truth.

Contemplation of the goddess's beauty was the highlight of the service to Hathor, often reserved only for the pharaoh and the priest and priestesses of the temple. What mysteries and rites took place inside the temple were hidden from public view. "Contemplation of the goddess within her shrine" was not a secret in the sense that one possessed some esoteric knowledge kept from everyone else; rather, the goddess conducted her own initiations into her wisdom for those who contemplated her beauty and power. Those whom she had initiated into these mysteries did not speak of them or enact them publicly. Nevertheless, most women in ancient Egypt adored the goddess and kept household statues of Tauret, Hathor, and Isis in niches placed beside their kitchen walls. Hathor assured them of their worthiness as wives to be loved, their right as women to be beautiful, and their duty as mothers to be nurturing.

The early Hebrews who followed Moses no doubt had little problem transferring their allegiance from Ra to Yahweh, as both were fairly strict, authoritarian, and patriarchal images of the divine Masculine; but they apparently had a bigger problem giving up their golden cow goddess Hathor. Without the gentle, good-hearted feminine energies to complement the masculine, who would nurture them?

Being the oldest goddess in Upper Egypt, Hathor was assimilated into nearly every other goddess. Even the so-called Songs of Isis are half devoted to praising the beauty and majesty of Hathor:

> Oh, Lady of the Beginning, come thou before our faces in this her name of Hathor, Lady of Emerald, Lady of Aset, the Holy!
>
> Come thou in peace, because of this her name of Hathor, Lady of Aset, the Holy!
>
> Come thou in peace, of Tait, in this her name of Lady of Peace!
>
> Come thou in front, to overthrow her enemy, in this her name of Hathor, Lady of the Temple of Suten-henen, the Golden!
>
> Come thou in peace, in this her name of Hathor, Lady of Inbut!
>
> Come thou in peace beside Nebertcher, in this her name of Lady of Hathor, Lady of Shet-Tekh!
> Shine, oh Golden One, beside her father in this her name of Bast.
>
> Go forward over the temples and by the side of the great temple, in this her name of Satis.
>
> The Two Lands become fertile—regulate thou the gods in this her name of Mafdet.
>
> Hathor overpowereth the enemy of her father by this her name of Sekhmet!
>
> Mafdet overpowereth exceedingly in this her name of Lady of Immu.
>
> She placeth perfume upon her head and her hair, in this her name of Neith. [82]

The Egyptian Goddess Zodiac

The zodiacal ceiling of the Temple of Hathor in Dendera was built around 600 B.C.E. by the Ptolemaic Greeks at the site of an earlier temple. Its astronomical and astrological data was said to reflect "the plan laid down in the time of the Companions of Horus"; that is, before the First Dynasty of Egypt which began about 3100 B.C.E., or earlier. The Dendera zodiac will seem familiar to those who know the Greek system of planetary signs signified by animal and human forms.

Twelve ancient Egyptian goddesses sit upon the zodiacal thrones, manifesting the diversity of all womankind. Owing to the diverse nature of goddesses, not every aspect precisely fits the Babylonian pattern; but such contradictions likewise occur in traditional astrology. The goddesses fit the pattern well enough to be considered as rulers of the following signs, planets, and houses. Because Isis tends to embody every woman, she is patroness of the entire zodiac.

The circular zodiac of Dendera, which shows the constellations, was said to have been laid down at the beginning of time.

Aries - Mars - First House Sekhmet

Sekhmet, one of three lionesses, rules the element of fire. Her name means "mighty, powerful one." Her tongue of fire consumes Ra's enemies, and she shoots flaming arrows into the hearts of evil doers. A warrior goddess, her heart burns with the courage of conviction. When the pharaohs rode into battle, they were honored to have her strength beside them. Impatient and hotheaded, her passion occasionally turns destructive, but the fury does not rage forever. Her ennobled passions are best used for healing and preserving others. Quick, dynamic, and confident, Sekhmet represents individual will power. With Ptah, her consort, she is cocreator of the universe.

Taurus - Venus - Second House Hathor

Goddess of music, dance, and love, Hathor was one of the most venerated goddesses, second only to Isis, with whom she shares this sign. Hathor usually takes the form of a beautiful woman with a headdress of cow horns surrounding the disk of the sun. The gold of the spiritual sun and the abundance of the greening earth are ruled by her. Like Venus, a bit of Hathor resides in all things artistic, beautiful, and practical. Like the cow, she is patient, giving, and nurturing, ruling the physical comforts of food, clothes, and gardens. As the double lioness Sekhmet-Bast, she also exhibits passion and sensuality. Hathor can be quite practical, performing her duties with pride. Despite an appearance of material concerns, she is a highly developed spiritual being. Her spiritual longings, however, take a practical turn, as in following the moon signs to know when to plant or when to wean children.

Gemini - Mercury - Third House Seshat

Seshat is nothing if not energetically creative. Inventor of the alphabet, she recorded the deeds of humankind and kept the akashic records. Goddess of books, keeper of mysteries, mistress of the library, she inscribed her facts on the leaves of the Tree of Life, keeping daily account of human life, the number of stars, grains of sand, and fish in the sea. She likewise provided a civilizing influence, creating the spaces in which humankind must live. In every city, she "stretched the cord" as architect, planning the building of the temples. Seshat creates through combining forms and recognizing the diversity of nature. In one hand, she holds the palm frond, symbol of eternal space and time; in the other, she holds the scribe's ink and papyrus. High priestess of reason, logic, and lan-

guage, she drapes her body in the panther skin to signify that she has tamed her wild energies.

Cancer - Moon - Fourth House Nut

The waters of creation—both sea and atmosphere—are the essential form of Nut. On her head she wears a water jug, a symbol of the maternal, fecund, and retentive. In the Heliopolitan tradition, Nut forms the body of heaven bent above Geb, the earth. This mother goddess appeared as a cow whose udders constantly provided the milk of heaven by which she nurtured the pharaoh during his life. Nut also gave birth to the other major Egyptian gods and goddesses—Horus, Osiris, Isis, Seth, and Nephthys. Like the fourth house that she represents, Nut is also a goddess of death who receives the bodies of the dead and incorporates them back into her body. She is not only the day-lit sky as the sun crosses it, but also the night sky crossed by the moon. Her body is studded with a thousand stars, said to be her innumerable children. Her open arms, as she lies outstretched and painted on the lid of the sarcophagus, lovingly receive the remains of the deceased.

Leo - Sun - Fifth House Bast

Called the heart of the sun god Ra and the soul of Isis, the feline Bast is a form of Hathor as goddess of love. The warmth and devotion of this Leo goddess appears sometimes in cat form; but her pride and self-assurance take a lioness form. Her energy is the germinating, tender warmth of the sun. Because of her great strength and personal power, she wears a uraeus serpent on her forehead, signifying the solar wisdom of the essential self. Bast is a goddess of protection, rather than of war. Most often, she was depicted as a woman with a cat's head and a basket of kittens. She connotes the gentler feline aspects—agility, beauty in motion, pride, friendliness, self-sufficiency, and a love of children and pleasure. As a goddess of love, Bast embodies not only universal love, but sensual and physical love as well.

Virgo - Earth - Sixth House Wadjet

The cobra Wadjet protected Horus after his birth in the papyrus swamps. She bears a snake's head upon a woman's body, and she holds a child

suckling at her breast. Because she suckled the weak child of Isis, enabling him to grow up to become a great warrior, she rules the wadjet amulet, or Eye of Horus that conferred its wearer physical strength and protection. She nurtures the physical body and instills perfection. Certain bones of the skull were identified with Wadjet, and she initiated the wearer of the uraeus into sacred knowledge. Awe of her struck the hearts of "those whose souls were made perfect." Called Mistress of Flame, The Green One, and Opener of the Lands, she is goddess of the harvest. Wadjet not only protects the human body, but cultivates the health of the fields and earth.

Libra - Venus - Seventh House Ma'at

On her head, Ma'at wears the ostrich feather of truth that is placed in the balance of the scales of justice at the moment when the heart is weighed in the underworld. Ma'at represents the moral precepts of justice, honesty, and integrity and the divine principles of cosmic order and law. On Earth her priests presided as judges in the pharaoh's court. Regulating not only daily life but even the path of the sun, Ma'at provides divine, unalterable laws. Inside the cupped hands of the pharaoh, Ma'at is the gift of harmony, balance, and reciprocity that the king offers in turn to the Divine. All things are her domain, especially the beer, bread, and incense that were traditional offerings. At other times Ma'at appears as two feathers, as two birds, as twin principles, or as the ma'aty goddesses, Isis and Nephthys, who are the polarities of light and dark, yin and yang, action and reception.

Scorpio - Pluto - Eighth House Heket

Heket is a mysterious goddess—half human and half frog. Sexuality, birth, death, and magic were her domains. She fashioned the child's form, life, and destiny in the womb, then assisted its mother as midwife during birth. During burial, she stood at the foot of the bier assisting the underworld gods in their ministrations to the dead. Most importantly, Heket is goddess of magic, embodying the power of the sorceress and the will to effect change. She possesses a deep, intense kind of power not easily transmitted to others. As

goddess of incantation, she manifests as the magical form of Isis. Her name derives from the Egyptian word, *heka*, meaning "effective utterance." Heka is the skill of knowing when and how to use the words of power to create or destroy form. This mystical art was handed down in an oral tradition, because its force was so intense that it had to remain secret.

Sagittarius - Jupiter - Ninth House Astarte

Imported from Syria, Astarte sometimes appeared with a lion's head. A daughter of Ra and goddess of war, she drove her chariot with one hand, gripping her arrows and bows, like the archer Sagittarius, in the other. Quick action, high energy, and a measure of wildness are her hallmarks. A lover of travel, and one of Egypt's least conservative goddesses, Astarte often appears riding naked and bareback upon a horse. She represents a familiarity with the wild, deep mystery of earth, animals, and the natural world. Shown holding lotus flowers, she is a lover of natural beauty and spiritual truth. Astarte's full-frontal nudity might also suggest the expansive, freedom-loving qualities of Jupiter. To some she was the sacred harlot, loving many, but never being owned by any. Her deepest truth is to remain true to herself.

Capricorn - Saturn - Tenth House Nekhebet

Nekhebet, the vulture on the royal diadem, protected the king, just as the vulture mother fiercely guards her eggs and nurtures her fledglings. In fact, Nekhebet might be considered overly protective, at times to the point of limitation. Nekhebet was also identified with death and sorrow. Vultures often swarmed about cemeteries and the houses of the dying, waiting to feast upon human flesh. On all the royal tombs throughout Egypt one finds the portraits of vultures carved upon the eastern and western doorways. The eastern vulture was the nurturing mother at the beginning of life, while the western vulture was the devouring mother at the moment of death. Nekhebet symbolizes the wisdom of the crone, the constancy of birth and death, the gestation of matter at the beginning, and the ingestation of matter at the end of life.

Aquarius - Uranus - Eleventh House Satis and Anket

Goddesses of the flood, Satis and Anket shared a temple near Aswan above the first Nile cataract; they also share attributes. While Satis wears antelope horns, Anket wears the horns of the gazelle. Both goddesses are linked to the star Sothis that annually predicted the Nile flood. As divinities of Inundation, these Aquarian goddesses represent abundance, fullness, renewal, and goodness and plentitude for all humankind. Satis bears a jug of cool water for the deceased during the purification rites, while Anket holds a papyrus scepter and stands in a boat that floats on a stream in the shape of an arm. Considered goddesses of a healthy body and joyful heart, Satis and Anket provided abundance for all. Individually, however, they were a bit too unpredictable, erratic, and independent to be entirely tamed or controlled, even by the pharaoh.

Pisces - Neptune - Twelfth House Nephthys

A quiet, passive goddess, Nephthys kept to herself, never acquiring her own cult. She was goddess of mourning, sorrow, and loss, as well as goddess of compassion, comfort, and support. As Pisces is the last zodiac sign, Nephthys was the last-born sibling; thus, she spent a good deal of her time in obscurity. Myths show Nephthys working under the cover of night as a weaver of illusions and dreams and as a goddess of self-sacrifice and sympathy. Some say she is the hidden Isis who guards occult things, invisibility, and that which is beyond the veil. In tomb paintings Nephthys appears as supporting the deceased from behind; her strength lasts forever, yet she remains hidden from direct sight. A creative goddess, her creativity arises from the unconscious. She represents dreams, ideals, psychic receptivity, and the unknowable. She was known as the extreme limit of anything that could be imagined—the end of the finite world and the bridge to infinity.

THE LAMENTATIONS OF ISIS

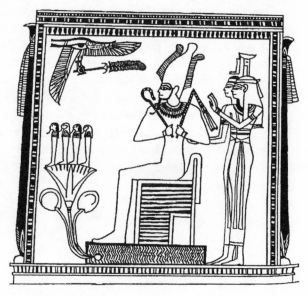

Sisters Isis and Nephthys support the resurrected god Osiris in the Hall of Judgment.

Appropriate for Days that Celebrate

- Mourning and Loss
- Retreat for Future Growth
- Winter
- Communion with the Dead
- Sacrifice
- Cutting Back the Garden
- The Death of a Loved One

Most religious rites and traditions center around a culture's story of its dead and resurrected god. Egyptian religion is no different. The myth of Isis and Osiris is the supporting pillar of Egyptian religion. Like the Christian story of the Last Supper wherein Judas betrayed Jesus during the Passover feast, so did Seth betray his brother Osiris in the midst of a grand feast held in Osiris's honor. Here's how it happened:

The good king Osiris, often called Unnefer the Beautiful Being, was in his twenty-eighth year. (Some say he was only twenty-eight years old, others say he was in his twenty-eighth year of reign.) After arriving in Abydos by boat, Osiris and his sister/wife Isis had been given the rich, fertile black land of the Nile valley and delta, while brother Seth and his sister/wife Nephthys were bequeathed the barren, red desert lands. Seth felt cheated in the bargain. In their land, the royal couple Osiris and Isis were much beloved, having taught their people the ways of agriculture and a nonviolent lifestyle. Seth's tribe, on the other hand, were still a rag-tag group of warriors and hunters who had to scratch a subsistence from the desert mountains and valleys. They wanted what Osiris had.

Osiris generously invited his brother Seth and Seth's whole entourage to join him and his people in a harvest festival. There was abundant food and copious amounts of wine and beer, both of which Osiris enjoyed. The goddess Isis was away on one of her state-sanctioned trips. The palace was all in festivity. There was music and dancing and merriment.

Seth appeared, bearing a gift—a box richly adorned with jewels and gold. As a party game, he announced he would give the box to any man or woman who might lie down in it and fit exactly. Of course, the trick was that it had been built precisely to the proportions of Osiris. Like Cinderella's fabled glass slipper, it would fit none except its rightful owner. When Osiris lay within it, Seth and his seventy-two rabble-raising companions closed him up inside and sealed the coffin with lead. Amid the ensuing confusion and under the cover of darkness, they hurried the box down to the river's edge and threw it into the Nile. Osiris suffered his first death, drowning in the jeweled coffin. The river carried him inside the box downstream, farther and farther from Abydos, until it finally came to rest in a foreign land, moored against a tamarisk tree which grew up around the coffin, completely trapping the body of Osiris within.

When Isis finally heard the news, she was beside herself with grief. She came home to Abydos to find that Osiris was dead, his body had vanished, and her younger brother was her husband's murderer. In the manner of widows of her nation, she cut off all her beautiful long hair and walked barefoot along the banks of the river, searching for the body of her husband. She no longer resembled the beautiful queen of Egypt, but appeared in the grim visage of a hag; thus, her own people rejected and scorned her. At last, following the river, she discovered that the chest had sailed down the Nile, clear out of Egypt into the Mediterranean Sea, and been cast onto the shores of Byblos.[83] The coffin had lodged in the branches of the tamarisk tree, concealing Osiris within; but even though he was hidden, the good wife Isis recognized that the tree contained the body of her husband and so would not leave it.

In the meantime, stories in Byblos abounded of an amazing tree that apparently had sprung up overnight beside the shores of the sea. The king of Byblos was so astounded by the beautiful tree, by its sturdiness, and by its miraculous growth that he had it hewn down and brought to his capital city to make it into the central pillar for his palace.

Dutiful Isis followed the fallen tree all the way to the palace gates. There she sat outside the community well, weeping and wondering what to do now that her husband's body had been taken from her yet again. Common as she seemed on the outside, Isis attracted the interest of the palace servants and the princesses. Who was this strange, ravaged yet beautiful woman sitting beside their well, and why was she crying? As the handmaidens of the queen came closer, they realized this mysterious woman exuded a most fragrant perfume that arose from the pores of her skin. It was said a divine ones had a fragrance that was the hallmark of their divinity; thus, the servants and princesses reasoned, this woman must be a goddess in hiding. She offered to plait the maidens' hair, and to be near her, they willingly complied.

Because of the delicious odor of sanctity about the woman, the queen decided to give Isis the royal babe to nurse. Now Isis was taken into the palace as nursemaid and given something she did not have before; an infant child to suckle and proximity to her husband again. Isis soon became an indispensable part of the palace household and was the much-loved nurse to the king and queen's children. But having lost a husband, Isis knew there is no worse grief than the death of a loved one, and so she decided to give the child of this queen a rare gift indeed for mortals—the gift of immortality.

At night, while the palace family slept, Isis made magic. She performed a kind of divine alchemy and thrust the babe into the fire in an effort to burn away his mortality. While the magical fire performed its task on the hearth, the goddess transformed her-self into a kite. She flapped her wings, fluttering about the column in which Osiris resided, keening and lamenting his death with strange, shrill, mournful songs.

This went on for some time, but on the last night of the transforming ritual for the babe, the strange singing of the hawk goddess awakened the queen, who went to investigate. Seeing her child in flames, the queen shrieked and dragged the babe from the fire, thus breaking the spell and depriving him of immortality. Seeing that her "gift" had been rejected, Isis swooped down before the terrified queen and transformed again into human form, revealing her true self as a goddess.

Terrified of having a woman of such power in her kingdom, the queen quickly asked, "What do you want?" She was willing to give anything to get rid of this witch in her house.

"I want the pillar that contains Osiris," Isis said.

Immediately granting her request, the queen had the pillar cut down and sent home with Isis in one of the king's boats. One of the queen's older children accompanied Isis on her journey back to Egypt, but was accidentally drowned before he returned. It seems that he audaciously stared at the goddess while she grieved and mourned over her husband's body. When Isis shot him the evil eye, he was so terrified that he lurched backwards and fell out of the boat.

The Lamentations of Isis and Nephthys commemorated the death of Osiris and always preceded the mourning festivals that came later in the month of Koiak. A number of reasons account for the festival being celebrated during the season of Inundation; but the main reason Hethara 17 was considered the traditional date of Osiris's murder was that his sorrowing wife Isis is inextricably linked with the festival called The Night of the Drop, which represents the tears Isis shed that caused the river to flood.

The mysteries of Isis and Osiris are as old as Egypt itself; the overwhelming power of the Goddess's dirges are as ancient as life itself. In the mystery of life and death, and through the unashamed grief over the loss of the Beloved, we contact the unfathomable nature of existence. "The grief for the lost one, the hope of again beholding him, the cry from the heart for help, the reliance upon the divine all-ruling destiny that shall bring the trial to a happy ending, and the triumph of a desire realized and a hope fulfilled: these sentiments," says James Dennis in his translations of the traditional Lamentations, "are as much a part of human nature now as then."[84]

These dirges were probably sung as far back as the establishment of the First Dynasty of Egypt, when warriors from southern Egypt conquered the Delta region. In all probabili-

ty, they are even older. Associations of Isis and Osiris with Byblos—the city north of Beirut and connected to the Canaanite goddess worship of Astarte—were already well-established as early as the Second Dynasty of Thinite Egypt.[85] The public reenactment of the rituals associated with the myth gradually gained its greatest national prominence during the Middle Kingdom years and continued in great popularity right through the Roman period. In all likelihood the songs were traditional and memorized, but the versions we have come to know as The Lamentations of Isis and Nephthys were recorded during the Greek occupation of Egypt around 300 B.C.E. Copies of variations of these songs were discovered in Luxor, one of them tucked inside a statue of the god Osiris. [86]

As the mystical Osirian rites spread through the Greek world and Roman Empire, the dramatic presentation of the Lamentations likewise grew in magnitude. In the mysteries of Isis, Greek and Roman women acquired their own heroic feminine figure, one worthy of adoration. The goddess spoke directly to women's concerns, to the loss and sacrifice required of being wife and mother. The mysteries of Isis especially appealed to those who identified a deceased husband, son, or brother with Osiris. The mourning rites provided them with an outlet for their grief and assured them that the deceased had a future life.

Many more women identified with the penitential aspect of the cult, says classical scholar Sharon Heyob, because it provided an outlet for the guilt over sins committed against husband, children, or family. Because the goddess especially abhorred infidelities, violations of chastity, or rape, Roman initiates exhibited exuberant self-castigation by throwing themselves into the icy Tiber River three times, then crawling naked through the streets of the city until their knees bled. Others sat for days inside the temple and made oblation upon oblation. Less fortunate penitents were said to be struck blind.[87]

In the eyes of later Christian and Roman observers, the public spectacle of grieving turned the mysteries into a carnival. Women participating in the Isia in Rome and even in Roman Busiris thronged into the streets during the feast day. At times there were said to be a thousand wailing, half-bald women in the streets, scratching their arms, tearing open old wounds, moaning loudly and beating their breasts.[88] Such public displays were never part of the true Egyptian rites, which were most often performed in the temple under the cover of darkness and about which initiates were to remain silent. These later public outbursts in Rome and elsewhere among noninitiates so degraded the Isiac rites in the eyes of the public that they were finally abandoned.

On the other hand, a highly visible lamentation probably appealed to Greek and Roman women precisely because their lives under Greek and Roman rule were so limited and desperate that they sought Isis in comfort for their sorrow. Desperate times create desperate people, and these indeed were desperate times. Philosopher Arthur Versluis reminds us of how important ritual is to the evolution of the human spirit, saying:

> The lamentations of the populace in concert with Isis, in search of her lost consort Osiris, wailing and mourning during certain festivals, mirrors humanity's longing for sacred knowledge, without which they live in fragmentation and ignorance. [89]

Perhaps that is why Michelangelo's sculpture of the Pietà—that is, of Mother Mary holding a slain Christ in her arms—has appealed to so many people. Perhaps that is the reason that the lamentations of Mary and Margaret over the death of Jesus strikes a chord in the hearts of so many women. Where there is great sorrow, there is the possibility of greater revelation of Light, of what initiates in the mysteries later claim to have seen: the brilliance of the sun shining in the midst of a dark night. The feminine aspect of the Divine most clearly revealed the mystery of life and death because, I believe, Isis (and Mary) symbolize the Great Mother who rules over both life and death generating both cyclical and eternal time. Succor in times of need the goddess Isis gave in abundance. So powerful and widespread was the worship of the compassionate (and passionate) Isis that it began to threaten not only patriarchal political authority, but also the worship of the gods.

At the height of Egypt's Isiac Mysteries, the Lamentations were recited in a number of important native temples, including the Temple of Hathor at Dendera, the Temple of Osiris at Abydos, the Temple of Isis at Philae, the Temple of Horus at Edfu, and the Isis-Hathor Temple at Memphis. The pharaoh would have attended only one of these temples as the high priest of the mysteries enacting the role of the fallen, then resurrected, Osiris. He may have been at Dendera; more likely he attended the rites at Abydos. Nevertheless, the priests and priestesses performed the rituals, with or without the pharaoh's involvement, with high ceremony and great spectacle.

Part of the ritual that celebrated the grief of Isis involved carrying an ox in a pall of black linen around the Temple of Dendera seven times during the course of the evening. The ox, of course, represented the shrouded body of Osiris and was followed by lamenting priestesses. The mourning text recounted the love of the goddesses for their brother, their

sorrow at his death, their ritual attempts at reviving Osiris, and his final resurrection before the eyes of Ra.

The Lamentations no doubt were similar to the actual keening rituals and songs performed at every funeral throughout Egyptian history, with the women following the bier, tearing at their hair, tears streaming down their faces, singing a lament for the dead. An early Middle Kingdom version of the Lamentations was found in the Coffin Text burial rituals of Amenemhat, mayor of the city of Bersha. The texts apparently were sung by lamenting priestesses who accompanied the burial rites in the tomb:

> The doors of the sky are opened to your beauty.
> May you go forth to see Hathor. . . . Stand! Live!
> You have not died. . . . Come to me, rise up to me,
> be not far from your chapel, turn to me. . . .
> Awaken to life! See, day breaks. Nephthys has
> favoured you, anew, anew, every day at night time
> when you are with the Unwearying Stars.[90]

In yet another version of the Coffin Texts, the goddesses Isis and Nephthys, depicted in temple illustrations at Abydos as two kites, stand at the foot and head of the bier respectively and sing back and forth to each other:

> Ah Helpless One! Ah Helpless One Asleep!! Ah
> Helpless One in this place which you know not—
> yet I know it! Behold I have found you on your
> side, the great Listless One.
>
> "Ah, Sister!" says Isis to Nephthys. "This is our
> brother. Come, let us lift up his head. Come, let us
> [rejoin] his bones. Come, let us reassemble his
> limbs. Come, let us put an end to all his woe, that as
> far as we can help, he will weary no more. . . . Osiris
> live! Osiris, let the great Listless One arise!"
>
> I am Isis. I am Nephthys. [91]

The Lamentations were so powerful that many of the participants actually fell into ecstatic trances during the performances. Worshippers of Isis in the town of Coptos were said to be inhabited by the spirit of the goddess herself. During the Lamentations the priestesses could walk barefoot in the midst of scorpions and remain unharmed because they were protected by Isis, who according to myth was protected by scorpions.[92] While the priestesses in the temples performed their ritual lamentations, the populace lamented in concert outside, roaming the streets, crying to each other and looking for Osiris. This custom might have given rise to the superstition that during the time of Lamentations the souls of the dead could actually walk among the living, an idea that

comes down to us to this day in superstitions about Halloween night, which precedes All Soul's Day in the Christian tradition.

By and large, the mysteries celebrated at Dendera became the largest of the Lamentation festivals during the Graeco-Roman period. Beginning on the 17th of Hethara, following a full moon, the rites were held for a period of nine days, or perhaps for the duration of the waning moon. In a similar vein, the Nandi tribe of East Africa also celebrates its mourning rites during the last moon phase. [93]

Before the festival could begin, the entire temple had to be ritually cleaned from top to bottom and fumigated, probably with incense made from myrrh gum and resins, the traditional Egyptian spice used in the practice of embalming. The two priestesses who would play the parts of Isis and Nephthys no doubt had trained their temple voices for some time and been in initiation for their sacred roles for a number of years. These preparations intensified in the week before the drama of the Lamentations.

Both women were required to be "pure," meaning that for the last seven days they had engaged in ceremonial purification rites that included daily meditations, washing their mouths with myrrh, chewing natron, and smudging themselves with burnt incense. The natron had to come from the city of El-Kab and the incense from the realm of Hathor, the Land of Punt.[94] In addition, the women had to be virgins. In the Egyptian language, the exact wording of the phrase *ni wepet* was they "who have not been opened."[95] It is not clear whether this phrase actually meant that the women should be childless, or non-sexual, or pubescent—all possible interpretations. The hieroglyph of the goddess each young women was embodying would have been inscribed on their forearms. Their heads were completely shaved, as was every inch of their bodies. Their bald heads were then covered with the long-haired braided wigs that symbolized the goddesses. In their hands they held either the tambourine or the sistrum with which they accompanied their singing. For the Lamentations and Osirian rites, the priestesses used special sistra which bore the face of Isis on one side of their handles and the face of Nephthys on the other.

After the lector priest opened the ritual, the two priestesses (goddesses) sang their song of sorrow in duet:

> Someone is brought in dead and our eyes are weeping for thee. The tears burn. Woe is us since our Lord was parted from us! O thou who art fair of countenance, lord of love. O Bull who impregnates cows! Come, O sistrum-player, gleaming of countenance, O thou who art uniquely youthful, beauteous to behold, Lord among women . . . O

Sovereign, come in peace. Drive trouble from out of our house. Consort thou with us after the manner of a male. [96]

The Isis priestess would await the appearance of Osiris as either the moon or a particular star. When the sign came, she traveled from her temple on the Island of Philae to the Osiris Temple located on the Island of Bigga. There she made offerings of consecrated Nile water, milk, and wine to Osiris in his sacred grove. The solemnity of the Osiris Temple was never disturbed. No one except priests ever set foot in the sacred grove, [97] and the god was not to be disturbed by fishing, fowling, or music making. In fact, no one could speak above a whisper while the services were being conducted. Because of the consistency and power of this monthly ritual healing of Osiris, pilgrims from Greece and Nubia alike flocked to the Isis Temple at Philae to receive a similar healing from the hands of the goddess.

Activities

1. When Isis lost Osiris, she searched all over Egypt and even into the lands beyond. Sometimes our grief over loss becomes a long process; it takes us on a journey into places quite unfamiliar and unexpected. You may want to begin to draw of map of your journey through grief. These may represent physical spaces through which you passed, or psychic and emotional ones. Was there a valley of tears, a place of shadows, a gap through the mountains, a desert and an oasis? Detail these places in both images and words. You may want to use different colors to represent the stages of your grief, such as red for anger, yellow for illumination, and so on.

2. Sometimes it's the small losses unmourned at the time that when added together create a body of sorrow. Explore these disappointments. Ask yourself what your heart wanted at the time. Recount what you got instead. See if you can detect a pattern in the losses, and even perhaps an unrecognized gift from the universe. If you have trouble bringing to consciousness these losses, try making a list of, say, fifty things you've lost in your lifetime. When you look over your list, see which ones hit you most strongly. Take time to grieve each loss.

3. Was there ever a time when rage or sorrow turned you mute? Even Isis stayed longer than was necessary in the foreign queen's house, waiting and mourning for Osiris, when Osiris was there before her inside the pillar all along. When have you failed to ask for what you needed? Ask for it now.

Isis mourns Osiris at the Temple of Hathor at Dendera.

THE FEAST DAY OF MA'AT

Ma'at wears the feather of truth which must balance with the heart in the underworld.

Appropriate for Days that Celebrate
- Balance and Order
- Arbitration and Justice
- Truth Telling
- The Rise of the Libra Constellation

Ma'at is not the abstraction that Egyptologist Adolf Erman would have us believe she is. She had her own priesthood and her own temple herds of sacred cattle from the Fifth Dynasty to the last. Her temples appeared in Nekhen and Karnak, as well as a number of other places.[98] At Karnak the old temple to Ma'at, goddess of balance and cosmic order, was built beside the Temple of Montu, the hawk-form warrior god. In complementary choice of companions, Ma'at balanced the very harsh energies of Montu, assuring that the destructive aspects of war might only be used to establish order.

Ma'at was called Daughter of Ra, Presider over the Palace, Mistress of Heaven, Ruler of the Gods, and Giver of Myriads of Years.[99] The viziers and chief justices of Egypt were called the Prophets of Ma'at, striving to achieve fairness and balance in settling all disputes, thus "satisfying the whole land."[100] Most of the prophets of Ma'at were attached to the city of Nekhen, or the Temple of the Elder Horus.

Ma'at emerged as an important figure in the mythic battle between Horus and Seth. (See the myth recounted in the festival of the Hierogamos of Hathor and Horus found in the season of Harvest on Epiphi 1.) After Seth blinded Horus by poking out his eye, the hawk god was called The Sightless One. The myth varies as to whether Seth blinded the right or left eye of Horus, or both, but it doesn't really matter. It should be understood that the two eyes of the god were the sun, his right eye, and the moon, his left eye. A new moon, or sun and moon conjunction, would occlude the moon every month, but the sun could equally be "blinded" by a solar eclipse caused by the moon.

The word *ma'at* was sometimes written hieroglyphically by inscribing two eyes, a right and a left. One eye alone is not enough to see with Ma'at, or to see true. When a god cannot see with both eyes, his vision is distorted. Thus blinded, Horus cannot see truth, the dual manifestation of reality. He, like Montu, the warrior god, is blind to the wisdom of the heart. Ma'at balances all things in opposition: day and night, upper and lower, left and right, spirit and matter.

The myth tells us that Horus stumbles blindly in the desert until the goddess Hathor finds and heals him. In Plutarch's version, however, it is not Hathor, but Thoth, the god of wisdom, who "brings back Ma'at" to Horus's eyes and restores his sight.[101] The ancient word *ma'a* had two meanings: as the noun "truth" and as the verb meaning "to see." The *ma'at* of Hathor that heals Horus's eyes is her cow's milk, and accordingly the cow goddess was always drawn with the Eyes of Horus, or the *wadjet* eyes. The *wadjet* is the all-seeing eye of truth like the eye the cow goddess possesses, and she bestows upon the injured god her ability to see truth clearly and judge correctly.[102]

As a goddess, Ma'at compassionately and perceptively envisioned our lives from beginning to end. Working in conjunction with Osiris in the underworld, she judged our hearts and life's work with her all-knowing eye. Hers was the eye of the crone, the wise woman, the seer whose gaze held the power to heal or curse in a single glance.[103] At death she became the scales that weighed the heart against the feather of truth. The hearts of those found lacking were devoured by a blood-thirsty hippopotamus-lion-crocodile monster named Ammit (an anagram of Ma'at). The *ab*, or "heart-soul," that weighed too heavily in the scales was tossed to the monster goddess known as the Eater of Hearts and devoured. At that moment, it became as if the soul of that person had never lived. On the lips of Ammit there were no second chances.

In the Hall of Judgement, the heart of the deceased

called out the deeds and misdeeds of its owner. The litany of actions one had not committed in life was called The Negative Confession. The heart-soul abhors not only the grievous crimes named in the Ten Commandments—such as murder, theft, adultery, slandering the gods, bearing false witness and coveting property—but also more mundane sins for which one must be accountable. So announces the heart in this "Negative Confession":

> I have not been a man of anger. I have done no evil to mankind. I inflicted no pain. I caused none to weep. I did violence to no man. I have not harmed animals. I have not robbed the poor. I fouled no waters. I have not trampled fields. I have not behaved with insolence. I have not judged hastily. I have not stirred up strife. . . . I have not insisted that excessive work be done for me daily. . . . I have not cheated in measuring the bushel. I allowed no one to suffer hunger. I have not increased my wealth, except such things as are my own possessions. . . . I took no milk from the mouths of children. [104]

If the lives we lived were "true," we were embraced by the winged Isis, yet another form of Ma'at, as the goddess of beauty and light. In this capacity Ma'at embodied mercy, as well as justice. I imagine that The Feast of Ma'at occurred just prior to The Lamentations of Isis at the beginning of the Osirian Mystery cycle because it was a precursor to the mysteries. (See Koiak 27.) To be initiated into the sacred ritual of rebirth, one had to prepare oneself, cleanse oneself of false piety, and examine the true nature of one's heart. The judgement of Ma'at was not an event that took place only after death; rather, it was constantly being performed.

The scales of Ma'at were eternal principles by which cosmic order was first established. In myth, Ma'at measured and drew the line which the sun god Ra followed as he sailed in his sacred barque across the sky. In life, *ma'at* was the balance one must attain between spirit, body, and mind. In a Karnak Temple relief of Seti I, the pharaoh's body was said to have come from the body of Ma'at. [105] (This may have to do, not with saying she was his mother, but with an emphasis on his body being in balance.)

In many New Kingdom tombs Ma'at appears small, luminous, and birdlike as she sits in the cupped hand of the pharaoh. The single, white ostrich feather, she wears in her hair is that which is placed on the scales when the heart is weighed at death. The pharaoh uplifts his hands offering to the gods Ma'at—the greatest treasure he possesses, that of cosmic law and truth. In the hand of a pharaoh, Ma'at represents human partnership with the Divine.

According to one way of thinking, Ma'at is a divine, eternal being, a goddess who was never born, does not age, and will not die. In heaven, she dwelt before form; she witnessed the dawn of creation, balanced the scales, and created order from chaos. She regulated ebb and flow; even the path of the mighty sun god Ra was set by her unalterable laws. She nourished the gods as their food and drink. In the mystical tradition of the priests of Memphis, Ptah and Ma'at cocreated the cosmos. When Ptah conceived the world through his tongue and heart, the goddess of truth and cosmic order came into being. Ma'at is called the Heart and Tongue of Ptah. [106] Once the primeval hill rose from the deep abyss, Ma'at descended from heaven to earth, embodying the gift of gods to humankind: balance, harmony, equilibrium, and order.

Ma'at represents what all humans strive for—harmony with all of creation. She is the delicate balance between animal and divine natures. Such equilibrium is difficult to maintain and must be the focus of daily attention. The papyrus of *The Eloquent Peasant*, dated from the Middle Kingdom, provides the key to a harmonious life:

> Speak Ma'at, do Ma'at
> For she is mighty.
> She is great and endures.
> Her value rests in the hands of those who use her.
> Ma'at leads one to sacredness. [107]

The Cairo calendar, the horoscopic and festival calendar of the general ancient Egyptian populace, tells us that on the day of Hethara 21 the gods and goddesses of heaven raise Ma'at in order to see Ra. [108] Ma'at was offered in the temples to all the gods and goddesses on a daily basis throughout Egypt. As the final day's ritual closed, the high priestess held in a cupped hand an image of Ma'at and offered it to the divine being as a way of saying, "On this day, order has been established."

The Feast Day of Ma'at may also mark the appearance of the early morning rise of the constellation of Libra with its emblem of the scales. With the scales upon the horizon just before dawn, the sun god Ra would rise through the midst of the image of truth and justice; thus, one could be assured that order, truth, and peace would reign throughout the day. At Ma'at's festivals, the participants were said to eat honey and eggs and say to each other, "How sweet a thing is truth." [109] The egg, of course, is the symbol of unity and wholeness, eternal life, and creation that comes directly from the Great Mother.

OPENING THE BOSOM OF WOMEN AND THE FEAST OF ISIS IN BUSIRIS

The African fertility god Bes assisted Hathor with the divine birth.

Appropriate for Days that Celebrate

- Fertility
- Motherhood
- Creative Energy
- Transition
- Coming of Age
- The New Moon in Libra

The festival calendar of Hathor's Temple in Dendera calls this the day of Opening the Bosom of Women. The Cairo calendar calls it The Feast of Isis in Busiris. These may be the same festival celebrated in two distant cities under two different names. On this day in Dendera the festival involved rituals and a procession of Hathor through a throng of women who were blessed by the goddess.[110] The ritual was especially important for newlyweds and childless couples. It may have been extremely potent for any royal queen who had not yet conceived a male heir with the pharaoh. According to the Esna calendar, the festival lasted two days, extending the festivities into the month of Koiak 1. [111]

The Cairo calendar suggests that the magic invoked in these festival rituals involved "naming the *doorways* that come into existence: The House of Ra, The House of Osiris, and The House of Horus." Those doorways may be the womb of the Great Mother in her aspect as Isis, Hathor, or Nut. Certainly, the true significance of the goddess Hathor (*Het-*

hor) is in her name, literally meaning "House of Horus." Because she is sometimes presented as the wife of Horus the Younger, it would be easy to mistake her name as being equivalent to "Lady of the House"; but in older traditions, Hathor is the sky, the mother of Horus the Elder, the hawk god, and what is being referred to is the womb which housed him during gestation. Says the ancient text: "Inside her body a house of Horus is being prepared, hence her name is Hathor." [112]

The magical hieroglyphs of the Pyramid Text which appear in the long passageway leading into the Tomb of Unas are spells related to the birth of the gods Horus and Sobek from the womb of the Great Goddess Mother. Barbara Walker believes that the triple goddess worldwide took the shape of the triangle and that the pyramid tomb was equivalent to the womb. The earliest tent dwellings of women had triangular doorways,[113] and even the bread of ancient Egypt was baked into conical loaves. It would not be surprising if these conical loaves were part of the sacred offering to the

Goddess, and once blessed, ritually eaten. The hieroglyphs for "bread" and for "earth" were both *ta*, definitely woman-derived words, the "t" sound always indicating the feminine ending.

It is possible, however, that there are two types of pyramids: one male and the other female. In Egypt such equilibrium and balance of energies was always at work in any spiritual practice. The Pythagoreans maintained that the upward-pointing triangle—that is, the pyramid of the pharaohs—was masculine and imitated the erect phallus of the Earth god Geb reaching toward the sky, and that the downward-pointing triangle was female, imitating the pubic region of the Goddess.[114] I must also point out that Hathor was known as Lady of the Peak, and so, as the goddess of the mountain, *is* an upward-pointing triangle. But in Egypt, such contradictions are not contradictions at all, but a means of approaching a multiple vision of truth.

Yet another emblem of the goddess was the *thet*, or "Knot" of Isis, a magical amulet always carved of carnelian or another red stone to symbolize the rich blood in the goddess's womb. Made to resemble a knot in a woman's girdle, the thet was similar in shape to the *ankh* (the hieroglyph meaning "life"), except that it had three loops. Two of these loops were closed, which may explain its relation to the two infertile times of the triple aspects of the Great Goddess as virgin, mother, and crone. Some of the fertility figurines found at Beni Hassan were made of knotted string, with the idea that the tying of magical knots completed the invocations to the goddess.[115]

This festival of Opening the Bosom of Women continued the dramatic rituals and reenactments of the myth of Isis and Osiris. Whereas the Lamentations earlier in the month recall the death of Osiris by Seth and the sorrow of Isis, this festival recounts a myth of mistaken identity, the myth of Nephthys and Osiris. Before Osiris died, he and Isis lived as man and wife but were unable to conceive a child. This sterility saddened the goddess. Apparently, the infertility was her own, for Osiris managed to impregnate her twin sister Nephthys in a case of deception and mistaken identity. Here's how it happened:

Seth's pent-up anger and midnight wanderings to hunt the wild boar drew him further away from the arms of his wife, Nephthys. Left too much alone, one night she stole into the palace garden of Isis and Osiris to draw near her siblings for comfort, listening to their voices and laughter as she sat under the moonlight behind the garden wall. Nephthys envied Isis and Osiris their relationship, and so one evening, inhaling the aroma of Isis's per-

The *thet* (Buckle or Knot) of Isis represented the magical womb of the goddess.

fume, she decided to steal just a bit of that luscious scent from one of her sister's alabaster jars and wear it. Then, perhaps, Seth would find her as irresistible as Osiris found Isis.

Alas, it did not work. So Nephthys began to wear her hair like Isis, to dress like Isis, to adorn herself in the makeup and jewels of Isis, to walk and talk like Isis. When she went into the villages, the women could not tell the difference between the sisters. They birthed their children into Nephthys's hands. They heaped baskets for her with honey, saffron, and cakes. They gave her a white goose in a reed cage for her supper. They held her hands and kissed her cheek, but nothing Nephthys did made Seth give her a second look.

Yet again, Nephthys found her way by the dark of the moon alone to the palace garden of Isis and Osiris. Dressed like her sister, she sat and wept into her hands, for her sorrows were many. There Osiris discovered her, sitting sad and beautiful as he strolled about picking the small, pungent yellow flowers of the melilote. He wove them into a garland for his Beloved's hair. His breath was taken away by her beauty.

"My wife, my sister," he said. "Why do you look so sad? Come to your husband. I will make you a happy woman."

He took her hand, and Nephthys did not protest. She did not cry out, she did not turn from his embrace. When he called her name, "Isis," Nephthys did not betray herself. Her heart was made glad by the love of Osiris. She fell asleep in the garden with the garland of flowers in her hair, and he went into the house to bring out his lyre and play music for her dreaming. But before he returned, Nephthys awoke and ran home. She entered the house and went straightway to her room, but the secret was soon to unfold, for Nephthys learned that she was pregnant. In nine months, she bore the child of Osiris, the jackal-headed god Anubis. Terrified of what Seth might do, Nephthys exposed the infant in the desert. In sympathy, Isis rescued Anubis and raised him as her own. Before she could conceive a child herself, Seth murdered her husband Osiris—in what we may assume was a rage over the whole affair.

Nephthys represents the mortal side of women. Her child is born of an earthly sexual union. Isis perhaps represents the spiritual side of women, for her child Horus is born of a spiritual union, a union of magic. Isis did not become pregnant until she had found her slain husband Osiris in Byblos and brought his body home. Immediately, she began magical means to reverse the decay of his corpse and restore him to life. The deep love and the great magic of Isis in her attempts to revive Osiris simultaneously opened the closed womb (bosom) of the goddess.

We have no written reports of the rituals that might have occurred at the Festival of Opening the Bosom, probably because early Greek traveling historians never witnessed a women's ritual, and because the scribes did not record the details since the pharaoh didn't attend the ceremony. We do have records of a figure who appeared as the dancing god Bes—god of childbirth and of children. He accompanied Hathor, dressed in his lion mask and standing inside a circle of dancing children, who all wore the long side braid that signified youthfulness. Geraldine Pinch recounts the Opening of the Bosom as an ancient puberty rite with African origins, much like the god Bes himself. [116] When a child reached adulthood, Bes cut off the lock of hair with his knife.

Whereas Bes carried his knife for male circumcision, the pregnant hippo goddess Tauret carried a similar knife; perhaps to tear, either symbolically or literally, a young bride's hymen. Possibly this ritual act was carried out by the married women or the midwives of the clan, who, in essence, were tearing the veil between the worlds of childhood and adulthood. Eventually, the same knife would be used to cut the umbical cord of a newborn, yet again ushering the initiate from one world to another.

The occurrence of the festival at the end of the month indicates that it is based on a lunar cycle, the important point being to spend the night of the new moon in vigilance, in supplication to the goddess, and perhaps even in embrace. Astrologically, the new moon represents the time of beginnings, or whatever is conceived and carried to fruition in the cycle of the full moon. Initiating any action under a new moon implies successful future completion. Richard Adams, a fine horary astrologer in California, points out that the "timing" of a petition to the goddess would have mattered a great deal. Hethara 30 would have been a particularly auspicious time to enact fertility magic, since it was believed that when the moon was moving from new to full, results tended to happen apace, and they happened more quickly if the new moon occurred in an astrological cardinal sign. In this case, a new moon in Libra, which is a cardinal sign, would have tended to doubly speed the process of fertility. [117]

The Knot of Isis

At the ends of the universe is a blood red cord that ties life to death, man to woman, will to destiny. Let the knot of that red sash, which cradles the hips of the goddess, bind in me the ends of life and dream. I'm an old man with more than my share of hopes and misgivings. Let my thoughts lie together in peace. At my death let the bubbles of blood on my lips taste as sweet as berries. Give me not words of consolation. Give me magic, the fire of one beyond the borders of enchantment. Give me the spell of living well.

Do I lie on the floor of my house or within the temple? Is the hand that soothes me that of wife or priestess? I rise and walk. The sky arcs ever around; the world spreads itself beneath my feet. We are bound mind to Mind, heart to Heart—no difference rises between the shadow of my footsteps and the will of god. I walk in harmony, heaven in one hand, earth in the other. I am the knot where two worlds meet. Red magic courses through me like the blood of Isis, magic of magic, spirit of spirit. I am proof of the power of gods. I am water and dust walking.

from *Awakening Osiris*
by Normandi Ellis

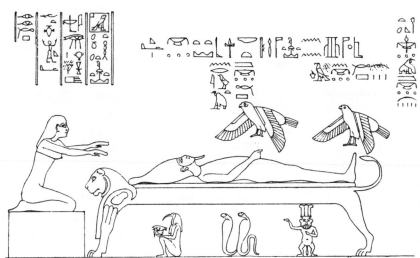

The power of the goddess to awaken the god and to magically conceive a child by him was an important fertility rite to the ancient Egyptians.

THE PLUCKING OF THE PAPYRUS FOR HATHOR

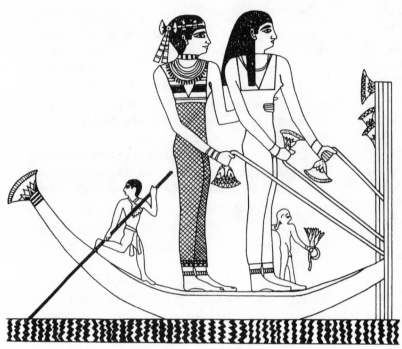

A mother and daughter sail amid papyrus
blossoms and gather flowers for Hathor.

Appropriate for Days that Celebrate
- Relaxation and Enjoyment
- Love Affairs
- Music Making
- Giving Yourself a Day Off
- Sisterhood
- Gathering and Planting Flowers
- Celebrating Children
- Deep Ecology

When the flood waters had subsided and the river was again calm; when the lotus and papyrus began to bloom; when the ibis returned, flocking to the river's edge; when the heat of summer subsided, but the long nights of winter had not yet begun, it was a beautiful time to go down to the river and sail among the florid marshes with a lover, family member, or friend. During this time the priestesses went to the river to gather flowers to weave into wreaths for Hathor, or to pluck the papyrus and lotus to make into rattles.

The Dendera calendar mentions this unusual festival, but C. J. Bleeker's compilation of Egyptian festivals gives no date for it. The research of Harold Moss reveals an unspecified Hathor festival occurring on this day. Possibly it is the feast day of Plucking the Papyrus for Hathor, since green papyrus grasses shoot up dramatically after the first moisture, and November 2 occurs during the season of Inundation soon after the waters have begun to recede. [118]

Papyrus was one of the most sacred plants in all Egypt, long the emblem of the tribes of the Lower Nile. Its triangular stem was reminiscent of the shape of a pyramid, of the divine triad of mother, father, and child, and also of the divine trinity of the Goddess. Nearly everything in ancient Egypt is made from papyrus: baskets, paper, furniture, sandals, even boats. Papyrus blossoms also appear to radiate from a central stem, giving the image of a fireworks display, or imitating the resplendent rays of the sun. The green color of the papyrus was associated with both Hathor and the cobra goddess Wadjet.

The Plucking the of Papyrus for Hathor is one of the oldest of the Egyptian festivals, but the Egyptian people always welcomed any excuse to sail upon the Nile. Sailing upon the

refreshing waters was like entering the cosmic moment of life's beginning. It may have been simply that the sky was blue, the waters sparkling and calm, and it was a perfect day for sailing; and so, says Naomi Ozaniec in the *Daughter of the Goddess*, "a pleasant day in the papyrus groves ended with offerings to Hathor which might accompany a request, a prayer, or a thanksgiving."[119]

Some researchers think that plucking the papyrus had to do with picking blossoms for the beloved, a well-known custom often depicted in tomb paintings. Papyrus memorials were as frequently offered to the dead in ancient Egypt as we offer roses. The symbolic intent is the same. Says C. J. Bleeker, "The plucking and offering of papyrus is not just an elegant gesture, it has also a symbolic meaning, for the papyrus is the token of renewing life and of the joy one wishes the person to whom the floral homage is paid."[120] The greening of the new plant symbolized the greening of all life, whether in this world or the next. Green was a color sacred to Hathor, who ruled not only the papyrus, but the green waters where they grew and the mines where the green gemstones sacred to her were found. Green was the sign of life, as this sweet, brief Hymn to the Sky Goddess found in the Pyramid Texts reveals:

O great strider
Who sows greenstone, malachite,
 turquoise—stars!
As you green so may Teti be green,
Green as a living reed![121]

Certainly papyrus, like roses, would have been appropriate offerings to make to a loved one or to Hathor, the goddess of love herself. The favored scepter of the goddess was a long-stemmed papyrus blossom. Dried papyrus blossoms contain a number of loose, rattling seeds that make a musical *shushing* sound when shaken. These early rattles may have been the archetype of the sistrum rattle sacred to Hathor.

The ancient *sesheset*, or sistrum rattle, derives from the word *seshesh*, which means "to rustle." The rustling of papyrus or the shaking of the sistrum were both invocations of Hathor; the sound was said to soothe her frazzled nerves. Naomi Ozaniec notes that the shape of the sistrum is like that of the uterus or the ankh, the symbol of life.[122] Early predynastic plaques have been found near Hierakonpolis, the first major capital of Horus in Upper Egypt, that portray women carrying objects shaped like the ankh sign; these are interpreted to be the dried papyrus blossoms that function like rattles.[123] The rattling of the seeds inside the papyrus was a sign of the potentiality of all forms of life within the pregnant belly of the Great Mother. The sistrum was always shaken at

moments of high religious significance, as when the mourners of the dead appear, when the pharaoh and the queen appear, when the songstresses begin to sing with the voice of the Goddess. The rattling sound that caused one to pay heed to the deity and to her worship was also said to frighten away evil spirits. Bleeker believes the sistrum shaking and papyrus plucking were originally intended to attain the Goddess's blessing for those fishermen, shepherds, and farmers who worked in the Nile delta.[124]

The Plucking of the Papyrus for Hathor is mentioned in the Fifth Dynasty Pyramid Texts. In Utterance 271, pharaoh Unas declares that having emerged from beneath the floodwaters, "it is [he] who has plucked up the papyrus . . . Unas is he who has united the Two Lands. Unas is he who will unite himself with his mother, the Great Wild Cow."[125] This wild cow is the mother of the sacred bull with whom the pharaoh is identified. In her wild cow aspect, Hathor was called *Mehurt*, meaning "The Great Flood." This cow goddess lived in the delta papyrus marshes. The sound of rustling papyrus forewarned that she was about to appear, parting the rushes with her horns.[126] Sometimes Mehurt appears in birthing scenes as the herald of imminent birth. The Great Flood when the waters of the ammonitic sac break signal that the holy child will soon emerge.

The festival may also be related to plucking an infant from the bullrushes. Certainly there is the myth of Isis leaving her infant son Horus in a clump of papyrus to be raised in secret by the powerful serpent goddesses who lived there. She abandoned him only to keep him out of harm's way, for Seth wanted to kill him. The same is true in the story of the infant Moses. His mother, fearing for his life, set him adrift in a reed basket, probably made of papyrus, and he was finally found and raised by the pharaoh's daughter.

This idea of the new life to come being cradled in papyrus also appears in part of The Osirian Mysteries occurring later in the month of Koiak. In Dendera, the papyrus plucked and offered to Hathor on Koiak 17 was, no doubt, woven into the papyrus boats that floated the 365 candles of light on Koiak 29. These burning lamps represented the resurrected light of Osiris.

The papyrus emerging from the flood waters of chaos symbolized the reemergence of life and world order. The words of power which became known as the famous Egyptian Book of the Dead were written on papyrus as a way of increasing their potency. Symbolically, life-giving words written on paper made from a life-giving plant had the capacity to renew life and reestablish order from the chaos of death.

An old Egyptian myth prophesied that the golden age of

Egypt would come to an end when the papyrus no longer bloomed along the Nile. That, of course, happened in 1971 when the Aswan dam was built. Papyrus no longer grows naturally at all in Egypt. The plant depended entirely upon the marshy landscape and the rich delta soil that were delivered by the floods. But all hope is not lost. The myth also said that the glory of Egypt would return when papyrus again bloomed along the banks and the herons returned with it. Herons have already been sighted, at least in the town of Luxor, and farmers are again trying to grow the plant to support the tourist industry and its demands for artistic renderings of ancient Egypt finely inked and painted upon a piece of papyrus.

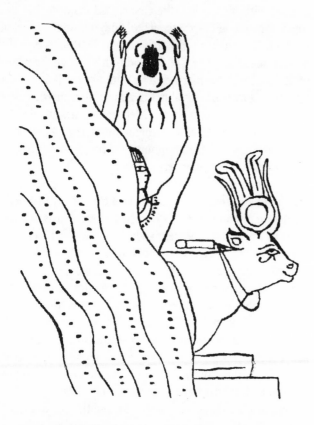

Mehurt, the divine-cow form of Hathor, emerges from the Great Flood on the first day of the world.

Activities

1. Experience a sense of wonder. Plan to get up and write with the dawn, or to stay up late in the middle of the night, writing by candlelight. Describe what you see, exactly as you see it. Note not only your feelings, but also the specific brilliance of the green leaves when, first thing in the morning, they seem lit up from the inside. Go out and gaze at the stars. Imagine yourself as star born. How does it feel to be twinkling? What wishes have been made on you?

2. Draw an image of a tall flower on a page in your journal. In diverse colors, name each petal as a joyful possibility you are now manifesting or want to experience in your life. Then down in the dirt, write the real stuff of where you are now. How does it feel to be you? What thoughts are occupying you? Now look at where you are, then at the petals where you are going. Running up the stem of your flower, write about the things you intend to do, or have already done, to get from here to there. Be specific. What, in Dylan Thomas's words, is the "force that through the green fuse drives the flower"?

3. Give yourself some sensual delights. Revel in the beauty and bounty of the Goddess. Spread bouquets of fresh aromatic flowers around the house, even if—and especially if—it's winter. Wear perfume every day. Put eucalyptus oil in lamp rings, especially in those places like the home office or library where you want to feel happy and alert. Invite a girlfriend to your house, get out your old records, and dance to some favorite tunes. Wear outrageous scarves and hats as you lip sync with the music. Life is a feast meant to be shared.

THE OSIRIAN MYSTERIES

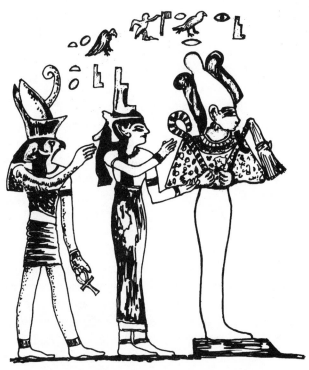

Horus and Isis send forth their healing energies to Osiris, who stands on the hieroglyph of truth.

Appropriate for Days that Celebrate

- Mourning and Loss
- Retreat for Future Growth
- Winter
- Communion with the Dead
- Sacrifice and Wisdom
- Past Life Regression/Karma
- The Death of a Loved One
- The New Moon in Scorpio
- Finding Lost Things

The dramatic, ritualized Osirian Mysteries are at least as old as the feasts celebrating the rise of the Nile and the new year. The mysteries were the longest-lasting festivities and the most far ranging in their influence on other cultures. Many religious festivals carry the undertone of the dying and resurrecting god. Even when acknowledging gestation and the return to life, the idea of death is never completely forgotten. In Egypt the cyclical nature of all life lies close to the bone. During the long Koiak festivals, the story of Isis and Osiris reaches a fevered climax, focusing on the god's first death and the goddess's journey through grief, then moving to her discovery of his body and his resurrection, followed by Osiris's second death culminating in his ascension.

In our myth, a part of which has been told under the heading of Hethara 17 (The Lamentations of Isis), we found Isis searching for the body of her drowned husband who had been killed by his jealous brother Seth:

After Osiris's murder, the first creatures to hear of it were the pans and satyrs, the half-men, half-beasts who lived in the desert wilderness. Lifting their sharp noses and catching the scent of death, they ran howling beneath a darkened moon in a blind animal panic.

Isis sought his body everywhere in Egypt, but it was nowhere to be found. Distraught, she tore at her clothes, beat her breast, and in wild grief, cut her long, thick black hair close to her scalp. Alone, dressed in her black mourning rags, the goddess wandered throughout Egypt, barefoot, dust covered, disconsolate. Up and down the muddy edges of the river bank, she peered into the sedge and papyrus clumps; she walked dusty streets and keened, seeking the coffin of Osiris. Though she had delivered their children, the village people no longer recognized her. Seeing a mad woman in black muttering to herself, moaning, weeping, raging, and covering her head in sand, the children screamed and the women ran

away from her. Those who stopped frozen in their tracks, she asked, "Have you seen my husband?" Most people were too frightened to speak, grief having shriveled Isis's once beautiful face into the grim visage of a hag.

On she walked; weeks passed. Many nights she slept alone in the desert, shivering in the cold, surrounded by scorpions and guarded by snakes, watched over by wild dogs who took pity on the half-mad goddess. Even the stars hid themselves from her view. Wherever she went, she asked, "Have you seen my brother, Osiris? Has his coffin come this way?"

"Go away," the people said.

At last she heard some children playing along the riverbank behind a screen of papyrus stalks. She crept to their hiding place and watched three girls place a doll inside a cradle. She approached slowly, so as not to frighten them, and discovered it was not a doll but a man inside a chest! Seeing her, the children did not run. Instead, one of the girls cried, "Look! It's Isis!" They told her they had dreamed the game of the man inside the coffin. In the dream they had seen many men covered in animal skins throwing a golden and jeweled chest into the river. It floated along the canal outside their house. When they came down to the river's edge, the chest flew open. They saw that a man was drowning, and they were afraid. The man called to them, but the coffin lid slammed shut and the golden chest floated north to the mouth of the river near Tanis, where the waters carried it out to sea.

As we have already heard, Isis found the coffin ensnared in the trunk of a large tree that was cut down and used as the supporting pillar of another king's palace. Managing to retrieve the tree and Osiris, at last, Isis sailed home with the body of her Beloved. Her boat touched shore in a grove of acacia trees, and when she stepped to the ground with Osiris, a spring of water erupted from a crevice in the rocks. Isis carried his body to a secluded cave in the mountains above Abydos. There she began to perform her lustrations and the recitation of magical words that would raise the god from death.

Prying open the jeweled coffin, she gazed at length on the form of her lost Beloved. The face of Osiris was as black as death, passive, immobile, the eyes dreaming. She touched his eyelids with her fingers; she anointed them with her tears. In wild sorrow she began to dance, to weep, to spin, her feet raising great clouds of dust. She spun round and round. She keened. She sighed. Her arms became great feathered wings. Kitelike she fluttered above the corpse of Osiris, chanting, singing, crying, as she had done in Byblos, mad with the grief of separation even now as he lay in her arms, enchanted by the power of her love. In the process, Isis managed to fill with life herself, having first transformed herself again into a swallow and attained the divine procreative energy neces-

sary to revive the god and conceive a child with him.

As she sang her songs of love, the great gates of heaven stood open, and the circling, unfaltering stars wheeled in the evening sky, weaving a new fate for Osiris. Amid the hills distant lightning flashed. The words of Isis were the words of a sorceress. Truth and love are the divine powers. Her speech was as pure as her heart and mind, her tongue perfect, her love mighty. She—who sought the lost one without ceasing, who loved him without fail, who traveled to the ends of the earth to find him and bring him home—she brought life back into the lifeless.

Feeling the knot of new life, of bone and flesh take hold inside her, Isis was filled with happiness, overwhelmed with joy. She who had conceived a god and raised a storm determined now to raise the dead, to raise the body of Osiris himself. Knowing she needed the help of Anubis and Nephthys, Isis sealed the entrance to the cave with a boulder. She disguised the resting place of Osiris with a maze of rocks, a winding labyrinth of white stone walls. Then, she left him there for only one night while she rushed off to find Anubis and Nephthys.

Before her magic could be completed, the spell was interrupted. As it happened, that same night Seth and his companions were out hunting boar when they stumbled upon the cave containing Osiris. Enraged to see Osiris lying half-awake upon a bier of flowers, Seth drew from his belt an Ethiopian knife. Its sharp obsidian blade he plunged into the chest of his brother, hacking the body into fourteen pieces. He cut the head from its body. He hacked off the arms and legs and penis. He disassembled the bones of his back. He quartered his brother like a slain animal and stuffed all the pieces in a leather sack, then carried the bits of the body down to the river and heaved them into the water.[127]

The Nile ran red with the blood of Osiris, and the scattered bits of his body drifted away to wash ashore later on the river banks—all but the phallus, which floated on top of the water like a lotus bud on a stalk. Osiris's clotted blood, mixed with the regenerative powers of the water, gave birth to an oxyrhynchus fish. In turn, the fish, newborn and hungry, spied the bobbing phallus. Because it seemed a tasty bit of flesh, the fish swallowed it, then sank immediately to the bottom of the river.

At the moment of Osiris's second death, Isis, who had been sitting with Nephthys many miles away, heard the cry of her husband. The sisters rushed out into the darkness, where they beheld the moon and gasped. A shadow had descended upon its face. In horror they watched as the moon disappeared bit by bit, eaten up by black shadow. Isis was seized with the knowledge of her husband's fate. "The light of that moon is Osiris," she cried. "And that black crescent shadow is the knife of Seth." Isis and Nephthys hurried to the river, only to spy on the banks of the Nile the severed

head of her husband. She threw herself onto it, weeping and kissing the blue lips of his mouth, speaking her words of power, breathing her goddess breath into him, but there was no Osiris left to receive her sacred gift. A madness deep and dark descended upon her, a sorrow greater than any despair she had ever known.

Yet Isis was not willing to surrender Osiris unto death, at least not while his heir grew in her belly. She was determined to gather all the missing parts of the god and resurrect him. The tomb of Osiris would become again the womb of his mother. His broken body would be gathered into Nut, the sky, even as she gathered to herself the multitude of stars. By her great magic, Isis would restore her husband's divine rulership. But to revive a god, Isis needed to teach the people her rituals of magic.

By the side of the river where she had discovered him, the goddess built for the god a place of honor. The eternal stones of the temple to Osiris stretched nearly up to heaven. For the benefit of the village people, she led them to think that she had found the body intact; but in secret, she had fashioned a body of wax, anointed it with spices of frankincense and myrrh, then wrapped it in the linen rags of her dress. This body she gave to the village priests and they buried it. The spirit of the god entered into the eternal stones that bore the likeness of his face. At the feet of his statues, mourners lay garlands of onions, garlands of lotus, garlands of desert flowers. They prayed, they sang, they danced, they burned incense. The life of the people restored life to Osiris.

This time joined by Nephthys, Isis sailed all over Egypt, searching for the other parts of Osiris. Wheresoever Isis found a piece—a foot, an arm, a leg, a thigh, his heart, bits of his backbone, his ears, his tongue, his jaws—she cried out with joy: "He lives! He rises up! The god is found anew!" In each city where she found a part of him, she built a temple in his honor and taught the people the burial and mourning rites, so that the Good Being would never be forgotten and his fame would exceed his evil brother's. Thus, Isis protected the fragments of Osiris by confusing Seth as to the real burial site of the body.

Yet the phallus of Osiris was never found, having been eaten by the oxyrhynchus fish. Without this final piece, Isis could not completely resurrect the god in this life. Nevertheless, she fashioned the missing phallus from cedar wood and gold. Then she whispered the words of power, passion, and remembrance so that in the next world Osiris might remember himself and give birth to all good things and all growing plants, all children, all souls. By means of her magical voice, she sacralized and mummified the body, creating a sahu, or "body of light," that would live and rule eternally in the next world. Thus, from beyond the grave, Osiris reigned in splendor, and after Horus was born, he delivered messages through dreams to his heroic son to set the world in order.

The sisters swathed Osiris in linen bandages torn from their dresses. Thoth and Anubis knotted the cords. The ground trembled. Heaven stirred. Nut, his sky mother, descended and lay entirely over the body of her son, embracing him. With her own divine hands she gathered him up, molded him into a living god, and took him into her heart. Isis and Nephthys spread their arms and began to sing the song of changing. "His body to Earth; his soul to Sky." The sisters transformed into hawks of gold; their wings stirred fresh breezes. On these winds, Nut sailed back into Heaven enfolding the soul of Osiris. Then Geb yawned and took the mortal form of his son into his own belly.

During the month of Koiak, all the chief sanctuaries of Osiris celebrated festivals remembering his life, death, and resurrection. Various temples emerged as prominent sites of Osiris worship, each claiming to have buried a sacred relic of the god within a shrine—his eye, his fingers, his heart, the soles of his feet—deposited there by Isis. In Abydos the head of Osiris was buried; the sacred backbone, or his sacrum whose image was the djed pillar, appeared at Heliopolis; his heart was buried at Arthribis. A great number of legs, or leg parts, washed ashore and were found in Heracleopolis (a thigh), in Sebennytos (another thigh), on the Island of Bigga (the left leg), in Edfu (a leg, presumably the right), and in Netert (a foot). And wonder of wonders, the missing phallus somehow wended its way to Memphis and was enshrined there.[128] There were probably more temples in Egypt claiming a part of Osiris than there were pieces to have been found; but later myths say this was a ruse by clever Isis to disguise the true location of Osiris's body so that Seth would never again find the sacred mummy and destroy the beautiful spell of eternal life that she had woven around it.

Each temple perhaps celebrated the mysteries of Osiris in a different way according to the powers of the sacred relic of the god's body deposited there. Lucie Lamy, stepdaughter and coresearcher with Schwaller de Lubicz, notes that in Thebes, Osiris appeared lying upon a bier shaped like a lion's body. As he raised his hand to his forehead in a gesture of awakening, his legs began to stir. In Coptos he was depicted as simply mummified, wearing the white crown.[129] On the Island of Bigga at the moment of Inundation, it was believed that the body of Osiris could be seen floating along the Nile.[130] The rumors of seeing Osiris rising were started by the priests in the Temple of Isis at nearby Philae. No doubt what they meant was that the Nile water itself was observed to rise. Still, to witness the god Osiris as the apparently spontaneously generated rushing flood waters must have been impressive. Thus, the islands of Bigga and Philae became important sites of pilgrimage throughout the Roman world.

While many festivals were for the exclusive benefit of the pharaoh, those festivals celebrating the myth of Isis and Osiris rejuvenated the whole community. True, some of the rites were occluded, intended only for the initiated; however, that is true of any religion in which the whole congregation participates in the celebration of a mass communion, but in which the actual intent of the rituals is understood and known by the presiding priests and altar attendants alone.

Spiritual celebrations and communion have a profound psychic effect on all participants, regardless of their level of initiation. The mysteries always call one to turn inward, to face the unknown with strength and courage and to seek the light in the darkness. The grief we feel in concert with Isis and the terror we feel in concert with the fallen Osiris are a psychic preparation for the advent of our own and our loved ones' inevitable deaths. On some level, we will all experience the potency of The Osirian Mysteries one day, but the initiate will have been prepared to meet death when it comes by having already died once. The power of Osiris lies in understanding that we shall not die a second death. One of the most powerful spells of The Egyptian Book of the Dead is a statement of faith intended to prevent one from dying a second time by recalling one's initiation into The Osirian Mysteries:

My hiding place is revealed. The hiding place of my soul is opened. Light has fallen within the darkness. . . . I have hidden myself within your body, O never-setting stars. My forehead gleams like Ra, my third eye open, my heart is within Isis. I know the words of power. Truly, I am Light Itself. I was not born to worthlessness. No evil can befall me. I live forever with thee, Father Earth and Mother Sky. I am the eldest son who sees and knows the mysteries. I am crowned with Light, a king among the gods. I shall not die a second time.[131]

The enactment of The Osirian Mysteries was a great crowd pleaser. It was not often that the public was allowed to enact the sacred rituals, and they really sank their teeth into their various parts. During this time, the priests and pharaoh bestowed their graces upon particular noblemen and noblewomen who dressed in lavish costumes and gave command performances as this or that god or goddess. The festivities began when one of the priests appeared in a jackal-faced mask of Anubis as the Opener of the Way. As Jean Houston describes the scene in her book, *The Passion of Isis and Osiris:*

It was necessary for a slight struggle to ensue with the crowds. The Way was not to be easily opened, and like the Catholic congregation who play the

crowd screaming for the release of Barabas in the Passion Play of Christ during the Lenten session, the ancient Egyptian crowds took the part of the negative forces standing in the way of the will of the gods, by attempting to prevent the procession from entering the temple. This was the dramatic physical realization of enacting one's own Sethian nature as an obstructor to the god's sacred transformation.[132]

Central to the understanding of The Osirian Mysteries was the experience of a ritualized death. In all probability at least two kinds of ritualized death were enacted: one that symbolized the murder of Osiris, and another that symbolized the defeat of the dark forces represented by Seth.

As the festivities opened, the general public would be milling about the streets outside the temple, going from one vendor to another, sampling tasty treats such as honeyed raisin cakes, pomegranates and figs, smoked fish, or grilled beef. Wearing their perfumed wax cones upon their hair, they gossiped and complimented one another on their jewelry. Being no more than themselves, the festival goers were nevertheless engaged as actors in a play that resembled the mythic banquet feast at which Osiris was slain. Their roles later switched to that of spectators who witnessed Osiris being locked inside the jeweled casket and cast into the sea. No doubt they struggled with the priest actors who were taking the parts of Seth and his men, and later they became the ritual mourners who displayed the wild abandon of grief as they moaned and cried loudly, tearing out their hair and covering themselves with mud. This same group would later converge in a mock battle scene that imitated the heroic son Horus and his Forces of Light fighting to overcome Seth and his Beings of Darkness.

During one act of the ritual murder of Osiris, the temple priests carried through the crowds a wooden chest, said to contain the body of Osiris. The dramatic appearance of the coffin had two major implications: On one level, it reminded people of the terrible fate that befell Osiris—how in the midst of gaiety and feasting, death came like a thief in the night. It reminded them that the grave is the destiny of every living being. On another level, it counseled people to live their lives to the fullest, to be filled with joy and to make something useful of themselves in the here and now. This odd juxtaposition of terror and joy in the face of death can be seen in one of the Harper's Songs, a grave inscription from the Middle Kingdom. Here, in the Tomb of King Intef, the musician sits with his harp and sings:

Follow your heart as long as you live. Put myrrh on your head, dress in fine linen, anoint yourself with oils fit for a god. Heap up your joys. Let your heart not sink. Follow your heart and your happiness. Do your things on earth as your heart commands. When there comes to you that day of mourning, the Weary-Hearted [Osiris] hears not their mourning. Wailing saves no man from the pit![133]

For the initiates and for the pharaoh, the mystery culminated in assuming the role of Osiris and contemplating one's own death. These mysteries were never spoken aloud, never recorded on the temple walls, and were only alluded to in later times by the Greek writers, most notably in *The Golden Ass* of Apuleius. Perhaps they were similar to the initiations performed in the later and modern mystery traditions of the Golden Dawn, the Rosicrucians, the Masons, and Knights Templar. Since the mysteries disappeared long ago and were shrouded in secrecy, it is difficult to say that what the Egyptians did actually resembles any other initiation experience. Perhaps the Buddhist rituals found in the similar Tibetan Book of the Dead were closer to the Egyptian Mysteries. The only remnants we have of these rituals reside within the ancient texts themselves, such as The Pyramid Texts, The Egyptian Book of the Dead, The Coffin Texts, and other writings. The texts say little about what rituals accompany the words and less about how the texts are to be philosophically interpreted by the individual.

In his book, *The Goddess Sekhmet*, Robert Masters recounts what he believes to have been The Osirian Mysteries. Masters assures us that, not intended for the faint of heart or the weak of will, the mysteries indeed forced one to enter into a dark night of the soul and encounter a grim visage of death. The initiates, he says, may have found themselves in profound states of trance engaged in meditations in the dark. Perhaps their experiences were reminiscent of the drug-induced *ayahausca* ceremonies wherein the Amazonian shamans of the rain forest to this day drink a potent tea in order to die

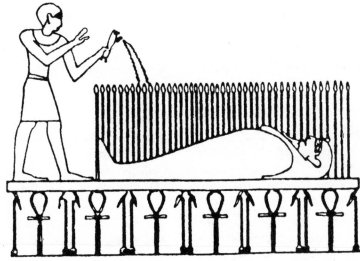

The mystery of death and rebirth was manifest as Osiris becoming the growing wheat.

to themselves and enter the spirit world. Similarly, many of the ancient Egyptian initiates underwent actual entombment within a closed sarcophagus, also perhaps in a drug-induced state.[134]

The events which befell them were believed to be in the same sequence that occurred to the newly dead. They may have encountered actual physical dangers, such as being thrust into an underwater pool and having to swim with a crocodile, or being thrown into a room filled with asps, or having to walk or crawl through darkened tunnels by torchlight with corridors leading off into rooms of horror yet unknown. Some initiates were forced to lie in dark, damp, close chambers dug under the floor of the temple, such as the ones which can be seen at the Temple of Dendera, perhaps entering altered states much like those later experienced by John Lily in his isolation chamber. All of these methods would have been means to lead the initiate into a shamanic experience of traveling between worlds.

During the long nights of terrible wakefulness and isolation, the initiates encountered visions of the terrifying demons that occupied the lower halls of the underworld, supernatural creatures who guarded the gateways into the psyche. Such demons perhaps represented the errors of one's life. They bore colorful names such as Upside-down Face, Lady of the Knife Dancing on Blood, or Gobbler of His Own Feces. Among them the most terrible of all was the goddess Ammit, the Great Devourer, the Eater of Hearts, the She of Lies whose name was an anagram of Ma'at, the Goddess of Truth. In all these processes, one was forced to face not only one's sins, but one's greatest fears: the fear of abandonment, the fear of utter annihilation, the fear that all our life on earth has been for naught, that our days have been utterly meaningless, that all is emptiness. The encounter with Ammit causes us to imagine what it would be like never to have lived at all. On occasion, some initiates were driven mad by the ceremonial horrors.

If these mysteries seem terrible, they are only a preface to the true agonizing terror of death that Osiris must have faced. The Book of the Dead recounts a conversation between Osiris and

the High God, the creator god Atum. At death, Osiris wakes in the emptiness of the underworld and, alone, cries out: "O Atum! What is this desert place into which I have come? It has no water. It has no air. It is depth unfathomable. It is black as the blackest night. I wander helplessly herein. One cannot live here in peace. . . ." Atum's answer—that there is a kind of illumination and quietude—does not satisfy Osiris, who has abruptly left the merriment of his companions for this world. In what seems one of the most chilling of dialogues because of its emptiness and finality, Osiris asks the god, "But shall I ever see your face?" and Atum answers, "I will not allow you to suffer the sorrow."[135] The sad, empty face of Atum is the face of the Void itself.

Yet those who came through The Osirian Mysteries on the other side found renewed hope and were reborn. What they learned about life, about themselves, about the nature of Being, and about the Divine cannot be easily explained. Says Jean Houston, "This mystery is the Great Secret of the Universe itself. It was not a mystery that can be taught; it was a mystery that needed to be experienced."[136] In *The Golden Ass*, the character Lucius summarizes his own transformative experience by saying that in the deepest darkness of night he saw the sun shining bright as day. Having seen the light in the darkness, initiates would be radically changed and never again live their lives in the ordinary way. Having been tried and tested in this life, Masters says, the initiation experience removed the fear of death, a fear that would prevent one from developing higher powers in this lifetime.

Another aspect to the Osirian drama was the ritual enactment of tossing Osiris's coffin into the Nile. His watery journey from Abydos to Byblos was probably enacted on the sacred lake of the temple, or perhaps by boats launched upon the waters of the Nile. To honor Osiris at the Temple of Dendera, thirty-four papyrus boats were set afloat, each boat lit with 365 burning oil lamps. Isis, Horus, Thoth, and Nephthys each had their own boats, as did a number of other gods and goddesses.[137]

Part of the mysteries involved in the contemplation of death and resurrection included day- and night-long vigils of meditation held in the Temple of Hathor in Dendera. Inscriptions on the temple rooftop illuminate the many forms of Osiris manifest in life and death. Vigils were held over the body of Osiris, or the comatose initiate who played Osiris, during the dark moon. Each hour applications of purified Nile water, sacred oils, unguents, and salves were made and applied to the inert body of the god, using a form of aromatherapy as a means of restoring his senses.[138]

The nearly inaccessible chambers above the sanctuary at the Temple of Isis at Philae are illustrated with images of the magical means by which the twin goddesses resurrected Osiris. Following an image of their performance of the Lamentations there are pictographs of two goddesses who reconstruct the scattered pieces of the god's body. Called Serket and Tait, they represent sacred aspects of Isis and Nephthys acting out their roles as sorceresses and weavers. They "put the skeleton in order, purify the flesh, reunite the separated members, revive the corpse, and recall its soul."[139] These are the same rites enacted in every Egyptian mummification and burial: the arrangement of the body, the protection by amulets, the purification with natron and myrrh, the winding of the mummy clothes about the body, and the recitation of sacred spells for the deliverance of the spirit and soul into the next world. These rituals completed, the entire procession moved out of the mortuary temple toward the sacred tomb of Osiris for the ritual interment.

In lieu of actually interring a body, the priests and priestesses imitated the funerary rituals each night by using the same symbolic magic of Isis. The fertile Nile mud was molded and shaped each night into a lunar crescent representing both the horns of the goddess Isis and the lunar power of Osiris as the god of cyclical time. The crescent then might have been filled with barley or emmer, as well as aromatic spices and gum.

In Abydos on the day of the new moon when the first crescent of light reappeared, the priests went down to the water's edge and drank from the cool waters of the Oserion, proclaiming that Osiris had been found.[140] By drinking of the water that reflected the image of their resurrected god as the moon, they ingested his divinity and regenerative powers, internalizing that sacred knowledge of the intricate ways of transformation and change.

Yet another secret connected with The Osirian Mysteries was the related festival of The Raising of the Djed Pillar, which simultaneously was the spine of the reborn god with all his parts realigned and the stylized Tree of Life (without branches) in which the god was ensnared at Byblos. Because trees were scarce in the desert clime of Egypt, they were considered sacred objects, being a tangible manifestation of the Goddess's power to nurture life, as in the living sycamore tree of Hathor, and of the god's power to support the structure of life, as in the cedar column of Osiris.

No doubt the initiates practiced their own mystery of the djed during their initiation ceremonies. In the mystery tradition the initiates learned to raise their serpent power, or kundalini energy, through the spinal column. The metaphor would be that the spinal fluid, or serpent power, rises through the trunk of the body as the sap rises through the trunk of a tree in spring, causing the leaves to burst forth and the tree to

bloom. Thus, raising the djed becomes the mystical secret of regeneration and opening of the third eye and crown chakras.

Through the resurrected god Osiris, and through the transformed life of the initiate, the entire world became accessible and the divine mystery known. Says mystery teacher Jean Houston, "In Ancient Egypt on the occasion of the Osirian festival at Abydos and elsewhere, the djed tree-pillar which symbolized the axis of the world, the spine of Osiris, and the initiation of the adept, was raised at the high moment of illumination, dramatizing for the populace the myth and meaning of this theme." [141]

The Osirian Mysteries concluded with a visible and dramatic reemergence of the risen god Osiris. The djed pillar was hauled upon its sledge, dragged into place, hoisted and raised upright by the heavy ropes held by the priests, At the moment the pillar settled into place, the crowd sang out with joy. Thus, the mysteries concluded as they began—with the revelry of the crowds drinking, dancing, and feasting. [142]

The similarities between the ancient Egyptian mysteries and certain core Christian symbols cannot be overlooked. The proximity of Jerusalem to Egypt alone must account for some of them, as would the history of the Jewish nation living in Egypt. Nevertheless, the Carpocratians, one of the Gnostic Christian sects, maintain that Christ was an initiate of The Osirian Mysteries and received six years of training from the priests in the Temple of Isis. [143] Jean Houston notes that one of the main dramatic lines in the Osirian Mystery plays included words saying, in effect, 'I am the resurrection and the life. He who believeth in me shall have eternal life.'" [144] Two hundred years later, The Osirian Mysteries had essentially become Christian mysteries as the legend of the Prince of Peace spread throughout the Delta southward, slowly eroding the old religion of Isis and Osiris. The last priests to remember the ancient mysteries were those living near Aswan at the Temple of Isis in the far southern edge of Egypt, where the last priestly hieroglyphic inscription was carved in 394 A.C.E.

Yet Osirian and Isiac rites lived on in traces of other cultures. The Isia Feast celebrated by the Romans in the fourth century A.C.E. was always held between October 28 and November 1 and was dedicated to the power and salvation of the goddess Isis. Its ritual features were the mourning of Osiris and the jubilation at his resurrection. [145] We moderns have inherited the Isia's ritual enactment of the terrible face of the death and its holy remembrance of the sainted souls. The festivals of Halloween and All Souls Day also coincide with the Celtic celebration of Samhain, a kind of New Year celebration on October 31 that announces the death of the old year and the return of the divine child. The Celts pay homage at their festival to "the Lord of Death who is the Lord of Life." [146]

Surviving Loss: The Sorrows of Isis

Grief affects people in different ways. In the initial phase of numb disbelief, we walk through our lives in a daze, simply going through the motions. There are phases of withdrawal and depression, phases of rage and anger, phases of denial, and phases of acceptance. We may learn to get on with our lives, but we do not forget. At certain times the pain associated with loss recurs, perhaps on birthdays or family holidays, perhaps on the anniversary of the loss of the loved one.

Everyone experiences loss: the death of a loved one, illness, a failed marriage or relationship, lost jobs, houses destroyed in disasters, aging or physical debilitation. The grief hits hardest when the event is sudden; we were going along fine, then wham! the universe slams us into a brick wall. Time does heal all wounds; still, scars remain or phantom pains come back to remind us of the way things used to be.

The experience differs for each of us. Some of us fall apart; others trudge on stoically, delaying grief. Some enter depressions and cannot find the way back to life. The strange truth is that loss is a gift. When things are going well for us, we often lead our lives skating along the surface. When we've suffered substantial loss, we're suddenly immersed—albeit unconsciously at first—into the rich development of our souls. As with any painful experience, it's tempting to find a way out. Many times antidepressants mask the grief and prevent us from dealing with the loss, prevent the healing, prevent the wisdom that will come. Grief over loss is not pathological, it is natural. Emotions are meant to be experienced, rather than cured.

The myths of Isis teach us a great deal about the stages of loss and sorrow. At various times in my life, I have mulled over differing passages of the Goddess's tale, comparing her life with mine, allowing her process of mourning to inform my own. We can use her story to make emotions and impulses more meaningful and to come to terms with the grief. These are the lessons Isis teaches us:

1. **GRIEVE THE LOSS.** Failing to mourn or delaying grief until a more suitable time is unhealthy. It can actually make us sick. When we are not true to our deep feelings, we cut off access to our spirits, which then find ways to insist upon being felt and heard. Failing to be conscious, we act unconsciously. When Isis hears that Osiris has been slain, she tears at her clothes, she tears out her hair, she walks barefoot across Egypt. Her grief is wild and immediate. Like many of us, she harbors the illusion that if only she could find him, she could bring him back to life. But everywhere she looks, she finds that he is gone.

2. **GRIEVE FULLY.** The tale of Isis's recovery from loss is a long one. She doesn't heal herself in a week or two, or a month. The process of mourning takes time. Give yourself the time to grieve. The more sudden or important the loss, the longer it takes to grieve. Don't rush in and try to fill the emptiness with noise or things to do. Feel the silence that loss has created. Emptiness is required before fullness. Delay making any changes or decisions unless you absolutely must. Let the process of your mourning be a natural sequence. Let the filling of the void be natural as well.

3. **ASK FOR AND ACCEPT HELP.** Nephthys, Isis's sister, is a great comfort to her in her grief. She likewise feels the pain, but does not jump in to fix it. Instead, she simply follows Isis's lead. Don't let false pride keep you from seeking solace from friends and family. Friends sustain us by simply reminding us of who we are. They love us in spite of the fact that we are suffering. You are not asking them to fix it; you are simply asking for them to hold your hand. To ask such of a friend is not weakness; it is an expression of your trust in and love for them.

4. **NURTURE YOURSELF AND NURTURE OTHERS.** Isis finds herself, even in the deepest of despair, braiding the hair of the Queen's handmaidens and tending the children of another woman. She creates a routine for herself, a simple one that involves feeding herself, caring for others, and managing the day-to-day affairs of running a house. She also spends much of her time engaged in deep meditation and reverie, considering her loss and undergoing her own process of transformation. Give yourself a routine, a guideline to follow. Sometimes the most

effective way to battle chaos is to establish order.

5. **SPEND TIME ALONE.** The shady part of the garden, removed from the eyes of the world, might be where you decide to sit down and have a good cry. It is important to get away for awhile and feel the pain, to explore the terrain of our grief, to get back in touch with who we are. Isis spends time isolated in the darkness of her cell in Seth's cavern in order to feel the loss, to come to know it and to learn acceptance. The temptation, of course, is to stay isolated too long, forgetting to come back into the world. We need friends to call us out into the world again, but there is no shame in a certain amount of withdrawal. It seems natural.

6. **ACCEPT LOSS.** Face the facts surrounding your illness, your divorce, your aging, your losses. You may be in shock initially, but you must finally tell yourself the truth about what has happened. As much as Isis tries to revive Osiris, she cannot; thus, she suffers yet a second grievous loss when she discovers his body has been rent and he is gone forever. You cannot hold onto the past because everything has changed. Accept that as part of the process. Loss in itself is neither good nor bad. It is simply what happens. You can't really get on with your life until you acknowledge loss and transition. Osiris has died; Isis grieves him, and finally she moves on with her life.

7. **ACCEPT ANGER.** It's natural to feel angry with the person who caused you to suffer—the lover who abandoned you, the company that eliminated your position—even if the person you're angry with is someone who left you through death. Women especially have a difficult time expressing the rage they feel at loss. The stare of the goddess is enough to frighten anyone. It caused the poor boy who accompanied Isis to fall out of the boat. We don't have to like what has happened, but we also don't have to inflict it on the innocent. On the other hand, if the loss has been due to physical or sexual abuse, we can use our justified rage in more constructive ways to make sure that such things never happen to us or to any loved one again.

8. **ENACT FORGIVENESS.** It's often difficult to forgive the boss who fired you, the lover who abandoned you, the one who caused you humiliation and suffering. It's hard to accept that the hands of fate sometimes work on us through the vehicle of other peo-

ple. Knowing that to be the way of the world, Isis finally comes to feel compassion for Seth, who slew Osiris. She wishes him no harm. In the end, all oppositions are tied: life and death, loss and rebirth. This isn't about winning or retribution, which continues the karmic struggle of light and dark; it is about understanding. Enact forgiveness for yourself as well, for whatever your part in the drama may have been, for what has been left undone. Live consciously aware of your actions and aware of the divine universal life force moving within you.

9. **BE OPEN TO CHANGE.** Isis no longer lives in the palace. She has found herself in reduced circumstances, a single mother trying to raise a child. Perhaps it isn't what she would have chosen. But she finds new life within her community, a strength derived from the solidarity of her sister goddesses who support her. Thus, she learns to use her time teaching and counseling other women. She finds herself living in a way more rich than she previously had imagined. Change is difficult, but one can not stubbornly drag one's feet about the inevitable. In situations of loss, the Divine is calling us to change, to learn flexibility. There is no permanence except in the strength of character we build. Likewise, your sorrow is not eternal. There will come a time of change yet again, a time in which you will be happy and feel loved.

10. **USE YOUR CREATIVITY.** Regenerate yourself by starting over. In the process of her mourning, Isis learns to spin the new genes of life. Out of death she fashions a resurrection, not simply of Osiris, which is emblematic of her life, but also of Horus, who becomes her progeny. Plant the seeds of new life; nurture something that is of value to you in the future. Perhaps you will plant a garden as a symbolic gesture toward the regreening of your own life. You might join the church choir, or take up photography or painting. If you've always wanted to write, or join the theatre, do it now. One thing loss teaches us is that there is no time like the present. These creative pursuits do more than simply fill time; they fill us with the knowledge that we are special, talented, and loved. They create the sense of renewed possibility in life, while providing us with both pleasure and therapy.

11. **USE MEMORIES IN A POSITIVE WAY.** Isis and her sister engaged their energies in building temples and shrines dedicated to the memory of Osiris. To remember the fragments of the god, the goddesses remembered him. Along the back roads of my state, family members erect small crosses at the site or place ribbons around trees. I don't find these things morbid. I find them reminders that a stranger has sent to me to take care of myself, to take care of what I value, to honor the losses. They remind me that all is change, but love abides. Perhaps you will want to plant a memorial dogwood, a blooming tree that will remind you of the capacity of life to renew itself. Keep what brings you pleasant memories; pack away for the time being what causes too much pain. I had an aunt who died of cancer, but during her death process, she undertook to collect family pictures and make a photo album to remind each child how special they had been to her. Her gesture showed me how her illness and eventual death were a kind of triumph of spirit.

12. **DEVELOP A DEEPER RELATIONSHIP TO THE DIVINE.** Find one blessing in life a day. Find two, then three, and so on. We may at first rail against the God who would not prevent our loss, but over time we come to discover that the need for spiritual succor draws us closer to the Divine. For Isis, Osiris appears in dream from the realm of gods to tell her that he is still alive. I have found my church to be a wonderful refuge during times of grief over loss. The passion stories of Christ's death and resurrection sustain me. It's not so much what the priest says or does, although sometimes words fall like divine synchronicities on my ears, as it is simply sitting in the pew and relating that ancient passion play to my own experience. I have found succor in reading books written by spiritual masters in various traditions. It is a way of immersing myself in the deep mystery of Being.

The Season of Sowing

The predynastic Naqada statue of the dancing Nile river bird goddess represents an early manifestation of Hathor.

THE VOYAGE OF HATHOR TO NUBIA AND THE VOYAGE OF HATHOR TO EGYPT AND HER FATHER

Children of Atum, Shu and Tefnut represent the twin energies of air and fire as the first children of creation.

Appropriate for Days that Celebrate

- Self-Confidence
- Protection
- Fathers and Daughters
- Traveling
- Reunions
- Reconciliations
- The New Moon in Saggitarius

Hathor loved not only music and dance; she had more festival voyages than any other goddess. Hathor was so loved by the people and the gods that, whenever and wherever she appeared, a celebration followed. The Voyage of Hathor to Egypt was a two-part festival held in Hathor's sacred city of Dendera. The first voyage in Tybi commemorated and completed the season of Inundation, while the second voyage, ending in the month of Mechir, began the season of Sowing.

Two separate myths illuminate these voyages of Hathor. In the first story from the Coffin Texts, we find the god Atum, the "Complete One" living at the beginning of time:

Alone and isolated, Amun lives in a gray netherworld that he creates from his own form. Neither light nor darkness exist individually, but exist simultaneously within Atum. Swimming about this nebulous cloud of being and nonbeing, Atum feels lonely and confused. He has trouble even thinking clearly, for where there are no poles of energized opposition, there are no distinc-

tions, no choices, no understanding, and no true creativity. There is only the Nothing and the All of the vast, unfathomable cosmic abyss.

Unable to bear the lonely chaos any longer, Atum calls out into the void, summoning Hathor—his feminine, creative self, his Holy Eye that possesses the power to see clearly. She is the creative matrix. Because a mother always knows her children, Atum sends her out to find the yet unborn twin god and goddess, Shu and Tefnut, who represent air and fire, the first pair of oppositions. As Hathor begins a journey that will take her to the ends of the universe, she chants: "I seek your saliva and your spittle. They are Shu and Tefnut." Because she is the eye of Atum, she can see what others cannot see. She looks long and hard into the obscuring clouds of chaos, until she finds there the hint of life, a glimmer of possibility and potentiality, lying side by side. Then, with both hands, she plucks out Shu and Tefnut and carries them back to Atum, saying. "They are Shu and Tefnut. I searched and I sought and I see. I have fetched [them to you]." [1]

From Shu and Tefnut, the first paired duality, the rest of the world is created. Shu and Tefnut beget the second pair of oppositions, Nut and Geb, the celestial waters of heaven and earth. Atum now describes himself as if he were the first cell multiplying and dividing, becoming all the forms of life. He calls out, "First, I am one, then I am two, then I am four, then I am eight, then I am millions." Shu is god of air as Tefnut is goddess of fire. Tefnut is often linked to the heat of the sun, becoming a solar aspect of Hathor or the divine feminine sun.

Air and light, moisture and warmth are required for the seed of potentiality of the All to sprout. Thus, the season of Sowing opens with reference to the sowing of the seeds of all creation.

In the second myth, Ra takes the role of cosmic Father to the twins, Shu and Tefnut, whom he deeply loves. However, his daughter, Tefnut (his solar eye, whom he sometimes calls Hathor), seems to be forever wandering off:

Tefnut never stays close enough to respond to her father's beck and call. Ra obviously needs her more than he will admit. This female eye of his is powerful, having a spitting cobra emerging from its inside corner. The cobra spits a constant stream of fire that appears not as flames, but as seeds, or light particles.

The eye goddess is angry and hurt, feeling unappreciated by her father. The sun god keeps taking advantage of her might and power without giving her due credit. The goddess decides, therefore, to run away to Nubia, a southern land where the people welcome and treat her with respect. Now Ra falls into a quandary. Without his fire power, he isn't much of an authority figure. When his rays no longer warm the earth, the people stop praising him. They taunt him, calling him feeble, saying that his life is short and his light waning, growing shorter day by day. Moreover, Ra misses his daughter, but can't bring himself to tell her in so many words; besides, he cannot leave the sky to chase after her, or else all of Egypt would plunge into total darkness.

Now Ra calls his brother, the god Thoth, who is wise, just, and patient. Because he is the lord of scribes, Thoth has a way with words. He will know just what to say to Hathor-Tefnut and will forge a contract with her. When he finally finds her in Nubia, she is still angry with Ra and reluctant to come home. In one ending to the legend Shu and Thoth travel to the Nubian desert to find Tefnut living as a ferocious lioness. They woo her with music and dance, promising that if she returns she will be given a beautiful temple filled with daily offerings of flesh and wine. Whereas Ra exists in heaven, she will exist adored and honored among the people.[2] *Hear Thoth's soothing words:*

O you who should be on the brow of Horus, where are you? If you are [here], I will put you on the brow of this king, that you may give pleasure to him who bears you, that you may make an akh [a divine spiritual light] of him who bears you, that you may cause him to have sekhem [spiritual power] in his body, and that you may put the dread of him into the eyes of all. . . .[3]

Still unconvinced by pretty words, Hathor demands a visible manifestation of Ra's sincerity. Much chagrined by his previous pompous attitude and missing his beloved daughter, Ra inaugurates a festival in Hathor's honor to celebrate her return from Nubia.[4] *At last Hathor-Tefnut agrees to sail home to Egypt with Thoth. When Ra finally sees her once again, he forgets his former reserve. He leaps, he dances, so overcome with joy that he cries out her name and clasps her to his breast. A Hathor temple on the Island of Philae at the first cataract of the Nile was later erected to mark the spot where Hathor-Tefnut set foot in Egypt again.*[5]

These two myths and their feast days celebrate Hathor as a solar goddess. The sun was said to be "traveling like Hathor." In its daily risings and settings, it was always roaming, not only from the eastern to the western ends of the sky, but also through the seasons from north to south. As the sun itself, Hathor was sometimes called Raet, or the female Ra.

The boat of the sun carried not only the solar disk by day, but also the souls of the dead by night. Floating on the deep cosmic waters, both divine and human spirits awaited regeneration and rebirth. This solar boat, shaped like the crescent horns that hold the sun disk on Hathor's diadem, symbolized the uterus of the Great Goddess.[6] In other words, the uterine boat was the true "house of the god," the form that defined him. Hathor was called House of Horus, which defines her as the mother of the solar god. Neither Horus (the pharaoh), nor Ra (the light), existed without the goddess to gestate him, to carry him, and to give him birth. The secondary divine principle flowed from the male, but the primary divine principle flowed from the female. She was his mother, but the continuous cyclical nature of life and of the sun remained ongoing. Thus, Hathor was also the next generation of the heavenly spirit. Not only was she Ra's daughter, but she was the mother of Horus, the reborn and regenerated Ra.

Hathor was also the sun itself. In this aspect, Hathor was sometimes called Raet, or the female Ra. The diverse hymns dedicated to her honor include praises for her solar aspects, calling her the Golden One and saying that she is "rising in the horizon," or that "the face of Hathor is bright for me."

The Voyage of Hathor to Nubia, and her return Voyage to Egypt and Her Father two weeks later, relate to Hathor's solar aspects and are linked to other goddess celebrations during winter solstice. The first sailing of the week begins at the

point in the year when the earth is tilted farthest away from the sun, thus casting the Northern Hemisphere into darkness for a longer period of the night. On the horizon, the sun appears to lie farther south; that is, closer to Nubia. But the winter solstice marks the return of the sun. After the earth has tilted as far away as it will from the sun, it begins to right itself. Thus, the celebration in the second week marks the beginning of the return to longer days and shorter nights for the next six months.

The festival contained components of a lunar feast day as well. The entire festival occurred during the waning phase of the moon as it moved from full moon just after the fifteenth of the month to dark moon at the end of the month. As the light of the moon began to disappear, the moon god Thoth was sailing after Hathor. With both Thoth (the moon) and Hathor (the sun's power) withdrawing their light from the sky, this new moon in December commemorated the darkest period of the year. The festival ended on a triumphant note, however, because Mechir 1-3, the final feast days, revealed on the horizon at dawn the simultaneous appearance of the crescent moon and the sun, signaling the return of light. The images of sun and lunar crescent resembling the horns of Hathor symbolized Thoth returning to Egypt with the sun goddess, who, after winter solstice, began sailing northward in the sky, returning home to Egypt.

The initial festivities began with a short three-day voyage that signified Hathor's leaving the land of Egypt, and no doubt the days were accompanied by sorrow and mourning. Perhaps the image of the goddess floating upon the waters was shrouded, and the doors of her shrine closed. The festivals in her temples at Dendera and Philae that followed at month's end, however, were tumultuous celebrations, with the "Golden Goddess", adorned in flowers and perfume, sailing upon the Nile waters in her barge amid the joyous songs, dances, and music of the crowds.

Whenever the goddess traveled among her people in procession, she did not make the voyage in one long stretch. Her itinerary consisted of several smaller jaunts here and there so that she might spend her time among her beloved people and as many who could might catch a glimpse of her beauteous golden face. The second, week-long voyage included stops at the temples of Edfu and Esna, where she also held honors, as well as any site in Upper Egypt that had a temple dedicated to Hathor. The bearers of her divine bark and sacred image hoisted the goddess upon their shoulders, carrying her from one street altar to another. At the end of the day, the goddess returned to her temple for a brief rest before going out again the following day to see to more and more of her celebrants.

Infusing Your Body with Light

We are all vulnerable to depressions and fatigues when we race to fulfill expectations of who we are and what we should be, whether they are our own expectations or someone else's. Others are quite willing to take advantage of us when we take advantage of ourselves. Sometimes we crash and burn, becoming angry, short tempered, and vulnerable to illness. To heal the schism and prevent burnout, it pays to go within, to examine one's dreams, to establish new ones, and to reclaim the self.

1. Everyone has a unique set of divinely inspired gifts. Make a list of one hundred things you have accomplished. Mark those that made you happy. Continue to express yourself through these gifts. Wherever you find your bliss, you are looking at a brightly illuminated part of your soul that calls you to follow it. Follow your own vision, not someone else's vision of your gift. Worth is to be judged by the Divine, not by others. Worth is something we feel in our hearts.

2. Observe your self-talk for a week, especially what you tell your body when you use the words "I AM." "I AM" is a powerful statement of being. Monitor your internal chatter and actively practice stress reduction. Obviously, ill people need to visit a doctor. Ask for help when you need it.

3. Once you know your self-defeating mantras, change them. Practice saying "I AM" with conscious attention to what you are creating. If you are unconsciously affirming a negative thing, practice saying what you are in a positive way: "I am healthy, whole, and my body feels strong." If a particular area continues to be a source of discomfort, it may be your unconscious mind taking the brunt of a burden so that you don't have to feel afraid. Tell yourself that your mind and heart are strong and can handle the scary emotion, that you will take the message over the pain. Then deal with the real issues.

4. Write your affirmations where you can see them. Tuck them into your wallet or pocket. Post them on the mirrors, the doors. the car dashboard. When you see your affirmation, read it. Say it aloud, then breathe deeply and keep breathing until you can feel its truth.

5. Once you affirm a deep desire, the universe has an amazing way of confirming your intentions. Announce your intentions by saying "I AM . . ." Watch the synchronicities appear.

6. Prayers affirm. Writing them keeps them conscious. Address the goddess by name; recall the myths and stories that represent her nature. State your situation and ask for her guidance. Say aloud what tribute you intend to give in her honor.

7. The ancient Egyptians used this powerful meditation to infuse their bodies with light. Each body part was dedicated to a divinity who directed the flow of life energy. This meditation may be recited upon waking while standing in an eastern window facing the sun, or before sleeping while lying in repose. After deep relaxation, begin naming the parts of your body that you dedicate to the Divine:

My head is the head of Seshat, filling with thoughts of the power of the Divine, remembering my soul's purpose.

My face is the face of Nefertum, the golden child arising above chaos in beauty.

My eyes are the eyes of Hathor shining in the darkness. I see love and joy in all things.

My ears are the ears of Anubis, hearing the messages of the Divine.

My nose and lungs are the nose and lungs of Shu, receiving fresh breezes that fill me with creative life energy.

My throat is the throat of Meret, its words are gentle songs.

My lips are the lips of Mut. What touches them receives my blessing and thankfulness.

My teeth are the teeth of Serket, strong and nurturing.

My neck is the neck of the Renenutet, which supports me and connects my intellectual, emotional, and physical bodies.

My right (or dominant) hand is the hand of Khnum, endlessly creative, giving life to things of beauty.

My left (or nondominant) hand is the hand of Anket, receiving abundance from the bounty of the world.

My forearms are the forearms of Neith, who weaves the destiny of one humankind.

My shoulders are those of Wadjet, powerful, healing, and strong.

My chest and rib cage are those of Tefnut, containing and protecting the delicate inner parts of myself.

My heart is the heart of Ma'at, living in truth and keeping my life in balance.

My backbone is the backbone of Seth, the foundation of the world.

My womb is the womb of Isis. (My phallus is the phallus of Osiris.)

My reins are the reins of Satis, receiving abundantly what is needed and eliminating what is not.

My belly and back are the belly and back of Sekhmet, source of my spiritual fire and power.

My hips and legs are those of Nut, carrying me safely through the day and night. Wherever I need to be, there I find myself.

My feet are the feet of Ptah, a firm foundation for all of myself.

My fingers are those of Orion and Sirius, sparkling and brilliant, creating anew, rebuilding, tearing down, heralding new life.

My bones are the bones of all the living gods and goddesses, the living *Uraei* that protects and energizes and life to its spiritual source.

There is no member of my body that is not the member of a divine being. My body knows what it needs to give and to receive. Thoth and Isis shield my body wholly, filling it with energy and radiating love. I am shining as Ra and Raet day by day. These are the words of power that live forever. As I rise and walk on earth, so do I rise and walk always in the realm of heaven, under the nurturing care and the divine power of the gods and goddesses.

BAST GOES FORTH FROM BUBASTIS

Appropriate for Days that Celebrate

- Lovers
- Motherhood
- Thanksgiving
- Magical Healing
- Protection
- Self-Confidence
- Naming Ceremonies
- Discovering Hidden Talents

The cat goddess Bast with her kittens and musical sistrum represents the tamed, fecund feline energy of the goddess.

The story of Bast leaving Bubastis, her sacred city of the Delta and Lower Egypt, is probably similar to the myth of Hathor's voyage from Dendera and Upper Egypt to Nubia. With both lunar and solar implications, Bast is an aspect of Hathor. Together, Hathor, Bast, and Sekhmet represent the trinity of the Great Goddess as Virgin, Mother, and Crone. In her solar aspect, Bast is called the Female Ra, or Raet, as is Hathor. In her lunar aspect, Bast plays moon goddess, twin of solar goddess Sekhmet. Whenever her solar qualities are the focal point, the goddess assumes a leonine form, and when her lunar quali-ties are at play, Bast appears as the cat. With regard to Bast and Sekhmet, the duality of the Great Feminine is very much at work.

During Graeco-Roman times, both Bast and Sekhmet linked with the Greek goddess Artemis. Artemis, a twin goddess, shared her birth with Apollo, as Bast and Sekhmet were twin sisters. As a lioness, Bast was likened to the Sphinx, which was likewise connected to the solar union of the gods Horus and Atum; wherein Horus, the falcon god, personified the rising sun and Atum, the god of endings, personified the setting sun. Researcher Martin Bernal believes that when the two gods' Egyptian names are combined—*Her* (Horus) and *Tem* (Atum)—they become *Hertem*, resulting in *Artemis*, a name feminizing the male gods more or less with the combined energies of Bast and Sekhmet.[7]

A number of Egyptologists citing Greek sources assert that Bast is the Soul of Ra—the *Ba-ra-aset*, making the connection that Bast, the cat, has nine lives because she bears nine souls like Ra, who created the Great Ennead or nine gods of the primordial era out of his own substance.[8] The ancient Egyptians themselves, however, said that Bast was the "Soul of Isis," literally *Ba-Ast*. If there is any mystery here, it is the mystery of the veil of light that surrounds Isis. It was said that she learned her magical *heka*, or "words of power," by penetrating the heart of the old, dying sun god. She knew him to the core as, of course, only a true mother could know. Here's the myth:

Ra was already an old man whose power was waning and whose spittle dribbled to the ground. Being an artist of great skill, Isis scooped up the spit fallen from the old man's mouth and molded it with some earth into the shape of a scorpion; she left the scorpion in the garden. In the night, the scorpion came to life. The next morning, as Ra strolled about earth viewing his creations and bragging about how wonderful they were and how wonderful he was for making them, he stepped on the scorpion. Stung, he began to shiver and shake. Sweat poured off his brow. His body writhed with convulsions. Feeling as if he had been set on fire, he cried out, "One of my creatures has poisoned me!" He begged his companions to free him from the poison; they all looked up into the already darkening sky and shook their heads sadly.

"Master," they said, "we cannot help you. You have said that there is no one in heaven or on earth as powerful as you. If that is

true, we are all doomed! If you, the Greatest God that Ever Lived cannot stop the pain, then no one can. Alas! Alas!"

One by one, Ra gathered all the gods and goddesses to speak his last words. They crowded around, beating their breasts, crying and wailing. At last, Isis appeared by his side. "Father of All," she said. "Whatever is wrong? Has some vile thing risen up against you? Tell me quickly."

As Ra tried to explain his situation, he grew weaker and weaker. Isis assured him that she could save him—but only if he revealed to her his secret name. "A man lives if he is called by name," she said.

The sun god said, "These are my names: Maker of Heaven and Earth, Maker of Time, Spark of Life."

"But those are not your name," said Isis. "You must tell me your secret name, or there is nothing I can do."

Ra nodded and said, "I am Khepera in the morning, Ra at noon, and Atum at eventide."

"Everyone knows that," Isis replied angrily. She sniffed and turned. "Go ahead and die if you want, but these are not your secret names."

By now, the old sun god lay half-dead. When he finally died, all the world would die, and nothing would remain of his creation, not even the faintest glimmer of its memory. Ra was sad to think of it, so he swallowed his pride, and whispering in the ear of Isis, revealed his secret name.

Then Isis chanted a magic charm, repeating his name and commanding the poison to leave. Ra regained his strength. In fact, he arose renewed and more powerful than before. In turn, Isis gained the power of Ra, knowing the mysteries of life and death and the power of transformation.

The story of Isis and Ra reminds us of the absolute authority and power of the Mother Goddess. Sekhmet, goddess of magic and might, may sometimes bare her teeth and claws, but in the Great Goddess's gentler, nurturing aspects Bast appears as a woman with a cat head. Often she carries a litter of kittens sitting in a basket draped over her arm. Mythologist Robert Briffault remarks upon the cat's great adaptability to motherhood and her ability to love substitute children equally with her own. Typically cats who have lost a kitten will willingly adopt the kittens of another litter.[9]

The origin of the medical arts was sometimes ascribed to Bast. She was especially known for her ability to soothe jangled nerves with herbal potions and to instill a sense of joy in those who felt oppressed. Like the purring of a cat, the sound of Bast's soft shushing sistrum calmed the soul and dispersed negative energies. When called upon, however, she could leap into action as the protector of the pharaoh and of her

father Ra. The high priests and priestesses of the goddess wore leopard skins to link them to these feline energies. Those who wore the skins were said to be great of magic. Bast sometimes appeared as the ever watchful, wily cat sitting calmly under the pharaoh's chair at one moment, then at the next, pouncing upon a serpent Apep—who signified the evil power of the god Seth—and rending it to shreds with her teeth and sharp claws. With Bast around, darkness would never conquer light.

Sekhmet, the fierce lioness, Bast's twin, was lauded as guardian of the world against evil. But her fierceness, so noble and heroic in times of war, was not as welcomed on the home front; thus, the goddess was tamed by drinking a magic potion. As Sekhmet calmed down, a cat's head soon replaced the lion's head, and Bast became guardian of the home. Sometimes, however, Bast still appears wearing the lion head on her breastplate as a reminder to others of the goddess's other self.[10]

The dual nature of the goddess—her loving nature on the one hand and her wild anger and abandon on the other—are nowhere more tightly woven than in the myths of Bast and Sekhmet. The prayers to Hathor, Mother of the Gods, are quick to praise both aspects, lest one offend the other. This Hymn to Sekhmet-Bast appears in The Egyptian Book of the Dead:

> Mother of the gods, the One, the Only,
> Mistress of the Crowns, thou rulest all;
> Sekhmet is thy name when thou art wrathful,
> Bast, beloved, when thy people call.
> Daughter of the sun, with flame and fury
> Flashing from the prow upon the foe;
> Safely sails the boat with thy protection
> Passing scatheless where thy fires glow.
> Daughter of the Sun, the burial chamber
> Lies in the darkness til thy light appears.
> From thy Throne of Silence send us comfort,
> Bast, beloved, banish all our fears.
> Mother of the gods, no gods existed
> Til thou camest there and gave them life.
> Sekhmet of the boat, the wicked fear thee
> Trampling down all evil and all strife.
> Mother of the gods, the great, the loved one,
> Winged and mighty, unto thee we call,
> Naming thee the Comforter, the Ruler
> Bast, beloved, Mother of us all.[11]

Because the souls of Ra and Isis both assumed feline form, it was bad luck to harm a cat. Perhaps that notion, coupled with the cat's excellent night vision, explains the appear-

ance of the cat as the witch's familiar and emblem of Hecate. In modern-day Islam, however, cats are considered "spiritually clean." A cat might even touch the Koran or walk freely in the Grand Mosque of Mecca, but the same privilege is not accorded the dog. Many Arab folk tales likewise suggest that cats can detect the presence of both djinn and angels.[12]

Even the contemporary Egyptian peasant harbors a few of these superstitions, believing that it is possible for the souls of twins to leave their bodies at night and inhabit the forms of cats. If the cat is harmed, the child may fall ill and die. If the cat is accidentally locked up, then the soul is lost and the twin will lie unconscious until the cat and his soul are released from bondage.[13] The cat possessing and having power over the soul is an idea as old as the Old Kingdom pharaohs. In the mortuary texts of his pyramid, Sixth Dynasty king Pepi II dedicated his heart to the protection of the goddess Bast.[14]

This festival appearing early in the Sowing season celebrates Bast's magical protective power and her fecund, nurturing abilities. Bast's color was green, emblematic of all things of nature growing through her gentle light, whereas Sekhmet's color was red, emblematic of destructive fire. Because Bast embodied the mild, fructifying heat of the sun, as opposed to the fierce stultifying heat of Sekhmet, she would have been the appropriate goddess to bless the fields with her warmth and cause the seeds to germinate.

The cat goddess was important prehistorically and remained prominent in the delta region through historic times. According to the histories of Manetho, Bast's sacred city, Bubastis, was active as early as 2925 B.C.E. Her influence likewise influenced the theology of the priests of Memphis, Heliopolis, and Sais.[15] During the Fourth Dynasty, the pharaohs Khufu and Khafre kept busy refurbishing and adding on to Bast's main temple, in addition to building their pyramids.[16] One royal inscription found on the Giza Plateau near Khafre's pyramid reads: "Beloved of the Goddess Bast and beloved of the Goddess Hathor." Such an inscription linking Bast and Hathor is quite remarkable, especially since no other inscriptions of any kind occur elsewhere on the site.[17]

During the Twenty-Second Dynasty of pharaoh Sheshonk I, Bast was elevated beyond a local deity of the Delta to the stature of a national heroine, chiefly because the lineage of the pharaoh descended from her sacred city of Bubastis. By 930 B.C.E. all of Egypt adored Bast. King Sheshonk I, who considered himself a son of Bast, boldly moved the capital city out of its long-standing home in Thebes and established his capital in Bubastis.

Although only a few crumbling walls remain in the city of Bubastis now, the earlier temples built during the Old Kingdom were restored, and new temples were built to honor the goddess. According to Herodotus, who visited the city around 600 B.C.E., no other temple compared with the grandeur of the Temple of Bast. It was built in the very heart of the city, situated on an island enclosed by two divergent streams of the Nile that ran on either side of a single passageway. Each stream seemed a hundred feet broad, and the banks of the river were "fair branched trees, overshading the waters with a cool and pleasant shade." A tall tower, the original tower of the city, Herodotus tells us, could be seen clearly from every part of the city. Inside the enclosure wall lay a beautiful garden of trees, carefully tended by the priests. At last, in the center of the temple stood the beautiful golden statue of the goddess Bast.[18]

Activities

1. Besides your own children, think of the people and things you have mothered—perhaps a child in the neighborhood, one of your children's friends, a coworker you mentored, a community project you began, an older person you cared for. Write these down. Recall the spiritual gifts you gave to each. Recall the spiritual gifts each gave to you.

2. Discover the power of your secret name. Research the origins of your name. If you were named for a biblical character (Mary, Sarah, etc.), recall her story. If you were named for a goddess (Rhea, Diana, etc.), recall her myth. Think about how her story applies to you. If named for a family member, research the chain of ancestry. In what ways is your life story linked with theirs? Begin to collage images representing that power; for example, Deborah (Queen Bee) might collect abandoned honeycombs and meditate on the message inherent in the object.

3. Both Bast and Sekhmet serve our creativity: Bast by nurturing; Sekhmet by limiting or destroying. Bast gives us the heart to pursue our dreams while Sekhmet gives us the will to carry them out. On a page, quickly list twenty of your creative desires, saying, "I want to (paint, travel . . .)." Go through the list again, noting what circumstance stands in the way. Determine what obstacles to eliminate and what nurturing to substitute. Finally, write affirmations stating, "I can/will (do whatever) because . . . ," listing what you will eliminate and how you will nurture your dream.

THE FEAST OF ISIS THE BLACK COW AND THE FESTIVAL OF RAISING THE DJED OF OSIRIS

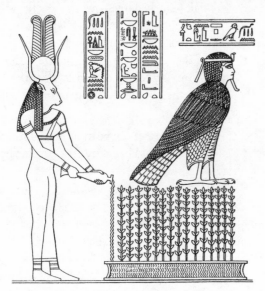

Isis the Cow brings forth the soul form of Osiris as she tends the growing wheat.

Appropriate for Days that Celebrate

- Mourning/Loss
- Regeneration
- Fertility
- Motherhood
- Gardening
- Wisdom
- The Winter Solstice
- Appearance of Orion Constellation
- Divination and Vision Questing

In Upper Egypt the mysteries of Osiris and Isis were celebrated at Abydos and Dendera during the season of Inundation. In Lower Egypt these same mysteries initiated the Sowing season in the Delta cities of Busiris and Djedu. Rather than using the flood motif, these mysteries of the Delta were intimately connected with the darkness of winter solstice and the deposit of new, black, rich soil that followed the annual flood. The mysteries of the Black Isis focused their energies on calling forth the creative, fecund powers of earth and calling upon the sunlight to return from darkness.

Two delta cities on the western bank of the Damietta arm of the River Nile became major centers for these mystery religions. Especially popular during the Graeco-Roman era, the twin cities of Busiris and Djedu had been sites of pilgrimage and worship to Osiris well before the establishment of the Old Kingdom. Located only five miles apart, the twin cities shared similar feast days. Probably the Isis and Osiris temples at Busiris celebrated the mystery rites of the Black Isis, while the Temple of Osiris at Djedu celebrated the mystery of Raising the Djed Pillar, which was the sacred backbone of Osiris.

What we know about The Feast of Isis the Black Cow comes from the records of Herodotus. He visited the temple of Isis, talked with her priests at Busiris, and was initiated into at least a portion of the rites. The initiates, performers, and priests and priestesses, he said, prepared themselves in advance of the Isiac Mystery rites by sexual abstinence, fasting, prayer, and ritual cleansing in the nearby sacred lake. The annual solstice festival was so popular that tens of thousands of pilgrims from all over Egypt and the Near East flocked to the little city to perform the rites of Isis and Osiris. If they were not initiated in the temple, they thronged the streets of the city observing the rites from a distance, beating their breasts and lamenting the death of Osiris.[19]

Herodotus tells us that during his initiation he dressed in a linen robe woven specifically for his ceremony. For a portion of the ritual he walked around the temple precinct in procession with his fellow initiates. Two priests led the procession; they were dressed as the dog-headed gods Anubis and Wepwawet, the Openers of the Way. The dog was sacred to the goddesses Isis and Nephthys, in accordance with the story that one night in a case of mistaken identity, Osiris begot the child Anubis with his sister Nephthys. As earlier related, dis-

traught by her ill-gotten pregnancy, Nephthys took the new-born into the desert intending to expose him; but Isis, child-less and compassionate, saved the babe and raised him as if he were her own son.

When the procession approached the temple door, the initiates were blindfolded and escorted through the door by their canine companions in a manner similar to Masonic rit-uals. Herodotus carried before him a branch of the gray-greenish-yellow herb absinthium, dedicated to Isis. Absinthium (meaning "spirit mother"), or wormwood, is a particularly strong narcotic known to produce visions and delirium.

Part of the winter solstice ritual that commemorated the grief of Isis involved either leading a living black cow, or car-rying a statue of the goddess in her golden cow form, covered by a pall of black linen. Seven times around the temple precinct and the shrine of Osiris the procession walked with mournful steps. Their journey in the dimming winter light represented the wanderings of Isis in search of the body of her Beloved; the ritual was often called the Searching for Osiris. In concert with the goddess, the participants danced the somber steps of the *muu* dancers, mourned and lamented the loss of the god, and searched for the scattered parts of his body. [20] As they mourned Osiris, they mourned also the dying light and warmth of the winter sun, beseeching Life and Light to come again in the reborn form of Osiris as Ra. [21]

In the temples of Abydos and Dendera as well as at Busiris, two priestesses played the parts of Isis and Nephthys, their lamentations recounting their love for the lost brother, their sorrow at his death, and their magical acts which revived and finally resurrected the god. The Lament of Isis, which the Greek celebrants called the *Maneros*, meaning the "Understanding of Love," were chanted in a solemn tune, equating the Egyptian god Osiris with the Greek fertility god Pan:

> Return, oh return. God Panu, return! Those that were enemies are no more here. Oh lovely helper, return, that thou mayest see me, thy sister, who loves thee. And comest thou not near me? Oh beautiful youth, return, oh return! [22]

The solemn occasion required the sacrifice of an ox that was carried in procession, shrouded in black like the body of Osiris and followed by the lamenting priestesses. After its sac-rifice, more wails and cries filled the air. The votaries scourged themselves with flails or beat their breasts, openly weeping and lamenting the death of the Osiris bull whom they called the Good Being. The animal's carcass was stuffed with flour cakes, honey, raisins, figs, incense, myrrh, and other herbs, then burnt and roasted over a fire with oil poured upon the flames to keep the fires going. Afterward they ate the ox. [23]

The ritual may look familiar to church goers who per-form similar communion rites with bread and wine. Knowing the God has died, the God is risen, and the God shall come again is the essence of the mystery tradition. In death initiations one contacts the sorrowful mysteries, but the joyful mysteries lie beneath them. The sarcophagus in which the body is placed bears upon its coffin lid the image of the sky goddess bending over the dead. Literally, the word *sar-cophagus* means "sacred eating," and the goddess is the eater of the dead. As the globe of sun is swallowed by the body of night, so the soul of light is swallowed by death and returned to the body of the Great Mother. There in peace and stillness one might gestate new life hidden away from prying eyes, deep in the womb of the Great Mother, safe within her. The tomb opening represents the vagina of the goddess, the entrance and exit into worlds. In the words of Hermes Tresmigistus, the hierophant of the mysteries, "There where everything ends, all begins eternally."

Mystery initiations performed under the veil of night use darkness as the vehicle that leads from death and sleep into healing and rebirth. Transcending earthly darkness, mythologist Eric Neumann says, "sublimates the very essence of life through the eruption from the depths of those powers that, in drunkenness and ecstasy, poetry and illumination, manticism and wisdom, enable man to achieve a new dimen-sion of spirit and light." [24] To spend the darkest night of the year inside the temple of the Goddess, in the sanctuary that represents her body, and to rise renewed at dawn the follow-ing day may facilitate all manner of psychological and spiri-tual transformations that leads one to die to the old life and embrace each day as if one were reborn.

This life-and-death battle of spirit was portrayed in the long mythic narrative of the Contendings Between Horus and Seth. A part of that story, called How Isis Gained the Horns of the Cow, formed a part of the mystery traditions of Isis:

By this time Horus, the child, had grown up to become Horus, the warrior. He had set for himself the task of "going about his father's work"; that is, of restoring the balance of power that Seth had appropriated. As the battle waged on, the contenders used deception and magic as weapons to transform themselves into fighting lions, or bears, or hippopotamuses.

While the two hippopotamuses wrestled with each other at the bottom of the water, Isis stood on the bank watching, fearing that Seth might kill her son Horus. She knotted a rope, cast a har-

poon of copper, and threw it into the water, aiming at Seth. As the warriors fought and rolled, the harpoon lodged instead in the side of Horus. He shrieked, "It is I, your son!" and Isis commanded the harpoon to let go. Again she cast into the water, this time snaring Seth. He shrieked, "It is I, your maternal brother!" Realizing she loved both her brother and her son, Isis commanded the harpoon to let go.

When Horus surfaced and leaped to the bank, he was angry with his mother. In a rage, he took the knife he wielded against Seth and, with a single stroke, cut off her head and carried it far away into the mountains. Now, Isis wandered about the banks, headless. The gods and goddesses in heaven looked upon her and were shocked by what they saw. Said Ra to Thoth, "Who is that coming without her head?"

"My lord," said Thoth. "It is Isis, the Great, the Divine. Her son Horus has cut off her head!" Then Thoth, the god of wisdom, descended to earth, cut off the head of a cow, and, by means of his words of power, attached the cow's head to the body of Isis. When she looked into the river and saw her reflection, she seemed surprised. "I have been remade," she said, "into the image of my mother."

The myth resonates more deeply with older women who find themselves identifying with their mothers. Teenaged children, courageous and hot tempered like the young Horus, will wage battles against the "rules and restrictions" of Seth. As a child takes the warrior's part, a parent may attempt to balance the power. With fierceness, the angry warrior turns on the parent and tries to "cut off her head." The heroine must learn the proper use of her strength, and the crone will have learned to stand out of the way.

Isis never turned away from Horus, even after what he had done. She had grown older and wiser, and she had changed. She had grown horns—the sign of enlightenment, like the dual rays of light that were said to have emerged from the forehead of Moses when he left Mount Sinai with the commandments of his God. The compassion of Isis became less emotional, less maternal, and more spiritual.

Within this myth lie traces of herstory. I sometimes think that what it represents is the final blow rendered to matriarchal culture by the brash young male god. If he wielded his power, he did not use it wisely. The way of Isis was the way of equity, honoring both the light and the dark, the order and the chaos. In the young patriarchal Horus god, the chaos became internalized and projected outward onto the world, doing great damage to the Mother who loved and sustained him. The Feast of Isis the Black Cow became a mourning ritual—not just for the lost Beloved alone, but also for the loss of power that all women have suffered under patriarchal rule.

The croning of women provides them entrance again into the wise blood, a time of power, of self-rule. There is an inner fire that burns brightly in the time of darkness. After all, that is the point of all death and transformation.

Evening worship at the Iseum was held on successive nights. During the Lights of Isis Festival the goddess's temple glowed with the brilliant lights of a thousand candles.[25] The dark, chilly winter air rang with beautiful hymns and music dedicated to the goddess, beseeching her as Mother of the World and its savior, requesting her gentle guidance and intercession, as in the following Hymn to Isis:

> O Thou, holy and eternal savior of the human
> race,
> Thou bestowest a mother's tender affections on
> the misfortunes of unhappy mortals.
> Thou dispellest the storms of life and stretchest
> forth thy right hand of salvation by which
> Thou unravelest even the inextricably tangled web
> of Fate.
> Thou turnest the Earth in its orb. Thou givest
> light to the Sun.
> Thou rulest the world. Thou treadest Death under
> foot.
> To Thee the stars are responsive. By Thee the
> seasons turn and the gods rejoice and the
> elements are in subjection.[26]

The Feast of the Lights of Isis was a precursor to the Christmas Eve service or Candlemas Day of the later Christian calendar. Similar festivals were held later in the year in Sais to honor Neith, at Bubastis to honor Bast, and even in the Greek port of Piraeus to honor Athena during the Eleusinian Mysteries. The goddess Isis in her infinite compassion spread her angelic wings and enfolded those who were oppressed and sick at heart. She pressed to her bosom all those in need of divine love and understanding. She comforted all those who doubted, wailed, and lamented, yet called upon her for salvation. "Those who invoke her name in faith," says R. E. Witt, "can enjoy the vision of her. In short, she promises her believers the satisfaction of their deepest needs."[27]

The Black Isis epitomized the great feminine principle of receptivity. Where Osiris was the overflowing Nile water, Isis became the fecund dark earth waiting to be filled with seed. Black-robed in her period of mourning, she becomes the Virgin Goddess, possessing all the creative potentiality of the dark night.

As a symbolic gesture that signified the fecundity of the holy marriage of Isis and Osiris, the ancient priests and

priestesses buried an effigy of Osiris filled with new, rich earth and seed. This "corn mummy," as it was called, was placed inside the temple gardens in a mound of earth under the shade of the sacred persea trees where it was allowed to gestate in the dark womb of earth.[28] The green sprouting seeds were a sure sign that Osiris had been resurrected into new life. These plantings generally occurred around the time of the new moon in the Sowing season. According to the Pyramid Texts, when the sun and moon united, Osiris appeared and a new period of growth began.[29] The sun-moon conjunction symbolized the sacred marriage of Osiris and Isis. On the walls of the rooftop terrace at Dendera appears a similar image. There the god Osiris with his flail represents the completed vegetation cycle and is said to be risen through the reaping and threshing of barley.

Modern-day Egyptians still celebrate the agricultural feast of Sham el Nesseem on the winter solstice by planting wheat, lentils, and other seeds to usher in the new year. The sprouting of the seed signifies rebirth, and the Egyptians will wish each other *Sana khadra*, literally meaning "Green Year."[30]

With her dramatic rejuvenating powers, Isis, like the Black Virgin of European shrines, was revered as a goddess of healing who provided emotional and psychological succor, healed the physical body, and appeared in dreams. Her power was so great that it sometimes frightened people; as often as she appeared as the portal of salvation, she also appeared as witch or sorceress. The medicines she brewed could raise the dead. Says Esther Harding, "This medicine was called *moly* and is thought to be the same as *soma*, or *hoama*, the drink brewed from the moon tree, which occurs in Persian and Hindu literature, and which, also, is said to bestow immortality."[31]

Another image of the power of Isis to resurrect the dead was the ritual raising of the djed pillar. In Abydos, the rite occurred during the month of Koiak, but in Busiris the pillar was raised in public ceremony at the winter solstice.[32] The djed pillar, hauled upon a sledge into the temple courtyard and lying on its side, was met by the icon of the black cow goddess. The priestesses sang the resurrecting song of Isis:

> The Cow weepeth for thee with her voice. Thou art beloved in her heart; her heart fluttereth, enchanted for thee. She embraceth thy limbs with her two arms, and cometh running steadily toward thee, for peace. Behold, her vengeance is accomplished for thee; she is caused to be mighty by thee. Thy

flesh hath she bound with thy bones for thee. She hath gathered for thee thy breath in front of thee, and made thy bones entire.[33]

The song of the Black Cow, sung by one priestess impersonating the voice of Isis, was probably accompanied by selected sister priestesses who rattled their sistra as a ritual means of driving away the serpent Seth who had killed Osiris and ensnared him. In shape the sistrum was very similar to the djed pillar itself, being comprised of four bars with each bar representing a different element of the natural world. The rattling disks or seeds enclosed within each bar activated each of the elements (earth, water, air, and fire). The Greek writer Plutarch believed that the sistrum reminded one that "things ought to be shaken up," that without awakening, the spiritual life falls asleep and dies away.[34] Sistrum music was the voice of the goddess and the music of her rattling seed awakened the inert god.

At last the djed pillar was hoisted upright by priests tugging on heavy ropes. The djed represented not only the lost and found spine of Osiris, not only the pillar in which the god had been enmeshed while in Byblos, not only the phallus of the god raised upright or the axis of the world, but also the sacred tree into which the *bennu* bird flew and built its nest, the sacred tree where the phoenix died in flame and was reborn from its own ashes. The Osirian Mysteries contained within them a visible, dramatic portrayal of the risen god Osiris and a tangible reckoning of the powerful force of Light and Life Energy.

At death the transfigured soul was carried into the neterworld on back of a flying serpent.

Through the resurrection rite, the serpent itself transformed. Where Seth is depicted as the ensnaring snake, the twin sisters Isis and Nephthys became the two fire-spitting cobra goddesses of Lower Egypt. Transformed, the spirit of the dead became a "serpent in the sky." As much as the snake was considered the bearer of the tidings of death, it was likewise the image of regeneration as the snake that sheds its skin.[35] The positive aspects of the omnipresent duality of light and darkness were no more well expressed than in the combined powers of the goddesses Isis and Nephthys to resurrect the dead. Together, they were sometimes called the *Shentyt*, twin divinities who presided over the cycles of time. The power of both goddesses acting in unison was necessary for evolution, for becoming even into eternity.

Above the lintel of each tomb entrance appeared the winged goddesses, Isis and Nephthys. Between them hung the sun disk of Ra, the solar god. The image of the actual sun

in the sky suggested the divine sun that radiated as the wellspring of being. The solar emblem marked the tomb door as the transitional point between life and death. Here, Osiris was reborn as the spiritual warrior, a solar masculine hero surrounded and protected by the feminine unconscious wherein the mystery of transformation occurred.

Isis and Nephthys, who uplifted the solar disk, wore around their heads simple bands of white linen, like those worn by women laboring in the fields. Their head bands suggested that these goddesses sowed seeds of light. Once the body was left like seed in the earth, it would rise again as golden grain. This mortuary symbol of the sun as seed revealed the true meaning of the magical phrase, "Open Sesame." When the soul stands in a transitional realm between birth and death, ". . . what matters," José Arguelles says, "is the seed."[36] The door represented that borderland, a crack between worlds where no matter how dark the dark may be, light seeps in around the edges. When Osiris died, he entered Light, he entered total consciousness.

To understand the way of fire, the way of light, the way of Ra, one must become like unto that fire, light, and god. The talent for becoming Light is best understood consciously during one's lifetime rather than learning it unconsciously after death; thus the power of the Osirian Mysteries. In his treatise on the sacred mysteries, the Greek philosopher Iamblicus spoke of initiation by fire. "One who thus draws down a deity beholds the greatness and the nature of the invading spirit; and he is secretly guided and directed by him. So too he who receives a god sees also a fire before he takes it into himself."[37]

On the day of the solstice, indeed, the dark turns toward light. The Festival of the Raising of the Djed illumines the true power of the goddess, for this is the day Isis raises Osiris from death. The constellation Orion—that is, Osiris—first appeared on the horizon at dawn in June during the final days of the year. Then it appeared low on the horizon, lying on its side, almost as if the god himself were dead, asleep, or dreaming. In her lamentations Isis sings: "I found him lying on his side, the Great Listless One." Sister Nephthys sings back: "Come, let us lift up his head. Come, let us rejoin his bones. Come, let us reassemble his limbs." Then Isis raises Osiris to put an end to his sorrow.

During the New Year's Feast, we discover that the star Sirius embodying Isis appears on the horizon. Each morning afterward, the star rises higher in the sky, seeming to push the constellation Orion ahead of it. By sunrise on winter solstice morning, Orion seems at last to stand upright. The djed pillar has now been raised, conducted into the realm of the Imperishable Stars, where the eternal souls dwell in Nut.

Osiris has entered into eternal life. The Festival of Raising the Djed of Osiris completes the promise of new life that began with the appearance of Isis as Sirius.

Igniting the Dream

In *The Search for Omm Sety*, Jonathan Cott tells how an Englishwoman named Dorothy Eady came to devote her life to keeping the mystery traditions of Osiris. Given recurrent visions of her former lifetime as a consort to pharaoh Seti II, Dorothy Eady moved to Egypt, married an Egyptian, and took an Egyptian name—Omm Sety. In the city of Abydos, near the temple Seti II had built, Omm Sety lived and kept the temple traditions until her death at the age of 77 in 1981.

Once an American woman who had lost her son in Vietnam was sent by the Rosicrucians to Abydos to spend the night with Omm Sety. Omm Sety asked the woman to fast and purify herself, then they entered the temple and spent the night together, praying to Isis. Beautiful music played by unseen hands wafted through the temple, lulling them to sleep. Omm Sety had no dreams that night, but on waking the other woman was elated. She said her son had appeared in a dream and told her that he had died instantly without suffering. He asked his mother not to worry, and assured her that he was happy in the afterlife.[38]

Although it was not necessary to have a dream interpreter in ancient times, dreaming in pairs was recommended. It was an honor to be the priestess initiating and interpreting a dream from Isis.[39] Dendera was the ancient Egyptian dream center, while ancient Greeks preferred the Isis temple at Busiris and Nubians slept in the Isis temple at Philae. The dreams might be personal, prophetic, or revelatory, taking the forms of simple messages, symbols, or prophetic visions. To receive such a dream, the dreamer might petition the goddess by reciting a prayer, such as this hymn by Isidoros, a priestess of Isis:

O hearer of prayers, Black-robed Isis, the Merciful, and ye great gods who share this temple with her.
Send joy and love to me, O Healer of all ills. . . .

The power of Isis to teach, heal, and succor through dream is legendary. The true power of Isis

lies in her miraculous ability to transcend the veils between worlds to interact with humanity. Since the goddess cannot intervene directly in human affairs, she sends clues and often a constellation of synchronistic events designed to facilitate one's self-healing.

Keeping a dream journal is a good idea—jotting down the images, then reviewing the symbols, puns, and recurring images. If you have time, lie back down and try to recall the dream in detail. Think about the images that may be recurring in other dreams. Typically, the dream keeps circling and incubating over time the themes in waking life.

The Egyptian dream goddesses include Hathor, Isis, and Sekhmet for teaching; Nephthys for precognition and hidden wisdom; Seshat for past-life recall; and Bast for sweet dreams. Certain herbs assist your dreaming—rosemary, vervain, lavender, heather, sage, primrose leaves, rose, and mugwort. Dream stones might include crystal, amethyst, aquamarine, pearl, and moonstone. Full and new moons denote the best lunar phases for dreaming, particularly when the moon is in Scorpio (Isis), Pisces (Nephthys), Cancer (Bast), Libra (Hathor), Gemini (Seshat), and Leo (Sekhmet).

TO RECEIVE A POWERFUL TEACHING DREAM: Retire around 8 P.M. Lay a white rose on the left hand corner of your pillow. Light a white candle. Burn fragrant incense—peppermint, rose, or lavender; or sweet herbs—sage or primrose leaves. Watch the moon rise outside, breathing deeply and peacefully. Stay with the moon as it turns from red to white. Say: "Isis, Lady of the Light, give me a dream upon this night. Unveil my mystic inner sight. Dispense your visions abrim with light." Now quietly contemplate the candle flame. Retire before the dreaming hour of 9:00 P.M., saying this final invocation: "Isis, Lady of the Flame, this spell I work in your sacred name. Usher my dreams to my waking mind. So by day my soul I find." Snuff out the candle flame and go straight to bed.

TO CONTACT A LOVER OR SPIRIT IN THE DREAM WORLD: This very ancient Egyptian spell appears in the Leyden Papyrus, derived from the magic of Isis who maintained her marriage to Osiris even in the next world. To contact a distant or potential lover, write the individual's name in blood on a rush leaf, then sleep with it under your head. To contact the spirit of a departed loved one, place a second similar rush leaf under the pillow of a departed spirit who will carry the message into the next world.

ON RECOGNIZING THE GODDESSES IN DREAMS: Often the goddess appears in a dream as an incredibly tall, beautiful woman, or as a teacher or crone. Or she may remain veiled and be simply a voice speaking. Or she may appear in one of her animal forms, as follows:

BIRD dreams sometimes signify the departure of the soul, astral flight, or spiritual aspiration. Birds in flight symbolize travel with a spiritual purpose, or a sense of freedom.

COW dreams may signify nurturance, maternity, and living close to the earth. To dream of milk is to dream of kindness, or the goddess may be sending a message about how you use your resources.

SCORPION dreams reveal hidden and mysterious changes, perhaps in preparation for spiritual initiation. They may also indicate stinging remarks.

FROG dreams announce deep transformation that betokens the magic of the goddess at work in your life.

FISH dreams indicate the spirit realm and spiritual thoughts. Gold fish, indicative of abundance, are particularly Isis-oriented.

SNAKE dreams symbolize occult wisdom, healing, and adaptability, while the snake bite connotes initiation into the deeper mysteries. Snakes shedding skin may relate to changes in self-awareness. To see a winged snake, or the Egyptian "serpent in the sky," is to attain immortality, or enter altered states of consciousness.

LION dreams connote power, strength, courage, and will. Lion taming means to tame your lower nature. Sphinx dreams indicate one may be on the threshold of deeper initiation.

CAT dreams indicate independence, playfulness, and sensuality. Often cats in dreams point to a growing psychic ability. Cats with kittens indicate matters of fecundity and abundance. Cat litter boxes mean taking responsibility for your actions.

THE BIRTH OF RA, CHILD OF NUT,
AND THE BIRTH OF HORUS, CHILD OF ISIS

The sky goddess Nut embodies the Milky Way, which is the source from which her solar child, Ra, sails each day and to which he returns each evening.

Appropriate for Days that Celebrate

- Your Birthday
- The Birth of a Child
- Motherhood
- Planting Anything
- The Hero's Journey
- Protection and Comfort
- Nurturing a Dream
- The End of a Cycle/Beginning Anew
- The Winter Solstice
- The Rise of the Cygnus Constellation

The birthday of the solar god, occurring at winter solstice, is one of the oldest festivals in human consciousness, and celebration of the Great Mother and her holy child runs deep throughout all the cultures of the ancient Near East. It's no surprise that the traditional birthday of the Christ child, born in Bethlehem and traveling with his parents into the land of Egypt, coincides with the birth of Ra, the sun (son) god, and Horus, the child of Isis, the spiritual warrior who saves the land from the evil and darkness of Seth. Like Christ, Horus also comes to do the work of his Father.

In Heliopolis at the desert's edge, there once existed a sacred tree, said to be the site where Isis stopped to suckle Horus when she was hiding in the Delta papyrus swamps because Seth was trying to kill her and the babe. The immense sycamore tree was centuries old and, when it died, someone always came to plant another tree in its place, trees being rather miraculous in the desert. This same tree shrine was visited regularly by Christian pilgrims as the site where Mary rested to suckle Christ during their flight from Egypt.

One of the myths about Isis and her infant son Horus that may relate to this winter solstice festival is the myth of How Isis Stopped Time and the Boat of Ra:

It was said that while the goddess was away from Horus, having left him in the care of her sister and several cobra nursemaids, one of Seth's henchmen, disguised as a scorpion, crept into the papyrus swamps and stung the infant. Nephthys ran to find her sister. The goddesses clustered around the child's lifeless body. Helpless, heart still, eyes clouded, Horus lay rigid as stone.

When Isis arrived, she saw the poison in the wound of her son's leg and, gathering him into her arms, tried blowing into him the breath of life; but he moved not his lips and took no food. She shrieked into the sky, "Horus is stung. O gods, the golden child, heir of Egypt has fallen."

Hearing her cries, the goddess Serket arrived, telling Isis to

pray to Thoth. "The child lives while the sun stays in the sky."

Then Isis raised her arms to heaven and called Thoth to stop all time, to stay the sun, to halt Ra's boat that had sailed for a million years. Thoth cried to the oarsmen, "Stop the boat!" He got out and descended to earth, now to sit beside Isis and teach her the words of power by which all humans live. He commanded her to repeat after him: "Ra lives; the poison dies." After a moment, breath returned to the child. His eyes fluttered, then opened; the twisted limbs unfurled.

"I am thirsty," Horus said. His mother, sitting beneath the sacred sycamore, gave him her breast and he drank. Thoth returned to heaven. The boat of the sun sailed on.

The Birthday of Ra, the sun god, is one of the oldest Egyptian festivals on record, at least as old as the festival of The Rise of Isis as Sothis and The Opening of the New Year. In Lower Egypt where Mesopotamian, Greek, and Egyptian influences all converged, the festival of the Great Mother's Child was prominent. In Lower Egypt and the delta region, Ra came to embody the sun; in Upper Egypt, the solar god was originally Horus the Elder. By the beginning of the Old Kingdom, however, the two gods Ra and Horus were fused in the ancient Egyptian mind. Both gods came to symbolize the holy child who is the light of the world, the Son (sun) of God; thus they share this birthday.

The myth of the solar child Ra and his mother Nut, the sky goddess, figured most prominently in Lower Egypt and the delta region because at that particular latitude in the northern hemisphere, the Milky Way most closely resembles the celestial image of Nut. Throughout Egypt, the nude body of Mother Sky can be found painted in the lapis lazuli colors of night, stretching along the tomb and temple ceilings or gracing the inside of sarcophagus lids. She stands on tiptoes in the eastern horizon; bending over, she reaches with hands over her head to touch the opposite horizon. Her body is spangled with the golden glimmering stars that represent all the souls of her children—those souls who have been born and who have died, and those who have yet to be born.

Often she is depicted with the golden globe of the sun pressing against her lips, waiting to enter her mouth, where she swallows it at sunset. The sun passes through her body during the dark hours of the night and is reborn the next dawn as a golden ball pushed above the eastern horizon by Khepera, the winged beetle, as the sun child emerges from his mother's womb. The Pyramid Texts of the pharaoh Pepi invoke this relationship between the soul of the dead and the Great Goddess of the Sky as the mother of all life, protectress of all souls, and divine receptacle of spirit:

Oh Osiris Pepi,
Nut, your mother, spreads herself above you.
She conceals you from all evil.
Nut protects you from all evil.
You, the greatest of her children![40]

In the Pyramid Text of Unas, Nut appears at the Milky Way, sometimes simply called the Great One, or Great Goddess, and sometimes called the Cool Region, which relates to the milky liquid form of our galaxy that appears to flow through the sky, almost like the Nile itself.

Throughout the year, the Milky Way changes shape; we never actually see all of it together at one time. But, if one observes it closely throughout the year, the shape of the goddess—her upper and lower body—can be pieced together to form Nut just as the ancient Egyptians depicted her. Where the Milky Way appears to split into two separate channels, the goddess's legs are formed. A swelling cluster of stars forms her head, then narrows above to become the goddess's extended arms.

During winter solstice, the brightest star in the Northern Cross (that is, the star Deneb in the constellation of Cygnus—often depicted as a bird in flight with its wings stretched) marks the precise location of the vulva of the goddess. It is from between this split in the legs that the child of Nut is born. Very early civilizations probably marked this same Northern Cross constellation by depicting the vulva of their predynastic bird goddess with the sign of a cross. During winter solstice, the constellation Cygnus clears the horizon about two hours before sunrise. The bright star Deneb rests only slightly above the horizon. As ancient sky watchers observed the increasing darkness of the days, the longer nights, and the colder weather, they must have imagined that the sun had died; but lo and behold! around 7:00 A.M. on the solstice, the sun arises again exactly on the spot where Deneb previously occupied the horizon, and suddenly the days become longer and the nights shorter.[41] Lo! the sun god lives!

The celebration of the birth of the sun god likewise celebrates the Great Mother, the cow goddess, from whose udders stream the brilliant blue-white stars that form our Milky Way. Our word galaxy comes from the word gala, originally meaning "milk," and the Egyptian goddesses Isis, Hathor, and Nut all align themselves with this great celestial cow by wearing the horned diadem. The famed Berlin Papyrus celebrates this day of the horned goddess and her child, saying:

Thou camest from thy mother, Nut; she spread herself out before thee at thy coming forth from her. She protected thy limbs from all evil; she followed thee as her babe. She drove away every dan-

ger from thy limbs, chiefly that which was harmful to thee, thou child, the lord. He goeth forth from Nut; he gazeth upon this land as its head, he the only lord, the child. Thou goest forth from this cow which conceiveth from the gods . . ."[42]

The original festival celebrating the sun's birth was called *Mesut Re*. When the Greeks adapted the ancient Egyptian calendar for their own, they used the old festival name to indicate the final month of the year, calling it *Mesore*. The month of Mesore begins in the Gregorian calendar on June 14. According to the ancient Egyptian Sothic calendar, in order for the birthday of Ra and the end of the year to coincide with winter solstice, one would have to return to an almost impossibly distant epoch in prehistory, perhaps 8,760 years before the time of the first pharaoh Narmer! (See Pachons 6, The Pregnancy of Isis and Nut.)

I have heard it said by scholars of classics and history that the ancient Egyptians knew very little about astrology or astronomy, but I do not for a minute believe this is true. They were most adept timekeepers, totally observant and obedient to the signals of the heavens, which were the images and messages of their divine gods and goddesses. For example, in the Osiris shrine at the Temple of Hathor in Dendera, Nut appears with a series of solar disks on her belly, rather than the traditional stars. Her husband, the earth god Geb, lies beneath her in a rather uncomfortable position. Lying flat on his back, he raises his feet upward and touches them over his head. Rather than being some odd yogic love position, his form symbolizes the earth turning in opposition to the sun in the sky (represented by the solar disks on Nut's body). Thus, well before European astronomers could explain the phenomenon, the ancient Egyptians understood all about the earth's rotation and explained it symbolically.

The Great Mother completely encapsulates the image of the divine Feminine as the experience of simultaneous unity and separation. In the west, at sunset, the Goddess is wife who receives the seed that travels through her darkened belly; She merges with the

Nut, the night sky, bearing the stars and solar disks often appeared on the lid of the sarcophagus

God. In the east, at dawn, the Goddess is mother who births the child; she and the God individuate. When mother unites with father—when Nut unites with Geb, or Isis with Osiris—opposites meet. The two are made one. The One contains the All, but its essential Oneness is created by the combined possibilities of the Two. Likewise, in the womb, mother and child are merged, sharing breath and blood, but at birth child and mother separate. The mystery of birth is the mystery of the macrocosm in the microcosm and the microcosm in the macrocosm. All is related to the process of merger and gestation, union and individuation.

Eventually, the myth of Nut birthing Ra merged with the myth of Isis birthing Horus. Originally Horus, the hawk god, came from Upper Egypt around the region of Hierakonpolis. Isis apparently began as a Delta goddess, but later became equated with Hathor, the goddess of Upper Egypt near Abydos and Dendera, as well as with the sky goddess Nut. By the time Memphis, the first capital city, was established in united Egypt, Ra and Horus—and Nut, Hathor, and Isis—were already beginning to conflate.

Ancient Memphis was a thriving religious center for priests and priestesses during the Old Kingdom. The main cult of Isis dominated the religious climate from ancient times, but because of three millennia of devastating floods in this low-lying area, not much is known archaeologically about the early development of the goddess. Remains have been unearthed, revealing a paved mosaic walkway illustrating the procession of Isis into her house of mysteries. To this birthplace of the Isiac Mysteries many Greek initiates later traveled on pilgrimage. Worshippers from far-off lands came to pray to Isis by reciting her great hymns, many of which were erected on stelas and columns. It was not unusual for the traveler to pay an Egyptian priest-scribe to copy the prayers and hymns into a second language and for the traveler to return to his country of origin with the exported prayers.

One hymn in particular, which formed part of the Lamentations of Isis and was most likely intoned at The Feast of Isis the Black Cow, illustrates the fusion of the mystery that involves both the death of Osiris and the birth of the sun god. Here Osiris and Ra-Horus are linked. The priestess impersonating Isis would sing:

Come thou to us as a babe, thou first great Sun God. Depart not from us who behold thee! There proceedeth from thee the strong Orion in heaven at evening, at the resting of every day! Lo, it is I, at the approach of the Sothis period, who doth watch for him. Nor will I leave off watching for him; for that which proceedeth from thee is revered. An emanation from thee causeth life to gods and men, reptiles and animals, and they live by means thereof. Come thou to us from thy chamber, in the day when the soul begetteth emanations—the day when offerings upon offerings are made to thy spirit, which causeth the gods and men likewise to live.

The hymn continues invoking the Great God of All in a phrase reminiscent of prayers to the high God the world over, whether his name be Yahweh, or Allah, or simply God:

Praise be to the Lord, for there is no god like unto thee, oh Atum! Thy soul possesseth the earth, and thy likenesses the underworld.[43]

In Memphis Isis shared her temple with Ptah, the main cult god of creation and fertility who shared common traits with both Osiris and Min. All three gods were connected with sacred bull cults, and it was the regenerative power of Osiris combined with Min and Ptah that was attached to the cult of the Apis bulls.[44] Because of the fusion of the God as Father in the west, and the God as Son born in the east, the sun gods Horus and Ra (and the resurrected pharaoh) are often called Bull of His Mother. Aligning with the Great Mother from whom all things come was the best assurance that a child, or a grown man, had of receiving his appropriate inheritance. It was being the son of the Queen Mother that put the pharaoh in direct line for the throne.

Because predynastic Egypt began as a matriarchal culture, women were always the inheritors of the arable land—that was one of those customs of the civilized which Isis taught her people. Thus, the marriage union was considered a highly desirable association; whereas unmarried men owned but their swords and shields, married men received abundant gifts—the love of wife and children, the security of the wife's inheritance, and the fruit of his own labors.

The product of this union was the Great Mystery; that is, life itself—the birth of the holy child. We associate the word *mystery* with the mysteries of Eleusis and the bull cult mysteries of the Myceneans—the Mycenean root word *mys* being synonymous with "initiation."[45] What is birth if not an initiation, a mystery of becoming? In the Egyptian hieroglyphs *mesi* meant "to give birth," and *mes* held two meanings: "to be the child of" (as in Thutmose, child of Thoth) and also "to sur-

prise." The hieroglyph denoting *mes* was the image of three fox tails tied together, three being the sign of multiplicity. What the fox and birth had to do with one another is still a "mystery," but it is well documented that even contemporary peasant women in Egypt who want another child often tie foxtails to the heads of their youngest child as a charm to secure a baby. It is a custom apparently harkening back to an ancient African tribal tradition.[46] In the ancient Egyptian tradition, to pass through the skin of an animal meant to be reborn; thus, only high priests and priestesses ever wore the panther skin as a sign of their initiation.

The Hierogamos (rite of the Holy Marriage) as the image of the marriage between the king and the land is one of the oldest mythological themes in the world, appearing not only in the marriage of Osiris and Isis, but in the marriage of Dummuzi and Inanna and of Arthur and Guinevere. I'm reminded of Wendell Berry's poetry which speaks simultaneously of the love of his wife and of his labor as a farmer, where he calls himself a husband of the earth. Woman as fertile ground is a metaphor as old as the earth itself. *Mer*, the ancient Egyptian word meaning "love" and the root for the name *Meri* or *Mary*, was written with the hieroglyph of the plow. The shape of the Egyptian plow was the triangle, a trinity of devotion where two equal lines are joined by a smaller one at the bottom. The image also suggested the family dynamic bonded in love; that is, the mother and father united by the child. This ancient word image implies that the fecund woman, like the earth, is opened and filled with seed.

Mythologist J. J. Bachofen eloquently reminds us of the significance of the plow as a model for marriage when he says:

The earth becomes wife and mother, the man who guides the plow and scatters the seed becomes husband father. The man is joined in wedlock with feminine matter, and this provides the model for an intimate, enduring, and exclusive relation between the sexes. The male plow opens up the womb of the earth and of woman as well; this twofold act is indeed but one, and in respect to the earth as to woman, it is no longer a hetaeric episode (of the holy prostitute or sexual initiation practiced anciently) but a conjugal union. The man's act does not aim at the satisfaction of sensual lust, but at the production of golden fruit.[47]

In her travels through Upper Egypt during the early 1900s, ethnographer Winifred S. Blackman observed that birth rituals among the fellahin still preserved this agricultural image of woman as earth and child as sprouting seed. On

the evening of the sixth day following a child's birth, the midwife comes to perform a winnowing rite. In two or three large baskets are placed salt, beans, fenugreek, lentils, wheat, clover, and maize. Over one of these baskets is laid a large winnowing sieve on which the child sleeps all night. In the morning, mother and child are ritually cleansed, their period of confinement now ended. The grains from the basket, and the baby too, are placed on the sieve, tossed and shaken several times. Then the child is wrapped in a white cotton blanket containing a few of these seeds and carried throughout every room of the house, then taken outside.

As the midwife walks she picks the seeds from the blanket and scatters them on the ground, chanting *Shalla 'a'n-Nebi*, meaning "Bless the Prophet." The child's eyes are then painted with kohl, using a goose feather as an eyeliner; and a piece of the child's umbilical cord, along with some of the seeds, are fastened around its neck in an amulet bag to ensure its health and protection. The father takes his baskets of grain and scatters them over his fields to ensure his having good crops for the year.[48] The rite having ended, the child is delivered to its mother and can now be named.

Activities

1. The divine star in Nut's belly is linked to the star that led the magi to find the holy child. It was/is the promise of our spiritual inheritance. Connect with that star. Know that your life journey toward it is your spiritual destiny. Draw the star at the top of a page, color it, embellish it, see its marvelous simplicity and infinite variety. Beneath, around, or outpouring from this star, name the particularities of your life that represent its abundance and its promise.

2. Imagine yourself in a moment in time, observing the stars from your backyard. Note the constellation of people, plays, and daily events around you. As you write, allow yourself to witness your own miraculous birth, then the birth of the world, then of the universe. Keep moving into the creative heart of the divine until you witness the seed self that will become you. Now from a cosmic perspective, witness again the miracle of your own life.

3. If a lack of time stands in the way of your creativity, you must, like Isis, learn to stop the boat of time. Stopping time will help you attend to the vital life that seems to be slipping away. Keep a one-week log of your daily doings and how you feel about them. Observe your choices, what motivates your choices, and how your body responds to each choice. Learn to do more of what you love and less of what you don't. If you feel bored seven out of eight hours, maybe it's time for a change. It's your life. You can choose your experience of it.

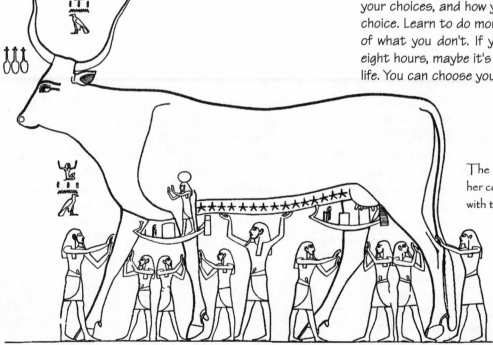

The neters uplift Nut the sky in her cow form. Her belly is strewn with the stars of the Milky Way.

Isis Returns from Phoenicia with Osiris

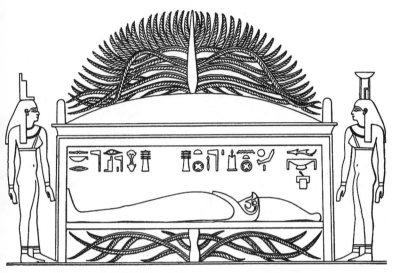

Isis and Nephthys watch over Osiris inside his coffin ensnared in the sacred tree.

Appropriate for Days that Celebrate

- Mourning and Loss
- Acquiring Wisdom
- Reunion/Return
- Finding Lost Things
- Setting Up an Altar
- Centering
- Patience as a Virtue

This smaller festival of Isis is part of the larger Osirian Mystery cycle that occurs all year long to commemorate the death of Osiris and his eventual resurrection. (See The Lamentations, Hethara 17; The Osirian Mysteries, Koiak 27; and Raising the Djed Pillar, Mechir 6.) This day celebrates that segment of the myth wherein Isis has traveled to Byblos and discovered the body of Osiris ensnared first in the tree, and second in the palace pillar. Having acquired the remains of her husband, she sets sail from Byblos to bring his body home.

The myth clearly states that when the coffin of Osiris was washed ashore in Byblos, it touched the sacred tamarisk tree, and the tree shot up to an enormous height, enclosing the god in its trunk. This magical sprouting corresponds with the mystical idea of the Tree of Life as representative of the Tree of Knowledge—that is, that life on earth mirrors life in the cosmos. Says Madame Blavatsky of this tree: ". . . in the beginning, its roots were generated in Heaven, and grew out of the Rootless Root of all being. Its trunk grew and developed, crossing the planes of Plerōma, it shot out crossways its luxuriant branches, first on the plane of hardly differentiated matter, and then downward till they touched the terrestrial plane. Thus [the Tree of Life and Being] is said . . . to grow with its roots above and its branches below."[49]

The mystery of the god within the tree trunk that supports the king's palace contains a revelation of tremendous psychological, physiological, and spiritual richness. In nearly all world religions, the tree is the *axis mundi*, the world tree, or center of reality. In Norse mythology, the tree is called Yggdrasil, and it sends its roots deep into the underworld. In Genesis, the Tree of Knowledge is the tree which tempts Eve to bite the apple and thus attain an understanding of good and evil, or life and mortality. This was the central understanding of the essential Egyptian Mysteries of Osiris. Isis and Osiris are caught between the powers of life and death. The god dies; the goddess resurrects and rebirths.

In Christianity, this same tree becomes the cross of human mortality and sin upon which Jesus hangs in order to die to the temporal flesh and become eternal and resurrected in light. In Buddhism, the Bodhi-tree is that under which the Buddha meditates on "nothingness," the understanding of which precedes his enlightenment wherein he can be in the world, but not of it. Thus, the tree of the sacrificed dying god becomes the site from which new life arises. In the Western world, the God/man hangs on the tree in an ecstasy of agony. In the Eastern world, the God/man sits under his tree in an agony of ecstasy, a state of magical union between the human and the Divine. In Kabbalistic thought, the tree is all of life's

possibilities and correspondences: its consistence, growth, proliferation, and generative and regenerative processes.[50] Osiris is the central pillar of both the Eastern and Western experience of the Divine, for his is the transcendence of agony and ecstasy within the tree. His coffin drifting down the waters of life to become embedded in the tree is the final process of incarnation in a physical, terrestrial body. The tree is the vehicle through which the fullness of humanity becomes possible.

For Osiris to enter the tree, and for Isis to find and bring it back to Egypt, means that the duality of life and death have finally been understood. Osiris understands it through death; Isis understands it through grief. But in the end, both are given new life. And it is Isis who, understanding this message, brings it back to her people.

This festival's appearance in the Sowing season may allude to the fact that the living flood waters of the Nile, imagined as the body of Osiris, have reached far into the fields, all the way from Southern Egypt to the Northern Delta, and now passed out of Egypt, emptying into the Mediterranean Sea. As the embodiment of the floodwater itself, Osiris too has passed through and out of the land of Egypt, and so has his mythology.

The flood has now reached the shores of foreign lands and touched and enriched the lives of many. Those who were strangers to the power of the Egyptian Mysteries are strangers to its truths no more. It was said that Queen Astarte of Byblos was given the sacred wood of the tree when Isis pried him from his coffin before taking him home. Astarte, it was said, built around this wood a temple shrine dedicated to the god Osiris. In the form of the King and Queen of Byblos, the whole constellation of the Mediterranean community—the Phoenicians, the Myceneans, the Greeks, and the Asiatics—witnessed the stability of Osiris and the magical healing power of Isis. They attained a glimmer of the mysteries and knew that the god and goddess are alive and dwelling in Egypt.

In this Sowing season, Isis returning from Phoenicia with the body of Osiris provides a myth of a second coming of

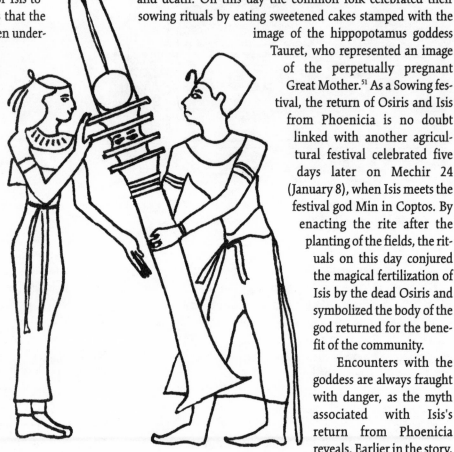

Pharaoh Seti offers the djed pillar of Osiris to Isis.

the god. Whereas once he appeared as the flood, now after the rites he will appear as the growing wheat. He will be seen in the greening fields as the plants that shoot forth in abundance. In the same way that the tree once sprouted around his body, now the seed of his body will send forth wheat and barley and spelt. The scattering of Osiris's body parts and of the seed generates a second growth.

The return of Osiris to Egypt represents his triumph over the limitations and restrictions of Seth, the god of sterility and death. On this day the common folk celebrated their sowing rituals by eating sweetened cakes stamped with the image of the hippopotamus goddess Tauret, who represented an image of the perpetually pregnant Great Mother.[51] As a Sowing festival, the return of Osiris and Isis from Phoenicia is no doubt linked with another agricultural festival celebrated five days later on Mechir 24 (January 8), when Isis meets the festival god Min in Coptos. By enacting the rite after the planting of the fields, the rituals on this day conjured the magical fertilization of Isis by the dead Osiris and symbolized the body of the god returned for the benefit of the community.

Encounters with the goddess are always fraught with danger, as the myth associated with Isis's return from Phoenicia reveals. Earlier in the story, we learned that while she was engaged as a nursemaid in the palace of the Queen of Byblos, Isis began to work a little magic on the Queen's son, a child whom she tried to make immortal by placing him into the fire at night and burning off his mortal flesh. In one version of the myth, the children became so attached to Isis that when she decided to return to Egypt with the body of Osiris, one of the boys, Pelusius, insisted on going with her:

As they sailed toward Egypt, Isis opened the chest containing the body of Osiris and fell weeping over it, embracing her hus-

band's corpse and lamenting. The curious child crept up on her quietly to watch, but then the goddess wheeled about, giving him a look so fierce that he was terrified and immediately died of fright. Another account said that he stumbled backwards in the boat, fell into the water, and drowned. The goddess, feeling sorry for his death, then and there built a temple to him and named the great city which grew up around it after the boy, who was called Palestine.[52]

This particular version of the myth lends a type of Gorgon-like energy to Isis. It is one thing to view the goddess through the mask she most often presents to her human children, the mask of Mother, Nurturer, and Lover. It is quite another to catch a glimpse beyond her veil and witness the true raw electrical energy of her power—the power of giving and of taking life, the power of creating and of destroying. In this case, Isis had not been approached with respect and honor, but with a kind of invasive innocence. Because the child did not know with whom he dealt, he suffered a terrible fate.

Other versions of the tale say that the boy did not die but returned eventually to Byblos, where he became a legendary hero in his land—a king made half-divine by his encounter with the dual loving and fierce faces of the goddess.

Activities

1. Draw an image of a tree and overlay it with the sephiroth of the Tree of Life. Or simply imagine a triangle in the crown of the tree, and draw three circles at each corner. Then imagine a downward pointing triangle in the middle branches of the tree, and draw three circles at the corners; the middle circle will appear on the trunk. Now draw another downward pointing triangle in the lower branches with circles, the lowest one of which is also on the trunk. Now draw one more at the base or root of the tree. In the root circle, list the daily circumstances of your life. In the lower trunk circle, record a dream. In the left-hand, lowest branch, write the shadow, the unlived life. In the right-hand, lowest branch, write the sacred acts of living. In the upper middle trunk, write the desires of the heart. In the left-hand, middle branch, write your limitations and obligations. In the right-hand, middle branch, write your expansive, creative self. In the left-hand, upper branch, write about your ability to transform and manifest. In the right-hand upper branch, write about what your spiritual journey requires. In the crown of the tree, write a letter from your higher self addressed to you that speaks to your goal. Hang this tree where you can see it to remind you of your own Tree of Life. Work with whatever seems difficult. Work with the tree until you are ready to create a new one.

2. Imagine that the wrathful deity, the frightful face of Isis, is one who shakes you out of your narrow, constricted ego world. Draw a Medusa face and hang it on a mirror. Attach sticky notes that remind you of the pettiness you want to exorcise: jealousy, envy, worry over money. As new problems appear, tack them to the mirror, and continue to work on them until you have opened yourself to the message of your true bliss. When you've truly tackled the problem, rip it off the mirror, tear it to shreds, and thank the Medusa for her truth.

3. One at a time, begin to gather a spiritual community, a group of people with whom you can share your intimate, newly acquired spiritual insights. Invite them in for coffee or tea, perhaps once a month, as a means of extending your understanding of spirit to other shores. If your community is scattered, try writing a letter to a friend once a month, exploring your insights almost as if you were exploring them in your journal, deeply, heartfully, and with great thanksgiving. You may find your friend will respond in kind and that you will have acquired a companion for the journey.

THE VOYAGE OF HATHOR
TO SEE HER SEVEN SISTERS

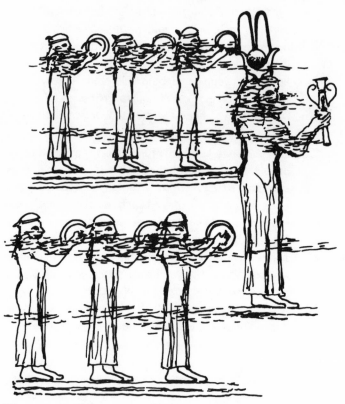

The portrait of the queen and her musician priestesses, representing Hathor and her sisters, was effaced by ancient religious zealots.

Appropriate for Days that Celebrate

- Sisterhood
- Divination
- Traveling
- Fertility and the Creative Arts
- Baby Showers and Gifting
- Goddess Mothering
- The Rise of the Pleiades

A third voyage of Hathor follows on the heels of the other two voyages lasting for the week (ten days) between Mechir 21 and 30. This time Hathor sails north from her temple in Dendera to the temple of the goddess at Beni Hassan to see the Seven Hathors.[53] The Seven Hathors were said to be the goddesses of fate and destiny who appear after the birth of the holy child. They functioned rather like fairy godmothers, blowing gently their breath of life into the child's face and bestowing upon the babe its true human destiny, foretelling the future and even the moment of death. Sometimes they appeared as seven cow goddesses who suckle the holy child. Sometimes they appeared as danc-

ing maidens whose music and belly dances assisted the mother in childbirth.

Each goddess had her own secret name by which she might be summoned: Lady of the Universe, Sky Storm, She from the Land of Silence, She from the Land of Khem (Egypt), She with Red Hair, She with Bright Hair, She Whose Name Flourishes through Skillfulness.[54] Like their older sister Hathor, these gentle, beautiful maidens could be appealed to by women in love in order to perform a love spell. Protective and powerful of magic, it was said that the red hair ribbons of the Seven Hathors could bind dangerous spirits and keep one from harm.[55] On many occasions the red

sashes imitating the girdles of these seven goddesses were worn by Hathor's priestesses.

On the walls of goddess temples or within the tombs, the Seven Hathors often appeared as singers, dancers, and priestesses assuming human form. In the Old Kingdom, mastaba tomb images of Hathor and her sisters were not uncommon. Carved on the walls of the tomb of Qar and Idut, a nobleman and his wife, one finds the seven goddesses making merry for the couple. Four goddesses dance the dance of life, while the other three measure time by clapping. The inscriptions reads: "Hail to you in life, Hathor, the places of your ka are propitiated that you should grow in what the goddesses desire."[56] Even in Ptolemaic times, the Seven Hathors retained their popularity as an image of the good life. On the sarcophagus of a nobleman named Unnefer appears a description of the Seven Hathors who richly blessed Unnefer's life: "Singers and maidens gathered together, making acclaim like that of Meret [goddess of music]. Braided, beauteous, tressed, high-bosomed, priestesses richly adorned, anointed with myrrh, perfumed with lotus, their heads garlanded with wreaths, all together drunk with wine and fragrant with the plants of Punt (myrrh), they danced in beauty, doing my heart's wish, their rewards were on their limbs."[57]

Not much is known about this long-standing festival of the people mentioned in the Dendera Calendar. In this season equated with Egypt's spring, the priestesses of Hathor went abroad, dressed in colorful gowns, beautiful jewels, and garlands of flowers. The rites they performed during this public festival would be the equivalent of what we might call Committing Acts of Random, Senseless Beauty. Wandering through town, singing and dancing, the priestesses occasionally stopped in the street or at the communal well, or knocked upon a door to single out a particular person to receive blessings from the goddesses. This transmission of divine grace was bestowed by a simple touch of the hand or lips with some emblem of the goddess, perhaps the sistrum or menat, perhaps a papyrus flower or lotus.[58]

Like the three wise men who journeyed from afar to bequeath the destiny of the infant Jesus with their gifts of gold, frankincense and myrrh, these goddesses likewise traveled from Dendera throughout Egypt to bless all mothers and their children. It may be the memory of this Voyage of Hathor to See Her Seven Sisters and the associated idea of bestowing gifts and blessings that is connected to the Christian celebration of Little Christmas on January 7.

As beautiful and loving as the Seven Hathors could be in this lifetime, as goddesses of fate, they also possessed fierce aspects. The heinous fate that befell Osiris at the hands of his brother might well happen to a mortal being. In the underworld, the dead had to know the sacred names of the Seven Hathors and pass their tests before entering into eternal life. Upon meeting the goddesses in the underworld, the soul of the deceased cried out:

> Hail, ye seven beings who make decrees, who support Ma'at on the night of judgement of the *uatchat* [wadjet], who cut off heads, who hack necks to pieces, who take possession of hearts by violence and rend the places where hearts are fixed, who make slaughterings in the Lake of Fire, I know you. I know your names.[59]

Seven was a powerful number in woman magic throughout the ancient and classical world. In Arabia the Seven Imams or Seven Sages were also thought to be seven mothers who make decrees. The Seven Krittikas of preVedic India were called the Razors of the World, who possessed the power to judge men and cut them down with moon-shaped sickles. In Greece at temples dedicated to Artemis and Athena, Seven Caryatid stood as the columns of the temples, much like the columns of Hathor that support Egyptian temples. These Caryatid were moon priestesses—the seven high priestesses who were the pillars of wisdom, called the Seven Mothers. In Greek mythology, the Seven Sisters of the Pleiades were a flock of doves born to Aphrodite, a Greek goddess equivalent to Hathor. In Old Babylon, the new year originally began with the rising sign of Pleiades, rather than the later, more traditional sign of the Ram.[60]

In Egyptian mysticism, seven was the number of creative process and progression. We note that there are seven sacred vowels in the ancient language, seven chakras or wheels of light in the etheric body, and seven notes in the musical scale. Likewise, there were seven veils that robed the goddess in light. In the language of architecture, the Egyptian pyramid had three angles and four faces, which equaled seven; that is, the number seven related to the energy of creative motion (three, or heaven) combined with stability (four, or earth).[61] The festival also occurred during a time of year when the Pleiades, the constellation that represented the Seven Hathors, was prominent in the eastern evening sky.

As an image of the union of spirit and matter, the goddess Seshat, the recording angel or scribe, appeared as an aspect of Hathor. A companion of Thoth, god of wisdom, Seshat inscribed one's life deeds in the akashic records; she was often depicted making notches in a palm frond with her stylus to record the years of one's life or writing in letters of gold on the leaves from the Tree of Life. Upon her head she wore a seven-petaled flower, protected by the inverted cow horns of Hathor.

The Egyptians assigned to Hathor and her seven sisters the art of divination and wisdom transmission, the magical mirror of Hathor being but one way to contact the spirit dimension. The Incans bear similar kinds of legend, as do the Greeks. The wise Egyptian always sought the truth and relied upon the knowledge that truth is often more than one thing.

Using Hathor's Magic Mirror

The British Museum of London houses a fine example of the magical mirror. Typically, Hathor's mirrors were made of bronze, and the handle of the mirror was shaped with Hathor's full form or with just her face at the top. The mirror itself was the image of Hathor's diadem, a lunar disk surrounded by crescents. Thus, the magic mirror and Hathor's energies were linked with the moon. The highly polished and reflective side was used for the age-old art of self-contemplation known as scrying (see below), while the other scoured or dented side collected negative energies and rebounded or dispersed them. The polished side aided one in viewing distant events, as well as gazing into the past and future. The scoured side became the means of dispelling inharmonious energy.

Invocation to Hathor

Sweet Hathor, queen of beauty, protector of the weak, shield us against the enemies of light. Adorn us in the raiment of truth and nourish and support us when our strength fails. Guide us in the interpretation of the heavenly signs and assist us in the daily routine of our earthly lives.[62]

Hathor's Mirror for Self-Contemplation

Scrying is an ancient form of meditation that involves learning to still conscious thought and to focus one's subconscious mind on the mirror. One learns to sit quietly, focusing on the breath, the eyes slightly out of focus. To scry into a mirror, try gazing beyond or peering in through the object, as opposed to looking at the reflection. If you cannot get beyond the surface image, focus your vision at a point between the two eyes. Begin by invoking Hathor, then simply breathe awhile into the mirror, imagining your life's breath carrying the record of your spirit outward into visible manifestation. Repeat your own name while holding your focus. It

may take awhile to get the hang of scrying, of learning to see true, but keep practicing. Keep a pencil and paper handy, for when the meditation is finished and you find yourself back in focus gazing into your own face, you'll want to jot down whatever fleeting thoughts or images have occurred to you. These will form a record to which you can refer later to determine the accuracy of your visioning.

Hathor's Mirror for Self-Protection

The great talent of Hathor's mirror is its ability to deflect negative vibrations. In any dream or altered state, it is important not to look into the eyes of one whom you suspect is sending you bad energy. Once you know the problem—the negative energy may manifest as recurrent computer malfunctions, or cars constantly pulling out in front of you—then visualize the situation and write the problem on a piece of clean white paper. Gazing into the polished side of the mirror, hold the paper with the written problem to the other side. Invoke Hathor as your protection. Raise the mirror as you gaze into it, holding it almost as a shield. State firmly that you send the unkind thoughts and energy back to their origin, then respectfully ask Hathor to be the messenger. End with a ritual blessing, perhaps burning the image of the negative energy in a brazier and making an offering of thanks. Since the mirror's job is to force one to look truly at herself and her reflection, placing the mirror in your windows will keep intruders from your home, as well as other forms of psychic invasion, such as spirit manifestations.

Seeing Afar

Again, invoking Hathor and entering a tranquil meditative state, gaze into the mirror, focusing beyond it and allowing your mind to go blank. Do not attempt to force any image to appear. Simply let the magic work. The image may cloud over as energy gathers in the mirror. Some people see the vision directly inside the mirror; others close their eyes and see with the third eye. When the mirror clouds over a second time, the energy is dispersing. Cover the mirror with a dark cloth and thank Hathor for your vision.

ISIS GREETS MIN IN COPTOS

The Isis and Min festival may have represented a first harvest.

Appropriate for Days that Celebrate

- Fertility
- Creativity
- Planting
- Abundance
- Contemplating Karma

This festival of Isis greeting Min resembles the earlier festival of Isis returning to Egypt with the body of Osiris on Mechir 19 (January 3). When Isis carries the body of her husband home, she hides him in a hillside grotto outside the city of Abydos. The story of her meeting with the fertility god Min in nearby Coptos refers to the secret rites she performs in the cave that cause Osiris's phallus to stir and rise to life. In this case, Osiris and Min have become mythically linked. Both gods wear the tightly bound mummy linens, combining the energies of Osiris, lord of the dead, with the energies of Min, the god of fertility, promoting the concept of resurrection from the grave.

We must not forget that the union of Isis and Min is a celebration of the body of Osiris. Osiris has become the deified, sensual body oriented toward earthly experience. For too many, this world is disdained because it focuses on experience that is far removed from the spiritual realm. Yet this feasting, boating, dancing, hiking, working fields, making-love-and-smelling-flowers aspect of the world reflects the pleasure of all life forms and forces. Through it we come to know the spirit in a tactile way, a method far more excellent than the rude guesses of spiritual wisdom made by the mind alone.

Little is known of this festival, other than a historical reference to it. Its rituals must have been very similar to those enacted during the Hathor and Min festival that precedes it on Paopi 5 (August 22) during the month of Inundation. Obviously, this Sowing festival is one in which Isis and Osiris reenact the older festival of Hathor and her consort. Whereas the first Min festival with Hathor during Inundation symbolizes potentiality, this second festival with Isis in the Sowing Season may symbolize actuality. In the earlier festi-

val, the statue of Min is paraded out of the temple in a ritual designed to fertilize the fields. In this later festival, he comes forth to reap what he sows. The Isis and Min festival may even have represented a first harvest, probably of lettuce—one of the fastest growing crops and considered by the ancient Egyptians, not only a sign of fertility and abundance, but also an aphrodisiac.

Isis was a goddess of agriculture as well as of motherhood. Her magic is both mystical and practical, knowledgeable in the proper sequence of events that call forth what she desires. She knows that there is a time for everything under heaven—a time to be born and to die, a time to gather together and to disperse. Essential in performing her magic, however, is understanding the nature of the elements. In that way the true magician uses the natural cyclical flow, rather than attempting to constantly row upstream in a hurricane.

One ancient myth uses agricultural themes to relate how Isis taught Horus about karma. To explain the nature of good and evil, she used the metaphor of corn (related to Osiris) and pigs (related to Seth). The story circulated for years under the guise of an alchemical legend recounted in the Arabic tradition. Quite likely its origin is indeed Egyptian:

Standing atop a sandy plateau with her young child Horus, Isis extended her arm across the fertile plain below them, indicating the greening fields, the animals in their pens, the thatch houses of the farmers, the canals flowing with water. She asked Horus, "What do you see?" He said he saw pigs and corn. When Isis asked where they came from, Horus replied that he did not know.

His mother smiled, draping her arm around his shoulder. This was her son's first lesson, the lesson that would set him on the

path of becoming a spiritual warrior. From this day forward, he would learn the charm of making, the art of discrimination, and the wisdom of making wise choices based upon an understanding of karma.

"It is very simple, Horus. So simple that you will forget it many times before you discover that you have actually learned your lesson. This is the secret of the world," she explained. "Always remember: from pigs, you get pigs. From corn, you get corn. It never comes about the other way around." Then, with a kiss of blessing, the goddess sealed upon her young son's forehead the knowledge of the difference between good and evil.

Min, the god of fertility.

Activities

1. Contemplate a mystery—something that is secret in some way: the process of decay, the birth of a child, the splitting of an atom. . . . Write about it from a scientific perspective. Find the universal laws and truths behind this mystery—that opposites attract, that the empty will fill, etc. Take each lesson as it comes and apply it in reference to events you are experiencing in your own life.

2. Number a few pages from 0 to your present age, leaving blank spaces. Think over the major turning points of your life. Record the events for those years. Note whether the events you listed dealt with recurrent issues: loss, betrayal, movement, balance, love, friendship, building, sacrifice. . . . Begin to weave a pattern and see your life as if it were a story composed by someone else. What accidental events turned out to be part of the plot? What has been the deeper story?

3. At the center of a page, write something you might do—move, quit a job, or remarry. Extend a thought chain from that idea sketching out a possible scenario, detailing actions taken and probable outcomes.

Then sketch alternate scenarios. Create a chain of actions, reactions, and alternate choices. Pick one or two that seem highly charged; then write a two-page journal entry of the daily life they would involve as if you were living it—waking in that city, going to that job, or cooking dinner for that person. Don't fudge as you write. Take the good with the bad. If no choice feels right, don't make the decision. If one feels absolutely true, then your imagining will bring it about.

THE BRILLIANT FESTIVAL
OF THE LIGHTS OF NEITH

Appropriate for Days that Celebrate

- Community
- Wisdom
- Self-Confidence
- Creativity
- Divination
- Mothers and Daughters
- The Winter Solstice

One night each year as evening approached, Egypt's people crowded into the delta town of Sais, to attend The Festival of the Lights of Neith. They carried with them a small vase of oil, salt, and wick. As evening fell, these lamps were floated out in sturdy little papyrus boats along the sacred lake at the shared temple of Neith and Isis and down the Nile River. Nothing remains now of the sacred lake, or of the walls and the temple that once stood on a high plain near the town of Sa el-Hagar.[63]

Again the Osirian Mysteries were performed, as they were during The Feast of Isis the Black Cow held at winter solstice, but they were so occult that Herodotus—the Greek historian who witnessed the festival—can't tell us much about them. Said he coyly, "For what end this night is held solemn by lighting of lamps, a certain mystical and religious reason is yielded which we must keep secret."[64] The temple rituals honored Neith as the mother of the universe, and Osiris, her son, as the resurrect-

Mother of the world, Neith wears upon her head the shuttlecock, emblematic of how she wove the web of the world.

ed god. During sunset the lamp wicks were lit and allowed to burn all night long. The sacred lamp signified the first Light of Spirit shining in the darkness, reminding the celebrant of how the soul's light shines after death.

The temple that Neith and Isis shared as mother and daughter was, in Graeco-Roman times, the same temple that was dedicated to Athena and Minerva. The sumptuous columns that graced the festival hall were of polished granite carved in the shape of palm trees, papyrus, lotus, and such manner of green growing things that called to mind the florid abundance of the first day of creation. Between two tall stone obelisks lay the sanctuary which enshrined the coffin of Osiris. Beneath the chapel lay a subterranean chamber that Herodotus describes as an enormous, "curiously carved," and exquisitely decorated "dungeon." In this chamber, he said, each man encounters "the shadows of his own affections and phantasies in the night season, which the Egyptians call Mysteries."[65]

At times Neith appeared as a serpent. Like the ouroboric snake that bites its tail, she represented the end and renewed beginning of life. Called Ua Zit, or Wadjet, she was the All. The serpent power gave her priests and priestesses the magical knowledge of the mortuary rites, the blood mysteries, and healing powers. She was "wise as serpents," and even Thoth, the god to whom all other divine beings turned when in need, checked his knowledge with Neith, leaving certain decisions to her because she was the oldest and wisest. Because of her snake association, the Greeks also equated

Neith with the quick-tempered Medusa and the wily Athena.[66]

The feminine mysteries of Neith and Isis celebrated the conundrum of the fecundating power of death, the mystery of reincarnation, and the rebirth of the individual as the emergence of creative light in the midst of darkest chaos. Neith was mother to the crocodile god of the underworld, Sobek, a creature noble and fierce sprung from the primordial waters of chaos. Isis was, of course, mother to Horus, the Light of the World. The two gods were linked, not simply by mythology, but even in their temple worship, especially in the Temple of Kom Ombo, where the right hand path to the sanctuary honored Horus and the left hand path honored Sobek. At Kom Ombo, the bride of both gods became Hathor. The Pyramid Text of Unas, Egypt's oldest religious text, indicates the tradition of mutually honoring both sons of Isis and Neith—the Light and the Darkness:

> Behold! Today Unas comes from out of the great
> waters,
> From the belly of the Female Crocodile,
> From the primordial deep, from the river in
> heaven above.
> He comes forth from Neith in a great flood of
> celestial waters.
> Unas is Sobek. His green plume on his forehead,
> His shape the shape of watchful witness.
> His chest uplifted, his breast fierce and strong.
> He rushes forth from between the legs and from
> beneath the tail of the Great Goddess,
> The one who resides in the splendor of Light
> The Radiant One herself.
>
> Behold Unas comes in the Boat of Time
> Through the watery canal from the Domain of
> Love.
> He sails from the divine celestial ocean.
> He comes from the waters of the Great Cow
> The Great One herself, the goddess Isis.
> He comes in peace and joy to this new, green
> pasture
> Which lies on the horizon in the Land of Light.[67]

The most ancient goddess, Neith appeared in Lower Egypt well before the first pharaoh united the kingdom. Her true name, *Nt*, meant simply, "the Goddess," but she had many names: Great She, Female Opener of the Way, Lady of Heaven, and the Female Sun. Sometimes she was simply called the Being or the One.

Her myths describe how before anything existed in heaven or on earth, Neith strung her loom across the expanse of nothingness and took up her shuttle. First, she wove the heavens in black cloth; then came the slender white threads of the Milky Way; then followed the white knots that became the stars. This was the body of herself, the celestial waters. Next, she wove great nets and cast them down into the deep primordial waters that were the innermost depths of her own being. Reaching into the deep, she fished up trees and grass, rocks and clouds, men and women, and all living creatures—frogs, fish, lions, gazelles, serpents, and fowl.[68]

Self-generated, mother of all the gods and goddesses, Neith as the primordial flood waters gave birth to Ra and to Sobek; as the embodiment of heaven, Nut, she gave birth to Osiris, Isis, Horus, Seth, and Nephthys. In essence, she was the Great Mother of Lower Egypt, as Hathor was the Great Mother of Upper Egypt; and early on during the Old Kingdom, the priestesses of Hathor likewise served Neith.[69] Being the embodiment of the divine power beyond the veil which no mortal could ever see face to face, she was "all that has been, all that is, and all that will be." The phrase had such a powerful ring to it that later Christian priests decided to borrow the language and apply it to their God.

As she created life within her magical nets, so did she take up the departed souls and receive them into her body. Old Kingdom tombs depicted her in the abstract patterns of the inscribed weavings that decorated the walls surrounding the pharaoh's sarcophagus. This image of the cloth of death was a sign of the goddess enfolding the soul of the dead, and the overhead stars painted on the tomb ceilings were likewise an image of Neith, or Nut, as the Milky Way receiving the spirit of the dead. Said one ancient Egyptian hymn to Neith,

> Hail Great Goddess who lives in the underworld
> twice hidden! Oh thou Unknown One! Hail, thou
> Divine Great One, whose veil has not been loos-
> ened. Oh, unloose thy veil for me. Hail, Hidden
> One, no man knows the way of entrance to Her.
> Come then, receive the soul of Osiris. Protect it
> within thy two hands.[70]

That protective gesture of a mother's love was perhaps best depicted in the outstretched arms of the golden statues of Neith, Serket, Isis, and Nephthys found about the golden shrine that held Tutankhamun's coffin.

From prehistory onward, Neith was the Great One in the city of Anu, or the City of Light known by the Greeks as Heliopolis. Her burning lights during this sacred festival represented an earthly image of her heavenly body. We have said that Neith was also Nut, the sky goddess who was the Milky Way; and that the Milky Way was the river of light that divided the heavens into eastern and western hemispheres, just as

the Nile divided Egypt into eastern and western banks. The floating of the thousand lights of Neith on the Nile waters mirrored the image of Nut's body as the Milky Way above. On this night, the thousand souls glittered above and below as the lights of Neith reigned in heaven and on earth.

So important was this festival that those who could not travel to Sais were required, wherever they were, to burn a lamp for Neith. Lamps, torches, and tapers were set in every corner of the house, burning until dawn. By this ritual that included every Egyptian—rich or poor, noble or peasant—the goddess collected all the shining lights of her beloved children and gathered their energy into her own starlit body. None ever born was left untouched by her love and might. The image of Nt (Nut or Neith) provides the earliest divine totem, the crossed arrows and animal skin, that signified the presence of the divine Feminine. Wherever she appeared on the standard pole stuck into the ground outside her holy tent, her people were called to worship. Feminist scholar Patricia Monaghan calls her "the essence of the tribal community."[71]

Making Prayer Flags

The earliest hieroglyph of the Divine was the sign of the flag. Flying outside the temple, it announced that the neter—the god or goddess—resided within. These flags accompanied the king as a sign of protection and allegiance.

Make and display prayer flags outside your home for the feast days of the goddesses. Or display them in your windows with your prayers and intentions stitched on the cloth so that the sunlight illuminates your prayer. Or fly them from your car's antenna and confuse rabid sports fans.

I have a prayer-flag wind chime made from the ring of an old lamp shade. From the cross pieces of the lamp shade hang several glow-in-the-dark plastic stars that remind me of the goddess Nut. From the ring hang flags of the goddesses of the cardinal directions: Isis (east), Nephthys (west), Neith (north), and Serket (south). These four goddesses surrounded the sarcophagus of King Tutankhamun. East is the realm of possibility and potentiality; west is the direction of successful completion. North is the way of the wise woman who dwells with the neters and sees the fates; south is the realm of the past, of incarnation and life experience.

My prayer flags are stitched on old blue jeans—maybe because I couldn't afford fine linen,

and maybe because I liked the idea of my prayers to the goddess deriving from something that seemed as familiar and comfortable as my skin. From the bottom of each prayer flag I've hung a small brass Tibetan bell. When the wind blows, the bells and stars make the music of the spheres.

The goddesses' names are stitched in colored embroidery floss in hieroglyphs. Green for Isis, red for Nephthys. Blue violet for Neith, yellow for Serket. These complimentary colors signify the four elements to me: earth, fire, water, and air.

With each goddess, I have stitched images that I associate with her myths. Neith's flag has arrows and bows, winders for thread, stars, flowing water, the ouroborus, and the cobra. Starting only with their names, I added their emblems over time. When my prayer to Neith was to develop higher spiritual intuition, I added the stars to her cloth, thinking as I did of the astral bodies, of the five-pointed human shape of the star and of how it was the emblem of spirit and eternal guidance by wise celestial beings.

As the time comes to add new images, let the goddess direct you. You'll know what she wants and what your prayers signify. To give you a start, these are the hieroglyphs of the goddesses

Isis	Nephthys
Neith	Serket
Sekhmet	Bast
Hathor	Nut
Seshat	Mut
Heket	Tefnut

THE BLESSING OF THE FLEETS BY ISIS

Appropriate for Days that Celebrate
- A New Car
- Traveling
- Protection
- A Boating Party
- Mardi Gras

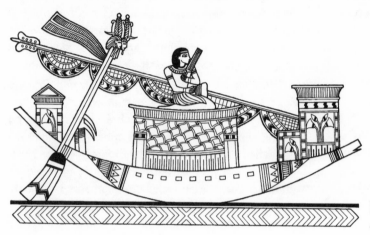

Boats carried both humans and gods in ancient Egypt.

The sailing of the gods and goddesses in ancient Egypt was a prominent theme from the dawn of their civilization. Boats were always the mode of transportation needed to connect cities on the eastern and western banks of the Nile, as well as cities north and south. The land of the dead as well as the image of heaven were also made in the image of Egypt, which means that to reach the Elysian Fields, or Field of Reeds as the Egyptians called it, the souls of the dead took their boats with them, or at least words of power to call the ferryman to row them ashore in the afterlife. In heaven, the gods and goddesses, too, had their boats of the morning, boats of the sun, and ferrymen of all the directions north, south, east, and west.

Isis was intimately linked with the boat in which she brought home the body of her husband from Byblos, as well as with the barge of the sun that she, manifesting as the sacred fish, towed for Ra in the neterworld. In one myth we find her encountering a ferryman much like Chiron in the underworld. Here's the story:

The Great Ennead in heaven was to hold a tribunal to determine whether to award Seth or Horus the ownership of Egypt. Seth insisted that Isis be excluded from the meeting because he feared her presence there might influence the decision of the gods in favor of Horus.

The meeting was to take place after dinner on the Island in

the Midst of the Celestial Waters. Seth, fearing the curse of Isis, warned the ferryman Nemty that he should not carry over "any woman who looks like Isis." While the gods were eating their bread and drinking beer in the Great Hall, Isis came to the shore and found Nemty sitting beside his boat. She had transformed herself into the image of a stooped old hag, dressed all in rags, but carrying a bowl of ground flour and wearing a small golden ring upon her finger. She asked Nemty to ferry her across to take the flour to the Great Hall in order to make bread for the gods.

Nemty answered, "Seth told me not to ferry any woman across."

Isis replied, "No, Seth told you not to ferry across any woman who looks like Isis. Do I look like Isis? I will give you one of these fine cakes if you take me there."

Nemty scoffed. "Do I look a fool? He said ferry no woman, and all I get for my trouble is a cake."

Then Isis offered him her golden ring and he took it, ferrying her across to the Island in the Midst.

Once there, while walking toward the gardens of the Great Hall, Isis transformed herself again, this time into a young, beautiful girl. Seeing this lovely woman coming and feeling quite safe and secure on the island, Seth went out into the garden to meet her. Finding her weeping, he asked what troubled her. She said she was the wife of a herdsman, to whom she had borne a son. But her husband had died, and a stranger had come to them, trying

to steal the cattle of the dead father.

"Is that right?" she begged Seth.

"It is not right," he said. "Stop weeping, dear woman. I will settle the matter in your favor. I shall be your defender and judge."

Then Isis transformed into a kite and flew up to the highest branch of the acacia tree. She called down to Seth, "Weep for yourself, Seth. You have judged yourself." When the god realized he had been tricked, he was furious, but the tribunal had witnessed the entire proceedings and seen that Isis indeed was right. They decided in favor of Horus, giving him the land of his father. To appease Seth, the tribunal gave him the right to accompany Ra in his boat sailing every day across the land. As for the lazy, money grasping ferryman, they chopped off his toes.[72]

In the Pyramid Text of Unas, the soul of the Fifth Dynasty pharaoh calls upon the ferrymen of the four directions, asking them to assist him in the same way they assisted Osiris—by laying down the four pure reed floats on which "he ascended towards heaven that he might cross toward the Cool [Region] while his son Horus was at his side."[73] On just such reed floats, perhaps the bodies of the dead were carried from the cities on the east bank to the necropolises located on the west. From the beginning of Egyptian history, the pharaoh was buried with the "boat of his father"—that is, the boat that carried Horus's father, the newly deceased Osiris, into the other realm.

In addition to the simple reed floats that might ferry one from bank to bank, the ancient Egyptians had larger river boats; curiously, they also possessed from an early date massive sailing ships designed for the high seas. Such boats would be highly unusual in a land located primarily between two deserts and sustained by only a single river, unless extensive trade and sailing were also part of this ancient culture.

Apparently, even high-seas travel was occurring well before the founding of Egypt. In the tombs of predynastic kings found within the ancient desert city of Nekhen in Upper Egypt, a number of exquisitely detailed illustrations of enormous sailing ships appear. In the 1970s a dozen large, high-prowed, seaworthy ships were discovered in Abydos buried in the sand near the Temple of Osiris, eight miles from the Nile River.[74] Their unusual high-curved prows were reminiscent of the lunar horns of Isis. These fifty- to sixty-foot-long ships were moored at enormous boulders placed at their prows to create the image of their having landed on the primordial high ground when the waters receded after the Great Flood. Five thousand years old and made of cedar, the ships were reburied in sand soon after their discovery, but their appearance there in the desert remains a mystery.

In another equally intriguing mystery, the historian Charles Hapgood came across a map drawn in 1513 which depicted the ice-free outlines of Antarctica. The map's notes indicated that this particular map had been redrawn based on the sailing maps of ancient Egypt, and that these older maps had been smuggled out of the Great Library of Alexandria by Roman soldiers before the library was burned. The question is: how could an ancient map give the precise outlines of Antarctica when the entire continent was covered in ice, and its true dimensions are only recently known now through the help of satellite mapping? Those ancient maps would have to have been drawn from a knowledge that precedes the Ice Age that ended around 10,000 B.C.E.![75]

These bits of information make all the more interesting the old myth that Osiris and Isis and their crew appeared on the shores of Egypt near Abydos in beautifully carved cedar boats. They arrived from the land of their birth, a mythical place called Punt, which scholars have variously placed as Arabia or Africa, or even distant lands south of Egypt. Certainly the Egyptian gods and goddesses are always sailing the celestial waters in their boats with great jubilation, returning home. Perhaps the pharaoh's boat was more than a symbol of the desire to sail toward one's homeland at death. Perhaps it also symbolized the ancestry of a man descended from sailors. The massive Lebanon cedar sailing ships of the Fourth Dynasty pharaohs buried near their pyramids are more than symbolic. On their oar locks, they show the wear and tear that actual long-distance voyages probably created.

I've always found the Egyptian preoccupation with boats for the dead fascinating. The Pyramid Texts mention two boats of Ra: the *maktet*, or "evening boat" and the *mát*, or "morning boat." Each is meticulously drawn to differ from the other boat. The morning boat carries a hieroglyph that depicts an instrument of war, perhaps a crook and knife. Traditionally, it sails always from dawn to noon, the implication being that the power of its light never wanes, the sun never sets, and the soul never dies. The evening boat carries an undetermined hieroglyph that early Egyptologist Alan Gardiner sees as a winder for thread (*ndj*). The hieroglyph is associated with words meaning "to counsel" or "to protect." It also contains the hieroglyph *heh*. In the hands of the gods, *heh* becomes equivalent with eternity, but it also means "to go around," or "to make a circuit," perhaps linked with the idea of the winder for thread.

Whereas the warrior energy of the morning boat was masculine, the evening boat was feminine. Many depictions of Isis towing the Boat of the Night can be found in illustrated copies of The Egyptian Book of the Dead. The symbols of thread and winding associated with the evening boat may

refer to the thread of life, an idea that the Greeks equated with their three spinners of Fate. The Moerae—Clotho, Lachesis, and Atropos—were triple aspects of the Great Goddess. The first goddess unwinds the thread of life; the second goddess weaves the cloth of destiny; and, at death, the third goddess cuts the thread. In Graeco-Roman times, these were also aspects of Isis as wife, mother, and widow. It is important to remember that the weaving of boat sails was a woman's occupation, and that traditional Egyptian offerings on this feast day were bolts of finely made new linen cloth.

Both Hathor and Isis are intimately connected with the sacred boat and travel by water. In Graeco-Roman times, Isis celebrated a feast called the Isis Pelagia which commemorated her traveling across the "Great Green"; that is, across the Mediterranean Sea to Greece and Italy. Because her people traded throughout the Near East, Africa, and afar, their travel led to Isis worship throughout the Mediterranean world. Wherever she landed, temples sprang up devoted to her. Called the Great Mother Goddess and She of the Innumerable Names, Isis assumed many of the qualities and traits of the previous older goddesses in her adopted countries.[76]

The festival related here, which is Greek in origin, is held in preparation of the season of sailing in the Mediterranean world. March 5 would probably initiate the first sailing and trading expeditions from the coastal cities, including Athens and Alexandria. It would be a time when the weather was warming, the nets were mended, and the boats repaired, ready to range upon the seas. It is likely that the Greek Pelagia was based on the Egyptian boating festivals devoted to Isis and Hathor, their original sailing days having coincided with the Nile's period of inundation. The Greek festival date may also have to do with the fact that there is an older Egyptian Middle Kingdom feast day that originally occurred on this day. Called the Repulse of the Troglodytes, it commemorated pharaoh Seostris III's chastising of the Nubian rebels.[77] Celebrated for a long time in Egypt, the feast was eventually abandoned. No doubt celebrating the time of Egypt's "repulsing foreign invaders" was not necessarily an event the self-proclaimed Greek pharaohs wanted the Egyptians under their rule to remember. Thus in Graeco-Roman days, the traditional offerings of linen to celebrate the "repulsion" became

the blessing of the sails of ships by the goddess Isis, a celebration of "inclusion" which counted Isis as the fair Mother Goddess of all the ancient world, probably an appropriate way to heal an old wound.

At any rate, in his book *Metamorphoses*, Apuleius has his character Lucius returning to human form, after having been changed into an ass (the emblem of Seth). His miracle occurs by the grace of the goddess Isis, who blesses and saves him from damnation and evil during her traditional ceremony of The Blessing of the Fleets. Thereafter, Lucius goes to the Temple of Isis and rents a room close to the the temple so that he can be close to his goddess and serve her to the end of his days.[78]

In all probability, it is the memory of this festival day—The Blessing of the Fleets—that brings to mind our idea of Carnival with its massive boats floating through the streets of the city of New Orleans. Mardi Gras in New Orleans even has traditional "Crewes" of Isis and Thoth whose occupants dress in outlandish costumes, tossing coins and necklaces to the people gathered in the streets. The activities are reminiscent of the Egyptian festival goer tossing his offerings of gold and jewelry into the Nile to increase abundance during the New Year's Festival. Much levity occurs on this traditional feast day that precedes Ash Wednesday. Although Fat Tuesday has become a party day for most contemporary society, it began as a religious festival, a time to acknowledge the gift and receipt of the blessings of prosperity before entering the forty-day restrictions that follow during the Christian Lenten season.

I once witnessed an actual Blessing of the Fleets in the month of April in the Mississippi delta town of Chalmette, outside New Orleans. The rites of the Roman Catholic priests were surely derived from the very similar blessings of Isis performed in Greece and Rome. As the priest and his attendants stood on the pier, local fishermen, shrimpers, and Sunday yacht owners slowly sailed their boats, decorated with flowers and ribbons, around the inlet under the gaze of the priest. As each boat passed by the pier where the priest stood reciting prayers, he sprinkled the deck of the boat with holy water, blessing boat, captain, and crew with the sign of the cross. The day ended with a traditional Cajun celebration of boiled crawfish and gumbo, flowing beer, and dancing long into the night.

Activities

1. Travel to a place you used to live over a decade ago, or to the site of a life-changing event. Sit in front of the house (place), contemplating the journey that brought you from then to now. Is the person you are now different than the person you thought you would become? How has the journey changed you? What part of your old life did you carry with you? What parts did you leave behind?

2. Travel to a place that is largely unfamiliar, but is a place of your ancestors—perhaps the home town of a relative. Walk around a bit and see the sights for the first time, then see them as if they were familiar and comforting. Visit some of the stores, the old home site. Eat in one of the restaurants. Talk to the people. Visit the grave yard and library. Discover what of this place resembles you. Write a detailed account of your journey and discoveries.

3. Sometimes we forget to honor the everyday. Here is one way to do so: Spend an entire day with a camera at your side. From the time you wake and every hour until you go to bed, snap a photo of wherever you are and what you're doing. Make double prints, then create a journal of your day, pasting each picture in order and trying to recall the exact thing you were doing, feeling, thinking. Write an ode or hymn of praise for each moment you have captured. If you've photographed friends, pass these out with a copy of your hymn of praise. You might even find yourself doing some things you wouldn't ordinarily do, just so you'll have some interesting pictures.

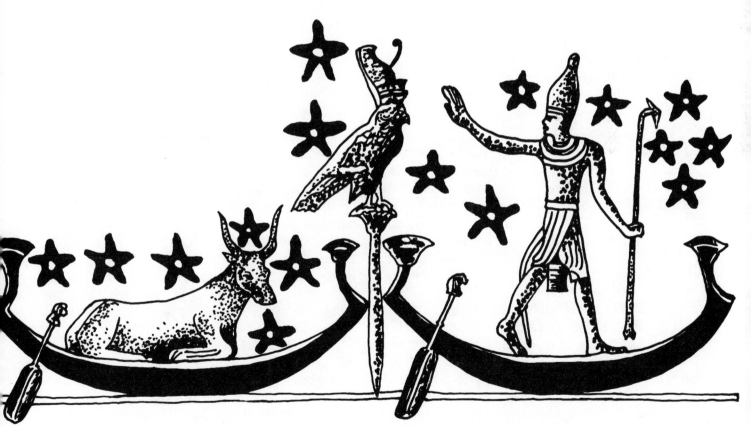

Isis and Osiris appear with Horus as constellations sailing through the night sky.

Isis Births Horus the Younger and Hathor Births Ihy

Hathor-Isis appears with her children Horus the Younger, right, and Ihy.

Appropriate for Days that Celebrate

- The Spring Equinox
- Motherhood
- Gardening and Planting
- Sisterhood
- Fertililty
- Initiating an Enterprise
- Family Celebrations
- Protection
- Coming of Age

After three thousand years of religious musings, the sky goddesses Nut, Isis, and Hathor, and the sun gods Ra and Horus, begin to share more and more of each other's qualities and epithets. Their similarities resulted in the festival calendar having two birthdays for the god Horus. One day Horus shared with Ra, the son of Nut, at winter solstice on Mechir 10. Horus the Younger, a son of Isis, shared his birthday with Ihy, a son of Hathor. Sometimes the child of Isis is called Harpocrates, another name for Horus, or sometimes the name denotes a second child of the goddess. The child of Hathor was called either Horus or Ihy. If the child were Ihy, then Horus is deemed the father. To explain the confusion it helps to remember that, like the Great Goddess and like many divine beings in religious traditions, Horus had a triple aspect: Horus the child; Horus the adult; and Horus the elder.[79]

Five hundred years before the First Dynasty, Horus the solar falcon appeared in Upper Egypt as the son of his sky mother. Her name was Hathor and her royal city was called Anut.[80] When Hathor merged with Nut, the sky goddess, another Lower Egyptian sun god, Ra, took on the qualities of Horus. His royal city was called Anu. Both *Anut* and *Anu* mean "City of Light," but Hathor's Anut was located in Dendera (Upper Egypt) and Ra's Anu was located in Heliopolis (Lower Egypt). By the Fifth Dynasty, the patriarchal god Ra had preempted Horus as the major solar deity. He assumed the power not only of Horus, but of the goddess Hathor as well. Hathor's primary domain was then relegated to the lesser orb, the moon. To completely understand Hathor, however, know that the Great She possesses both solar and lunar qualities.

When Nut and Hathor are merged, Hathor is mother of the elder Horus. When Horus is depicted as the son of Isis, Hathor becomes his wife. Horus, son of Isis and Osiris, was called twice-born. Conceived of Isis and Osiris once in the spirit while the god and goddess still lay in the womb of Nut, he was conceived a second time on earth in physical form when the magic of Isis called him forth. The child so divinely

born then becomes the heroic god Horus who battles evil in the form of Seth to avenge his father's death and save the kingdom.

Before he can become Horus the hero, he must first be Horus the child. As the story goes:

Seth intended to kill the pregnant Isis so that Osiris would have no heir and his land would thus fall to his remaining living brother. To escape Seth, Isis hurried away to bear her child in secret. With Nephthys, she went to the home of the cobra goddesses who dwelt in the Delta: Renenutet and Wadjet. Isis knew it was her child's destiny to combat Seth's destructive forces; but while Horus was yet small and vulnerable, she needed to suckle him, comfort him, hide him, and train him in her magic. In order for him to grow up incognito, as it were, Horus was raised by the cobra goddesses. Isis distracted attention from him by continuing her work throughout Egypt as its Queen Regent. As often as she could, she came and went from the papyrus swamp where her child was being protected and tended by his nursemaids.

The story of the divine child being raised in secret appears in several mystery traditions, including the flight of Mary and Joseph to save Jesus from Herod, the hiding of Arthur by Merlin and his fostering by an old couple, and the discovery of Moses in the bullrushes by the pharaoh's daughter. In each case, the young hero's power and identity are not revealed until he is mature enough to protect himself.

Horus, the child, may appear under one of three names: Harsomtus, Hareseis, or Harpocrates. The child of Hathor and Horus is Ihy. All children of the goddess wear a long, curling braid of hair pulled to one side of their heads. When the child attains puberty, the side lock is shorn. Egyptian peasant children still wear a similar style. Winifred Blackman, who traveled among the fellahin and observed their customs, noted that the mothers grew their children's hair in similar tufts, dedicated to either a Muslim sheikh or a Coptic saint, as a magical means of protection.[81]

Occasionally, the Horus child is called Hareseis, meaning "Horus of Isis." The Dendera festival calendar sets the date of the "Conception of Horus, son of Isis and Osiris," as Epiphi 4, making this the birthday of Horus, son of Isis.[82] Often Hareseis appears as the harpooner, spearing Seth in his disguise as either a hippopotamus or crocodile.[83] He is very similar to the god Harsomtus, or Horus the Uniter of the Lands, who appears in the early Pyramid Texts.

Harsomtus, divine child of the God and Goddess, manifested in the body of the pharaoh. Any time the pharaoh sat between his divine parents in statuary, he assumed the Harsomtus role. The name comes from the Egyptian word

haresemt, meaning the "Horus who pleases." At Edfu and Kom Ombo, Harsomtus (the pharaoh) appears as the son of Horus and Hathor. The Edfu birth house depicts rituals performed in honor of the divine triad: Horus, Hathor, and their child—variously Harsomtus and Ihy. Both children—Harsomtus and Ihy—wear the side lock of youth and touch their fingers to their lips. The reliefs also show the heroic son spearing a crocodile and/or a hippopotamus, emblems of the devouring aspects of Seth.

Frequently, Horus the Younger is called Harpocrates, from the Egyptian appellation *Har-pa-khered*, meaning "Horus the Child." Yet an infant, Harpocrates sits on the lap of his mother Isis with his head supported and cradled in her arm, waiting to be suckled. Sometimes he appears as the vulnerable, hungry child with his fingers stuck in his mouth. Blue faience amulets of this image, called "the cippi," were used to protect mother and child and to ward off dangerous creatures, such as snakes, scorpions, lions, and crocodiles. At other times, Harpocrates assumes his future destiny by appearing as a naked child riding on the back of a crocodile. Like Harsomtus, he can appear as the child of any divine couple—such as Horus and Hathor, or Montu and Raettawy—but most often he is the child of Isis and Osiris.

In one version of the myth, Isis has two children: the warrior god Horus begotten of Osiris through magical means, and Harpocrates, the weak son born with a limp begotten of the spirit of Osiris, who visited Isis in dream. Again, Harpocrates holds his finger to his lips, revealing his hunger. The Greek philosophers who visited Egypt's temples during the Ptolemaic era viewed this gesture as an indication of the need for quiet and secrecy. They believed he symbolized the silence that cloaked the Osirian and Eleusinian Mysteries.

Nearly every major Egyptian temple ground contained a side temple they called the House of Incarnation. This *mammisi*, or "birth house," celebrated the womb of the goddess Isis and the birth of the pharaoh as the embodiment of her divine child. In the Mammisi of Ptolemy VII at the Temple of Isis on the Island of Philae, one finds the sacred image of Isis suckling Horus. One could not enter the shrine without having been ritually cleansed by bathing in the Nile waters and fumigating oneself with incense. On one wall the pharaoh presents his offerings to Osiris and to Isis, who is nestled among the papyrus nursing Harpocrates in a scene that recalls later depictions of the Gifts of the Magi during the Christian era. In another illustration Horus, in hawk form, stands atop a clump of papyrus. The outer walls of the little chapel depict the emperors Tiberius and Augustus offering to the divine triad milk and incense, a golden collar, geese and

gazelles. Elsewhere, Isis is presented with beer, rattles, mirrors, breast plates, linen, necklaces, and eye paint.

In one dramatic portrayal by Tiberius, Isis is being offered the blood of the emperor's enemies.[84] This tasteless offering is typically Roman; the native Egyptian priests would never have offended the goddess by such an offering. They well knew how Isis had worked to civilize barbarians and to write laws putting an end to human sacrifice.

Finally, this day commemorates the birth of Ihy, child of Hathor and Horus, whose name means "jubilation." The old hieroglyphs dub this feast day The Festival of Jubilation. Ihy shares more traits with his mother than with his father. His name implies that he was fond of music, dance, and merrymaking. In portraits he appears as the sistrum player attending Hathor, sometimes holding the menat. In various places he is called "Lord of bread, in charge of beer."[85] In childlike pose, he stands naked, wearing the side lock of youth and sucking his finger.

At Dendera the three gods—Harsomtus, Harpocrates, and Ihy—are merged inside two birth houses. One, built during the Ptolemaic era, celebrates the birth of Ihy. The other, built during the Roman era, celebrates the birth of Harsomtus. At the Edfu birth house of Ptolemy IX, the younger Horuses are in complete confusion. Here, while priestesses dressed as the Seven Hathors dance and play their instruments, Hathor suckles her child called Horus, but behind her stands Ihy holding the sistrum. Meanwhile, in the same birth house, Khnum, the ram god with wavy horns, shapes the god Harsomtus and his ka on a potter's wheel.

The Birth of Horus has obvious solar implications (see Pachons 6, the Pregnancy of Nut), but it is the cycle of the lesser orb, or second son, to which our attention is drawn. In the temple Khnum shares with Neith and Satis at Esna, the priests declared that the Birth of Horus was accomplished on this "second lunar day of the month." Egyptologist Richard Parker believes the phrase indicates a spring new moon festival, for the same appellation is given with regard to Osiris who is reborn on the second lunar day of the month during his Osirian rites in the month of Koiak. Both Horus and his father appear in the sky as the first sliver of the new moon.[86] The lunar eye of the god—that is, the moon—was called the Left Eye of Horus. Related to shamanic practices, its powers included divination and descent into the underworld to commune with the gods and the ancestors. By appearing in his son's dreams, Osiris was said to have trained Horus as a warrior.

Being goddesses of the sky, Isis and Hathor exhibited a similar lunar power. The connection between women and the horned goddess dates as far back as 18,000 B.C.E. with the Venus of Lauscaux. With heavy thighs, hips, and breasts, she sat contemplating the cow horn in her right hand and touching her belly with her left. The notched horn symbolized the thirteen lunar months related to the menstrual cycle and to her initiation into motherhood at the onset of puberty (at around thirteen years of age).[87] Upon their heads Isis and Hathor wore the disk and crescent moons that spoke of their lunar qualities in the life-giving fluids of the Women's Mysteries: milk, blood, and Nile water. It is no accident that Hathor is the patron goddess of astrology, since the mantic art begins by observing the connection between the moon and the cycles of human life.

Because the new moon and the spring equinox coincide only once every twenty-eight years or so, this lunar festival celebrating the divine mothers Hathor and Isis and their children intentionally occurs as near to the equinox as possible, thus honoring the dual lunar and solar qualities of both goddess and divine child. Where Horus is twice-born within the space of little over a week, this first lunar festival celebrates the birth of Horus the child; the second solar festival celebrates the conception of the Horus the hero as Ra.

The following hymn from Gebelein shows how ancient is the worship of the sky mother and her child. In this hymn Isis, Hathor, Mut, Nut, and the cow goddess Mehurt have become intertwined as the Great Goddess who births her heroic son:

> My majesty precedes me as Ihy, the son of
> Hathor. . . .
> I slid forth from the outflow between her thighs
> in this my name of Jackal of Light.
> I broke forth from the egg. I oozed out of her
> essence.
> I escaped in her blood. I am the master of the
> redness.
> I am the Bull of the Confusion. My mother Isis
> generated me. . . .
> [This happened] before the disk had been fastened
> on the horns, before the face of the sistrum
> had been molded.
> The flood . . . raised me up while the waters gave
> me [life]. . . .
> I built a house [in Punt] there on the hillside
> where my mother resides beneath her
> sycamores.[88]

Planting Seeds, Planting Intentions

Seeds signify the beginning and the end of life, the essential Alpha and Omega, containing all the

potentiality of the future and all the wisdom garnered from the past. In ancient Egypt, seed was sacred to Isis and Osiris, who mutually devoted their powerful energies to teaching humankind the ways of agriculture, thereby assuring an abundant future. Knowing how to select, plant, nurture, hybridize, harvest, and store meant learning to attune to the mysterious, regenerative Life Force. Hidden in the dark, fecund earth (subconscious mind) the seed lies in wait, germinating through the nurturing warmth and rain (the power of divine Love) until it bursts forth (into consciousness) and flourishes, growing by the power of the Light (supraconsciousness).

In the tombs of the dead, priests and priestesses planted a "corn mummy" in a bed shaped like the god Osiris. As Lord of Vegetation, he was called Nepri, or "the one who lives, having died." Seeds were buried in rich, alluvial dirt, watered, and left in the tomb. When the plants sprouted, which they did even in the dark, they were a sign that the soul of the dead had transformed.

Seeds remind us that for every end, there arises a new beginning. They remind us that when we care for and nurture what we love, it grows to sustain us. In the spring, I have watched our rural community bind together; one farmer helps another cultivate his field, each taking turns. Planting seed together is a loving communal act, which is why in large city neighborhoods the community garden is such an important part of life.

Seeds are essential magic, a clear manifestation of intent. I plant them whenever I begin a new life phase, a new project, a new intention, or incubate a dream. In times of transition, I plant them knowing that the Goddess of heaven and earth will provide, support, and sustain what is best for me.

Gather together your community of friends and family. Have each person bring a packet of seed, a clay pot, and a dream to share. Sitting in a circle, one at a time, share a dream that feels important and large—not a personal dream, but one that seems to teach. Others in the group may listen quietly or comment briefly on how that particular dream manifests in their own lives. Pass around a communal water jug that each hand has stirred and blessed by saying, "I honor your dream. I honor your intentions. May life be given abun-

dantly. May these waters make it so."

On slips of paper, write your intentions for yourself and your community. Place the folded paper in the bottom of the clay pot, then cover with a little potting soil. Each individual declares aloud what his or her intention may be, what is growing within and without. As you pass each cup around the circle, one at a time, the community responds to the stated intention by breathing the warm breath of life into the pot and asking for a blessing for that particular person's life.

When the pots have returned to their origin, plant the seeds, covering them with soil and again stating the intention aloud. Pass the pots again, each person breathing life upon the plan and saying, "May the goddess bless your endeavor. May your dream find fruition." To conclude, pour water from the communal jug on the plant, naming the powers of the Divine that source the seed, including the soil (Isis), the light (Raet), the air (Ma'at), and the water (Anket). Thank these divine guardians for their abundant gifts. Vow to honor life in all forms, to willingly receive the gift and use it to sustain and nurture one's self and one's community.

Some people prefer to plant flowers. Beautiful communal gardens to the Goddess can be made in day care centers, school yards, senior citizens centers, or shelters for battered women. The shape of the flower bed need not be complicated. One may use a pattern based on the horns of Hathor, which is essentially a circle surrounded by two larger, curving crescents. The solar disk might be planted in flowers that are golden and represent the sun. Sunflowers or marigolds would be a nice choice, and the lunar crescents in white lilies of the valley. Or one might choose to plant yellow and white iris, perhaps ringing the border in deep purple iris, for the colors of night. The throne of Isis would be a fairly simple and angular shape to make.

As each flower is planted, remember the story of the Goddess and the blessings she provides us. Simply telling an old myth while one works would be a wonderful way to instruct children in Egyptian mythology. If you need a healing, ask for the healing. We might plant each flower with a prayer to reclaim the divinity of our own bodies and to claim ourselves as healers and priestesses of the Divine.

The Season of Harvest

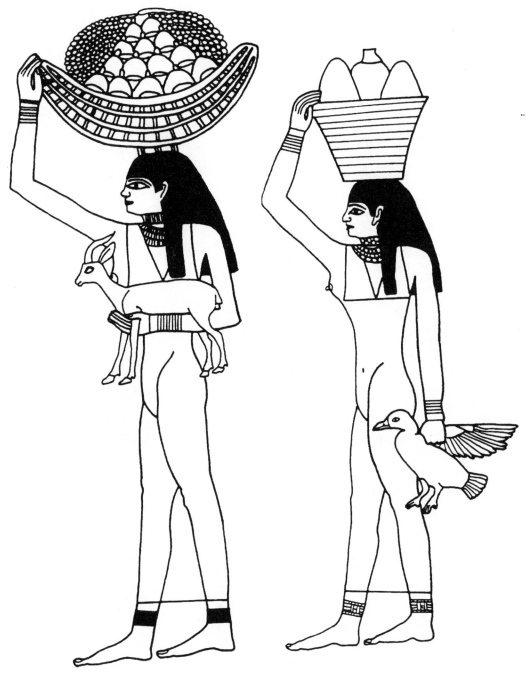

Priestesses carry the harvest offerings to the temple.

THE FEAST OF THE HAND OF THE GOD

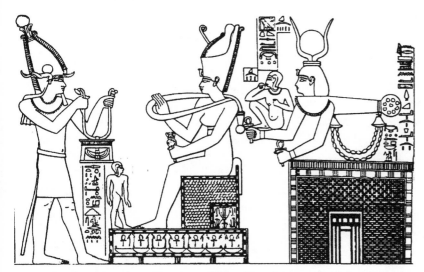

The pharaoh makes offerings to the goddess Mut, seated, who is supported by the menat goddess holding her unborn child.

Appropriate for Days that Celebrate
- Fertility
- Creativity
- Sexuality
- Partnerships
- Marriage and Love
- Abundance and Proliferation
- The New Moon in Pisces

This little-known festival dedicated to Hathor and Isis was celebrated at the Temple of Edfu. It doesn't sound like a goddess festival, but it is, for the Hand of the God was called Iusaas or Iusaaset. This goddess, honored in the city of Heliopolis, wore upon her head a scarab beetle, the symbol of transformation.[1] She was the counterpart of the god Atum; literally, his hand. In the Pyramid Texts an early genesis story recounts how the divine All, the androgynous Atum, created the world from the substance of himself. It reads: "Atum was creative in that he proceeded to masturbate with himself in Heliopolis; he put his penis in his hand that he might obtain the pleasure of emission thereby, and there were born brother and sister—that is, Shu and Tefnut."[2]

For those with delicate sensibilities, the story may seem crude, but it begs the question: How does a divine creator of undifferentiated substance procreate? The deity must divide itself into male and female parts—the phallus and the hand. These yin and yang parts then manifest the first polarity of god and goddess, or Shu and Tefnut. Most Egyptian creation myths use the motif of the One becoming Two, thus creating male and female—the first pair of sacred oppositions. Before differentiation, there is only the All, the Mother-Father, the One; after differentiation, there is multiplicity, of which we humans are so much a part that our intellectual musings trap us in categorical rationalizations.

We're still trying to decide if the divine One was originally male or female. Do we call It "the God" or "the Goddess"? Language, by its nature, attempts to categorize, and there is no way to speak of what existed in the undifferentiated All. The truth can only be understood through the great Mystery of creation itself. Thus, we have Atum and Iusaaset as the divine parents of the Light of Manifestation, Ra.

Like Isis with whom she is sometimes identified, Iusaaset (whose name means "She Comes While She Grows Large,"[3] a name underscoring the masturbation motif), had a sister called Nebet-hotepet, who is linked with Nephthys. Her name probably means "the House of Offering," perhaps referring to the womb of the All which is offered for use during the conception, gestation, and birth of the world. It is no accident that The Feast of the Hand of the God occurs between two other birth festivals, The Birth of Horus the Younger on Parmuti 28 and The Pregnancy of Nut on Pachons 6. It is, after all, a season near the spring equinox, when light has returned to the sky and the days grow in length. It is a time when the world is made new again, when the Hand of the God brings forth life from the waters of chaos. It represents the union of masculine and feminine energies to create and sustain life. In all probability, three festivals celebrating the same event arose in different locales

during prehistory and were later adapted to accommodate all three local divinities.

One of the many love poems found in the Chester Beatty Papyrus, this particular verse draws together all the springtime, creation, and birthing themes, and I well imagine it being recited in court for the king on this feast day. It reminds me of a scene in Shakespeare's *Romeo and Juliet*, wherein the young lovers lie in bed wondering if the sound they hear is the nightingale or the lark. Many of the love poems in the Chester Beatty Papyrus are unusual in that they were written from the point of view of a woman. If the scribe were not female, and there were a few, then it represents a sympathetic step toward understanding the female mind:

> The voice of the swallow speaks and says:
> "Day is breaking—where will you go?"
> O bird, you shall not distract me,
> For I have found my loved one in his bed,
> And my heart is more than glad
> When he said to me:
> "I shall not go afar off,
> But my hand is in your hand,
> And I shall stroll about,
> Being with you in every pleasant place."
> So he makes me the foremost of maidens,
> And he injures not my heart.[4]

As a reflection of their cosmic procreative abilities, the Egyptian queens and high priestesses bore the title, the Hand of the God. The queen's title reflected her ability to bring forth the god Horus, the next generation of heirs to the throne. The high priestess's title reflected her ability to manifest and maintain the divine powers of regeneration and fecundity within her entire community. The idea of a Roman Catholic nun being the Bride of Christ (the word derived from the Latinate *nonna*, meaning "mother,") is probably based on the idea of the priestesses being the Wife of God, or the Hand of the God. In ancient Egypt, the Nun (god) and the Nunet (goddess) were a pair of divine beings representing the fecund, creative waters of the cosmos.

The question has arisen as to whether or not priestesses who represented the Hand of the God actually engaged in a sexual rite for ceremonial purposes. Some Egyptologists, contemplating the birth scenes in the Temples of Luxor and at Deir el Bahri, suspect that a ritual marriage was reenacted by the pharaoh and his wife performing the roles of the Amun-Ra and Hathor. E. O. James believes the practice in Sumer of the *hetaera*, or "sacred prostitute," which was originally attributed to worship of Inanna and her male consort Dummuzi, was transferred over to the Egyptian rituals.

Commenting on the Sumerian practice, he said that "since the intercourse of the god and the goddess had its reciprocal effect in the reunification of nature, the annual sacred marriage was an essential ritual observance in the seasonal cycle. Indeed, all the principal deities in Mesopotamia are represented in the texts as celebrating their nuptials, which on earth were reenacted in the temples by the king as the divine bridegroom and the queen (or a priestess) as the goddess."[5]

James goes on to imagine that the Egyptian ritual involved the sacred coupling of the pharaoh and his wife during the Opet festival while the pharaoh's concubines, the musician priestesses, provided appropriate music to celebrate the union.[6] On the other hand, so to speak, the Greek word *hetaera*, which was interpreted only as "companion," always indicated a woman who had full equality with men during the Hellenic period. A hetaera was one who attended school, established salons, and participated in vital social and intellectual pursuits.

While Barbara Walker suggests the name derives from the Egyptian word *heter*, meaning "friendship,"[7] it is just as likely that it derives from *hetra*, which would mean "house of Ra," another name for the womb and the high priestess as the Hand of the God. Yet another Egyptian meaning for *heter* is "union," which may indicate both the concept of marriage or of any unification of people and forces working in a communal way.

Three symbols strongly associated with Iusaaset and the high priestess were the ankh, the *thet* (or "Buckle" of Isis), and the menat of Hathor. The ankh, of course, was the traditional symbol of life, but the true meaning of its hieroglyphic image has remained a matter of dispute among scholars. Scholars with a symbolist bent see the ankh as the emblem of the unification of the female and male principles of life, the circle being feminine and the cross being masculine. Others liken it to the feminine sign for Venus/Aphrodite and the womb of life.

On the other hand, early Egyptologist Alan Gardiner suggested that the ankh might simply represent a sandal strap. One possibility that reinforces his suggestion is that the courtesans of Ramses II in the Temple of Abydos called him "Lord of many provisions and abundance of corn. There is a plenteous harvest wherever his sandals may be."[8] It is not impossible for the Egyptian mind, steeped in puns and symbolic thinking, to have embraced both meanings simultaneously. It is more likely that a sandal strap resembled the ankh than that the ankh is derived from the sandal strap. The scribe probably thought that he'd made a pretty sly pun, referring not simply to the growing fields of grain where the king walked, but also to the sandals of Ramses under the beds

of his courtesans. The pharaoh was said to have sired well over ninety living children and in his day was considered the embodiment of Min, the fertility god.

At any rate, whenever it was held by either a god or a goddess, the ankh provided the divine blessing of long life to the pharaoh, or symbolically it could be held to the nose of the deceased as a means of creating rebirth in the next life. The ankh has always been the primary symbol of the womb of the Great Mother.

The design of the *thet*, or "Buckle" of Isis, resembled the knotted cords of the girdles of Isis and her priestesses. Usually red in color and encircling the hips, it became one of the primary symbols of a woman's fecundity. As an amulet placed in the grave, it brought new life and rebirth to the beneficiary. The amulet was accompanied by a "spell" called the Knot of Isis to bring the power of its magic into manifestation:

At the ends of the universe is a blood red cord that ties life to death, man to woman, will to destiny. Let the knot of that red sash, which cradles the hips of the goddess, bind in me the ends of life and dream. I'm an old man with more than my share of hopes and misgivings. Let my thoughts lie together in peace. At my death let the bubbles of blood on my lips taste as sweet as berries. Give me not words of consolation. Give me magic, the fire of one beyond the borders of enchantment. Give me the spell of living well.

Do I lie on the floor of my house or within the temple? Is the hand that soothes me that of wife or priestess? I rise and walk. The sky arcs ever around; the world spreads itself beneath my feet. We are bound mind to Mind, heart to Heart—no difference rises between the shadow of my footsteps and the will of god. I walk in harmony, heaven in one hand, earth in the other. I am the knot where two worlds meet. Red magic courses through me like the blood of Isis, magic of magic, spirit of spirit. I am proof of the power of gods. I am water and dust walking.[9]

The menat was the necklace of Egypt's Aphrodite, Hathor. Most scholars agree it means pleasure and jubilation of some kind. It symbolized, not only fertility, but joyful sexual response. Consisting of three rows of beads with a rather phallic-looking counterpoise, the menat combined male and female creative principles in action—the circle and the phallus involved in mystical union. Given to the dead, it allowed revitalization in another world, recalling the union of Isis and Osiris to create Horus.

In one Middle Kingdom tomb, we find the deceased in the midst of a party being offered the menat by several dancers, musicians, and singers. The dancers wave the menat, exclaiming, "To increase your vitality, the necklace of Hathor. May she bless you. . . . To increase your vitality, the neck ornaments of Hathor. May she lengthen your life to the years you desire."[10] Musical priestesses often played the *crotalum*, an ancient type of castanet, with one hand and held the menat in the other.[11] The shape of the menat itself recalls the cochlea of the inner ear, that part which enables us to hear and distinguish different pitches. All by itself the menat would be played like a rhythm instrument, its rattling beads creating a sound similar to the sistrum.

Often one finds images of the priestesses of Hathor standing before the pharaoh or one of the male gods—perhaps Osiris, Atum, or Ptah—wearing the menat and pushing on the necklace with her hand to make the counterpoise stand erect behind her. Perhaps the menat display was part of an ancient fertility rite, or a simple offering up of one's female sexuality. Others have suggested that the menat was used as a talisman, a means of preserving one's joy and virility. Margaret Murray believes this is so. She comments that "the vulnerable place to strike a person is the back as he cannot see the blow coming, physical or magical. The menat, which hung at the back between the shoulders, gave this protection, for in it the goddess Hathor was immanent."[12]

Discussing the menat, Lucie Lamy describes a courtesan goddess named Iusas-Nebet-Hotepet who appears as a reclining woman draped in red linen covered with a network of pearls and wearing the menat necklace. The name Iusas-Nebet-Hotepet is probably a combined usage of the names Iusaaset and Nebet-hotepet, who are forms of Isis and Nephthys. Lamy goes on to explain the symbolism of the necklace worn by the priestess who is the Hand of the God. "The menat necklace and its counterpoise are related to notions of birth, rebirth, or the passage to a new state. The menat . . . endows the deceased with 'the persistence of life, durability, and ever-renewed youth.'"[13]

Another interpretation of the offering gesture is that the rise of the menat at the back of the head indicates an unconscious response to standing in the presence of the beautiful goddess, Hathor. The rise of the menat may correspond to the rise of kundalini power up the spine, indicating the arousal of the sexual energy employed in rejuvenation and spiritual creation.

With its three strands, the menat may likewise represent the triple aspects of the goddess. The necklace may be linked with a Hathor-like goddess based on the Arabic goddess Manat, who was a goddess of fate and destiny. Related to the

moon, her aspects were said to be threefold: she represented Kore, the Virgin; Allat, the Great Mother; and Al-azza, the powerful Crone.[14]

In the Temple of Dendera, which has been called the Castle of the Menat,[15] The Feast of the Hand of the God was probably a day in which all women bearing children, including the wives and concubines of the pharaoh, might come to the temple to be blessed by Hathor. Perhaps the day began with a sunrise devotion to the goddess as Mother of the All. Perhaps amid the strains of beautiful music, the priestesses touched each pregnant woman's belly and breasts, or anointed their faces with perfume, or even milk,[16] whispering words of welcome to the unborn children, saying the same words the priestesses used to greet the nomarch Senbi, "For your spirit, behold the menat of your mother, Hathor. May she make you flourish for as long as you desire."

Hymn to Isis

Enchantress and wife, she stamps and spins. She raises her arms
to dance. From her armpits rises a hot perfume
that fills the sails of boats along the Nile.
She stirs breezes that make the sailors swoon
and opens the eyes of statues. Under her spell,
I come to myself; under her body I come to life.
Dawn breaks through the diaphanous weave of
her dress. She dances and draws down heaven.
Sparks scatter from her heels and on earth tumbles
forth an expanse of stars. . . .[17]

Activities

1. In your journal, explore what it means to you to be a cocreator of the universe with the Divine.

2. Gather some magazines that you feel free to cut up. Leaf through them, searching for images that appeal to you. Perhaps the images hint at where you focus your energies or where you will focus your energies in the future. Cut out the images and lay them aside. Outline your hands on a sheet of paper. Slowly, meditatively, begin to trim, sort, and paste the images onto the image of your own hands. You might use the right hand for things that you already create and the left hand for things you will create in the future. Around the edges of these hands, write a myth of yourself as the creatrix of this world.

3. Our bodies are instruments of our connection to the physical universe. Reestablish a connection to your body's natural wisdom. With crayon, outline your body on a long sheet of butcher paper. Begin at the top of your head and record what each part of your body remembers: your hair, your cheeks, your nose, etc. Try to list both joys and sorrows. When you find a part of your body that holds many strong memories, make note of it. Later, return to that spot and write a dialog with that part of your body.

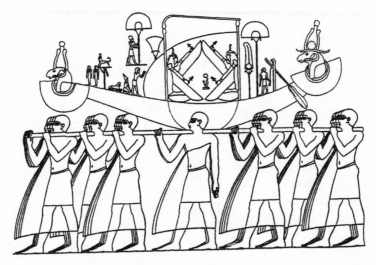

Priests carry the sacred boat of Amun in procession. Within the shrine sit the ma'aty, the two winged goddesses of truth.

The Pregnancy of Isis/Nut

Appropriate for Days that Celebrate

- Pregnancy and Motherhood
- Anticipation and Preparation
- Love Affairs
- Planting and Gardening
- A Coming-of-Age Party
- The Celebration of a Healing
- The Spring Equinox
- The New Moon in Aries
- Protection (especially of children)

A pregnant Isis holds the waz scepter of power as she sits on the birthing bricks.

When the birth of Ra occurs soon after winter solstice, we have only to count backward 272 days, the number of days that a human child gestates in its mother's womb, to find the spring equinox as his conception day.[18] The Birth of Ra and The Pregnancy of Nut are ancient, prehistoric feast days. Although the pregnancy of the sky goddess was celebrated as a feast day with great fanfare during very early kingdoms, the significance of Nut's day somewhat diminished with the rise of the patriarchal connection between Ra and the pharaoh.[19] As the Isis and Osiris cult grew to predominance, Nut's day was assumed by Isis.

The insemination of Nut was highly unusual, for she conceives the solar god with her mouth by swallowing the seed of the dying sun at the end of every day and birthing him again at dawn. This symbol of the ingestion of the light as a form of spiritual transformation recurs again in the appearance of Nut on the sarcophagus lid, the Greek word *sarcophagus* meaning "sacred eating." The Egyptian word for *sarcophagus* was *het-neb*, meaning "house of gold."

Nut's story is reminiscent of two other myths: that of Isis as the fish who swallows the phallus of Osiris to conceive Horus; and that of Sekhmet, the leonine form of Hathor who devours the children of Ra—all humankind—at the end of the world. Sekhmet's creator-husband Ptah is said to birth the world with his lips and tongue by speaking the words of power.

Nut, of course, appears at night as the Milky Way, the shape of which resembles a woman bending over earth. On the evening of the spring equinox, just after sunset, one can observe on the eastern horizon the vulva of the goddess where the Milky Way appears to split into her two legs, and on the western horizon the large cloud that outlines her face. Appearing within the face is a slight concave image representing Nut's open mouth. The open mouth of the goddess and the place where the sun disappears at sunset during the spring equinox are exactly aligned.[20] Such an insemination must have been a scary sight.

In the meantime, as night descends, the stars appear like the seeds of all the children of the goddess. The star's five-pointed shape resembled the living human torso with head, arms, and legs. Whenever the star appeared drawn within a circle, the symbol for *duat* or "the neterworld," it signified the transformation of the spirit inside the womb of Nut. In just such a manner, the hieroglyph of the sun was drawn with a single dot inside a circle, representing the germ within the seed, or the pip within the egg. The springtime festivals that honor *Eostre*, a form of *Astarte* and *Hathor*, likewise celebrate

the laying of the golden egg. Both Persians and Egyptians celebrated the springtime surge of available life energy by exchanging colored eggs, usually red eggs to signify the blood of the goddess.

Around this time of year in the Christian tradition, we hold a similar feast celebrating the rebirth of the divine Son on a day called Easter, which always occurs on the Sunday following the first full moon after the spring equinox. *Easter*, of course, derives from the name *Eostre*. We still celebrate it with images of proliferate bunnies and eggs, symbols that perhaps harken back to ancient Egyptian symbols of Osiris as the hare, or Good Being, and Ra, the sun, as the Golden Egg of the goddess. The combined creative energies of the resurrected Osiris and the perpetually reborn Ra, appearing as Osiris-Ra, create the opportunity for the appearance of Horus as the spiritual warrior who appears in Egypt as the Saviour, the spiritual principle of Light that finally conquers Darkness.

Horus the Elder, the earliest predynastic form of the falcon, was likewise considered a son of Nut. He was the second of three brothers born of the sky goddess, although only Osiris and Seth chose to incarnate on Earth. Horus the Elder, the celestial Horus, preferred to remain close to his mother as the soaring falcon. The younger Horus, the terrestrial Horus, was conceived by a winged mother, Isis, whose magic had transformed her into a kite at the moment of his conception.

This linking of the spiritual warrior to the springtime natural world of sunlight, birds, and the gestation-birth-and-regeneration cycle of the solar principle recurs in the hymns of the pharaoh Akhenaten. Akhenaten abandoned the worship of multiple gods during his reign, theorizing a sole creator sun god named Aten, yet his poems alluded to the veneration of the sky mother as a solar deity. The progenitor he adores shows all the nurturing, procreative qualities of the bird goddess that graced two thousand years of ancient Egyptian history; and his beautifully crafted Hymn to Aten grasped the link between the regeneration of the natural world and the regeneration of the human spirit through divine intervention:

> It is you create the new creature in Woman,
> shape the life-giving drops into Man,
> Foster the son in the womb of his mother,
> soothe him, ending his tears. . . .
> When the new one descends from the womb

> to draw breath the day of his birth
> You open his mouth, you shape his nature,
> and you supply all his necessities.
> Hark to the chick in the egg,
> he who speaks in the shell!
> You give him air within
> to save and prosper him;
> And you have allotted to him his set time
> before the shell shall be broken;
> Then out of the egg he comes,
> from the egg to peep at his natal hour![21]

In Parmuti 28 we mentioned how the increase of light in the spring stimulates a bird's pituitary gland, causing it to secrete the hormones that speed egg development. Light enters the body through the eye as a means not only of creating images, but also of bringing about transformation in both physical and psychological ways. Light speeds up reproduction. Light is the cure for those experiencing Seasonal Affect Disorder. The solar eye of ancient Egypt, the *wadjet*, or "Right Eye of Horus," was used as an all-purpose physical and spiritual healing talisman. Both enlightenment and healing manifested as sunlight appear in this wadjet, or third eye. The magic works by means of the pituitary gland. This kind of magic, which Isis was said to have taught her son, engages the glandular power of envisioning and healing. Early hospitals in Alexandria at the Serapeum were under the protection of Horus. This healing Eye of Horus is still used by the medical profession in the abbreviated form of the "℞" to indicate a prescription for medical treatment.

The wadjet, or fire-spitting cobra, represented the healing eye of the goddess.

The birth of a child in ancient Egypt was always cause for celebration since, in essence, the whole world—all of life—was being recreated again in that moment. The birth mystery was a communal event among women. The mother was attended by a midwife, her assistant, and a number of female relatives in a manner reminiscent of the way Isis visited her sister goddesses in the papyrus swamps to birth Horus. The attendants who assisted in a child's birth on earth embodied the spiritual midwives in heaven. One such mortal birth is recounted in the Westcar Papyrus, which tells the story of how Ruddedet, a high priestess of Ra, gave birth to triplets. These three sons later became the first three pharaohs of the Fifth Dynasty. Their births were prophesied by Djedi, a magician who visited King Cheops, builder of the first pyramid at

Giza in the Fourth Dynasty. The tale originates from a Middle Kingdom papyrus:

When the time for the mother's delivery had come, Ra sent forth the following divine beings: Isis and her sister Nephthys, Meshkhent [the goddess of the birthing brick], Heket [the frog goddess of transformation], and Khnum [the ram god who sculpts the child and its ka, or "spiritual double," on his potter's wheel]. These divine beings were accompanied by seven dancing girls— that is, the Seven Hathors—sister goddesses of fate who sang to the child in the womb and bequeathed its spiritual, astral, and physical destiny. Into the birthing chamber Isis and her entourage hurried, dismissing the befuddled father and shutting the door. Isis stood before the mother, at the gateway between heaven and earth, so that the newborn child slid from the womb into her arms. Nephthys stood behind. The god Khnum sat nearby at his potter's wheel, forming the body from bits of clay, alongside its ka. Heket with her words of power hastened the birth process by commanding the change from fetus to child, while Isis called forth each child by name. The babes slid easily into her arms and each was found to be "strong boned, his limbs overlaid with gold, his headdress of true lapis lazuli."[22] Each child was bathed, his navel cord was cut, and he was laid upon a pillow. One by one, Meshkhent thereupon pronounced each child's fate as a great king, and Khnum gave health to his body.

In the Egyptian tradition, the newborn's entire body and all parts of its birth process were considered holy. Even the placenta, the bit of flesh that sheaths the human form, was treated as sacred: Wrapped in fine linen, it was stored in a jar; then at the time of death—many decades later, if the Seven Hathors were kind—it was brought out again and buried with the body. A piece of the child's umbilical cord tied into a little pouch and hung around the babe's neck is still considered a health charm among the fellahin women. For their work as midwives, each one of the neters was paid with a sack of grain, which is still the traditional payment to the midwife among the peasants of Egypt.

Activities

1. Create a space in your home for meditation and the gestation of your dreams. Find a corner away from family distractions where you may feel the presence of the sacred. Collect whatever images imbue you with a sense of the divine: candles, incense, flowers, a meditation pillow, objects of beauty and mystery. Visit this shrine each day and when you approach, remind yourself that you live in the present moment in divine grace.

2. Pick a day of importance, perhaps your birthday, or the first day of spring, or the beginning of the new year. Imagine your life one year from now. Explore the specific details of that life in your journal. Describe its smells, its images, its place, its feelings. Imagine it clearly so that the image becomes a reality of your life, a future self toward which you are moving.

3. In ancient Egypt, midwives embodied the Seven Hathors who blessed each newborn. Perhaps recently a child was born into your family. Create a blessing for this child. Anoint its head with holy water, asking for wisdom. Anoint its eyes, asking for clear vision and insight. Anoint its chest, asking for love and compassion. Anoint its belly, asking for health and long life. Anoint its feet, that the child may walk the a good path in life. Anoint its hands for creativity. Anoint its throat that it may sing beautiful songs and become a speaker of truth.

Springtime growth has always inspired celebrations of divine birth and rebirth.

103

THE FESTIVAL OF RENENUTET

Appropriate for Days that Celebrate

- Completion
- Harvest
- Protection
- Nurturing
- The Full Moon in Libra
- The Rise of the Star Spica

Renenutet, the cobra harvest goddess, nourishes and protects the young king with her magical power.

After Isis escaped from the prison of Seth, she hurried straightway to the papyrus swamps, being followed by her seven protective scorpions. There she determined to birth her child in secret, hiding in a blind of reeds and making a nest of papyrus. Four goddesses attended the birth of Horus, among them Renenutet and Wadjet, the cobra goddesses, and perhaps Serket, the scorpion goddess, or Heket, the frog goddess, a likely occupant of the papyrus swamps. After Horus's birth, Isis, who was also newly widowed, became the quintessential single mother, having to travel to the local villages and work with the women there. Seth sent forth his legions throughout the land to search for the child to kill it. Because Seth was looking for Horus, Isis had to leave the infant safely hidden in the swamps under the care of the cobra goddesses. He needed strong and wise protectors, for his enemies came forth disguised as serpents, scorpions, crocodiles, and hippopotamuses. Renenutet became his nursemaid, as well as his guardian. While his mother was away, she suckled the infant, holding him to her breast as if he were one of her own. While the child slept, she encircled him with her serpent body, her head erect, her tongue licking the wind, trying to detect the approach of danger.

Renenutet was considered the goddess of a bountiful harvest and good fortune. Any child who grew up to become a scribe—which meant being bright and employable, thus never going hungry, or having to labor in the fields or fight in the army—was said to have been born with Renenutet on his shoulder.[23]

As early as the First Dynasty, The Festival of Renenutet recounted the serpent aspect of the goddess as the harbinger of death and renewal. She who renews herself sheds her skin. Symbolically, the serpent represented the young being brought forth out of the old, as well as the wheat seed being brought forth from the mature plant. She was a goddess of abundance, causing the tree boughs to be laden with fruit, the grapes to hang in great clusters, and the stalks to bend down under the weight of their vegetables, supplying all things in millions.[24]

During the Egyptian Harvest festival dedicated to the delta cobra goddess, the pharaoh tread grains of barley underfoot. Traditionally, the offerings of the first fruits of the harvest were given to the goddess Renenutet and to the souls of the dead. The winnowers would place upon the threshing floor bowls of fresh water and a heap of grain in tribute to the cobra goddess. After threshing, the harvesters and the ferryman who carried the bounty to the storehouses on his boat would be paid with in-kind offerings of grain.

In the tombs of the dead, these payments to the ferryman of souls were called *hmt* and written with a hieroglyph indicating three grains of some substance. The grains have been interpreted either as grains of gold—thus, the origin of the gold coins which the dead are said to give the boatman Chiron who ferries souls across the River Styx in Greek mythology—or they are interpreted as grains of seed; that is, payment in kind for the ferryman who transports the newly

threshed and harvested soul to the Elysian Fields. Significantly, *hmt* was another word for the female goddess, depicted in her cobra form. No doubt the offerings to the ferryman originated with Renenutet. Even today, modern Egyptian peasants leave a little grain on the threshing floor, or an elaborate "bride of the corn" bouquet, as an offering to satisfy the *afarit* (the underworld spirits).[25]

Certainly the cobra goddess needed to be appeased. If she were not one of the stealthiest and most feared creatures, ready to strike with deadly force at the slightest provocation, she would not have made a very good guardian for the imperiled infant Horus. With simply a gaze, she had the power of the Eye to mesmerize the enemies of Horus. As companion of the pharaoh, she protected the fields from vermin, drought, and theft. In the birth process, she appeared in the mammisi with her sister goddess (either Heket or Meshkhent). Whereas her sister urged the babe to come forth from the womb, Renenutet provided him with the will to live. In that regard, she was very much a goddess of destiny, in control of one's future abundance and fortitude. The power of Renenutet is that she is both nurturer and warrior goddess.[26]

Cooking with the Goddess

It's easy to become lost in the esoteric. I find these recipes a wonderful way to think about how the Goddess affects me on a practical, day-to-day level, how she nurtures and informs me continuously in all aspects of my life.

Isis Asparagus for Abundance and Fertility

1 ½ pounds fresh asparagus spears

³/₄ cup chicken broth

¼ cup sliced green onions

1 teaspoon dried tarragon

12 Bibb lettuce leaves

2 teaspoons crumbled blue cheese

1 ½ tablespoons sliced toasted almonds

Snap off tough asparagus ends and remove scales. Boil chicken broth over medium high heat. Add asparagus, green onions, and tarragon. Reduce heat and simmer uncovered 6-8 minutes. Remove asparagus and discard remaining broth. Arrange asparagus on lettuce leaves; sprinkle with blue cheese and almonds. Serves 6.

ABOUT YOUR INGREDIENTS:

If they had asparagus in ancient Egypt, certainly it would have been associated with the gods of fertility, Osiris and Min, because of its shape and the way it grows, and with Isis and Hathor, the goddesses who cultivate the fecundity of Osiris-Min. Plant some in your garden. It takes a while to cultivate an asparagus crop, and careful nurturing and planning. Allow the first year's crop to go to seed, so that the fruitfulness it brings can be continuous. Asparagus can only be harvested in the spring, when new life seems to be popping up all over. It, like your prosperity, has to be gathered in at the right moment.

Almonds, because they are seeds, represent abundance in all its forms and are associated with Isis, Hathor, Satis, Sothis, and Anket. Carry a few almonds in your pocket to bring you luck. Eating almonds, because you are eating the seed of the life, increases your wisdom.

Blue cheese, of course, is associated with the cow goddesses, Nut and Hathor, as well as with Isis. Their gift of milk is the gift of the Mother, a sign that in all forms she sustains her children. The gods Osiris, Min, and Unnefer, the hare, were said to love lettuce. In small quantities, it was considered an aphrodisiac.

Onions were always a staple gift offered to the gods and goddesses of ancient Egypt, and even to the dead. They were said to prevent illness and to promote long life and happiness, which is why onions were sometimes tossed behind the groom and bride. Onion skins are burned to attract wealth. To throw away an onion skin meant to throw away prosperity.

Tarragon, sometimes called "little dragon," perhaps because of its serpentine shape, is a culinary herb related to mugwort or wormwood, plants sacred to Isis. Said to relieve fatigue, tarragon sprigs placed in the shoe speed one's journey.

Cobra Goddess Cookies for Protection

³/₄ cup all-purpose flour (or ½ whole wheat, ½ all-purpose)

¼ teaspoon baking powder

¼ cup margarine, softened to room temperature

2 egg whites or ¼ cup egg substitute

½ teaspoon crushed anise seed

1 cup rolled oats

Sift together flour and baking powder. Blend in

margarine until light. Beat in egg and anise seeds. Stir in oats until well blended. Divide dough into sections, then roll each section into a $1/2$-inch snake. Cut snakes into 2 inch sizes, and curl them into cobra or serpent shapes. Bake on a lightly greased cookie sheet at 375° for 8-10 minutes. Makes about 3 dozen serpent goddesses.

ABOUT YOUR INGREDIENTS:

Goddess of the grains and wheat, Isis was related to Demeter in Greek mythology, and both the Osirian Mysteries and the Eleusinian Mysteries were related to understanding the cyclic birth, death, and regeneration patterns contained in the upheld sheaf of wheat.

Anise is linked with the protective gaze of the sun. In its star-like growth pattern, anise resembles the crowns of Isis as Sothis, the Dog Star, or Seshat, the goddess who wears upon her head the star, or eight-petaled flower. If you're growing your own anise, culinary lore suggests that you pick the seeds at their most potent times, either at midnight or early in the morning before the dew dries.

If one has children, baking and eating anise cookies together offers strong medicine. It was said if one slept with anise beneath the pillow, it dispelled bad dreams. A child who has nightmares might try sleeping with one anise cookie under her pillow as an offering to Isis to protect her from worry and harm. For mothers, dried anise plants hung on the bedpost were said to restore youth and beauty. Hung about the room, anise repels the evil eye and protects those within the magic circle.

Opet Bakalava

$1/4$	cup honey
$1 1/2$	tablespoons reduced-calorie margarine
$1/4$	teaspoon allspice
	dash of ground cloves
$1/4$	teaspoon vanilla extract
6	sheets of frozen filo pastry, thawed
2	tablespoons ground walnuts

In a saucepan over low heat, combine 3 tablespoons honey, allspice, cloves, and margarine, until margarine melts. Remove from heat and add vanilla. Cut filo in half crosswise. Place each filo sheet on waxed paper, and lightly coat the filo with cooking spray. Top with second sheet of filo and cooking

spray. Brush with 1 teaspoon honey mixture. Repeat layers twice. Sprinkle top layer with 1 tablespoon walnuts, leaving 1-inch margin on long sides. Roll up like a jelly roll starting with the long side. Place seam side down on baking sheet coated with cooking spray. Repeat process. Brush remaining honey mixture over filo and cut each roll diagonally into 4 slices. Bake at 300° for 30 minutes. Drizzle remaining honey over warm filo. Serves 3.

ABOUT YOUR INGREDIENTS:

Ancient Egyptians offered the gods a dish they called "honeyed cakes." I imagine it similar to bakalava of the Greek tradition. I often take Greek words and examine them for Egyptian meanings, to see if some hidden magic lies within the language. In ancient Egyptian, *ba-kara-fa* (they had no "l"; only an "r") would have meant something like "carrying the soul of the Divine within the shrine of the self." That seems an appropriate offering to the Divine, and resonates well with all the goodness tucked inside this tasty dish of filo and honey. The "delta" shape of the bakalava represents the womb of the ancient mother who carried within her belly the soul of the Divine.

Honey was widely used in resurrection magic in the ancient world. Dedicated to Isis and to Hathor, honey was used as a preservative and as a healing ingredient. It was the essential ingredient in curing styes, headaches, cataracts, and blindness. Mixed with menstrual blood and seed, then planted in the garden, honey was said to create in the mother's womb the fecundity of life.

While the Egyptians did not use walnuts, they did use sesame seed in their cakes, perhaps an interesting variation on the bakalava. The sesame, like the walnut, was the seed of fertility. In fact, sesame was linked to understanding the divine Mysteries, which were contained endlessly within the sesame seed. Once opened ("Open Sesame"), the seed revealed to the initiate all the magical wisdom of the ancient priests. Sesame was also said to bring luck, abundance, and love.

Of the spices included for this Opet Festival offering, allspice is said to attract abundance, money, and good luck. Clove attracts money and love, as well as producing spiritual vibrations and driving away hostile forces. Vanilla brings love your way, as well as mental and physical vitality.

Isis Finds Osiris

The festival called Isis Finds Osiris celebrated the return of the light.

Appropriate for Days that Celebrate

- Mourning and Loss
- Finding Lost Things
- Reunions

Based on the solar calendar, The Lamentations of Isis and Nephthys was a sorrowing festival that bemoaned the loss of light in the northern hemisphere. Six months later came another season festival celebrating the return of the light. Called Isis Finds Osiris, this feast day recalled the theme of the winter solstice festival wherein Isis the Black Cow searched for her husband. The same cow that represented Isis reappeared here and was led seven times around the Temple of the Sun in Heliopolis. On the third night of the festival, the priests went to the river's edge, removed from a box a casket of gold into which they poured holy water, and cried "Osiris is found!" Then fertile soil, spices, and incense were mixed to form a crest of mud, representing the union of Isis and Osiris.[27]

In the Greek version of the rites, the attendants marched toward the Aegean Sea with a wooden chest, reminiscent of the coffin of Osiris. Hidden inside this chest was a vessel of gold over which the initiates poured fresh water, shouting again, "Osiris is found!"[28] The popularity of this festival occurs out of season, so to speak, because the agricultural season in the northern hemisphere does not begin until after the spring equinox. Among the Greek initiates of Isis, this feast day was linked to the Thesmophoria, a festival devoted to Demeter the goddess of agriculture and marriage. Like Isis, Demeter had also lost a loved one, her daughter Persephone, to the power of the underworld. As Osiris arose to bring renewed life in Egypt, so did Persephone's return initiate the spring growing season in Greece.

The Greek writer Herodotus described how two women of noble birth from Egypt, called the Danaids, brought these sacred rites to Peloponesia and taught the women there how to celebrate the feast day.[29] In Athens two noble women were chosen to preside over the festival as Isis and Nephthys. They alone performed the temple duties and prepared the festal meal. The Thesmophoria was strictly a women's festival, and a part of the mysteries included mixing seed corn with menstrual blood and planting it to initiate a bountiful agricultural year. After the planting, the women cloistered themselves within the temple to commune with the goddess Isis during the night.

Similar mystery rites of Isis and Osiris continued in Egypt unabated year after year. Participants returned annually to the temples for reinitiation and to celebrate the festival of renewal. The sacred act of performing the Osirian rites was the equivalent to sacred remembering. To forget one's name, to forget one's sanctity, to forget one's relationship to the Divine was to die while still living. It was the worst of all possible sins. Therefore, the rites were celebrated yearly. Each spring, Osiris was mourned; each spring, his body and spirit were reunited; each spring, he was remembered and reborn.

Activities

1. Take a walk through your neighborhood. Imagine that everyone and everything you see contains the image of the Divine. Say a blessing of thanksgiving for all these gifts. Don't forget to include yourself. When you return home, write about what it means to find the Divine without and within.

2. Make a list of all the objects you remember having lost in your lifetime. Pick one and describe what that object meant to you and how you went about trying to find it. Describe your search, your state of mind, your actions and reactions. In the process of searching for what was lost, what other things did you find?

3. Explore the idea of companionship. Everyone needs a companion for the journey—a friend, a guide, a partner, a mentor, a beloved. Perhaps you are searching for such a someone. Who is it you search for? What gifts will that person bring? What gifts will you share in turn? Where will you meet the companion? How will you recognize each other?

The Osirian rites of renewal were designed to assure a bountiful harvest.

THE GREAT FESTIVAL OF BAST AT BUBASTIS

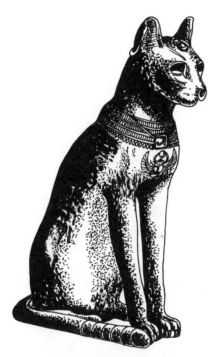

Bast, the cat goddess, wears the Eye of Horus necklace and the winged beetle of transformation as emblems of her healing power.

Appropriate for Days that Celebrate

- Lovers and Marriage
- Motherhood
- Thanksgiving
- Trickster Energy
- Self-Confidence
- Dancing, Feasting, and Merriment
- Sensual Delight
- Creativity and Beauty
- Wine Tasting
- New Moon in Aries

Herodotus calls The Great Festival of Bast at Bubastis one of the most important festivals in all of Egypt, not to be missed. Certainly it was one of the most sensual feasts. At times bawdy, at times ecstatic, the Great Festival celebrated Bast in her manifestation of Hathor as the Lover and called to mind the feminine mystery of the goddess's duality.

Bast, the cat goddess, was the tamed version of the bloodthirsty lion goddess Sekhmet. Her dual nature is revealed in the myth of how Thoth prevented Sekhmet from devouring all humankind by tricking her into drinking wine disguised as blood. The wine so soothed her frazzled nerves that she lay down on the river bank, purring, luxuriating, and transforming into the gentle cat Bast. Thereafter, Bast became the goddess of festivals, intoxication, motherhood, sensuality, and the arts in general. (See Thuthi 20, The Inebriety of Hathor.)

Drinking wine, of course, is still viewed as a high religious sacrament, its color reminiscent of the blood of the Divine and the reminder of spiritual renewal. Wine drinking among the Egyptians was also a religious sacrament, not only

because it reminded one of Sekhmet's near destruction of the world, but because the wine-drunk initiate loosed the reins of logic that bound one to rigid thinking. Through inebriation one approached the ecstatic. Bubastis was the wine capital of ancient Egypt, its rich delta soil providing large pharaonic estates bearing the choicest grapes. Great connoisseurs of wine, the Egyptians were careful to label all their jars, defining the vintage year, the name of the wine maker, and the quality of the wine.[30] The white wines of Lower Egypt were called the Wine of Bast, while the red wines of Upper Egypt were called the Wine of Sekhmet.

Whereas Sekhmet embodied the powerful, intense rays of the sun, Bast, the second daughter of Ra and Lady of the East, embodied the dawn light. The Greeks equated her gentle light with the moon and the solar light, with her sister goddess Sekhmet. The connection between the moon and the cat goddess Bast intensified in other cultures, creating in later time an aura of "witchy-ness" around the divine Feminine and her cat companion.

Bast usually appeared as a woman with a cat head, often

surrounded by kittens, a sign of her nurturing capacities. Families often owned a number of cats as pets. Affectionate and graceful, they made great companions, and they kept away the mice and snakes. When the cat died, it was mourned as a beloved family member, mummified in great ceremony, and buried with honor. Fifteen centuries later when the Suez Canal was being dug, workmen had to stop for weeks at a time to clear away the multitude of cat mummies they had accidentally uncovered in ancient pet cemeteries.

Nearly every mother with children had a house with a wall niche devoted to Bast. Before the cat goddess were laid fresh flowers, cups of milk, or other offerings. Whereas large, powerful images of Sekhmet appear most often in the temples of the pharaohs, the little cat figurines of the goddess with round head and pointed ears were made in great quantities for private devotion. Nowhere was Bast more likened to Isis than in the home as the protective, compassionate, nurturing image of the mother. In fact, Bast's name is thought to derive from the combined words *ba* and *Aset*, meaning "Soul of Isis." But wherever an image of Bast appeared, the cat goddess also likely wore a necklace bearing the Eye of Horus, or wadjet; or else she wore an aegis that formed the head of Sekhmet, as a reminder of the mercurial ability of the goddess to turn from lap kitty to warrior in the blink of an eye.[31]

Throughout the delta in general, and at her sacred city Bubastis in particular, Bast was adored for her sensuality, congeniality, and loving nature. Even in modern Egypt the cat is still considered the epitome of beauty and grace. Winifred Blackman reported observing fellahin men and women putting a powder made of dried and pounded cat placenta in their eyes during the Yom Sabat en-Nur, or Sabbath of the Light. It was said to make their eyes beautiful, and to be told one had the eyes of a cat was considered a great compliment.[32]

The worship of Bast is as ancient as the beginning of the Old Kingdom, and her capital city was at least as old as the Fourth-Dynasty reign of King Cheops. The royal bloodline of the Twenty-Second Dynasty arose in Bubastis, and its pharaohs made it a point to honor their native goddess by embellishing the city with beautiful gardens and gleaming temples. In fact, a part of Bast's temple was said to have been built around an ancient sacred persea tree. The Greeks especially loved Bast, and her festivals were never more popular than during the Graeco-Roman period. When migrating Libyans appeared in the delta around 100 B.C.E., the population of the city soared once again.

April and May were Bast's most important months, for that is when her Great Festival brought visitors from far and wide, clattering through the streets, clustering along the river banks, and crowding their boats onto the Nile. Attended by men, women, and children alike, the festivals often drew over 700,000 people, and the days were filled with dancing, music making, wine drinking, and love making, as well as bawdy jokes and good humor among friends. This day the closeness of friends and family drew together people near and dear to each other. The Harpers' Songs of Egypt exhibit the kind of joyful exuberance typical of this day, when sorrow and loss were far from people's minds. Rather, the passion of living in the now became the focus of life under the auspices of Bast:

> Make holiday, call out with pleasure!
> Join incense and fine oil together.
> Lay garlands of lotus and fine linen on thy breast.
> The woman whom thou lovest best,
> Seats herself at thy side.
> Thou shouldst not hide anger in thy heart,
> Nor brood on things that have happened.
> Put music before thee. Make holiday!
> Follow the heart as long as you live.
> Do what is right. Be calm, friendly, content,
> Happy, not speaking evil.
> Give drunkenness to thy heart every day.
> Make holiday! and take heed:
> No man may take his possessions with him.
> And none who go away ever come back.[33]

Bast's temple stood on an island in the middle of the river and could only be reached by crowding onto the little ferry boats that plied up and down the Nile. Some of the larger boats filled with richly adorned noblemen and women sailed all the way from ancient Thebes down river to attend the festival. As they approached the little towns along the Nile, the villagers could hear the swelling strains of music coming from the flute players and the women playing castanets. They could hear the voices of songstresses and sometimes trickles of laughter, for well before Bubastis was reached, the wine and beer were already flowing. As the boats neared town, the villagers came down to the edge of the water to greet the entourage. Sometimes they stopped in town for fresh supplies, and even more people crowded onto the boats to join the sailing party. In ribald humor, women in the passing boats would hike up their skirts, call out to the male bystanders, and laugh as they sailed by. Once the party reached Bubastis, they made offerings and sacrifices. Then they drank more wine. Herodotus said that in Bubastis at The Festival of Bast more wine was consumed than at any other time of the year.[34] Delicious foods were also provided, such as honeyed breads, raisin cakes, pomegranates, figs, roasted fowl and meats. The streets fairly writhed with dancing, music

playing, and singing all day and night.

In part, the uproarious festival recalled the myth of Hathor and Ra, of how the goddess of love and beauty revealed to the god her sexual mysteries:

Eighty years after the death of Osiris, his family members were still arguing over who should inherit Egypt: Osiris's hawk-headed son Horus, or his brother, Seth.[35] War after war, council meeting after council meeting, the dispute waged on, wearing thin the patience of god and goddess alike. Nerves frayed, the gods began to quarrel among themselves. Ra, the eldest of the gods, rose at last and made a dramatic, sonorous pronouncement of his final, final decision. At that moment the young, impertinent council member Baba, a red-buttocked monkey god, jumped to his feet, pointed his finger at Ra, and laughed.

"What would you know about it, you old wind bag?" Baba asked. "Look to yourself! Your shrine stands empty!"

Cranky and sorely aggrieved by this insult, the old sun god stormed from heaven's council hall and locked himself in his room. Baba was immediately thrown out of the council, but still Ra lay sulking on his bed, so insulted that he refused to speak to anyone and would not come out of his room.

After some time, Hathor decided to pay the old god a visit. Garbed in her golden array and in an aura of wondrous perfume, the beautiful sky goddess tiptoed into Ra's room, where she found him lying, sulking on his bed. She smiled beatifically; and before either could say anything, she raised her skirt over her head and spread wide her vulva in front of his face. Ra laughed uproariously. At the sight of her, the old god rose up, returned to the council hall, sat with the Great Ennead, and the meeting resumed.[36]

Hathor could be full of surprises. She almost purposely blows her siren image to become a kind of buffoon. Her antics in the judge's chambers, however, succeeded in their intent. Her nakedness makes the overly serious god laugh and forget his troubles. Still, the obvious sexuality of the scene is a reminder of the deeper feminine mysteries of life, birth, and creation. When Baba tells Ra that his shrine is empty, he isn't telling Ra to "go home"; he's accusing the god of impotence. Instead of fighting back, Ra turns passive and lies down on his couch in a sadness and stillness reminiscent of the death of Osiris. What can resurrect the God? The same thing that resurrects Osiris—the sexuality of the Great Goddess. As Isis resurrects Osiris, Hathor causes Ra to rise. The erection is literal, figurative, and symbolic. When Hathor raises her skirt, she shows Ra her "empty shrine," which makes him laugh, but also reminds him of the power of emptiness. It is the space waiting to be filled with life and

creativity. Her intent is not necessarily seduction, but simple exposition. In essence, she presents Ra with a doorway, an entrance, an exit, a place of transition, which is what the womb of the goddess always is. To pass through the portal is be transformed. Ra is given an opportunity to change.

The goddess provides the opportunity. The response is up to the individual. Ra's response is to laugh at his own foibles and to rise up to meet his challenge. Of course, there are other choices. A separate folktale relates how one day Hathor came upon a cowherd watching over his cattle in the swamps and decided to disguise herself as one of his cows. When she suddenly transformed again in front of him, revealing herself as a naked woman with tousled hair, the cowherd was so frightened that he turned his cows toward home and beat a hasty retreat.[37] When Hathor appears naked, she embodies the Great Mother who is simultaneously the Great Lover. Mortal men might find the Mother's sexual boldness frightening, while the gods might find it kind and generous, as well as outrageously funny.

Some scholars of Egypt view Hathor's sexuality and The Festival of Bubastis as simply lascivious. Spiritual truth cloaked in sexual humor becomes a difficult combination for the Western mind. To the Egyptians, The Festival of Bubastis worked in several ways: It provided a release from the daily drudgery of life, an antidote to despair and to overly serious matters. It allowed people to express strong emotion, giving them an alternative to making war. It was a day of laughter and poking fun, rather than of frontal assault. The festivals were a great equalizer, a kind of national holiday in which everyone could participate. For the oh-so-lofty and superior, this dip into the primal, sensual world could be a humbling experience, reminding us all not to give ourselves airs.

For any man or woman who could gaze at the naked truth without becoming embarrassed and averting their eyes, the nakedness of the goddess offered a view of the divine mystery of duality, opposition, and ecstatic union. With the view that sex is the common experience among birds and bees, humankind, and gods alike, there comes a sense of the unity of all things in spirit, a certainty that creativity and regeneration are the pulse of the universe. For women, especially, the day reminds us that sex is not a male prerogative whereby men select the choicest fruits and women wait to be picked. When the goddess is vibrant and alive in her own sexuality, she exhibits the right to pick and choose her mate, to determine when she will and when she won't, to attend to her creative cycles without interference, and to decide to have children or not.

Women's freedom to choose a mate and express their feelings of love were two of the benefits of ancient Egyptian

society that women in other cultures did not often have. Ancient Egyptian women openly discussed sex, and birth control methods were well known.[38] Throughout the culture circulated a number of myths, hymns, and poems that dealt, sometimes frankly, sometimes humorously with a subject that many people today might consider taboo. Lovemaking was playfully called "spending a merry day," and the delight in which one engaged in song, dance, lovemaking, and sensual pleasure was considered pleasing to Hathor.[39] Courting in ancient Egypt was often controlled by the women.

The sistrum often appeared bearing the image of the goddess.

Some of Egypt's most beautiful love poems appear to have been written by women.[40] In ancient Egypt intellectual equality and literacy go hand in hand with the personal freedom women experienced. One of the tamer, sweeter versions of love poetry seems like something a priestess of Hathor might have written after spending a merry day at the Great Festival in Bubastis. Reminding me of the later ecstatic love poetry of Rumi, it reads:

> There are flowers of Zait in the garden.
> I cut and bind flowers for you,
> Making a garland.
> And when you get drunk
> And lie down to sleep it off,
> I am the one who bathes the dust from your feet.[41]

Bast possessed qualities of a Dionysian type, including not only the sensual desires of animals, but also a love of poetry, dance, and song—the higher states of ecstasy that elevate humankind above the simply bestial. The priestesses of Bast and Hathor not only played harp, lyre, guitar, flute, sistrum, tambourine, and drum, they were often the composers and choreographers of sacred dance and music. Their instruments, played for and dedicated to Hathor, Isis, and Bast, were part of the sacred rites of music intended to arouse and shape the emotions of the participants and listeners. Mythologist Joseph Campbell notes that in this way music established a "shared consciousness" so that through the group ritual of music and dance the celebrant "reconciled the fragmented person with herself [and] reinserted the individual into the whole that surrounded her."[42] Musical vibration communicates without words. The significance of these rituals, then, Layne Redmond reminds us, was simultaneously political, spiritual, intellectual, and emotional.[43]

The sistrum was the quintessential musical instrument of Bast, played by priestesses at all her rites. Many times the sistrum was surmounted by a cat face or by a seated cat, a sym-

bol evoking the blessing of abundance. Sometimes referred to as the emblem of love or the fertility awakener, the sistrum originated in Nubia as part of the local fertility rites.[44] The sound of its music can still be heard today all along the Nile wherever the sistrum player is invoking the fecundity of the Great Goddess. Like the ankh, the sistrum's shape connoted the union of masculine and feminine energies, with its upper loop containing the "seeds" or rattles representing the feminine womb, and the lower elongated handle representing the masculine phallus. In the mystical tradition sistrum playing reproduces the creative harmony of the world, with the four bars inside the loop representing the four elements of the natural world. Seed rattles replicate the jarring chaos of the universe that quickly falls into rhythm and harmony; the seeds themselves signify life being cyclically destroyed and reproduced.

Hathor priestesses were the primary musicians of ancient Egypt. Says James Blades in his history of percussive instruments:

> All records from this period [Middle Kingdom, circa 2,000 b.c.e.] show the performers as women; in fact, the whole practice of the art of music appears to have been entirely entrusted to the fair sex, with one notable exception, the god Bes, who is frequently noted with a drum with a cylindrical body.[45]

Bes, of course, was the musical companion and dance partner of Hathor in Dendera. Dressed in leopard skins, he wore a long beard and resembled an African pygmy. While only Bes played the cylindrical drum, reminiscent of the African *djembe*, the priestesses of Egypt accompanied him on tambourine-frame drums. They beat the drum with their hands, rather than with a stick, for the human hand beating the drum increased the potency of the religious ritual, by duplicating the beating of the human heart.

Rhythm played an important part in ritual. Rhythm, whether in music, dance, or nature, connotes immediate apprehension of the recurrent cosmic cycles. We know rhythm by observing the cosmic motion of stars, the change of seasons with their growth and decay, the monthly cycle of menstruation, the movement of the tides and moon, and, of course, the beating of the human heart. In the womb, we connect with the mother's heartbeat, and her body mirrors all life on earth and in heaven.

Likewise, dance, the graceful attainment of simultaneous balance in motion, was also the image of the movement

of the cosmos. Nearly every important event, from feast days to funerals, involved dance. The movements of Egyptian dance are reminiscent of sacred African dance ritual. As the chanting of sacred words or syllables increased, the rhythm of the dance gestures and strict ritual breath patterns likewise increased until they reached an almost frenzied pace. The sheer physical exertion of combining all three—breath, chant, and dance—created altered states of consciousness, the outcome of which was collapse into ecstatic union with the Divine.

Symbolist Schwaller de Lubicz believed that such a search for supracorporeal consciousness was a natural, instinctive religious response, and that religious litany and chant bear a similar if somewhat less exuberant effect. The point of the dance, the song, and the breath is to simply stop thinking and learn to be at one with the moment in which the Divine will appear. "The continual repetition of a gesture or word," Schwaller de Lubicz notes, "is intended to fascinate the mind in order to give free expression to the 'understanding', be it psychic or higher."[46]

C. J. Bleeker agrees with scholar of primitive religions R. R. Marett that the earliest religious impetus manifested through dance rather than through thought. Says Bleeker, "Dance, song, and music comprise the oldest means employed by man to express his emotions and reactions to life and the world."[47]

That Hathor was the beloved patroness of dance and music attests to the great age of the goddess. She was first worshipped around 5000 B.C.E. by dancing priestesses on the Nile river banks, their arms upraised in an ecstatic flight imitative of the Bird Goddess, their Mother of the Sky. At her temple in Dendera she was known as the Queen of Happiness and Mistress of Drunkenness, Jubilation, and Music. Five thousand years later at the Temple of Isis in Philae, Hathor was invoked as "the lady of the dance, the mistress of songs and dances accompanied by the lute, whose face shines each day, who knows no sorrow."[48]

Activities

1. Keep a small notebook beside your bed. Before you go to sleep, reflect on the day's events and record the blessing you have received.

2. Get into your cat nature for a day. Do things in a catlike way. Do a few things that make your body purr, such as taking a bubble bath, wearing silky clothes, brushing your hair, or rubbing yourself in scented body lotion. Nap in the sun. Curl up beside someone you love. Eat tasty treats, but only when you feel like eating. Find an object of curiosity or beauty and gaze upon it in silence. Stretch; become aware of your muscles, of how your body feels in motion. If you're a playful kitty, give yourself a more strenuous workout. Get a massage and feel how good it is to be pampered. Know yourself to be beautiful, graceful, and sensual. Relax for the day, then dress up tonight for some fun on the town.

3. Throw yourself a Goddess Party. Invite some friends to come dressed as their favorite goddess. In addition to food and drink, ask each goddess to share a song or part of her life story, making the evening into a performance. If you prefer a masked party, send along a set of paper sunglasses with the party invitation, directing your friend to decorate it with feathers, glitter, or trim in any way that seems an appropriate rendering of their goddess energy. Perhaps you'll offer a prize to the best-dressed goddess. Like The Great Festival of Bast at Bubastis, you may make your party an annual event, one to which every party goer is hoping for a personal invitation.

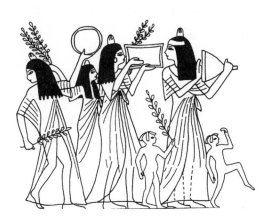

Young girls and women play drums and carry sprigs of wormwood in festival procession.

THE GOING FORTH OF NEITH
ALONG THE WATER

Appropriate for Days that Celebrate

- Completion
- Marriage
- Protection
- Wisdom
- Self-assurance
- Justified Rage
- Rebirth

The goddess Neith as she appears on the shrine of Tutankhamun.

Among the oldest manifestations of the goddess is her appearance as the serpent. Ancient Egyptian hieroglyphs denoting the divine female are usually accompanied by the hieroglyphic symbol of the cobra, connoting "goddess." The serpent, associated with Neith, Isis, Sekhmet, Meretseger, and many other delta goddesses, was the sign of the healer, the high priestess, the shamaness and visionary. Serpent power was radical energy, both dangerous and transformative. The veils between this world and the next were said to have been woven into a curtain of snakes.

Goddesses of fate, weavers, and storytellers were natural companions to the serpent, whose endless undulations across the sand resembled the weaving of the web of fate, the back-and-forth movement of the shuttle that forms the cloth, or the zig-zag twists and turns of the storyteller's plot. The Great Goddess continuously shed her skins, transforming herself into first virgin, then mother, then crone. Neith embodied all three forms and used her power to hold human destiny in her hands. Mother of creation, Neith wove the web of life; she spun the cloth on which the infant child was delivered and wound the cloth about the mummy being wrapped for burial. (See Pamenot 5, The Brilliant Festival of the Lights of Neith.)

Isis, too, knew serpent magic, was a weaver of the web of life, and became a teller of tales. One myth recounts how, after Osiris had died and while she was pregnant with Horus, Isis was kidnapped by Seth:

In a tale reminiscent of the Miller's Daughter and Rumpelstiltskin, Isis was imprisoned in a sunless room beneath a mountain and forced to weave for Seth. As Osiris was trapped in the underworld, so Isis became ensnared in her own prison. She forgot for a moment that she was a goddess and the embodiment of the creative matrix. Instead, she sat and wove, and as she wove, the life within her grew—a hidden, deep, and mysterious process.

As she worked the loom, she listened to the voices of the dead, gathered their words and memories, and spun them into lullabies for her unborn child. Because her tapestries were beautiful, Seth sent his courtesans to Isis. She taught them the art of transforming flax into thread, thread into linen, dead matter into new life. She combed the flax; she saved the seed. She taught the cycles of transformation, separation, unification, desire. She taught the stringing of the loom, the plucking of individual strings, the insertion of fine golden threads. She taught precognition of the shuttle's path and the making of patterns. Each day the women came to admire the handiwork of the goddess and the fullness of her belly.

"Teach us the magic of weaving fine children," they said.

"Pray as you weave," said Isis. "With prayers clot the blood and knit the bones into form. Weave what you envision: a ladder to heaven with threads of sunlight through gold wings. I make a

web of flesh and ensnare in it a soul shining and silver as a fish. I weave a story old as memory, long as the life of a god. Sing to the child: May he live long, flourish, and grow in health. Bind his fate with love and blood and desire. With every thread speak his holy name. That is the cloth of life."

At last Thoth, god of wisdom and of time, rescued Isis. One night he sent seven scorpions—who were the Seven Hathors, or goddesses of fate—to creep under the door to her cell and help the goddess escape from Seth. She seemed reluctant to leave at first, but the Hathors cautioned her with tales of Seth's misdeeds against the people and his plans to kill her child. They told her stories of her son's destiny. They reminded the goddess of her true power.

"Hide the child," they said. "He will grow strong. On gold wings he'll soar to the highest heights of the gods. He'll sit on your lap, and he'll sit on the throne of his father. He will avenge Osiris. He will possess the Two Lands. Name him Horus, the twice born." With their pincers, the scorpions clipped the ropes that bound Isis and accompanied her as she came forth from her prison cell. When Seth's henchmen tried to stop her, the creatures stung them to death.

This festival that bears the name of Neith was actually celebrated by the priests of Amun during the New Kingdom era. It seems a prime example of how, over a pattern of several hundred years, the divine myths of one neter become usurped and enmeshed with the festivals of another. The feast day celebration continued even while the prominence of the original deity waned.

During the New Kingdom era, every ten days a veiled image of the god Amun was put into his naos on the sacred barge, hoisted upon the shoulders of his priests, carried out of his temple down to the river, and ferried across the waters from Karnak to Deir el-Bahri. Every ten years, amid more elaborate pomp and circumstance, he made a similar voyage from east to west to the Temple at Medinet Habu. In this way the "veiled" mystery of the living presence of the Divine and the soaring spirits of the resurrected dead were united. This veiled image of Amun manifested as a serpent god called Kneph who lived in a cavern beneath the temple of Medinet Habu. He was equated with the great Ouroboros of cosmic creation.

Called Kematef (He Who Has Completed His Moment) at other times, this same horned viper was celebrated for swiftly shedding his skin at the end of one life cycle and the beginning of another.[49] His ten-day cycles coincided with the length of one Egyptian week and so became the impetus for Amun's weekly visits to Deir el-Bahri. Amun's second trip to Medinet Habu celebrated a decade-long cycle of transforma-

tion. Ten in Egyptian number magic is 1 + 0, which represents the beginning and the completion combined. The horned viper, called Lord of Life, was so sacred that these reptiles were sometimes mummified and buried beneath the temple as a means of magically protecting and sustaining the viper's self-regenerating power.

Before Kneph or Kematef, the great goddess Neith, oldest of the divine beings, was the original primordial serpent lying in the cosmic abyss. Serpent of the cosmic deep, Neith knew that the Great Flood that destroyed the ancient world was likewise a cataclysm that spawned regeneration. She knew that without death there comes no second birth. Linked with Nut as goddess of the deep celestial waters, Neith births the sun god Ra and daily recreates the light of the world. Unlike Nut, Neith had no mate. She was an androgynous being, called by the Esna theologians "the male who acts the role of the female, the female who acts the role of the male."[50] As both male and female, she completely understands duality; in fact, she created it. Therefore, she is not to be crossed. The goddess giveth and the goddess taketh away. The power of Neith existed in her strength as a warrior, and all the gods and goddesses of Egypt bowed to her. One meaning of her name is "crown," and like Tefnut, she was the fire-spitting cobra of the pharaoh's crown, as indicated in this Hymn to Neith:

> You are shielded! She is coiled on your brow.
> You are shielded! She is draped about your temples.
> You are shielded! All you gods of the South, North, West, and East; all the great nine gods who follow you.
> Their ka's rejoice over this king
> As Isis rejoiced over her son Horus when he was but a babe in Egypt.[51]

Because both Neith and Hathor shared the common appellation of Great Sky Goddess, this festival of Neith—originally a Lower Egyptian festival—was linked with Hathor in Upper Egypt. In Dendera the feast lasted five days, during which time the Hathor priestesses visited the temples on the west bank and the desert tombs in the Valleys of the Kings and Queens. Neith and Hathor were never far from each other there. The horned viper goddess Neith was easily found crawling through the desert sands represented by Hathor as Lady of Amentet (or the land of the dead).

This festival alludes to the disappearance of the star Sirius, which vanishes from the horizon during this time of year. On the average there are seventy days in which Sirius, the herald of rebirth, is said to have gone underground before reappearing at dawn on New Year's Day. The disappearance

of the brightest star in the sky recalls the mythic phoenix who flies from Egypt every 1,460 years and returns to Arabia. There, fanning its wings, it sets itself ablaze in its own nest and arises reborn from the ashes.

On one level, the bennu bird of Heliopolis represented the power of Ra (who is linked with Amun as supreme deity). But at a deeper level, it represented the power of the goddess manifest as Sothis; that is, the star Sirius. One linguistic clue is that the word for "phoenix," *bennu*, and the word *weben*, meaning "to arise starlike in brilliant light," are related. Arabia is simply a metaphor for the East or the eastern desert, from which the star of the goddess rises anew.

It is my feeling that this festival of The Going Forth of Neith harkens back to an old idea of the star Sirius as being an image of the goddess, as an image of rebirth in brilliance, and as an image of the Ouroboric serpent biting its tail. The cyclical nature of reality is within this mystery of the serpent goddess shedding her skin: As she begins one cycle, she completes another.

Calling the Circle of Crones

Goddess power is meant to be shared. Much of what she teaches is unity, community, and strength in numbers. As much as it takes a whole village to raise a child, it takes a whole community to raise the level of consciousness. It is time to call together your sisters and brothers in spirit, to recite and listen to the stories that hold our deepest wisdom and deepest longings. Sometimes we need to be reminded of our own power and inner resources. As much as we learn to speak powerfully, we must learn to listen just as powerfully and deeply, to draw up from the waters of the unconscious the fullness of our being.

One of the most useful hieroglyphs I have discovered is the word *ma'at*, or "truth." Its phonetic glyphs are accompanied by two signs: the image of a scroll tied with string and three grains of corn. The rolled-up scroll alludes to the power of the life's story, the secret wisdom of the heart. The grains of corn indicate multiples of anything, perhaps hinting that the truth is always more than one thing. More than our own personal narrative, it is the story of all of us.

For a time I lived in a community of strong, diverse women. We spanned twenty years in age; we were virgins, mothers, and crones who met once a week to write and to share food, as well as the stories of our lives. We jokingly called ourselves the Thursday Night Crones. We never planned the topic but would pull a word or phrase from a book, or from the air, and write it down. Whatever we wrote was the feeling of the moment. The writing became like looking at a crystal, with multiple facets, but each reflecting the truth. Each of us learned to listen with deep empathy. Without judgement, we honored each other's passages. Without worrying about what we would say, we were able to hear each other. If we arrived feeling confused, or out of kilter, we left feeling loved, heard, and valued. Such was the power of story, of what Clarissa Pinkola Estés calls "Singing Over the Bones."

We wrote by candlelight, by moonlight, around the pond, by the fire, in the midst of blizzards, rainstorms, and tornadoes, on quiet evenings under stars. We wrote with children running in and out of rooms or quietly writing alongside us. On energetic nights, we covered three or four topics, each suggested by a different individual. At times we recalled a favorite goddess myth and wrote about that. We brought objects that meant a great deal to us from the past, touchstone images or talismans, and we each told our stories. We brought pictures of our mothers, and grandmothers, and daughters, then shared a story from their lives.

Beginning with a core group of four women, we expanded to about thirteen. Not everyone attended each session, but if only two people gathered, the stories continued to unfold. At times we wrote long distance, reading to each other over the telephone. There was no thought of "What are we going to do with all this stuff?" We were already putting it to its greatest use—as a means of dialog among us, as a means of enriching us, as a way of drawing close as sisters. Each piece of writing became an individual thread that wove the whole cloth of a community. Although all of us no longer live in the same community, the cloth we wove is strong and has held us all together.

May your own cloth be similarly woven and spread for the feast.

Writing Topics for the Group

1. The myth of Neith's creation retold as if it described your life right now.

2. Simple themes: "Leaving," "Returning," "The Long Flight."

3. One of my favorites: "What Happened When the House Burned Down." (The burning may be actual or metaphoric.)

4. "Gifts From the Universe." (This could be a list, or a long elaboration.)

5. "Secrets I Learned at Ten." (Optional writings might include secrets you learned throughout each decade of your life.)

6. "What I Wanted Was . . ." (This should be speed-written without thinking about it at all. Just write for 10-15 minutes everything you wanted, anything that comes into your head. Optional writings might include a similar list of what you got.)

7. "Where I'm Going . . ." (This could detail an actual trip, a life direction, a new decision, or a marvelously lush escapist fantasy.)

8. "In My Dreams . . ." (This may detail an actual dream, a situation you want to change, or a fantastic story of an alternate life.)

9. "Changing Skins . . ." (This may recall life changes or explore alternative selves.)

10. "What Happened in the Dark . . ." (This may explore the night, the unconscious, or the underworld.)

11. Number a piece of paper from 1-50. As quickly as you can, generate a list of possible topics you might want to write about next time.

Neith appears in her magical, protective form as the rearing cobra, which is the uraeus appearing on the king's crown.

THE HIEROGAMOS OF HATHOR AND HORUS

Appropriate for Days that Celebrate

- Marriage and Love
- Family
- Motherhood
- Traveling
- Divination
- Sensual Delight
- Homecoming
- Weddings
- The New Moon in Taurus
- The Integration of Masculine & Feminine

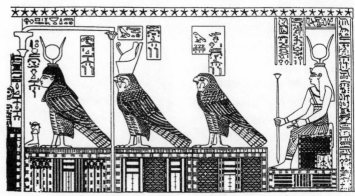

Hathor and Horus the elder celebrate their sacred marriage, appearing in hawk and human forms.

First came Hathor, goddess of love, born of no other goddess or god, mistress of all divine beings; the womb of heaven, she contained all its scintillating possibilities: the milky swath of innumerable stars that are the souls of all awaiting birth, the cyclical wheeling of the zodiacal constellations, the changing moon phases, and the eternal birth and rebirth of the golden light of the sun. At birth, the Golden One soothes the babe, proclaiming, "For you, I light a fire in the sky. My love dispels darkness." At death, the frail ones cry out to her, "Blue-lidded lady of dawn, golden lady of the mountain. . . . Let an old man rest in your arms. Let him look last on love's face, breathing love's breath."[52]

In the myth of the Contendings of Horus and Seth, the seductive, healing goddess Hathor teaches Horus, the fiery god of war, the true nature of love. It is a story of first love, of true transformative power, wherein after the young Horus meets Hathor, his life is never again the same. He must give up his selfish, egoistic, super-macho ways of being in order to enter into the domain of true relationship, or *hierogamos* (from the Greek *hiero*, meaning "sacred," and *gamos*, meaning "marriage"). As the story goes:

After Horus impetuously cut off the head of his mother Isis for setting Seth free when she had snared him, he ran away into the desert mountains, carrying his mother's head. Finding an oasis at last, he fell asleep beneath a sycamore tree. Unbeknownst to him,

the god Seth was hot on his heels. Finding Horus there, he seized him, threw him to the ground, and snatched out his eyes. The eyes he buried in the desert sand; he left Horus blind in the desert, the night descending. By morning, the two eyes had transformed themselves into two bulbs and sprung into lotuses. The flowers would have died, but for the water they received falling freshly from the tears streaming down the face of Horus.

Hence it was that after the violence Horus committed against his mother, violence befell him in return. He suffered the lesson of karma. To some degree what the young Horus learns is that he is not the golden boy, the center of the universe. He has to pay for the crime of his selfish temper, and pay dearly with his sight, but it is a wound that opens him to relationship, a wound that rends the heart and allows another person to enter with the gift of love.

In the morning the goddess Hathor came into the desert to her sacred sycamore and found there the gift of the lotuses and the blind and weeping Horus. The cow goddess healed the blindness of the god with honey and the milk of human kindness; that is, she placed in his blind eyes drops of the precious, life-giving fluid which emanate from her own essential nature. She healed the right eye, then the left. Hearing her say, "Open your eyes," Horus opened them and gazed upon the face of the goddess, immediately falling in love.

The myth of Hathor and Horus helps us to understand the true power of the goddess, the power to live and love again. After Horus has injured and betrayed his own mother, the goddess still finds a way in her Hathor manifestation to turn the other cheek, to instruct and heal him. There is no greater power than love. And there is no greater love than the love of the goddess who sees in life limitless creative potential, even in the direst of situations.

The embodiment of love itself, Hathor ruled life from beginning to end in all its varieties of feminine relationship: sister to sister, mother to child, wife to husband, woman to earth, and in all relationships to the Divine—priestess to goddess, soul to heaven. But it was as the patron goddess of love that she was most well known. All women in love were her priestesses. Common folk cast love spells in her name. For three thousand years, pharaohs and scribes extolled her beauty and grace in a multitude of prayers, poems, and songs. She especially blessed the artists of the world, its scribes, painters, dancers, and musicians. The strumming of the lyre and harp, the rhythmic shushing of the sistrum and menat, the trilling of the pan pipes and flute pleased her. Bodies in motion, whether in dance or in lovemaking, brought her heart joy.

Mistress of the Garden of Earthly Delights, Hathor shaded lovers beneath her sycamore trees, fanned their passion with her gentle breezes, and nourished them with her figs, dates, raisins, and honey cakes. Her earthly manifestation was as the goddess of the sensuous. What sounded sweet, tasted sweet, smelled sweetest and was beautiful to the eye—in all these resided the goddess Hathor. From the depths of the Nile she brought forth brilliant lotus blossoms to perfume a lover's hair. Her myrrh trees sent forth aromatic spices, and the twittering of birds in the acacia filled the lovers' ears. In her cool garden pools they bathed, whispered, and laughed amid the oleander and moonlight. Day and night, the mistress of beer and wine was celebrated with festivals of jubilation, party going, and sometimes drunken revelry where naked maidens danced like acrobats and serving girls carried round platters of roasted duck and onions. This Hymn to Hathor merely touches on all the possibilities of manifestation of the divine Goddess of Love:

All hail, jubilation to you, Golden One, sole ruler of the world,
Mysterious one who gives birth to divine beings, who forms the animals, molds them as she pleases, who fashions men and women.
O Mother, luminous one who thrusts back darkness, who illuminates every human creature with her rays;

Hail, great one of many names. . . .
It is the Golden One! Lady of drunkenness, music, dance, of frankincense and the crown, of women and men who acclaim her because they love her.
Heaven makes merry, the temples fill with song, and the Earth rejoices.[53]

The celebration of Hathor's love affair with the world and her sacred marriage to the handsome, heroic Horus began in Dendera on Epiphi 1 and usually lasted for fourteen days. Depending on the lunar calendar, however, the festival could have begun as early as the middle of Payni.[54] The important fact was that the boat arrived in Edfu during the new moon in the month of Epiphi.[55] The temple inscriptions insisted that The Hierogamos of Hathor and Horus must take place precisely on the day of the sun-moon conjunction, for the sacred marriage represented the union of the two most important lights in heaven: Hathor, the moon, and Horus, the sun.[56] The ancient Egyptians called this the Day of the Beautiful Embrace.

The festivities no doubt rivaled those of the May Day spring celebrations in Europe. Certainly, every veiled bride in elegant array who voyages down the aisle amid music, flowers, and solemn dance to greet her husband at the altar enacts the sacred marriage of Hathor to Horus, her Beloved. Their vows are exchanged and sealed with the conjunction of lips, a kiss as promising as any astrological conjunction of sun and moon. Grains of rice rain down upon the couple as a sign of fertility and abundance. Sweet cakes are eaten, wine consumed, and dancing lasts long into the day. At last, the happy couple voyages away down the street in a lavishly decorated sacred barge that resembles the groom's car, and they honeymoon in some exotic resort near the water—Niagra Falls or the Bahamas.

On the inner face of the east pylon of the Temple of Edfu is a minutely detailed description of the annual Festival of the Reunion.[57] As early as the Payni 18, initial preparations for the sacred marriage began. The priests and priestesses engaged in the same frantic preparations for the bride and groom that precede any wedding. The god and goddess were spiffed up and polished, beautiful garments were sewn for the occasion, arrangements were made for food and flowers, and rehearsals were held for dancers, musicians, singers, and attendants. The artisans were busy in their studios carving, painting, polishing, and encrusting in rich jewels the wedding presents for the happy couple. There was much to do before the big day arrived when Hathor set sail from Dendera to Edfu.

In anticipation of the celebration, townsfolk from nearby Diospolis Parva, as well as from the desert oases, camped along the banks of the river and outside the temple walls. The days grew hotter, and the tension preceding the big day mounted. Most of the initial ceremonies were performed in privacy within the temple walls. The general public only overheard the strains of music and the singing. The following week began with high-pitched, feverish excitement as the public awaited the Beautiful Sailing of Hathor.

Four days before the new moon, the gates to the temple courtyard at Dendera opened. Four gatekeepers, dressed as the gods of the four directions and bearing golden staffs, appeared. Out came the steward of the temple stores, three treasurers, and the bearers of the smouldering altar fires. White-robed priests and priestesses appeared, their golden earrings, breast plates, and necklaces gleaming. The well-oiled bald heads of the priests glinted in the sunlight. The perfumed wigs of the priestesses sent above the crowds a cloudy aroma of myrrh. There came the sacred astrologers, the *wab* priests and priestesses, the prophets and prophetesses wrapped in their leopard skins, and the sacred scribes male and female, bearing the holy writ, the words of power. Out came the bearers of the sacred emblems, walking backwards, followed by several thurifers with the smoky perfume of incense billowing after them. At last the small golden barque appeared, carrying the divine naos, the tabernacle of Hathor, hoisted on the shoulders of sturdy priests dressed in white linen kilts.

The procession moved silently toward the river and the barque took its place in a barge named *Neb Meru-t*, meaning "Mistress of Love." Carved on bow and stern, adorned in shining gold, was Hathor's beautiful face, complete with her horned diadem and delicate shell-like ears, looking not so much like a cow as like a mermaid. The boat of the goddess was towed by five other boats sailing ahead of it.

In one of these boats, the divine statue of Horus of Nekhen awaited in his shrine. From the boat's mast flew the emblem of the falcon. Inside this boat sat the full choir from the city of Hierakonpolis (ancient Nekhen), and the temple treasurer from the oldest Horus temple in all of Egypt. In the boat that led the procession sat the king's steward. The mayor of Edfu, along with more minstrels, rode in a third boat, while yet other officials took their stations in the remaining two boats. Although these were the only "official" boats in the procession, the Nile was teeming with boats that day. Courtesans, noble men and women, and any and all who could afford it took out their own boats or hired one in order to float along downstream beside the goddess of love. No one was willing to miss any of the grand pageantry of this day.

Each member of the entourage played a definite role. Lucie Lamy describes the bustling, administrative scene, saying, "The nomarch or governor of Elephantine and his retinue had to oversee the 'opening of the waters' [the constant sounding of the water's depth, essential to avoid running aground on the sandbanks, so frequent in the Nile], while the vizier of Dendera and his company kept constant watch. The mayor of Hierakonpolis held the cable at the bow, the vizier of Komir held the one at the stern, and these two cities also provided the crews of the guide boats."[58]

Pharaoh's soldiers stood in parallel rows, flanking the banks, each shouldering his weapon to protect Hathor. Young boys and men from town, as well as farmhands from nearby fields, filled in the gaps, imitating the soldiers by brandishing leafy palm tree branches. As the boats sailed by, they raised their voices, shouting, calling out a greeting to their mistress and her entourage. Many of them began to run as fast as they could, following the boats all the way from Dendera to Edfu. In four days they would travel nearly 106 miles along the banks on foot, all for the love of Hathor.

One day's journey covered nearly thirty-seven miles upstream. The boats arrived early at the province of the Great Nun, making their first stop at the Temple of Karnak. Everyone on board, including the divine Hathor and Horus of Nekhen, emptied out of the boats and went ashore so that Hathor and her procession could visit the other goddesses of Karnak. Hathor sailed upon the waters of Lake Asher, which is the sacred lake shaped like a lunar crescent that half encircles the Temple of Mut, the vulture mother goddess. After sailing, the goddess and her priestesses entered the Temple of Mut to receive her blessings. Hathor visited the lion goddess Sekhmet in her nearby temple, then the entire procession paraded around the festival courtyard of Thutmose III, which claimed over one hundred granite statues of the goddess Sekhmet, that wild ravaging lioness aspect of Hathor. Homage was paid to Sekhmet in her Hathor role as Eye of Ra. It was not the ravaging aspect of Hathor which was being emphasized by the goddess of love, but the gentle, loving, nurturing aspects of Hathor as Bast. Yet it should not be forgotten how closely love and enmity lie!

At dawn on the second day, the long, strenuous sailing began again, and oarsmen kept up the pace by chanting as they rowed upstream forty-four miles to Komir. At Komir lay yet another temple dedicated to the creator god Khnum and his consort, Anket, goddess of the flood. Again, Hathor and her entourage exited the boats to visit the sanctuary of Anket where offerings were made. A great feast followed with bread, beer, and a variety of foods and provisions being distributed to the festival participants and pilgrims.[59]

The third stop on the following day was only thirteen miles upstream at Hierakonpolis (or Nekhen), home of the Elder Horus and prehistoric capital of Southern Egypt. This was the original site of the worship of Horus and of the Great Sky Mother. Hathor again left her boat to pay tribute to the local Horus god. Much of the third day was spent resting and preparing for the grand festival of the following day. Further upstream at Edfu, the gods Horus and Khonsu, the moon god, were already being carried out of their temples amid similar festivities to those that occurred at Dendera a few days before. Their processions of priests, astrologers, prophets, and minstrels carried the gods to the river banks and set them in their boats. The prow and poop of the ship of Horus was, like Hathor's, ornamented with a golden image of its divine owner—in this case, a falcon's head surmounted by a solar disk. The boats set sail downstream, in order to go out the following day to meet Hathor and her retinue on the waters as they approached.[60] Back in Hierakonpolis, a sacrificial ox was obtained from one of the local people and brought aboard one of the boats. Despite being on his home turf, the local falcon god reentered his boat that evening in order to join the procession and sail with Hathor all the way to Edfu.

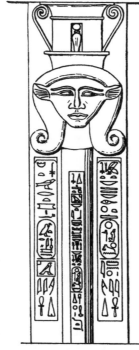

Hathor-headed columns, depicting a woman with cow ears, decorated the temple at Dendera.

On the fourth day, after sailing only twelve miles, the two retinues met on the Nile waters, somewhere north of Edfu, at a place called the Seat of Horus.[61] When the great, gleaming ceremonial barge of Horus appeared on the waters, a riotous greeting filled the morning air, with joyous fanfare amid the mingling of music and voices. The boats moored, and again everyone got out. At that moment a most important ritual had to be performed: an augury had to be taken. The priests of Edfu had brought with them four geese, representing Horus's four sons. Each goose was freed from its cage to fly in the four cardinal directions. If they failed to fly in their proper directions, it was an ill omen meaning that some obstacle stood in the way of the marriage ceremony. Amends would have to be made.

If the geese did not fly, the masts of the ships were lowered, the ritual cloths taken up, and the sacrificial cattle beaten. Each participant was required to get down on the ground, bowing low to the goddess of cosmic order, Ma'at, and to offer up gifts to her. Following that, the musicians, who had brought with them jujube and willow, had to weave the sacred plants into bouquets as an offering for Neith, the Great Goddess, Mother of All. If Neith was pleased, she might open the way for the rest of the ceremony to continue.

The entire boating party then returned to their boats, hoisted their masts, spread the altar cloths anew, herded and boarded the divine cattle, and finally continued in procession toward a site called the Mound of Geb. Here, everyone got out once again and additional offerings were made to the god of earth. That concluded, the party reboarded. The two parties then sailed together toward the Edfu temple precinct, having to arrive there precisely at the eighth hour of the day. According to the Egyptian method of counting sunrise as the first hour, the eighth hour would have been some time in the early afternoon, say around 2:00 P.M. on Epiphi 1, the day of the new moon. The vessels had to pull up alongside the wharf at the exact appointed hour. Considering that the geese might not fly in their appointed directions and additional ceremonies would then be needed, the priestesses and priests always planned ahead for the ill omen, so that the happy couple could arrive at their honeymoon suite at the Temple Edfu on time![62]

At last the boats pulled up at the wharf of the Temple of Edfu. No doubt when the boats arrived, the crowds lining the banks hurried down to the water's edge to meet them; and when the final docking was completed, a great cheer arose, a wave of excitement equivalent to the doors of the church opening and the bride appearing in the portal with her father. The river bank burst into the sound of music and celebration from all directions, with shouting, singing, and tambourines echoing all over town. The people cried out for joy. Menats, sistra, and crotalums vibrated. All the while, the priests were busy carrying the provisions for the feast from the boats and distributing them to the villagers who had come from districts all across Egypt to celebrate this festival day. Dressed in their finest clothes, every man, woman, and child was spiffed up, rubbed from head to toe with fragrant unguents, their hair braided in beautiful coiffures. There were dances on the banks, in the temples, in the streets. Certainly, it was a day to see and be seen.

In the court of Edfu, the happy couple was greeted by the town's finest singers, musicians, harpists, and dancers. The divine barques, preceded by their emblems, were carried on the shoulders of the priests from their ships to their repositories in the temple. Texts from the sacred books were read,

sacrifices of beer and wine, milk, dates, and bread were made.

At last, Horus and Hathor were reunited. The ritual marriage took place privately for three days inside the temple. The priests, priestesses, and all the company of the temples left the god and goddess in their suites to enjoy their time of conjugal bliss alone. Meanwhile, outside the temple walls, the entire population of Edfu and many of the participants from surrounding communities continued their gay celebration: drinking, feasting, singing, and dancing. While the divine honeymoon couple remained secluded in the temple,[63] all the priestesses and priests of their entourage repaired to a sanctuary located on the rooftop where they performed more rituals and gave more offerings to "the godly souls."[64] Alone in the darkness and silence of the temple—peace and quiet at last!—the goddess and her consort Horus "consummated the beauteous embrace." On the fourth day of the month, the couple's young son (either Ihy or Horus the Younger) was conceived and born eight months later on 28 Parmuti.

Not much is said about the actual rituals that occurred during these three days. The details were known by the priests and priestesses alone. E. O. James suggests that a sacred rite of lovemaking may have been reenacted by the pharaoh and the queen, or by the priests and priestesses. Certainly, with all the drinking, feasting, celebrating, and engaging of the sensual appetites during this week, those rituals were indeed reenacted somewhere near the vicinity of the temple!

One sacred song performed for the wedding celebration was called Hymn to the Golden One. It was set to music and sung in chorus by several priestesses while the pharaoh enacted the offering rituals:

> The pharaoh comes to dance,
> He comes to sing for thee.
> O, mistress, see how he dances!
> O, bride of Horus, see how he skips!
> His hands are washed,
> His fingers clean.
> O, mistress, see how he dances!
> O, bride of Horus, see how he skips!
> He offers thee
> This urn filled with wine.
> O, mistress, see how he dances!
> O, bride of Horus, see how he skips!
> His heart knows truth, his body knows strength;
> No darkness dwells in his breast.
> O, mistress, see how he dances!
> O, bride of Horus, see how he skips![65]

More rituals, celebrations, and offerings continued for the next ten-day week. Sometimes the rites took place at the Temple of Edfu. Sometimes the happy couple traveled together to other sites, such as the town of Behedty. There rituals were performed for them, especially those celebrating Horus as the young, vigorous hero who conquered Seth and those honoring Hathor as his companion and healer after he was wounded in battle.[66] In general, the tour of Hathor and Horus by water rather resembled a long honeymoon voyage—one in which the pharaoh participated—that included a survey of the kingdom. On the fourteenth day as the full moon approached, the priests, priestesses, musicians, and entourage of Hathor reunited and bid their farewells to Edfu; then the ships returned downstream to Dendera with Hathor alone. Her arrival there was most welcome. The people of Dendera wept upon seeing the boat bearing their goddess come sailing back home. She had been sorely missed during her long, two-week absence.

The first record of a celebration of The Hierogamos of Hathor and Horus appeared during the reign of the Middle Kingdom pharaoh, Amenemhet I, around 2000 B.C.E. Linked with the harvest rites of this season, it commemorated "the first fruits of the field" and was held in honor of the ancestors.[67] Because of the timing of the Inundation, May, rather than September, was the traditional season of harvest in Egypt, although some spring crops might have been harvested earlier in the season.

When the Greeks and Romans began to celebrate the Hierogamos, they decided the day was a planting festival, according to their more northern calendars attuned to the spring equinox. C. J. Bleeker resolves this inconsistency by explaining the entire festival as an agrarian one that celebrates both the beginning and the end of life. He sees the sacred marriage as a celebration of the Nile Flood, a celebration of the god and goddess recreating the world anew, and in honor of that, he believes, offerings made to the divine pair represented the first fruits of the harvest, as in the first wheat, the first calf, the firstborn of the god and goddess.[68] Of course, as with any festival in Egypt, there has been some dispute among scholars. Some believe the ancient Egyptians were celebrating a Hierogamos; others, that the festival was simply a reunion,[69] no more or less than a friendly meeting of the god and goddess.

In the union of the god and the goddess, all life has its regenesis. Of all the festivals in Egypt, this truly was Hathor's day. It was a festival in honor of the bride, for it is she who becomes mother of the holy child. The Hierogamos is always a union of opposites. In this pair, Hathor is the divine Mother, the sky, and Horus is both the falcon god and the earthly king. It is a sacred marriage of spirit and flesh, heaven and earth, like the marriage of Inanna and Dummuzi in

Sumer, of Shakti and Shiva in India, and of all marriages in all the traditions worldwide. Every royal couple who ever lived, including Charles and Diana, reenacts the Hierogamos, a marriage sacrament as much for the renewal of the land and their people as for themselves. The pharaoh's traditional heb sed festival is a related theme, where the masculine energy of the king serves to renew all life.[70]

Here, on Hathor's day, the feminine energy serves not only to renew all life, but to recall all the cycles of time, the rhythmic flux and reflux. It may seem unusual for a gentle, sensual, loving goddess to go a'courting and inhabit for two weeks at a time the very masculine temple of Edfu. Does Hathor belong in a temple dedicated to the warrior qualities of Horus fighting Seth, wrestling with crocodiles, and jabbing hippopotamuses with spears? Of course she does, says C. J. Bleeker: "Hathor had every reason to participate in the festivals of Edfu. . . . She appeared there as the Sun-Eye, as goddess of fertility, as goddess of the dead, and in these qualities was not only an honored guest, but above all a godly figure whose presence must be considered indispensable. By virtue of her personality and dynamic power she helped to a large degree to actualize magnificently in ritual the mythic concept on which the festival was based."[71]

The god of war and the goddess of love, like Ares and Aphrodite, continually march along hand in hand. Each in his or her own way controls the power of life and death. Power is the aphrodisiac. Of what else was Cleopatra thinking as she reenacted the sacred marriage of Hathor and Horus, sailing along the Nile under the gaze of her subjects in a resplendent boat filled with silks, tapestries, fruits, flowers, musicians and singers, as well a well-cushioned dais for herself, to greet Marc Antony?

Cleopatra played her Hathor-Isis story to the hilt, marrying great warriors—first, her brother Ptolemy; and after his death, Julius Caesar, with whom she toured Egypt sailing in her divine barge; and lastly, Marc Antony, her great love. She bore Caesar a son and birthed two children with Marc Antony—a boy she named Alexander Helios after the sun, and a girl she named Cleopatra Selene after the moon. She celebrated her maternity by building an elaborate birth temple dedicated to her son Caesarion, portraying herself as the divine Mother of the God, Hathor. To commemorate Antony's victory over the Armenians in 34 B.C.E., she and Marc Antony posed as Isis and Osiris for a pair of statues they had carved of themselves. Cleopatra even called herself Queen Isis, dressing in the traditional garb of the goddess and creating a fashion statement other Greek women emulated.[72] If she was not as beautiful as Hathor, Cleopatra was at least charming, cunning, and as necessary to Caesar and Marc Antony as Hathor was to Horus. Without her influence as Queen Regent, they would have had a difficult time setting foot inside Egypt.

Egyptian Tarot Spreads

Most people agree that Tarot cards originated in the Renaissance with the Romanians. Some say they derive from Egypt. I rather think they do, at least it's a wonderful curiosity to me that the letters TARO seem to spell out not only ROTA the wheel, but ATOR (or Hathor) in an endless circle of repetition. Tarot is the closest access our culture has to the equivalent of Egyptian hieroglyphic thinking. Whole worlds could be discovered in the hieroglyphs to those who knew how to read them. The mysteries revealed themselves in symbols that spoke, not to the conscious, but to the subconscious mind. Learning Tarot involves sitting with the cards and simply looking deeply at them, stilling any conscious groping after fact. The cards teach the reader what they mean.

The spreads that follow were gleaned from a variety of sources, or have been developed over time. They can be used with the Waite-Rider or BOTA Tarot, as well as other decks, including Murry Hope's Cartouche cards, Nancy Blair's Amulets of the Goddess, and Ralph Blum's Runes.

Clearing the Energy

Keep your Tarot cards in a piece of wrapped dark fabric, stored inside a box specifically used for this purpose. Clear them by passing them through the candle flame once or twice a year. If the cards have gotten old and worn, you might replace them but know that it will take some time before they begin to become accustomed to your energy again.

123

Sothis Spread

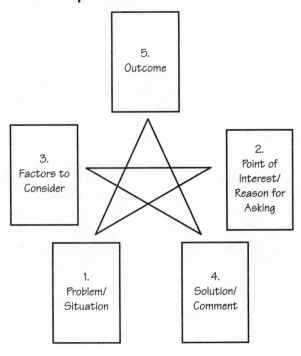

Sothis Spread for Spiritual Guidance

This star-shaped spread related to Isis as Sothis has never failed to give me concise yet detailed answers to a question. It works especially well with the Egyptian imagery of the Cartouche deck for which it was designed by Hope, but most Tarot decks and the runes also work. Results are best if the question is stated in specifics; i.e., I would appreciate some guidance about dealing with my child's problem X. If clarification is needed, I draw another card and lay it in position next to the card in question. Because the layout seems to address itself more to major spiritual themes in one's life than to transitory experience, I often separate the Major Arcana from the Minor Arcana. Using the Major Arcana, I shuffle, cut, and lay out the cards so that I can apprehend the forces at work behind my question. If I wish to know the practical manifestation these forces take on this plane of experience, I then shuffle, cut, and lay out the Minor Arcana cards.

The Guardian Goddesses Reading

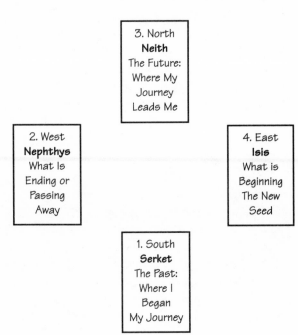

The Guardian Goddesses Reading for Situation Analysis

The guardian goddesses Isis, Nephthys, Neith, and Serket appear in the cardinal directions of Tutankhamun's tomb, guiding and protecting the boy-king in his time of transition from this life to the next. In times of one's own heady transition, I find this reading a comfort. I lay out three cards for each position, interpreting the triad as a sequence of unfoldment. In such situations where one needs the counsel of wiser women and goddesses, this layout works nicely. After the Tarot cards are laid, accompany each set by a single amulet drawn from Nancy Blair's Amulets of the Goddess. Knowing which goddess guards that portion of my journey, I know on whom to call for guidance and protection. When I do this reading, I sit facing north, the direction of my future, Then beginning from the south, which is the direction of the passing present—i.e., this incarnation—I lay out the cards in a clockwise spiral to west, north, and east, as shown.

Seven Hathor Spread

This seven-card spread named for Hathor's sisters, the goddesses of fate, can be substituted for a more traditional ten-card Celtic Cross reading. Its chevron shape, evocative of bird wings, links the Seven Hathors with the Pleiades who appeared in Greek myth as seven swans. The left side provides the sequence of events, the right side its commentary.

Hathor's Wheel
for Astrological Information

The horoscope layout follows the traditional astrologer's pattern for drawing the natal chart. I've used it as a general guide to illuminating a traditional astrological natal chart and for forecasting or prediction. This layout can be used with great success on New Year's Eve, at winter solstice, or for birthdays. I don't find it useful to do this particular spread more than twice a year, since the influences it covers tend to be very broad. But there may be astrological occurrences—for example, a major eclipse of sun or moon affecting a person's chart—which might warrant doing another reading for clarification. You may choose to lay out either one or three cards in each house. (If three, then go around the circle three times.) Obviously, the more Major Arcana cards that appear in the spread, the more the person's life runs according to a kind of spiritual destiny or imperative. The numbers can be used to determine the span of time it may take the events to unfold. For example, a Three of Cups, The Lovers (#6), and the Knight of Wands appearing together would mean that the event might occur within nine months or nine weeks (3 + 6 = 9). Interpretations for the various combinations depend, obviously, on the querent and on the house in which the card appears. The above cards in the fifth house might indicate a love affair with a fiery, passionate individual that will be a satisfying relationship. In the tenth house, the same cards might indicate the initiation of a successful business relationship with a younger man, perhaps a fire sign. The querent and the young man would share a deep, empathic connection.

Seven Hathor Spread

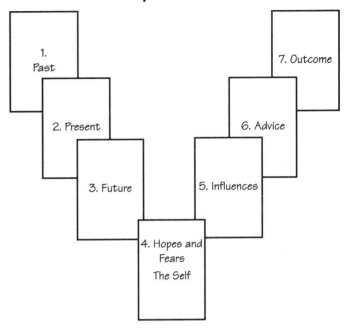

Hathor's Astrological Wheel

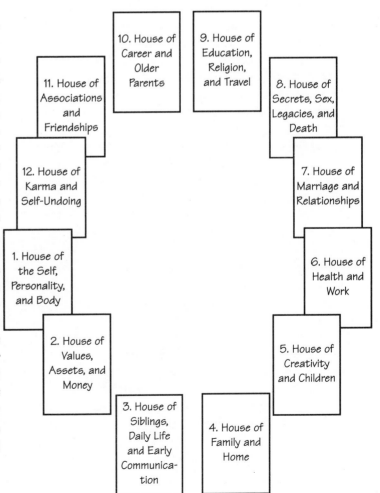

THE CONCEPTION OF HORUS

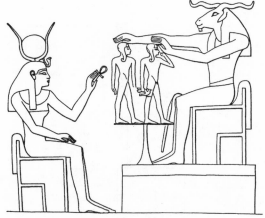

Hathor gives life to the unborn child and his ka, which Khnum molds on his potter's wheel.

Appropriate for Days that Celebrate

- Conception
- Initiations and Beginnings
- Pregnancy
- Nurturing
- Motherhood
- Fertility and Abundance

Four days after The Hierogamos of Hathor and Horus on Epiphi 1, we celebrate The Conception of Horus, son of Isis and Osiris. His actual birth occurs in the month of Parmuti, ten months later.[73] Ancient Egyptian midwives often considered a full-term pregnancy as lasting ten months. This feast day celebrates the potentiality of the heroic child, as well as the Great Mother in all her divine forms. In spiritual terms, the marriage of the goddess and the god is always occurring, whether we call that divine couple Hathor and Horus, or Hathor and Horus the Elder, or Isis and Osiris. In any merger of oppositions, or two divergent forms of energy, lies the possibility of a reconciliation of the two—that is, the divine gift, which is the possibility of action from an alternate and unexpected source.

The Conception of Horus always celebrates the conception of the king. I suppose not many people know their actual conception day, but I discovered mine some years ago, and the information thrilled me in a rather Egyptian kind of way. I was conceived on the last day of the previous year, which also happens to be my parents' wedding anniversary. With the seed of the new year and the seed of new life lying so closely side by side, I can see my birth, like that of some female Horus, as a product of the Hierogamos. My own conception day I celebrate as a time of high potentiality. My daughter's conception I tend to celebrate as the incubation of the heroic child who will follow me. To the ancient Egyptian, who dwelt within his mother's womb before birth and during conception, and who will return to her womb at death to await new life, the power of conception is the link to the power of overcoming death.

Nowhere is the relationship between the king and his sky mother more beautifully expressed than in this ancient Hymn to Nut, found among the earliest tomb prayers ever written in the Pyramid Text of Pepi:

O Great One who became sky, you are strong and mighty.
Every place fills with your beauty. The whole world lies beneath you. You possess it.
As you enfold Earth and all creation in your arms
So have you uplifted me, a child of the goddess,
And made me an indestructible star within your body.[74]

Hathor, like Isis, is a triple goddess. As Sky Goddess (Nut/Hathor) she mates with the Sky God (Geb/Horus the Elder) to create all the children and possibilities of the world. As Hathor-Isis she mates with Osiris to create Horus. As the younger Hathor she mates with Horus to create Ihy. Heroine of the tale, she marries the Hero and conceives the Hero. In fact, it might be said that Hathor conceives three generations of heroic gods, enacting roles that include Mother, Grandmother, and Great Grandmother.

The Mistress of Love knows no age; her power generates constant and ceaseless becoming, and the love she bestows blooms eternal. Sexual love, maternal love, and spiritual love—these represent her passion for all her cosmic creations. The Great Goddess bears the children of the world and raises them. She teaches women to nurture, to weave, to domesti-

cate animals, to raise crops. She civilizes her people and teaches her children the laws of righteousness. She shows them how to bury the dead, to pay homage, to pray. She stands between worlds and points the way toward renewal, through the land of death and into the passage of rebirth.

The feast of The Conception of Horus celebrates the Queen Mother as the mortal embodiment of the divine Great Mother. In the birth chapel at the Temple of Luxor we find a delicate rendering of the immaculate conception of pharaoh Amenhotep III as the embodiment of Horus. Well before conception, the divine child's birth is preordained. On his potter's wheel, the god Khnum already shapes the twin images of the pharaoh and his *ka*, or "divine double". The spiritual contract has been struck between Khnum and the High God, in this case, Amun.

Actual conception occurs in heaven. On earth the god Amun inhabits the body of the pharaoh's father; but in this spiritual portrait, the god Amun and Queen Mutemuia, the mortal mother of Amenhotep III, sit close together atop a hieroglyph depicting the sky. Their knees touch, their hands clasp, their eyes meet. Tenderly, Amun lifts his hand to touch Mutemuia's face, as if he were offering her the heady perfume of a lotus blossom. Held aloft by two goddesses, Serket and Neith, who act as heavenly angels, the feet of the divine couple never touch the ground. The images resonate with stories of the Christ Child's immaculate conception, the angelic messengers to Mary and Joseph, and the white dove that represents the descent of the Holy Spirit which stirs the seed in the womb of the Virgin Mary. Pregnancy and potentiality always begin in the realm of the spirit.

After conception, Amun informs the "father" of the child, Thutmose IV, that the royal heir has been conceived. As the power of Amun has been conveyed and embodied in the husband of Mutemuia, the contract to some degree has already taken place. Now we see that the power of divine motherhood has been conveyed to Mutemuia through the embrace of Isis, the Great Mother of Horus. All that remains is for Thoth, lord of karma and time, to announce to Mutemuia that she has conceived a son.

This same scene appears throughout Egypt—in the birth chapel of Queen Hatshepsut at Deir el-Bahri, in the birth house of Nectanebo at Dendera, and at both birth houses of Trajan at Philae and Edfu. In the Greek versions of the story, the divine spiritual partner is usually depicted as Hathor, rather than the queen; the father is sometimes depicted as Horus.[75] The Hierogamos always takes place between the divine beings of heaven, who use the physical bodies of the royal couple, so to speak, to conceive and create the heroic, divine son on earth.

The principles that support such a spiritual impregnation are the goddesses Serket and Neith, who are seen actually supporting the feet of the divine couple. Serket, the scorpion, represents the cosmic fire, even as the goddess Neith, in this case, represents the weaver of destiny, the one who creates the invisible matrix of the world. Amun, the High God of the New Kingdom, always acts as divine father of the royal son. This conception motif is more than the political tableau most Egyptologists would have us believe: that a pharaoh invents a divine birth to support his right to the throne. In fact, this image is the central mystery of all marriage: Sexual intimacy is a sacred act.

The tenderness and sweetness of the Hierogamos, say the ancient texts, permeated the royal bedroom, even the whole palace, with the fragrance of ambrosia, the scent of the gods. Egyptologist Lana Troy notes that in the conception scene at Queen Hatshepsut's temple, her mother, the royal queen Ahmose, confesses to Amun, "You have permeated my

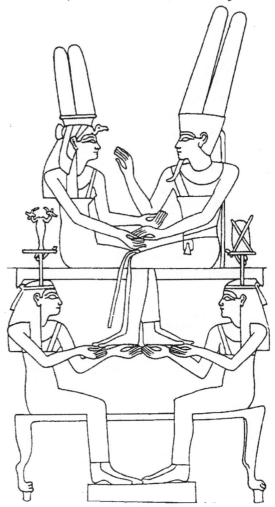

The conception of the divine child takes place in heaven as Serket and Neith uplift the feet of the embracing king and queen.

majesty with your spirit. Your fragrance is through all my limbs." Troy explains that the term *idt* (meaning "fragrance") is used as an euphemism for the seed of the god."[76] Likewise, the voice of the queen singing was said to "sweeten" the heart of the pharaoh; the voices of the priestesses of Hathor sweetened the heart of Horus. The Egyptian word *nutchem* meant "sweet," and in superlative fashion *nutchemy* or *nutchem-nutchem* meant a word equivalent to "sexy."

In festival, the royal consorts, the courtesans, and the priestesses and daughters filled the temple with their incense and perfume, with their devotion and beauty. These fragrances arising from the bodies of women filled "the Eye of the God" and released him from sadness. In the royal palace and gardens, the courtesans ambling through the courtyards greatly pleased the pharaoh, as the wind bore to his nose the scent of their fragrances, which were like those from the Land of Punt, birthplace of the goddess Hathor.[77]

Astrologically, the conception of any divine undertaking might take place during the fertility ceremonies associated with the time of the new moon. A dark moon, just beginning to return to light, promised success for all unions. An astrologer friend of mine recently explained that there exists an astrological connection between the natal moon phase of the birth mother and the moon phase at the time of conception. If the two phases lie within three days of each other, the mother is more likely to conceive.[78] That certainly was borne out in my chart. In this case, we find that Hathor's birthday falls on Hethara 1, which is a traditional new moon day in Egypt. Thus, the festival celebrating The Conception of Horus, her son, on Epiphi 4 would lie precisely within the three days of fertility, according to the aspect of the new moon. Additionally, the sun sign dominating this period of time is Taurus, the bull (or cow), which is typically associated with Hathor, the Great Goddess of Dendera.

Aromatherapy and the Scent of the Divine

In ancient Egypt the presence of a divine being was heralded by the alluring scent that emanated from her breath and skin. Smell is the body's most basic sense, linked to the reptilian brain, the oldest part of humankind's developing intelligence. The odors we breathe tell us essential information, whether to eat the thing, run away from it, or make love to it. Nothing could be a more basic instinct.

The ancient Egyptians invented the practice of aromatherapy through a process called enfleurage, which involved pressing the aroma of flowers and herbs into fatty oils, such as olive oil or safflower oil. The perfumes were lavishly used in all manner of skin lotions and pressed into the wax cones that one often sees atop the heads of noble men and women at parties. The Temple of Queen Hatshepsut outside Luxor depicts a long harrowing journey made to the Land of Punt in search of myrrh and other spices that were used in temple offerings to the gods and goddesses, or in the process of mummification.

The making of ritual incense and essential oils was a highly magical occupation involving an early knowledge of chemistry, as well as of the alchemical potencies of herbs and flowers. The words *chemistry* and *alchemy* both derive from the ancient name for Egypt, which was the Land of *Khem*, meaning the "Black" Land. Thus, alchemy became associated with the "black arts," wizardry and sorcery; the knowledge was considered a secret, one of the mantic arts. Today, major perfumeries still keep their ingredients patented and a mystery.

Much of the magic had to do with growing the essential herbs and flowers in the proper environments and picking the leaves and flowers at the right moment when the scent was at its peak. It also had to do with knowing how to mix the ingredients into the proper combination of bases. How many thousand thousand lotuses might it take to create just one ounce of essence? The local perfumer was also employed as a highly powerful healer, creating poultices, teas, and medicines, as well as being an embalmer.

One might use aromatherapy for healing and for enhancing visualization during meditation. Consider the uses to which you want to put the fragrances in terms of the goddesses whose domains are enhanced by certain scents (i.e., the scent of lily evokes Isis in healing broken relationships, while the scent of cinnamon evokes Anket for securing abundance.) To use magical aromatherapy, acquire a number of essential oils and incenses, and read up on the magical art. If you want to make your own aromatic massage oils, bath soaps, or whatever, I suggest reading Scott Cunningham's *Magical Aromatherapy* as a guide to the safe, recommended use of various herbs and flowers for magical purposes. If time is a factor,

consider buying incenses and prepackaged herbal baths, teas, soaps, and massage oils; but remember, while synthetic fragrances may evoke the image of the divine power, they may not contain the essential natural magic linked to the oil of that herb or flower.

When harvesting flowers and herbs for making essential oils, give reverence to the goddess, to the earth, and to the spirit of the plant. Leave enough leaves and blossoms to assure future growth and pollination.

Note: Musk, that mainstay of the perfume industry, is not gathered from herbs or flowers. It involves killing a whale to obtain its scent gland. Many magical books list musk as one of the main ingredients in love potions. Personally, I think using real musk is bad magic, although synthetic musk may be acceptable.

Fragrances of the Goddesses

BAY — For purification and psychic awareness. Linked with Nephthys.

BERGAMOT — For peace, happiness, and sleep; also for stress relief and self-nurturance. Linked with Tauret.

BLACK PEPPER — For banishing, protection, and courage; also for mental and physical energy. Linked with Pakhet and Sekhmet.

BROOM (SWEET GRASS) — For household protection and peace. Linked with Nephthys.

CAMPHOR (BDELLIUM) — For physical health, energy, celibacy, and banishing bad energy. Linked with Meretseger.

CARAWAY (SEED FORM) — For physical revitalization, mental clarity, and soothing troubled relationships. Linked with Renenutet.

CARDAMOM — For sexual attraction and opening the heart chakra. Linked with Isis, Iusaaset, and Mut.

CATNIP — For peace and beauty. Cat goddesses love it for it stimulates playfulness. Primarily linked with Bast, as well as Mafdet, Pakhet, Raet, Sekhmet, and Tefnut.

CEDAR — For spirituality, self-control, memory, and past lives. Linked with Isis.

CINNAMON — For abundance and prosperity. Linked with Anket and Isis.

CLOVE — For memory, mental clarity, protection, and courage. Linked with Nephthys.

COFFEE — For mental and physical strength; especially aids decision making. Linked with Sekhmet.

COSTMARY — For calming emotions and purification inside and out. Linked with Serket.

EUCALYPTUS — For purification, physical cleansings, banishing evil, and dispelling negative energies. Linked with Ma'at.

FRANKINCENSE — For increasing spiritual power and contact with higher mind; also for purification, consecration, protection, and exorcism. Linked with Isis, Nut, and Serket.

FREESIA — For love, peace, and gentleness. Linked with the Seven Hathors.

GALANGAL — For psychic awareness. Linked with Tefnut and Wadjet.

GALBANUM — For use as a purgative which acts as a counterirritant. Linked with Serket and Meretseger.

GARDENIA — For peace, love, relaxation, and higher spirituality. Linked with Satis.

GARLIC — For purification inside and out; and for health, energy, and protection on all levels. Linked with Sekhmet.

GINGER — For energy, courage, and magical protection. Linked with Mafdet and Neith.

HOPS — For relaxation and sleep; also promotes healing. Linked with Bast, Hathor, and Sekhmet.

HYACINTH — For overcoming grief and bringing peace. Linked with Isis.

JUNIPER — For detoxification, personal and magical protection, and antisceptic uses. Linked with Sothis.

LAVENDER — For rebirthing and soul retrieval, as well as health, love, and emotional well-being. Linked with Isis, Meskhenet, Nut, and Seshat.

LEMON — For cleansing, self-control, and pure intention, as well as health and healing. Linked with Hathor, Raet, and Sekhmet.

LILAC — For love and personal and spiritual purification. Linked with Iusaaset.

LOTUS — For peace, love, protection, and happiness in the environment and within the heart. Linked with Bast, Hathor, Nut, and Sekhmet.

MIMOSA — For dreams and psychic visions. Linked with the Seven Hathors.

MUGWORT — For psychic awareness and dreams. Linked with Anket, Nephthys, Nut, the Seven Hathors, and Sothis.

MUSK — For love and body awareness. Linked with Bast, Iuasset, Meskhenet, and Tauret.

MYRRH — For healing, cleansing, and purification (often used to clear and/or charge magical amulets and talismans); also for developing higher mind, spiritual wisdom, and memory (especially useful in recalling past lives). Linked with Hathor, Isis, the Seven Hathors, and Sothis.

NAIOULI — For protection against psychic attack. Linked with Serket.

NUTMEG — For abundance and heightened psychic awareness. Linked with Anket and Tefnut.

ORANGE — For increasing physical, mental, and magical energy. Linked with Satis.

PATCHOULI — For physical strength, sexual attraction, and abundance; also for heightening kundalini energy, which can be useful for self-confidence and deep magic. Linked with Mafdet, Sekhmet, Serket, and Wadjet.

PEPPERMINT — For purification, mental clarity, memory, and concentration. Linked with Raet, Sekhmet, and Tefnut.

ROSE — For beauty, peace, love, and opening the heart chakra; also for sexual passion. Linked with Isis and Mut.

ROSEMARY — For memory and concentration; also for love and long life. Linked with Neith, Raet, and Seshat.

SAFFRON — For physical energy, concentration, and memory; also said to hasten childbirth. Linked with Meretseger, Meskhenet and Satis.

SAGE — For protection, calling elementals, and clearing negative energy. Linked with Heket, Ma'at, and Seshat.

SANDALWOOD — For mental clarity , strength, healing, and sexuality; also for developing higher spirituality. Linked with Isis, Iuasset, and Sekhmet.

SPEARMINT — For protection during sleep and healing. Linked with Renenutet.

STAR ANISE — For psychic awareness. Linked with Nut, Seshat, and Sothis.

STYRAX (BENZOIN) — For physical, mental, and magical energy; also for protection of physical property. Linked with Sekhmet and Wadjet.

VETIVER — For abundance and protection of the home. Linked with Anket and Bast.

VIOLET (usually synthetic scent) — For purity. Linked with Nut.

YARROW — For courage, love, and psychic awareness. Linked with Mehurt.

YLANG-YLANG — For calming anger, anxiety, and tension; also promotes peace, love, relaxation, and sexuality. Linked with Pakhet and Tefnut.

Ancient Egyptians used knowledge of the alchemical potencies of plants to make perfumes, incense, teas, and medicine.

HATHOR RETURNS TO PUNT AND THE SAILING OF THE GODS AFTER THE GODDESS

Appropriate for Days that Celebrate

- Farewells and Partings
- Ending Relationships
- Reconciliations
- Croning
- Entering the Underworld
- Recovering the Past
- Wildness
- Protection

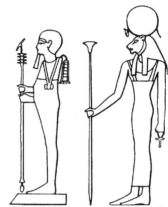

Sekhmet guards her consort Ptah. Together, they represent the creative and destructive powers of the universe.

Summer in Egypt is not simply harsh, it is nearly lethal. In the days before the damming of the river, this time of year all the banks and fields were so dry that they cracked open with enormous fissures, yawning mouths sometimes a foot deep. With the river having emptied itself out, there was no movement of water and no rain; and what water remained in the dismal Nile riverbed was so slimy and stagnant that it was not fit even for animals to drink. Most of the wildlife and birds moved on to greener fields for the season, and the animals that did remain were hungry, thirsty, and prowling. No wonder the final festivals of the Harvest season were filled with rituals intended to appease the powerful goddesses of death, for it was now that the Great Mother appeared in her crone phase.

The season begins with the *khamsins*, those horrific winds that arise in March and continue for nearly two months. These southern winds peak in velocity throughout the day and die back a bit at night, but the gales are so strong they whip the sandy desert through the city, bearing with it contagion and respiratory illnesses. Nineteenth-century traveler Amelia Edwards described her encounter with the khamsin thus:

It came down the river about noon, showing like a yellow fog on the horizon and rolling rapidly before the wind. It tore the river into angry waves and blotted out the landscape as it came. The dis-

tant hills disappeared first; then the palms beyond the island; then the boats close by. Another second and the air was full of sand. The whole surface of the plain seemed in motion. The banks rippled. The yellow dust poured down through every rift and cleft in hundreds of tiny cataracts. But it was a sight not to be looked upon with impunity. Hair, eyes, mouth, ears, were instantly filled and we were driven to take refuge. . . . Although every window and door had been shut before the storm came, the sand found its way in clouds. Books, papers, carpets, were covered with it; and it settled again as fast as it was cleared away.[79]

The goddess can show quite a nasty temper, and one of the things most likely to grate on her nerves is not being given the respect and honor properly due her. Ra made this mistake twice. Once, he was miffed with his human creatures and sent Hathor in the guise of the lioness Sekhmet to devour them. She so liked the taste of blood, she began devouring all creation (see Thuthi 20, The Inebriety of Hathor). In a separate incident, Hathor as the lioness Tefnut ran away and left Egypt because Ra had the audacity to give away her throne and title as his Left Eye to some male god, probably Horus (see Tybi 19-20, The Voyage of Hathor to Nubia).

Either way, the goddess withdrew her blessings from earth, and the land became parched and barren. In turn, all

the remaining gods and goddesses in heaven came to Ra, irate, terrified, and demanding that he do something to convince the goddess to come home and stop her savage ways. Without her benefaction, all humankind, all life, all of nature—which in fact was the divine spirit on Earth, the neters themselves—would disappear forever. A little befuddled and quite egocentric, Ra at first was reluctant to admit he made a mistake. The desiccation of life went on for some time, and apparently, since Egypt became nearly unlivable during her absence, the other gods hopped into their boats and attempted to go sailing after her.

Egypt in midsummer, in the fierce heat, in its howling wind and sandstorms, is indeed a godless place. But, it is not Goddess-less; rather, it is the experience of the wildness of the goddess who will not be tamed. Whether as Tefnut or Sekhmet, Hathor goes forth into the desert and jungles to experience her wild nature. In myths all across cultures, the land dies away and grows sterile when the goddess leaves. In Babylonia, Ishtar leaves for "Edin," the underworld, as Tefnut leaves for Nubia.[80] In Sumeria, Inanna descends to the underworld to meet Ereshkegal, her dark sister of death. In Greece, Persephone is abducted, but comes to like Hades and his dark, wild world.

Where has Hathor gone? She has returned to Punt, her mythical homeland. And where is Punt? Some scholars suggest that central Africa was the mythic land to which Queen Hatshepsut sent an expedition, bringing home exotic animals, gold, plants and myrrh. Margaret Murray, however, believes that the Land of Punt indicated any trading station as far away as the Indian Ocean[81]

Hathor shares her connection to Punt with Min, Egypt's oldest ferility god and her consort in prehistory.[82] With his erect phallus and tightly bound feet, Min represents the concept of eternal creative potential that arises from the Source. Like creator gods Amun and Ptah, Min originates from the fecund cosmic world. (*P-unt* literally means "The Being" or "The Source.") He creates earthly life from his divine essence. When Hathor sails from Egypt to the Land of Punt, the goddess likewise returns to her own Source. One can imagine her sailing on the waters of the Nile as it pours into the sea, then joins the Great Ocean, the cosmic soup from which life sprang and to which all life inevitably returns. The neters of Egypt who embody its plants and animals—its fish, ibis, grasses, and grains—do not want her to leave. When she sails away, they wither up and die. In the natural world we observe the end of the vegetative cycle and the migration of animals. In the mythic world, the gods and goddesses likewise leave Egypt to sail after Hathor and bring her home.

When the goddess finally returns, she returns whole—

that is, with the duality of her personality intact—and usually filled with the seed that betokens renewal. In one early Thinite myth, the hunter Onuris, whose name means "He Who Brings Home the Distant One," returns to his clan with a lion goddess named Mehet at his side.[83] Her name means "She Who Has Been Filled," or "She Who is Whole and Wholly Herself," the true Eye of the Divine. The goddess is likewise filled with the holy seed of life and light.

The sailing of the gods after her implies that the male principle must be served by the female principle. The fire is tamed by the water; thus, the goddess overcomes her destructive nature by drinking the Red Nile waters that resemble blood (see pg. 9), or by being given a higher place of honor as the third eye on the forehead of her father, Ra. This Hymn to Wadjet (as an aspect of Hathor and Neith), which appears in The Egyptian Book of the Dead, expresses the divine power of the goddess as the rearing cobra (uraeus) on the brow of the pharaoh:

> The goddess Wadjet comes to thee in her form of
> the living uraeus, to anoint thy head with her
> flames. She rises up on the left side of thy head,
> and she shines from the right side of thy temples
> without speech. She rises on thy head during each
> hour of the day, even as she does for her father Ra.
> And through her the terror which you inspire in
> the holy spirits is increased. . . . She will never
> leave thee, awe of thee strikes into the souls,
> which are made perfect.[84]

Egyptologist C. J. Bleeker warns us that the waters on which the goddess sails are also the symbol of the primordial deep, the waters of death and chaos.[85] That which brings life also bears a dark undercurrent. The nature of the goddess is always twofold.

As the Great Goddess of Love and Beauty, Hathor belongs to none but herself. No divine father begat the falcon god Horus originally; there was only his divine mother, Hathor. She has been later linked with a number of gods, including Horus, Min, Amun, Ra, and Shu. No wonder the gods were sad when she left; she was every high god's adored first wife and favored lover! Apparently, she had many consorts, but they were attached to her after the fact. She always shared the power equally with the gods and, unlike the goddesses in Greek myths, was never placed in a subordinate position to them. C. J. Bleeker speaks of her as if she were Queen Elizabeth, or the Divine Regent of Heaven when he says, "Hathor always jealously guarded her independence and never allowed herself to be trapped in any mythological system that could detract from her true nature."[86]

The same is true of her as the Great Goddess of Creation and Destruction. As Sekhmet, the lioness, she reigned well before Ptah, who became her consort after she returned to Egypt. Prior to that, she was a concubine of many gods. "To her," says Robert Masters, "the eight gods offer words of adoration," for they considered her mightier than themselves because she was self-begotten.[87] Her holy name, *sekhem*, meant "power."

The Decrees of Sekhmet were handed down at the end of the "reign of Ra"; that is, at the end of the solar year when the harvest was drawing to a close and before the next growing season began.[88] Sekhmet was said to wear red garments, a reminder of her carnal nature. As the inebriated Bast she may have indulged in the orgiastic rites at the Temple of Dendera. Perhaps she was the original scarlet woman for whom the red lamps of brothels glow. Perhaps red reminded her of her favorite bloody drink from the waters of the Nile. Certainly the red henna (or Egyptian privet) that adorned the heads of women in Egypt was a tribute to her, said to be her "magic blood." Heads, hands, and feet were dipped in the colors of the goddess. Cheeks and lips were brushed with her paint. Even the mummy cloths were sometimes dipped in henna as a sign of rebirth from the blood of the Mother.

No doubt, the idea of red as a symbol of both death and fertility is linked to the actual appearance of the Nile at this time of the year. At the end of the harvest season, when the Inundation first begins to trickle forth, the waters are at first green, then they turn into an opaque, dark ruddy color.[89] The Arabs called this the Red Nile. The bloody waters were caused by a type of red algae which was being pushed out of the Central African tributaries and down river by the melting snow and floodwaters.

This red-looking water occurred every year and was the natural phenomenon behind the myth that Thoth created an intoxicating river of blood to entice Hathor (in her lioness form of Sekhmet) to stop devouring humankind. The Old Testament considers the river of blood the first of the "ten plagues" that Yahweh cast upon the pharaoh to induce him to release the Hebrews from Egypt, but the pharaoh probably wasn't convinced since the river turned red annually. It was usually followed by a sudden burst of life-generating activity along the Nile banks. The first rising of the waters would have caused the dormant insect cases buried in the sand banks to crack open and the insects to fly forth, and the more stagnant waters would have been filled with frog eggs become tadpoles, become frogs. Thus, even the plagues of locusts, flies, and frogs might have been seen as predictable.

At any rate, while the rise of the Red Nile follows on the heels of the hellishly dry and hot summer in the Egyptian desert, it is also the precursor to the rebirth of the new year. Just as Hathor and Isis opened the new year by their appearance as the rejuvenating star Sirius, it's logical that Hathor and Sekhmet, the devouring lioness, would be responsible for closing the solar year.

This festival probably occurs in the month of Epiphi because it refers to a period of time when the flood waters and the Dog Star Sirius were both rising in midsummer. We know that when a calendar does not account for the one-quarter day, each solar year will be off by a full day every four years. Thus, the star would rise a day earlier every four years and make a complete cycle through the calendar every 1,460 years. Or it may be that this festival falling close to the summer solstice refers instead to the solar disk; that having reached its farthest point north in the Northern Hemisphere, it begins to move southward again toward Nubia. Thus, the feast day may be invoking an image of Hathor as the sun disk, or the "Golden One."

Activities

1. Recall your childhood home or a home you knew quite well. Write about this house in five-minute timed writings, exploring each room individually. Write each entry for a full five minutes without stopping. Contemplate what you have written, then spend another minute or two defining what you mean by "home."

2. Think of someone who was once dear to you and from whom you feel estranged. What is the nature of the separation? What purpose does this separation serve? How appropriate to your current life is this arrangement? Find a way to forgive, but still maintain a healthy boundary.

3. Write about what you will miss when you die. Be specific. Name the people, the places, the things, the activities. Perhaps you can make a list of 1 to 100. If there are specific people on your list, take a moment now to write a letter or send a card, telling them specifically what you love about them. This same exercise works if you are contemplating a move to another city. To alleviate the sadness of leavetaking, write a similar list of 100 things you will love about the place you are going.

THE FESTIVAL OF MUT: FEEDING OF THE GODS

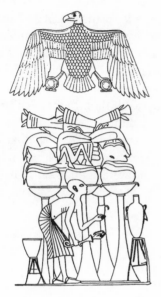

Appearing in vulture form, Mut receives her abundant festival offerings.

Appropriate for Days that Celebrate
- Completion
- Harvest
- Sacrifice
- Thanksgiving
- The End of a Cycle
- The New Moon in Gemini

Rain seldom falls in Egypt; the southern regions receive less than an inch annually. The Nile this time of year reaches its lowest point, its stagnant waters creating nationwide sickness and disease. When the earth itself cracks open into great, dry, desolate chasms, one sees how precarious all life in Egypt really is. Even when the river is flowing freely, only the narrow green growing fields beside the river keep the entire civilization from drying up and blowing away, becoming like the vast desert wastelands that surround Egypt on both sides.

Still, despite times of desolation, the gods must be fed. The Festival of Mut became a great sacrifice in times of scarcity. This time of year the common people had little to give. Their taxes had been levied at harvest time, and their fields laid barren and dry. Even the temple stores of the pharaoh and priests were low. Giving one's life resources to the Divine became a powerful statement of faith and belief in the promise of abundance yet to come.

The choice of the goddess Mut to represent this feast is most appropriate. Sometimes called the Great Vulture Mother of Terror, Mut feeds upon the remains of the dead. In her talons she tears the last shred from the carcass of an animal and picks the bone clean. Nothing is thrown away, nothing is wasted; thus, she sustains Life. Myths about the vulture say that when her young are hungry and the land barren, she herself makes the supreme sacrifice by tearing her own flesh

and plucking at her breast, feeding her fledglings with drops of her own blood.

When the pharaoh Thutmose III of the Eighteenth Dynasty made his offerings and supplications on this day at the "Altar of the Feast," he made them to the goddess Mut-Hathor. The walls of the Temple of Ptah, an older temple near Karnak which Thutmose III refurbished, describes Mut's festival in vivid detail. Even though the bigger Temple of Mut in Karnak and the very opulent Temple of Amun stand not far away, the pharaoh makes his offering inside this smaller temple. Perhaps the reason is that inside the Temple of Ptah resides a large, black basalt statue of the goddess Sekhmet, who is Ptah's ferocious lion consort. Sekhmet, a leonine form of Hathor, was said to be "great of magic." Certainly magic would have been needed to bring new life to such a barren landscape. Only a magician goddess, a Sekhmet or a Mut, could bring life out of death, creation out of destruction.

Thutmose III beseeches the goddess by calling her Mut, meaning "Mother," but he recognizes how easily the goddess can revoke her love and bounty. If the nurturer feels stretched beyond her capacities to nurture, she may turn on her children. I'm reminded of a hamster my daughter once owned named Sweetie, who lived in a tiny cage. Sweetie gave birth to fourteen babies one night, and through the course of the evening devoured ten of them, one at a time, all but their lit-

tle heads. The cries of the babies woke my daughter. I remember sitting up at 4:00 A.M. trying to explain to my five-year-old the myth of Kali-Ma, the Hindu goddess of creation and destruction. I tried to express in simple terms the concept of sacrifice for the common good, the conundrum of the ends justifying the means, and the law of survival of the fittest. After she went back to sleep I sat up thinking about how too much fertility, too much abundance, was not a good thing; that without death and loss—an emptying of the overfull— what we ultimately create is chaos. Order in the cosmos is maintained by balance. Give and take is not just another way of saying, "Be nice and share." On a higher level, it often demands sacrifice. The goddess feeds us, and we feed the goddess.

Thutmose III has been careful to please the god and goddess of this small Karnak temple. He has provided thrones of gleaming electrum for Ptah, Sekhmet, and their offspring Nefertum. He has filled their temple with vessels of gold and silver, with "every splendid, costly stone," with fine linens and "ointments of divine ingredients." On the day of her feast, he himself stands before the altar of Sekhmet (Mut-Hathor) and makes the sacrifices that will bring back to Egypt "life, prosperity, and health." His gifts line the offering table— many jars of wine and jugs of beer, ducks and geese, a multitude of loaves of white bread, bunches of vegetables, baskets of fruits, and "offerings of the garden and every plant."[90] All these are burned in the altar flames in the presence of the goddess to assure renewal of the land and of the pharaoh. While the fiery flames consume the meal, the pharaoh looks away, for it is not polite to watch a goddess eat.

The prayers of Ramses III inscribed in the Papyrus Harris shed light on the kinds of petitions made before the gods and goddesses. Each prayer began with a recitation of the divine powers, then followed a long list that served as a remembrance of the offerings made to the gods:

All hail Gods and Goddesses, rulers of heaven and earth and the world between, all you who stand glorious in the Boat of a Millions Years beside of your father, Ra. His heart is satisfied when he sees your beauty. He makes prosperous the land of Egypt, bringing forth the Nile that overflows like the sweet words of your mouths. . . . He rejoices and flourishes at the sight of this—the greatness of Heaven, the might of Earth—giving breath to nostrils that once were closed.

I am your child whom your hands fashioned, whom you crowned as ruler of every domain. . . . I restored your temples that once lay in ruin. Before you I laid a table of divine offerings, increasing your previous bounty. I had wrought for you treasures of gold, silver, lapis lazuli, and malachite. I designed their storehouses and filled them with numerous possessions. I filled your granaries with heaps of barley and spelt. For you, I built houses and temples, carved with your name forever. . . . By the hundred thousand, I made you table vessels of gold, silver, and copper. Out of finest cedar I hewed your sacred barges to float on the Nile, bearing the Great House [shrine] overlaid with gold. . . .

Mighty deeds I did and performed a multitude of benefactions for the gods and goddesses living South and North. I fashioned their images, adorned them and placed them in houses of gold. What had fallen to ruin in their temples, I rebuilt. . . . I planted for them groves of sycamores and dates, gardens of flowers and vineyards. I dug for them lakes upon which their glittering boats might sail. I brought to them divine offerings of barley and wheat, wine, incense, fruit, cattle and fowl. . . . Behold! the list is before you, O gods and goddesses, that you may know the offerings, the sacrifices, all that which I did for the glory of you, and the benefit of your *kas* [spirits].[91]

I once sat before this same fearsome black granite statue inside Sekhmet's temple. The wonder is that she still reigns there when so many antiquities have vanished from the sites. But then Sekhmet has a reputation for vengeance. One "magical" means through which the priests protected the statues of the goddess from vandalism was to coat the stone with anthrax! Sekhmet was also known as the Goddess of Pestilence.

One temple I've never seen, but which has endlessly fascinated me, is the Temple of Mut located in the Dakhleh Oasis, which sits over three hundred miles into the Sahara Desert west of Luxor. No less than three temples there are dedicated to the Vulture Mother Goddess, Mut. The temple on the eastern side of the oasis dates from the New Kingdom, although Old Kingdom mastaba tombs and Neolithic traces of settlement have been found there. The Mut temple on the south side of the oasis dates from the Third Intermediate Period, and the triple shrine to Amun, Mut, and Khonsu dates from the Graeco-Roman period but was later occupied by Coptic monks. On the ceiling of the latter temple appears the zodiac that reveals Nut as Mother Sky but portrays the earth as a red androgynous creature with breasts, a penis, and

the whiskered face of a lion.[92] Sekhmet was sometimes portrayed as such an androgyne, and it may be she who is represented here, a manifestation of earth as the fiery goddess herself. If not here, then certainly she can be found in the decans of stars depicted on the temple ceiling; for rather than portraying the entire sky with its thirty-six decans, this astronomical ceiling devotes itself to only seven—the seven which are said to represent "the demons under the command of Sekhmet"[93]—and these demons and decans were both the cause of death and misfortune on earth. Were I living amid the vast, trackless Sahara, imprisoned by its sand three hundred miles from the living waters of the Nile; were I witnessing my cattle dying of thirst and their deaths heralded by the flapping wings of black, circling vultures . . . I, too, might portray the earth as surrounded by the demons of Sekhmet. Dakhleh's Temple to Mut is but a reminder of what would become of all Egypt were the Nile to run dry.

There is no Nile to rise in the Dakhleh Oasis to break the monotony of its endless desert-scape; there is only the blessing of the life-giving waters of the oasis that miraculously provide over seven hundred hot springs, cold springs, and lakes bubbling through the red stone and sand from underground waters. The water is so brackish, however, that it must be pounded and stored in cisterns, allowing the salt to settle before it is potable. Despite the sand, the heat, and the lack of running water, there grow dates, mangoes, apricots and citrus fruits, and all manner of vegetables. The terrible face of the vulture mother Mut, indeed, can be bountiful when she pleases.

Activities

1. Return some gift of the goddess to her today as a sign of your thankfulness. You might plant a cedar tree on a piece of land that needs reclaiming in honor of Isis who flew around the cedar tree that contained the body of Osiris. Or create a pond on some swampy part of your land. Buy some goldfish and dedicate them to Isis, the fish who tows the barge of the sun through the watery abyss of the underworld. Imagine the frogs that visit your pond as embodiments of the goddess of magic, Heket.

2. Number a page in your journal from 1 to 100. List all the things for which you are truly thankful. Recall especially the times when you had little and, from out of nowhere, the goddess gifted you with her abundance. Recall the gifts you were given that you didn't know you needed but turned out to be great blessings.

3. Start a compost in your backyard in honor of Mut, for whom everything in life and in death and decay were sacred. Plant a beautiful moon garden filled with herbs, flowers, vines, and fruits all dedicated to the moon goddesses around the world. To determine the flowers, scents, and colors each goddess likes, take a look at Patricia Monaghan's book *Magical Gardens*.

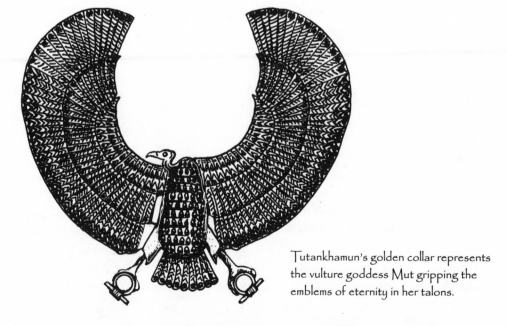

Tutankhamun's golden collar represents the vulture goddess Mut gripping the emblems of eternity in her talons.

THE FEAST OF RAET (PAKHET) AND THE FEAST OF HATHOR AS SOTHIS

Appropriate for Days that Celebrate

- Duality
- Self-Confidence
- Reclaiming One's Power
- The Summer Solstice
- Fertility and Abundance
- Renewal
- Preparation for the Future
- Mothers and Daughters

Hathor appears in two guises this day. For The Feast of Raet (Pakhet) she manifests a fierce lioness face, while for The Feast of Hathor as Sothis she arrives as the beneficent goddess of starlight. The Feast of Raet may have originated in Lower Egypt and The Feast of Hathor as Sothis in Upper Egypt. The Pyramid Texts praise Raet as the female sun. Light of the Land and consort of Ra in Heliopolis, she appeared most often as a woman with cow horns surmounted by a golden solar disk, a form similar to Hathor, the Golden One. Her leonine form portrayed her passion and fierceness.

Raet and Ra originated as a pair of creative divine beings, much like the ogdoad of Hermopolis. The ogdoad were eight primordial beings who dwelt in the cosmic soup before creation. They were the seeds waiting to burst into being. The males of each pair assumed the form of frogs; the females were serpents. The four pairs were Nu and Nut, who ruled the cosmic waters; Heh and Hehet, the divinities of endless space; Kek and Keket, the rulers of darkness; and Amun and Amunet, whose domain included the great void and whatever remained hidden, unfathomable, and unknowable. As time went by, the females of these pairs were forgotten, with the exception of Nut, the Sky Goddess. Amunet became Amentet, the Western Lands, which contained the hidden land of the dead and the realm of the gods and goddesses.

These united pairs expressed both the latent potentiality for life and the empty face of the earth before the divine breath stirred the cosmic waters and brought forth light. The duality of that emerging light expressed itself as the regenerative powers of Ra and Raet. Some myths call Hathor the mother of Ra, linking her both to Nut who held him in her belly before creation and to Raet who birthed the sun, all space, and time. The Greeks equated Raet with the huntress Artemis.[94] Perhaps her name derives from the Egyptian phrase *Raet-mes*, meaning "child of the sun goddess."

Originally part of the triple solar aspect of the Great Goddess, Raet was disregarded as the priests of Ra gained power in the city of Heliopolis. Demoted from mother of Ra to consort of the god and finally to his daughter, Raet's power as the Eye of Ra was stripped from her. No wonder that when the goddess returned to focus what most legends recalled was her violent temper. Most of the voracious, destructive aspects of the Great Mother were parceled out to

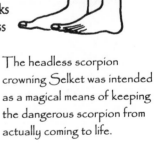

The headless scorpion crowning Selket was intended as a magical means of keeping the dangerous scorpion from actually coming to life.

the lion goddesses. But the lioness was also a fierce protector and an agile hunter. On the savannah, the lioness remains staunchly alert, relying on stealth and speed to ward off her brood's enemies.

Like other female members of the ogdoad, Raet also appeared in coiled serpent form. During construction of a tomb in the necropolis of Thebes, one New Kingdom workman stumbled upon a living image of her in cobra form. He composed a marvelous hymn to the rage and vengeance when one forgets the power of the divine Feminine. Legend recalls that the laborers living in the Valley of the Kings had warned him of the violent magic of the Lady of the Peak. They called her Meretseger, a fierce form of Raet-Hathor who guarded the tombs of kings and queens. Because the arrogant workman scoffed at her power, the goddess struck him blind and violently ill. Not until he had made amends, begged her forgiveness, provided her offerings, and composed this hymn and erected it on a stela on top of the mountain, did she release him from his pain:

Behold! I say, to the great and small . . .
 Beware the Lady of the Peak!
 For there is a lion within her.
The Peak strikes with the stroke of a savage lion.
 She is after him who offends her.
 I called on my Mistress
And found her coming to me as sweet as a breeze.
 She was merciful to me,
 Having made me see her hand.[95]

No pharaoh loved the protective lion goddesses more than did Queen Hatshepsut. Sole female ruler of the Eighteenth Dynasty, Hatshepsut may have portrayed herself wearing the symbolic pharaonic beard, but she aligned her heart with the goddess power of Hathor. To celebrate the goddess's beauty, she commissioned temple reliefs of herself and Hathor engaged in joyous, artistic endeavor. Whereas the New Kingdom patriarches flanked by marching soldiers conquered foreign lands, Hatshepsut expanded the nation's borders by engaging Nubia and Asia in harmonious trade and cultural exchange. Rather than waging war, Hatshepsut protected Egypt by a bit of prophylactic magic. Around Egypt's borders she erected large, magical statues of the lion goddesses Raet, Tefnut, Sekhmet, Pakhet, and Mafdet who were Hathor's warrior aspects. By the queen's words of power, legend says, these magical statues sprang to life and ravaged any intruders, or at least frightened them into leaving Egypt.

When Ahmose, an earlier pharaoh, finally purged Egypt of the invading Asiatics (Hyksos), the goddess temples were left in ruin. One hundred years later, Hatshepsut restored the forgotten goddess temples wherever she found them, saying that her heart "searched for the sake of the future," and that "truth was the bright bread" on which she fed.

Lamenting the ruined state in which she'd found the Temple of Hathor at Cusae, Hatshepsut said, "The ground had swallowed up its august sanctuary . . . children played upon its house, and the [uraeus] caused no fear."[96] To return the city to prosperity, she rebuilt Hathor's temple, overlaid the images of the goddess with gold, and reestablished the temple services. The offerings she conducted in the temple she called Feasts of Light. When she found the abandoned temple of Pakhet in the cliff dwellings outside Beni Hassan, she restored that temple as well, refurbishing its doors with fine acacia wood and fitting them with bronze bolts. The offering tables she stocked with silver and gold, chests of linen, and vessels wrought of precious metal.

Pakhet long served the town of Beni Hassan as its patron warrior and protector. Closely linked with Bast and Sekhmet, she demonstrated the nurturing, protecting aspects of Hathor. Called Lady of Sopdet, Pakhet became identified with the star goddess Sothis and, thus, with Hathor and Isis. The word *sopdet* referred not only to the star Sirius, but to "sharpness"; that is, to the extreme brilliance of this star. Like the claws of the lioness, its light was sharp enough to rend the veil of night and kill the serpent of darkness. Some illustrated texts depict a cat or lion pouncing on Seth, the serpent of darkness, holding him down with her paws and raising a knife to his throat.

Egypt's gods and goddesses possessed multiple souls, and Pakhet was one of the souls of Horus. Called Horus-Pakhet, she appeared with a female body and a male head, resembling the Sphinx. In The Egyptian Book of the Dead, she transforms into an androgynous divinity called Sekhmet-Bast-Ra. A female form with a male head, she uplifts the wings attached to her arms, while two vultures arise from either side of her neck. She bears the phallus of a man and the claws of the lioness.[97] It seems that to appreciate her full complexity, the goddess must manifest as all things at once, lest there be any misunderstanding about the extent of her powers. Says one hymn:

Praise to thee, O Lady, greater than any other gods. The Eight Ancestral Souls of Hermopolis adore thee. The living souls in their hidden worlds praise thy mystery, for you are their Mother. You are the source from which they sprang, and it is you who makes sound their bones, who saves them from terror, who makes them strong in the House of Eternity.[98]

Isis, too, appears this day in one of her crone aspects, as a protecting, avenging goddess. As Pakhet, Sekhmet, and Raet are fiery aspects of Hathor, so is Serket, the scorpion goddess, an aspect of Isis. In the earlier myths of Isis, we find her trapped in Seth's prison, from which she escapes through the magical power of seven scorpions. The scorpions suggest the protective aspect of the goddess's wild emotions and her elusive, fiery nature. Once the scorpion energy appears and attaches itself to Isis, she has the power to transform her life into that of a great worker of miracles, able now to heal and command the elements as well as her own destiny:

When Isis leaves Seth's prison, there is no going home, no going back to her former life. At a loss for what to do next, she roams the countryside alone, lost in her deepest thoughts and feelings; yet she is accompanied by her scorpions: Tefen and Befen, Mestet and Mestetef, Thetet and Maatet and Petet. Ragged, hair shorn, feet covered with dust, she is unrecognized by any of the people. Wild and haunted, she appears quite mad—a stranger in a strange land. Seeing her coming down the road with her entourage of scorpions, people slam and lock their doors.

When a wealthy noblewoman scorns her, Tefen, one of the scorpions, decides to take revenge. Creeping under the rude woman's door, it stings her child to death and burns down her house. Soon Isis, having found sanctuary in the home of a poor, compassionate woman, hears the wails of the townspeople keening over the dead child and the ruined house. Immediately she knows one of her scorpions has done it. She returns to the noble lady's house and tells her that she has words of power to heal and raise the child from the dead. The noblewoman begs Isis to do so and to forgive her indiscretion.

Calmly and powerfully, Isis calls the scorpion's poison to come out of the child and enter the ground, speaking in magical words: "The child lives; the poison dies." Turning to the women gathered about her, Isis recounted the nature of being a crone: "I am alone and in sorrow greater than anyone in Egypt. I am an old hag no longer seeking the love of any other. Turn away from me, but point me straightway to the swamps and to the hidden places."[99]

A wild woman, Isis no longer cares what other people think. She has become eccentric, going where she wills, answering to no one, keeping company with the wrong crowd, her scorpions, or no one at all. She has become what we might call a witch, but a wise woman with the power both to curse and to heal. Accepted, or rejected—either way it doesn't matter to her. Isis isn't always nice, but she is always her powerful self.

Whereas The Feast of Raet celebrated the bloody red goddess and the end of life, The Festival of Hathor as Sothis in Dendera signaled renewed life. The combined feast days may have presented Egyptian women an opportunity to celebrate the menopausal phase of their lives. On the one hand, the goddess is bloody and raging, and on the other, she has become powerful enough to resurrect the dead. She has entered her wise blood phase. Geraldine Pinch notes that the lioness form of the goddess may denote "the dangerous 'impurity' of menstruation" in women.[100] If Pakhet and Raet mark the end of life, or the end of one stage of life, it may be that they represent the kind of death wherein a woman leaves behind childbearing and becomes her own shining individual, a renewed women embodied in the star goddess Sothis.

Jeremy Naydler reminds us that in Egypt "every natural cycle was felt to be an image of spiritual processes."[101] The true power of Hathor to transform cannot be fully appreciated until one sees that the patron goddess of astrology embodies the living spiritual power of the sky. She rules the arcs of time throughout the universe and the cycles of life on earth. To one who knows how to look astronomically, the sky mother reveals her secrets. "Mistress of the sky, queen of the stars, and ruler over Sirius,"[102] her celestial influence drives the seasons, the epochs, and the fate of all humankind. Source and birthplace of all celestial beings—the sun, the moon, and the stars—Hathor is the divine creative matrix.

In her Dendera temple she is Sopdet, whom the Greeks called Sothis and identified as Sirius, whose appearance "makes Hapi (the river) come swiftly."[103] Since Isis as Sothis (Sirius) opens the new year on Thuthi 1, one wonders how the festival of Hathor as Sothis thirty-two days earlier can also be dedicated to Sirius. Perhaps imprecise calculations of the solar year account for the same star rising on different dates, in two different eras. Or perhaps another reason exists. Two years before his death, Miebis, last king of the First Dynasty, celebrated birthday feasts for two distinct goddesses: Seshat and Mafdet. The scanty record implies that the festivals occurred simultaneously, the birthdays of Mafdet and Seshat seeming to fall on the dual feasts of Raet and Hathor.

As recording angel, Seshat tracked life's major events, including four major ones falling on the same day: New Year's Day, the date of Inundation, the king's birthday, and the anniversary of his ascension to the throne. It seems likely that Seshat's own birthday coincides with the new year's festivals of the early Egyptian dynasties. She exhibits the combined imagery of the star goddess, Sothis, and the horned cow goddess, Hathor, by wearing a diadem that represents a star between a pair of inverted cow horns. One might likewise note that a star also depicted the souls of the dead, and the inverted cow horns resemble legs. To gather the full implica-

tion of this image, one must observe the night sky.

Both Isis and Hathor are Nut's daughters, and both goddesses are Sothis (Sopdet), meaning "star"; but on Thuthi 1, Isis appears as Sirius, and on Mesore 3, Hathor appears as Deneb. Near dawn during summer solstice, the Northern Cross constellation (Cygnus) seems to hang inside the Milky Way. Here, low on the northeast horizon, the Milky Way breaks into two streams of light resembling the legs of the sky mother. Between these channels lies an open cavity (the womb of the goddess) where hangs Deneb, the brightest star of the Northern Cross, which is equated with Hathor.

In Dendera, Hathor's holy city, two goddess temples align in different directions. The Hathor temple aligns to Deneb and the Isis temple aligns to Sirius, but only the older Hathor temple celebrates the appearance of Sopdet.[104] Nevertheless, on their respective birthdays, divine starlight streams into the otherwise darkened chapels to shine upon the faces of the goddesses. Each star marks a time of cosmic renewal. Hathor's star signals the end of the year, of the season, of the cycle of creation, while Isis's star signals the dawning regenesis. As the intense sunlight and heat begin to lessen after summer solstice, Hathor appears as "Mistress of the north wind, who opens the nostrils of the living and gives wind to the god in his ship."[105] She ends the fierce khamsin winds and sandstorms of late spring and early summer by blowing her clear, sweet breath upon earth's face. Her appearance as Sothis signals an end to drought and scorching heat, just as Isis signals the coming flood.

At noon in Dendera, Hathor was carried through her temple to the roof where she appeared flanked by the king and queen. The queen shook the sacred sistrum of Hathor, proclaiming that evil was driven from the land by the mistress of heaven.[106] Hathor was joined to her father Ra, the sun, allowing his light to illuminate her beautiful face. Thus, she was imbued with new life for the coming year. The brilliant rays caused the golden statue to glisten and shimmer on the crowds below, so that, in turn, Hathor shone her light upon the people. Says C. J. Bleeker, " . . . often in the Ptolemaic temples, Hathor appears as a figure of light, as a sun-eye [and] some sort of interchange of radiation takes place between Ra and Hathor: the two divinities reinforce each other's potential of light."[107]

In the beautiful moment that father and daughter shone together, it was said all the gods and goddesses of Egypt fell into a festive mood. Thus say the Dendera inscriptions, "The East clasped hands with the West," which Bleeker interprets to mean that harmony reigns.[108] I believe the moment also signifies a conclusion of the cosmic cycle wherein the land of birth (east) unites with the land of the dead (west). Thus, the Ouroborus is complete; life and death and rebirth are made one.

The New Year's feast, Egypt's oldest ceremony, predates the Fourth Dynasty and the rise of the cult of Ra. In truth, this feast is Hathor's day par excellence, for it inaugurates all that the goddess is said to stand for: new beginnings, abundance, joy, peace, and resurrected life. This Hymn to Hathor celebrates her as the goddess of abundance:

> There comes wine together with the Golden One
> and fills thy house with joy.
> Live in intoxication day and night without end.
> Be happy and carefree whilst male and female
> singers rejoice and dance
> To prepare for thee a beautiful day.[109]

Activities

1. Make a list of things you have eliminated from your life in the past year. Why did you give them up? Make a list of things you want to eliminate from your life and why. Make a list of things you want to achieve and things you are willing to give up in order to attain them.

2. Recall a joyous accomplishment and describe the process of its attainment. What did the process of striving feel like? What supported you in your desire? What sacrifices did you make? What benefits have you derived? Think of a far-reaching goal you want to attain now and imagine it step by step.

3. Buy a frightening Halloween mask—one that perhaps feels like you when you are angry. Or, if you prefer, make one molded to your own face and decorate it. This is your own protective Gorgon image. Hang it on your wall to frighten away evil spirits, negativity, and doubt. You might even want to name the situations, attitudes, or people you need to chase away in order to make room for your creative self. Jot them down on sticky notes and encircle your mask with them. As the situations disappear, remove the notes one by one. Be sure to thank your Gorgon for taking care of you and making room for your creativity.

THE EPAGOMENAL DAYS

The Birthday of Osiris
The Birthday of Horus the Elder
The Birthday of Seth
The Birthday of Isis (The Night of the Cradle)
The Birthday of Nephthys

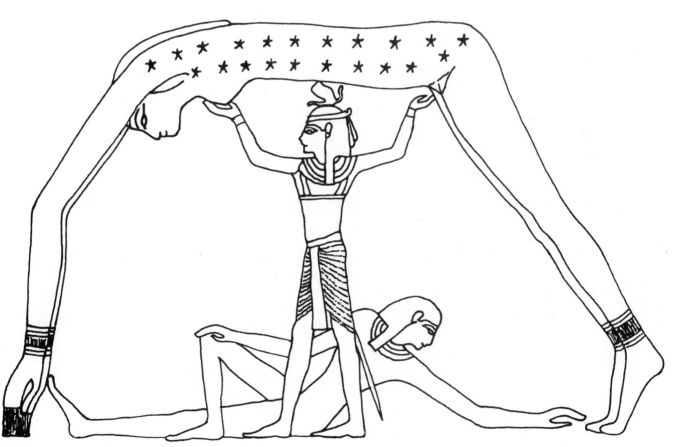

Shu, god of the air, uplifts the sky goddess Nut who hovers above the earth god Geb, her husband.

BIRTHDAYS OF THE GREAT GODS
AND GODDESSES

Appropriate for Days that Celebrate

- Completion and Endings
- New Life
- Divination
- Restoration and Meditation
- Fertility and Abundance
- Thanksgiving
- Motherhood
- Wisdom
- Rediscovering the Lessons of the Past

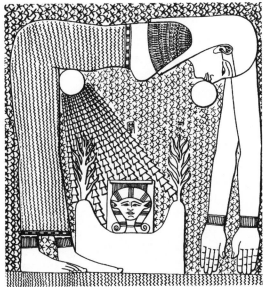

The sky goddess Nut and the solar disk illuminate the goddess Hathor in her temple at Dendera.

Because a solar calendar of 360 days (that is, twelve months of thirty days each) does not equal a solar year, the Egyptians soon discovered that they needed a short thirteenth month of five days to most nearly approximate the year. Thus, the five Epagomenal Days were created at the end of the year (or at the beginning of time, depending upon your theology). On these five days were born the five great gods and goddesses on earth: Osiris, Horus the Elder, Seth, Isis, and Nephthys.

Epagomenal Day 1 (July 14)
The Birthday of Osiris

This day was considered a good day to be born. The following hymn was recited to the moon in the sky just before the dawn light: "O Osiris, bull in his cavern, whose name is hidden . . . Hail to thee. I am thy son, O father, Osiris. The name of this day is The Pure One."[110]

Epagomenal Day 2 (July 15)
The Birthday of Horus the Elder

This day was not a good day to be born. Many children born on this day might die because their souls longed to return to the sky. The following hymn was recited before a statue of the falcon god: "O Horus of Letopolis . . . protection is at the hands of thy holiness. I am thy son. The name of this day is Powerful of Heart."

Epagomenal Day 3 (July 16)
The Birthday of Seth

On this day all offices, shops, and temples in Egypt were closed. People were warned not to leave their houses because The Birthday of Seth was considered horribly unlucky.[111] It was a terrible day on which to be born. The following hymn was recited to appease the god: "O Seth, son of Nut, great of strength . . . I am the brother and the sister. The name of this day is He Who Makes Terror."[112]

Epagomenal Day 4 (July 17)
The Birthday of Isis
(The Night of the Cradle)

The Cairo Calendar mistakenly transcribed the latter part of Seth's Hymn—"The name of this day is He Who Makes Terror"—onto The Birthday of Isis. Rather, the hymn

143

should read: "O Isis, daughter of Nut, the eldest mistress of magic, provider of the book, mistress who appeases the two lords, her face is glorious. I am the divine power in the womb of my mother Nut. The name of this day is The Child Who is in Her Nest."

By calling this the day of the child in her nest, we are given an image of the winged Isis, the spirit child of heaven who will later take form as a mortal woman. Sometimes this holy day is also called The Night of the Cradle. In Hathor's temple the priestesses of Dendera called it The Beautiful Day of the Night of the Child in the Cradle, the Great Festival of the Entire World.[113] Sounding very much like a Christmas holiday that celebrates the birth of the hero, this feast day instead celebrates the nativity of the mother of the hero, the birth of the heroine, the savior queen of heaven. The child in the cradle is Isis, and the child's mother is Hathor. The mother is the sky; the daughter is the light of the world.

In all ancient Egyptian calendars, the fourth epagomenal day was considered the most fortunate day of the entire year, indicated by three signs for the word *beauty*. It was a wonderful day to be born, and all of Egypt held a great feast this day in honor of Isis. With the exception of Seth's Birthday, the epagomenal days were celebrated throughout Egypt, but Dendera's largest celebration was reserved for The Birthday of Isis. On this day, "Dendera is exalted and perpetuated, since Isis was born there as a dark red woman."[114]

The reference to the color of Isis has been viewed at times as a reference to her ethnicity. Other readers suggest it meant she arrived in Egypt from a foreign land, possibly the lost Atlantis. The red color may have referred to Hathor in her Sekhmet form, for the fiery lion goddess was depicted wearing a red dress. Perhaps the red dress referred to the "scarlet" woman, a veiled allusion to the goddess's sexuality. Or it might have referred to the Red Nile, the bloody color of the flood waters as they begin to rise this time of year. (See Mesore 3, The Feast of Raet/Pakhet.) Red may also be seen as the color of fertility, the color of the mother's blood, the color of the carnelian amulet called the *thet*, or "Buckle" of Isis, which represents the blood red cord that binds the child to its mother in the womb.

Green, another color favored by Neith, Hathor, and Sekhmet, represents the gentle, nurturing side of the goddess.

Isis as Sopdet links the rise of the star Sirius with her birthday.

Thus, red and green Christmas boughs harken back to the red and green dresses of the Great Mother who rocks the holy child in its cradle.

At year's end—whether in December in the Julian calendar or July in the Egyptian calendar—the closing year implies renewal and a cyclical return to life by celebrating the birth of the Savior. On rare occasions, as in the Twenty-First Dynasty of Menkheperre, a special celebration occurred when The Birthday of Isis coincided with the *Per Sopdet*, or the "Coming Forth of Sothis," which announced the New Year Festival and the rise of the Dog Star that was Isis appearing as Sothis.[115]

The day may have been one of preparation for the rising of Isis as Sothis to come. The Temple to Isis at Dendera is inscribed as "the place of the birth of Isis [which is] northwest of the Temple of Hathor, its portal is turned to the east, and the sun shines on its portal when it rises to illuminate the world."[116]

Isis remains one of Egypt's favorite daughters. The mystery of this day is how Hathor gave birth to Isis and Isis gave birth to her mother. This feast celebrates the total mystery of motherhood—how a woman's life changes and begins a new phase with the birth of her child. No longer Maiden, she is Mother, a completely different creature than she was. As the mother creates the child from her body, so the child creates a new creature, a new identity known as "Mother."

Where Hathor is Great Mother of the Gods, Isis is Great Mother of the World. She civilized her people by establishing fifteen Divine Commandments similar to the ten commandments Moses brought down from Sinai. She created every day for the joy of her children, providing creative opportunities and equality for women and men, the establishment of a religious tradition for the entire culture, and the definition of love as being filial, spiritual, and erotic. The Greek words for those loves are *phila*, *agape* and *eros*. Says R. E. Witt, "In short, [Isis] promises her believers the satisfaction of their deepest needs. There is no end to their telling the praises of their almighty mistress, Isis, the name above every name."[117]

The following Hymn to Isis appeared around 200 A.C.E. Written by an anonymous Greek sailor, it was found in front of the Temple of Isis in Athens. The writer claimed that while he was in Egypt, he became blind and feared he would die. Taken to the Isis sanctuary in Memphis, he begged the goddess to heal him. In return, he vowed to copy the words to this Hymn to Isis inscribed on the stela outside the Temple of Ptah. The power of Isis is nowhere more explicitly and poetically stated than here:

I am Isis, mistress of every land, and I was taught
 by Thoth and with Thoth I devised the letters,

both sacred and common, that all things
might not be written in the same way.
I gave and ordained laws for men, which are
inalterable.
I am the eldest daughter of Thoth. I am the wife
and sister of Osiris. I am she who finds fruit in
the field.
I am the mother of Horus.
I am she who rises with Sothis. I am the goddess
of women. For me Bubastis was built.
I divided earth from heaven. I revealed the map of
stars. I commanded the ways of the sun and
moon.
I created creatures in the sea. I fortified the gods'
truth.
I brought together woman and man. I determined
that women might birth their children in the
tenth month. I established the love between
parents and children.
I punished those who did not honor their fathers
and mothers.
Together with my brother, Osiris, I brought an
end to the eating of men.
I revealed the mysteries. I taught men to see the
manifestations of gods. I made holy the gods'
places.
I destroyed the reign of tyrants. I prohibited
murder.
I ensured that women were loved by men.
I made truth brighter than gold or silver. I showed
men that the truth was good.
I devised marriage.
I taught the Greeks and barbarians their
languages.
I made it so that good and evil could be
distinguished by their natures.
I brought fear to those who broke their promises.
I delivered evil-doers into the hands of those they
injured. I set the penalty for injustice.
I granted mercy to the penitent. I protect the
guardians of truth.
With me, the gods' justice prevails.
I am Queen of river, wind and sea. Those honored
in life are honored by me.
I am Queen of war. I am Queen of the
thunderbolt.
I stir up the sea and calm it. I shine in the rays of
sunlight. I inspect the course of the sun.
What pleases me shall come to pass and I create

its end.
With me all things are reasonable.
I release those in bondage. I am Queen of sailing
ships. I dam the rivers if I please.
I built the walls of cities. I am called the giver of
laws. I raised the islands from the murky
depths into light.
I am Queen of rainstorms.
I rise beyond destiny. Fate listens to me.
Blessed art thou, Egypt, who has nourished me.[118]

Epagomenal Day 5 (July 18)
The Birthday of Nephthys

Ironically, the Cairo Calendar never completes its Hymn
to Nephthys. It reads only: "O Nephthys, daughter of Nut,
sister of Seth, she whose father sees a healthy daughter. . . . "
The unfinished horoscope is almost fitting, for nothing in the
Egyptian world view ever truly ends; it only begins again.

Plutarch suggested that the name *Nephthys* really meant
"at the land's end," or referred to the limits of anything, such
as the end of life, the conclusion of time, the last day of the
calendar, the edge of the horizon. . . . [119] The Pyramid Texts
compare the voyage of the dead into the neterworld with the
sailing of the boat of the sun below the edge of the horizon in
this Hymn to Nephthys:

> Thou risest and settest, thou goest down with
> Nephthys, sinking in the dusk with the evening
> bark of the sun; Thou risest and settest with the
> morning bark of the sun. [120]

Nephthys, the wife of Seth, was she who always existed
closest to dissolution, to the edges of things, and to chaos. She
could never be fully understood, and so ruled the world of the
vast unconscious mind, the land of dreams, and the unseen
pulse of the universe. The Coffin Text describes the moment
of death as one in which Nephthys appears, saying, "Secret
are the ways for those who pass by when light perishes and
darkness comes into being."[121]

The enigma of Nephthys is that while she represents the
end of life, she also represents renewal. With Isis, she gath-
ered the scattered parts of Osiris and reunited them, her ener-
gy being devoted to the god's rebirth. Says the Pyramid Text:
"Nephthys has collected all your members for you in this her
name of Seshat, Lady of Builders. [She] has made them hale
for you, you having been given to your mother Nut in her
name of 'sarcophagus.'"[122]

Alongside Hathor and Isis, Nephthys is a fecund god-
dess. Lana Troy notes the parallelism of the ancient names of
Nephthys and Hathor; that is, *Nebt-Het* (Lady of the House)

and *Het-her* (House of Horus). Both houses refer to the womb of the goddess where the divine child and the renewed life await.[123] Nephthys is mother of Anubis, god of the underworld who opens the paths between light and darkness, Being and Nonbeing. Likewise, Hathor and Nephthys have been called the mothers of the child Ihy, whose name means "Jubilation."

Where Isis is the mature regal woman, Nephthys represents the younger feminine aspect. Plutarch believes Isis represents the manifest and Nephthys, the unmanifest. She and Isis are two aspects of the Great Mother, one an aspect of light, the other of darkness. They act as mirrors, sharing the joys of birth and the sorrows of death of the Beloved. Childless herself, Isis raises Nephthys's son by Osiris, Anubis. When Osiris dies, Nephthys mourns with Isis. What happens in the spirit world (Nephthys) affects the natural world (Isis); and what happens in natural world affects spirit. The sisters are called the *Ma'aty*, or the "double truth," and appear as a pair of swallows, two migratory birds representing both the arrival of winter (death) and the subsequent arrival of spring (renewal).

Their sisterhood is even stronger than the marriage partnership between Isis and Osiris. For Isis, he is Other; but Nephthys is her Other Self. In *Psyche's Sisters*, Christine Downing defines sisterhood as the one sibling relationship that lasts from birth to death in which people are drawn closer by the celebrations of life and its sorrows. The sister, she says, is so like us and so unlike us that she is truly shadow.[124] The duality of the Great Goddess manifests itself in this relationship between Isis and Nephthys, as it does in the relationship of the Sumerian goddesses Inanna and Ereshkegal and in the Greek goddesses Athena and Pallas. Likewise, the biblical wives of Lamech were dual birth-and-death goddesses. Adah, the first wife, was "Brilliance," the Alpha, the Beginning. Zillah, the second wife, was "Shadow," the Omega, the End.[125]

In the ancient Feminine Mysteries, two sister goddesses often merge to express the inextricable link between life and death and to foster the idea that unity and community are stronger. Whereas the patriarchy portrayed the hero as battling chaos alone, the old matriarchal pairs of sister goddesses provided images of women supporting the endeavors of other women, encouraging their power, and supporting their dreams.

As the goddess reminds us, one passes through darkness to approach light. Again, quoting the optimism of the Coffin Texts: "May you wake to life. Behold the earth is bright! Nephthys has favored you, you being renewed daily in the night."[126]

Once the calendar was established, every pharaoh thereafter swore a solemn vow *not* to change the calendar one iota, even to account for the true extra quarter day of the actual solar year.[127] Because the god Thoth had established the laws of time at the dawn of human history, and the gods knew more of such cosmic secrets than mere mortals ever could, no king or priest could change the cosmic law. And no Egyptian pharaoh ever did so, until the time of the Greek rulers.

These celebrations were especially held sacred in Dendera at the Temple of Hathor and in nearby Abydos at the Temple of Osiris, for it was said that there resided the oldest temples in Egypt, the cities that were the birthplace of the gods and goddesses. Here, then, is the story of the Birth of the Beautiful Children of Nut:

Atum created two children: Nut, the daughter, was the beautiful, ethereal body of Heaven; Geb, the son, was the Earth that lay below. They were a pair of divine lovers who lay together as one in an embrace as long as eternity. Geb inclined himself ever toward his wife, the Sky, rising up as a hill, a mountain, or a pyramid toward that which he adored. In the same way, Nut, covered in shimmering stars, bent herself over head to toe, to hover above Earth, her beloved. Between the two of them there existed space, in which their children might be born.

In the body of Nut dwelt the thousand souls that were the stars and planets calling out to each other like sparks of fire in the darkened heavens. Nut bore Geb a pair of sons who emerged red and round from her vulva during the hours of dawn and dusk. One she named Ra, the golden child and noble Sun. The other she named Thoth, the silvery orb of Moon. Crawling upon Nut's belly, circling ever round her beloved body, the Sun and Moon measured the cycles, and because of them there existed time, in which other children might be born.

Just as quickly as Nut had birthed her first two children, she became pregnant again and her belly swelled with new presence. As her excitement about the impending birth grew, so grew the irritation of her firstborn, Ra. Jealous of his mother's love, he, who by birthright was heir to the kingdoms of Heaven and Earth, devised a way to separate his parents. Relying on the strength of Shu, he commanded the god of air to uplift Nut. Now she found herself removed ever farther from her beloved Geb; she was able to see him, but unable to touch him except at the edges of the horizon where her fingers and toes brushed the Earth.

Ra then decreed that no other child should be born on any day of his year. Decree or not, Nut's belly continued to swell with her children. She bellowed and moaned like a great cow whose udders are too full of milk. Because she could not deliver her children, they became an unbearable burden. Meanwhile eons

passed. The brothers and sisters, yet unborn, still lived in the shadow of Nut's womb. At last, they grew entirely into their adult bodies. Their mother lowed as she knitted the web of flesh, binding their fates, tying knots, stitching time to space, spinning the whole cloth of their stories.

There was Osiris, brother, son, father, husband, watcher in the dark. There was Isis, woman, wife, widow, dancer, goddess of desire, mother of a god. There was Horus, whom the mortals called Hero, the divine son of a divine couple, twice born, once in Heaven and once on Earth. There was Nephthys, lady of the house, mistress of the shadows. And there was Seth, the warrior and rebel.

Isis, Osiris, and their brothers and sister slept nine ages inside the Great Mother. The ages passed. And the ages passed again. The children grew tall, beauteous, and full of desire. Brother married sister—Seth and Nephthys, Isis and Osiris. Together they lay four ages, eight thousand years (but what is time to lovers?). In deep rivers of passion, then soaring birdlike to the heights amid great waves of light, the two pairs of lovers imagined, then counted and named the greater and lesser constellations. They gave their names to the stars.

Ages passed while the five children lay in the dark moon of their mother, waiting to be born. But in the outer world, things fractured. Waves of light bent in ten thousand directions. Forms took shape, breathed, walked on land. A ball of flame roared across the Sky, scorching Earth, burning the belly of Heaven, frightening animals and blinding men. Women fell face down upon the ground. The savannah lands withered; the elephant, the giraffe, and the baboon withdrew into the darkest parts of the world. Grains shriveled on their hollowed stalks. Shamans slaughtered lambs, oxen, birds, chieftains, children. Holy dancers entwined themselves in asps, chanting, "Great Mother! What sin have we committed that you must torture us with such bright contempt?"

Nut, the Sky, gave forth no answer but the panting of the hot wind and the rustle of dried papyrus stalks. The labor of Heaven was long and arduous. Her lament became the soured waters of Earth. Once-verdant fields turned to dust. The sun god, Ra, roared through the world, searing and blinding. It was not day, for there was no night. There was only Ra, who reigned supreme in the outer world, and no one else.

And so the last age passed in the dark, pulsing womb of the Great Mother. Only her son Thoth, the moon god, felt sorry for her. He saw how sick his mother the Sky had become, and he saw how Earth, his father Geb, grieved. He heard the mutterings of the unborn children and sympathized, for he knew what it was to be hidden from the world by the Sun's powerful light.

No other way to birth Nut's children could be found, no way to release the mother's burden, except that moments of time be stolen from the grain heap of eternity. A great sacrifice was needed. Where these unborn children grew beautiful and did not suffer from the ravages of time in the womb of their mother, now they must be born into time. Time would hold and bind them to the eternally shifting forms of light and dark, night and day, until the end of all things. And the children and their mother agreed.

Thus it was that somewhere in Heaven, or on Earth, the subtle and cunning moon god Thoth played endless rounds of checkers with his arrogant brother Ra, the Sun. Thoth let Ra win most of the games, but over a period of time he slowly won from Ra several small parts of the god's golden light. Furious at having been deceived, Ra beat his hands on the gaming table, and the Earth shook. Thoth gathered his winnings, finally forcing Ra to agree to give Thoth five days of his light, one day for each child of Nut that was to be born.

At length Ra agreed. Then the five children gathered at the edge of the great abyss, drawing lots to see who should be born first. Osiris. Horus. Seth. Isis. Nephthys. With a sigh of relief from the mother and a rush of amniotic waters, Osiris, the first man-god, was born complete with his seven souls—his intelligence, his names, his heart, his shadow, his flesh, his beatific body, and his double. Because he was the first to see the world as a divine god-man, the Great Mother gave him the most beautiful eyes. He fell out of Heaven and into time. Where his feet first touched the ground there rushed up a green field of wheat. Wherever he passed, the dry rocks cleaved and water flowed to the ground.

Then Horus was born, but with some reluctance. He clung to the belly of Sky—a hawk of gold whose clawed feet never pressed against Earth. Keen were his eyes and wide his vision. To the ends of the universe he flew and back again. From the heights he observed how the laws of Heaven and Earth were formed; how deep the night, how bright the noon, how cool the shade, how beautiful the dusk and dawn.

Impatient to be born, Seth pierced the Great Mother's side with a knife and came forth like a bolt of lightning. Malformed by his rage at having been pent up so long in the dark, he was born with the head of an ass, a hideous sight to behold. His heart hardened into a lump of iron. On the day of his birth, Ra sent forth a whirling wind filled with red and ochre sand. Then Seth changed himself into an asp and slithered away into the crevice of some desert rock.

On the fourth day, the sudden sandstorms ceased. Isis slipped through the portal of time like a gently falling star. In the eastern sky just before the rising of the sun, hung a bright, white star, which was the fiery soul of the goddess herself, hung between the

horns of the pale, white moon. At the divine birth of the beautiful daughter, there came not a moan from the lips of the sky goddess, but a song like that of a lark. Said Nut, "I am mother of the gods; but you, my daughter, shall be mother of the world! As I have given birth to you, my children, you have given birth to me. You have molded me, you have shaped me, you have loved me and created me in the image of your Great Mother." Then a breeze like the caress of a woman's hand wrapped itself around the world.

On the fifth day the goddess Nephthys was born amid a shroud of mystery. With the caul cast over her face, she hid her light in the way that the face of the moon is hidden by day. Or in the way that some distant stars can only be glimpsed at night from the corner of the eye. On the evening of her birth, wolves howled and frogs gulped air, leaping from the depths of the river. She carried truth with her into the land of Egypt, but hers was a kind of truth that could only be glimpsed in dreams. Perhaps it was because she was last born that on Earth Nephthys so often sat apart from the others.

Osiris and Seth divided the land between them. Osiris was given the black land by the rivers; Seth acquired everything else, mostly the mountains and the red deserts. Seth spent his evenings hunting wild boars; Osiris spent his day cultivating grapes in his arbor. In green gardens of light Isis sang her woman songs of becoming, while by night Nephthys sang her songs of unbearable sorrow. The gods and goddesses remembered their becoming, their births into the world, and their lives in the womb. From these patterns was the world made, and they called their land Khem.

An Old Year/New Year Celebration

The ancient Egyptian new year began on July 17, when the goddess Isis appeared as the rising star that heralded the annual Nile flood. The week preceding the new year was filled with festivals. When we moderns celebrate New Year's Eve by eating, drinking, feasting, dancing, and blowing horns, we participate in a tradition of ringing out the old and bringing in the new that is as old as Egypt itself. Amid all the celebration, the ancients never forgot the spiritual reason for this great party. Priests and priestesses also spent time in meditation, focusing their attention on exploring the mysteries of life, death, and rebirth.

My own Old Year/New Year ritual is based on the ancient Egyptian days but adapted for our December/January celebrations. These simple meditations and journal exercises can be performed before a birthday or during any week that feels appropriate for a yearly review. I usually do them in December, spending an hour each day writing in my journal, marking my passage through the year and preparing for the year to come. It seems fitting, at this time, that I should celebrate the goddess's part in my life. By noting the cycles through which I have passed, I acknowledge the part she has played in the births, losses, and rebirths of the year.

The Night of the Mothers

The Night of the Mothers is dedicated to Hathor (Nut), who bestowed her gifts of love, light, and joy for over six thousand years. So ancient was she that all the other Egyptian goddesses fused with her, including Isis, who became the prototype of the Virgin Mary. As the night sky, she offered a peaceful respite from the blazing sun, which explains why the feminine holds the passive, dark, and intuitive attributes. Her body hung with stars, which were her divine and mortal children. A six-thousand-year-old portrait of Hathor depicts her as a dancing woman, holding and uplifting the stars. A more common portrait of her was as a beautiful woman carrying between her cow horns a solar disk, or perhaps the moon, or the egg of the world.

One of her oldest aspects was as Tauret, a prehistoric, pregnant hippo goddess. With her swollen belly and her tongue darting between her teeth, she was the laboring, pregnant Great Mother. She ruled the in-between places of life—womb and tomb, the borderline between birth and death. Here, she lent her powers by assisting in the transition between two worlds. In ancient times, her celebration coincided with the winter solstice. The longest night of the year represented a period of waiting, of transition; it was a time of longing and a time of dreams.

The Night of the Mothers is a period of potentiality. It is the woman in labor about to give birth to life and to dream. Her birthing is full of intention. The Goddess does not give birth by accident, but by design, by longing. She imagines full well the gods, humans, plants, and animals she wishes to manifest. The secret to manifestation is desire and intention.

This night, meditate on the future. Specifically, what is it you wish to manifest in the

coming year? What part of yourself will you birth? A single, clear, specific statement of intent puts us in the frame of mind where we can succeed at our goals. As we are children of the divine creative matrix, we share in her magical divine power. We can create matter ourselves. Knowing what one wants, and keeping it foremost in mind, is the most likely way to bring it about.

The Birth of Osiris

Nut's firstborn son, Osiris, was a compassionate being who married his sister, Isis. His brother, Seth, married the other sister, Nephthys. Osiris and Isis ruled agriculture, or the lower Nile delta. Seth and Nephthys formed a nomadic, hunting tribe living in the more barren, southern plain.

God of civilization, of marriage, of the duty a man offers his wife, Osiris taught the art of agriculture and communal living. Like grain gods through-out the world, he represented sacrifice and renewal. As corn, he was trodden into the ground, rested in the darkness, and then was reborn. As god of the Nile, he was the source of abundance appearing as the annual flood that replenished the fields.

Osiris, firstborn child of Nut and husband of Isis, appears in mummiform.

Osiris was also a figure of death and sacrifice. When he died, Isis grieved, and in her grief erected temples dedicated to Osiris throughout Egypt. At her temple at Philae, far to the south, near Nubia, just below the first cataract of the Nile, Isis awaited Osiris's return to Egypt as the manifestation of the annual flood. The onset of the flood was signaled by the rising of the star, Sirius, who was the celestial Isis, heralding her husband's return.

On this day, recall the natural gifts of the world. Write thank you letters to the universe which gives us abundance every day. Contemplate the blessings you have received this year. Recall the ways you have spent your time. Look back through your journal and write a time capsule of the year. This yearly summary, when kept consistently for several years, helps you to see how your life unfolds over time, where your energies were spent, and whether or not you are consciously applying yourself to your own becoming.

The Birth of Horus

Horus was twice born—once of sky (Hathor) and once of his mother (Isis). His first life was created once in the womb of heaven, and his second was created on earth. Horus embodied spirit cloaked in matter, the intertwining of divine fate and human will. Born weak, he grew strong through his mother's magical, protecting love. At last strong enough to avenge the death of his father, the hawk-headed Horus embodied the spiritual warrior; and every pharaoh embodied Horus. Thus, the pharaoh was the living son of the goddess, which gave him the divine right to rule Egypt.

The trinity of mother, father, and child was sacred to Egyptians. When opposites attract, one and one make two, and from that union issues a third principle, the balance. In the trinity resides stability, the balance between reception and action. The warrior hears the spiritual call of the unconscious, then moves into the realm of action, but he always balances his active and listening phases.

Horus is hawk-headed because, like his sky mother, he belongs to the celestial, intellectual realm. For the skilled warrior, thought and meditation precede action. Isis was said to have taught Horus the law of cause and effect. Like the biblical notion of reaping what one sows, the law of karma Isis teaches is simple. Pay attention to exactly what you wish to manifest; then follow the course of action that brings about harvest.

This night, meditate upon what it is you want to manifest. Use your intelligence to form a plan of action. What steps must you take to achieve your goal in the coming year?

Horus the Elder appears in a marsh thicket wearing the crown of Upper Egypt.

In this way you participate actively in your own becoming. Through conscious effort and will, we achieve our highest spiritual potential.

The Birth of Seth

Seth, Nut's third son, variously appears as a pig, an ass, and, more often, a jackal. Early Egyptian kings honored him as god of wind and sand storms, whose sudden, violent appearance disrupted the normal flow of life. As Osiris was Lord of Life, Seth was the Harbinger of Death. Theirs was a classic Cain and Abel story; as Cain slew Abel, so Seth slew Osiris.

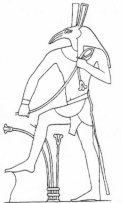

Seth holds the heraldic plant of Upper Egypt.

Personification of the desert, in psychological terms, Seth is associated with loss, restriction, and sterility. Yet he is an important god. As death destroys form, Seth separates us from the old and makes way for the new. Ancient initiates spent many weeks inside tombs and temple mortuaries mummifying the dead, sitting with the dead, contemplating death until they have lost their fear of it. Only through such loss and darkness could the human soul become radiant and divine. This is the true meaning of the alchemical dictum that the philosopher's stone teaches us how to turn lead into gold.

This night, contemplate the losses and restrictions of the year, recalling the lessons learned. Try to see the pattern that is unfolding. What were your sorrows and disappointments? How were you changed by them?

The Birth of Isis

The birth of Isis is one of the most joyful celebrations of the year. For nearly three thousand years, the ancients worshipped her as the queen of heaven and earth, the most powerful goddess of all. One Hymn to Isis reads:

Open the gates of heaven, draw back
 the bolts.
I have come to sing for thee, O Isis.
I have come to praise thee, O Flame.
I have come to adore thee, O Great
 Speaker of Spells.
 How beautiful is thy face, happy,
 renewed, refreshed as the day
 when thy mother Nut first
 fashioned thee.

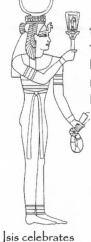

Isis celebrates with upraised sistrum and menat.

All praise to the Queen of Earth and
 Heaven.
All praise the goddess Isis.[128]

Isis possessed many forms and names. As Ma'at, goddess of truth, she embodied the balanced laws of nature . As Hathor, queen of the sky, she nourished her children. As Sothis, manifestation of the star Sirius, she heralded the flood and the return of abundance. A great sorceress, Isis could manifest in any form she pleased. She once turned herself into a scorpion and learned the secret name of Ra, the name that was the key to the highest magical power. In truth, Isis already knew Ra's secret name. Like Hathor and Nut, she was a sky goddess; and therefore, Ra's mother. It was she who first gave his secret name and power to him. The veiled Isis reminds us of her penetrating mystery and awe when she declares:

I am all that has been, and all that
 shall be.
And no man has uncovered my face.
No one has ever lifted my veil.[129]

Childless when Osiris was slain, she wanted nothing more than to bear a child. After searching many years to recover her husband's body, she transformed into a hawk and lowered herself upon him; thus, his spirit passed magically into her, and the conception of her son was immaculate. Her Egyptian name, Auset, literally means the "seat" or "throne." She wore a throne on her head to remind us that the child who sat on the throne, i.e., the child in her lap, was heir of Egypt. Like Hathor, Isis was a goddess of love, of health, of feasting, and dancing. Her celebrations were joyful celebrations of life.

This night, praise Isis and spend a moment recalling your enthusiasms of the year and your magical accomplishments, creations, and joys.

The Birth of Nephthys

Nephthys, Nut's last child and the beloved sister of Isis, was sometimes called the Veiled Isis. On her head rests the symbol of the temple and the cup. "Lady of the House," her name refers to the divine house, the temple of the spirit. Whereas Isis ruled heaven and earth, Nephthys ruled the unseeen of dreams, hidden mysteries, and psychic phenomenon. Goddess of the unknown, her power

lay in the tomb where she assisted Isis in the mysteries of transforming the deceased into living creatures of light.

When Osiris died, Nephthys joined Isis in mourning and helped search for his body. Although married to the wicked brother who slew Osiris, Nephthys supported her sorrowing sister. She became the goddess of women, especially of the woman healer. She brought healing dreams and comforted those who suffered. She and Isis together initiated temple prayer and worship as a means of paying respect to Osiris and to all the gods and goddesses.

This day, spend time reviewing your dreams of the past year. Observe the developing patterns of the messages sent to you by your unconscious mind. Reap these healing messages. Recount life's amazing synchronicities and how the dream heralds transformation.

Nephthys, wife of Seth and twin of Isis, was called Lady of the House, wearing the emblem of the house on her head.

The Death and Resurrection of Osiris

The transition between the old year and the new recalls the sacrifice of Osiris and his subsequent, glorious resurrection. In ancient times professional mourners dressed as Isis and Nephthys often followed the body to the tomb, keening. But the living must stop at the gates of death, while the dead travel on in the neterworld in darkness.

To ease this terror of the unknown, the ancient Egyptians devised a funerary text, that we call the Book of the Dead. The ancient Egyptian title is more appropriate. They called it the Book of Coming Forth By Day. It contained hymns and prayers to the gods and goddesses, described the layout of the underworld, and provided ritual prayers for protection and spells for reincarnation and transformation.

Egyptians believed that the heart, not the mind, records our life thoughts and deeds. They believed that in the neterworld, the hearts of the dead were placed on a balance called the scales of Ma'at, or the scales of truth. If the heart was lighter than a feather, the dead could pass through the darkness to rebirth. If the heart was heavy, it was thrown to the hippo-crocodile-lion goddess Ammit, called the Devourer of Hearts. Once the heart was eaten, that was the end. The soul transformed no more. It would be as if the individual had never existed.

Having passed judgment, the soul was free to continue on its journey through the underworld, called du'at. In this land of darkness were seven magical gates, guarded by three monsters each. In the underworld one met twenty-one terrifying aspects of the Great Mother, goddesses with names like Vulture Mother of Terror, Lady of the Flame, Lady of the Knife.

Having passed through du'at, one found the boat of Hathor and sailed in it across the lake to the Island of Flame, where the mortal coil was burned away and one became a being of light. This voyage symbolized the passage of the solar barque as it traversed the body of the sky goddess. It marked the blending of conscious and unconscious powers into supraconsciousness. When one reached the other side, Hathor would be waiting to greet the dead, offering comfort, succor, and a cool drink of milk from her breast.

At some point during New Year's Eve, read some of The Egyptian Book of the Dead, or more precisely, the Book of Coming Forth By Day. Reading it is a way of letting go of the past and preparing to enter the new. Or choose one card from the Tarot pack to represent the summary of the months passed. In this manner you may find yourself able to translate your passage through the year into useful spiritual terms.

This New Year's Day, do nothing, or everything. My grandmother used to say that what we did on the first day of the year will be what we do the rest of the year. I try to be loving with my family. I call a friend and meet for lunch. I read. I write. I take long walks. I eat a good meal. (I try NOT to clean house.) This day, go where the spirit wills. I wish you abundance and the many blessings of the goddess for the new year.

 Appendix

APPENDIX: A BRIEF HISTORICAL OVERVIEW

Prehistoric Egypt c. 5000-3150 B.C.E.

Many of the local female divinities with their attendant mythologies emerged into major goddesses. Legends say the sons of the Companions of Horus ruled Egypt, establishing law and order according to the teachings of Isis and Osiris.

Thinite Dynasties c. 3150-2686 B.C.E.

Upper and Lower goddesses are merged when the early kings unite Egypt. Shared mythologies develop.

Old Kingdom c. 2686-2181 B.C.E.

Dynasties 3-6 mark the diminishing importance of the star cult and the rise of the cult of Ra, which resulted in many mother goddesses becoming daughters of the sun god. The focal center of Egypt was in Memphis and the Delta region.

First Intermediate Period c. 2181-2040 B.C.E.

During this period of unrest, many pharaohs ruled and unity was lost.

Middle Kingdom c. 2040-1786 B.C.E.

Dynasties 11-13 return order and prosperity. Thebes emerges as Egypt's capital city.

Second Intermediate Period

c. 1786-1552 B.C.E.

During this period of unrest and internal strife, Egypt was overrun by foreign rulers, most notably the Hyksos.

New Kingdom c. 1551-1085 B.C.E.

Major temple refurbishment began. Thebes emerged as the capital city. The cult of Amun dominated. Akhenaten established the one god religion of Aten, and soon after his reign, the Hebrews left Israel. Queen Hatshepsut rules for many years and reestablishes the prominence of the cult of Hathor.

Third Intermediate Period c. 1085-718 B.C.E.

The priests of Amun and the native delta kings battle for rulership.

Late Period c. 718-343 B.C.E.

The Nubians develop their own lineage of kings and refurbish the temples near Aswan. They soon lose control to rulers from Sais, the delta city. Invading Persians end the Late Period.

Graeco-Roman Period

c. 343 B.C.E. - 323 A.C.E.

Alexander the Great conquers Egypt. Rulership passes to Egyptian-born rulers of Greek lineage known as the Ptolemies. In an ill-fated move, Cleopatra loses Egypt to the Romans. In the end, the Byzantine rulers establish Christianity as the nation's religion, and the Coptic religon arises.

CHAPTER NOTES

Introduction

1. Mircea Eliade, *Myth and Reality* (New York: Harper & Row, 1963), 12.

2. Naomi Ozaniec, *Daughter of the Goddess: The Sacred Priestess* (London: Aquarian Press, 1993), 216.

3. John Michell, "The Ancient Temple and Modern Cosmology," interview by David Fideler in *Gnosis* 15 (Spring 1990): 48.

4. James Breasted, *Ancient Records of Egypt*, 5 vols. (Chicago: University of Chicago Press, 1906), 4:84.

5. C. J. Bleeker, *Egyptian Festivals: Enactments of Religious Renewal* (London: E. J. Brill, 1967), 25.

6. Ibid.

7. In addition to those texts cited here, in-depth exploration of the astrology of the Egyptian temples and its calendars can be found in the following volumes: Jane B. Sellers, *The Death of Gods in Ancient Egypt* (London: Penguin, 1992); Franz Cumont, *Astrology and Religion Among the Greeks and Romans* (New York: Dover, 1960); and Rupert Gleadow, *The Origin of the Zodiac* (New York: Atheneum, 1969).

8. In 238 B.C.E. during the reign of the Egyptian-born Greek king Ptolemy and his wife Bernice, the celebration of The Rising of Sothis in Bubastis was held on 1 Payni (or April 15). At that time, the feast coincided with the official date of The Festival Voyage of Bast and was celebrated with the coincidental gathering of the crops. Apparently, the priests had begun to note the great differences between the traditional dates of three major festivals: The Festival of the New Year, The Rise of Sothis, and The Rising of the Nile. The New Year Festival, set to the civil calendar, only recurred on the same true day every 365 years. The Rise of Sothis was actually closer to the true calendar of 365.25 days. By using a calendar with only 365 days, however, the priests noted that every four years the star appeared to rise one day earlier. The more variable date for the rise of the Nile caused by melting snow in the high mountains always came consistently at the end of the summer, around one to two weeks on either side of the traditional festival date. Noting a way to amend the error by creating a leap year, Ptolemy and his priests announced on the Canopus Stela that from then on, every four years an additional day would be added to the calendar and that day would be known as The Feast for the Benefactor Gods. See Anthony J. Spalinger, *Three Studies on Egyptian Feasts and Their Chronological Implications* (Baltimore: Halgo, Inc., 1992), 36.

9. The second or third king of the First Dynasty (name uncertain) celebrated a feast of the goddess Yamet during his sixth year of reign. We do not know where the festival occurred or what functions the goddess Yamet served. From what we can tell, the festival was not annual and was never repeated. In the second year before his death, the last king of the First Dynasty, perhaps King Miebis, celebrated the birthdays of Seshat and Mafdet. Perhaps the birthday feast of Seshat is also the New Year's Festival of Hathor as Sothis. Mafdet, the lioness, appears to be an exclusively Old Kingdom goddess, for we hear little about her in later texts. The Fifth Dynasty pharaohs, Userkaf and his successor Sahure, apparently celebrated more festivals to the goddess than did their predecessors. In his fifth year, Userkaf visited and made offerings in the temples of Hathor and Nekhebet; Sahure in his fifth year visited three different Hathor temples in Egypt and Libya, making offerings and building temples. He also visited the temples of Nekhebet, Buto, and Sekhmet. See Breasted, *Ancient Records of Egypt*, 1:57-72.

 The worship of Hathor was so popular during the Old Kingdom that more festivals were dedicated to her honor than to any other neter. More men and women participated in her worship than participated in the worship of all the other gods. More children were named after the goddess Hathor than any other neter, as a means of placing the child under divine motherly protection. In a study of the temples and cults of the Old Kingdom during the Fourth and Fifth Dynasties, one finds ancient records revealing that 109 people (83 women and 26 men) participated in the cult of Hathor, as compared with only 70 people participating in the cult of Horus, 41 people participating in the cult of Ra, and 14 participating in the cult of Osiris. See Lana Troy, *Patterns of Queenship in Ancient Egyptian Myth and History*, Boreas Uppsala Studies in Ancient Mediterranean and Near Eastern Civilizations 14 (Stockholm, 1986), 73.

10. Spalinger, *Three Studies on Egyptian Feasts*, 19.

11. Correspondence with Reverend Harold Moss, Church of the Eternal Source.

12. William MacQuitty, *Island of Isis: Philae, Temple of the Nile* (New York: Charles Scribner's Sons, 1976), 85.

Innundation Festivals

1. Porphyry, *On the Cave of Nymphs*, trans. Robert Lamberton (Barrytown, N.Y.: Station Hill Press, 1983), 34.

2. Graham Hancock and Robert Bauval, *Message of the Sphinx* (New York: Crown, 1996), 170. See also Lucie Lamy, *Egyptian Mysteries: New Light on Ancient Spiritual Knowledge* (New York: Crossroads, 1981), 6.

3. Herodotus, *The Histories*, trans. Aubrey dé Selincourt, (reprint, New York: Penguin, 1972), Book 2:148.

4. E. A. Wallis Budge, *The Gods of the Egyptians*, 2 vols. (New York: Dover, 1969), 2:52-54.

5. For more information on the stellar alignments of the Great Pyramid, see Robert Bauval and Adrian Gilbert, *The Orion Mystery* (New York: Crown, 1994).

6. Author's translation of Pyramid Text Utterance 302, line 458. See Alexandre Piankoff, *The Pyramid of Unas*, Bollingen Series XL, no.5 (Princeton N.J.: Princeton University Press, 1968), 21. *The Meshetiu* represents the Great Bear constellation, which was a part of the northern sky lying next to the North Pole, where the stars never set. Thus, they were called The Imperishable Ones.

7. Richard Parker, *The Calendars of Ancient Egypt*, Studies in Oriental Civilization, no. 26 (Chicago: University of Chicago Press, 1950), 32-33.

8. John Anthony West, "Ancient Egypt: The Meaning Behind the Magic," *The Quest* (Winter 1991): 80.

9. John Anthony West, *The Traveler's Key to Ancient Egypt* (Wheaton Ill.: Quest Books, 1995), 385.

10. Parker, *The Calendars of Ancient Egypt*, 33.

11. Lamy, *Egyptian Mysteries*, 6.

12. Lawrence Durdin-Robertson, *The Goddesses of Chaldaea, Syria and Egypt* (Clonegal, England,1975), 21.

13. Breasted, *Ancient Records of Egypt*, 1:284-85.

14. Ibid., 262.

15. Parker, *The Calendars of Ancient Egypt*, 33.

16. Graham Hancock, *Fingerprints of the Gods* (New York: Crown, 1995), 438.

17. Breasted, *Ancient Records of Egypt*, 3:94.

18. Ibid., 2:70.

19. Tamara Siuda-Legan, *The Neteru of Kemet* (Chicago: Eschaton Productions, 1994), 1.

20. E. A. Wallis Budge, *Dwellers of the Nile* (New York: Dover, 1977), 106.

21. J. G. Wilkinson, *The Ancient Egyptians: Their Life and Customs* (New York: Crescent Books, 1900), 251.

22. G. A. Wainwright, *The Sky-Religion in Egypt* (London: Cambridge University Press, 1938), 59-60.

23. R. E. Witt, *Isis in the Graeco-Roman World* (Ithaca, N.Y.: Cornell University Press, 1971), 99.

24. Breasted, *Ancient Records of Egypt*, 2:313-314.

25. Wilkinson, *The Ancient Egyptians*, 323.

26. Based on the calculations of Anthony J. Spalinger and Richard Parker, who researched early Egyptian calendrics and the coincidence of the simultaneous risings of Sirius and the Nile. See Anthony J. Spalinger, *Revolutions in Time: Studies in Ancient Egyptian Calendrics* (San Antonio, Tex.: Van Siclen Books, 1994), 4.

27. Ibid.

28. J. Norman Lockyer, *The Dawn of Astronomy: A Study of the Temple Worship and Mythology of the Ancient Egyptians* (Cambridge, Mass.: MIT Press, 1964), 247.

29. Translation by Noel Stock in *Love Poems of Ancient Egypt*, trans. Ezra Pound and Noel Stock (Norfolk, Conn.: New Directions, 1962), 27.

30. C. J. Bleeker. *Hathor and Thoth: Two Key Figures of the Ancient Egyptian Religion* (Leiden, Netherlands: E. J. Brill, 1973), 91.

31. Robert Masters, *The Goddess Sekhmet: The Way of the Five Bodies* (New York: Amity House, 1988), 44.

32. Bleeker, *Hathor and Thoth*, 91.

33. Masters, *The Goddess Sekhmet*, 44.

34. Bleeker, *Hathor and Thoth*, 51.

35. Nancy Blair, *Amulets of the Goddess* (Oakland, Calif.: Wingbow Press, 1993), 71.

36. Geraldine Pinch, *Votive Offerings to Hathor* (Oxford: Griffith Institute, 1993), 243.

37. Bleeker, *Hathor and Thoth*, 99. Bleeker believes Hathor and Min are Egypt's oldest goddess and god. The original sky mother was simply Nt, meaning "goddess," and could have been either Nut, Neith, or Hathor.

38. Troy, *Patterns of Queenship*, 14:95.

39. Ozaniec, *Daughter of the Goddess*, 72.

40. E. O. James, *Myths and Ritual in the Ancient Near East* (New York: Praeger Publishers, 1965), 53.

41. Pinch, *Votive Offerings to Hathor*, 243.

42. James, *Myths and Ritual in the Ancient Near East*, 115.

43. Lamy, *Egyptian Mysteries*, 12.

44. Barbara G. Walker, *The Woman's Dictionary of Symbols and Sacred Objects* (San Francisco: Harper & Row, 1988), 374.

45. John Anthony West, *Serpent in the Sky: The High Wisdom of Ancient Egypt* (Wheaton, Ill: Quest Books, 1993), 163.

46. Ozaniec, *Daughter of the Goddess*, 78.

47. Pinch, *Votive Offerings to Hathor*, 244.

48. Serge Sauneron, *The Priests of Ancient Egypt*, trans. Ann Morrisett (New York: Grove Press, 1960), 93.

49. Winifred S. Blackman, *The Fellahin of Upper Egypt* (London: George Harrap and Company, 1927), 98-99.

50. Parker, *The Calendars of Ancient Egypt*, 39.

51. Author's translation. See Budge, *The Gods of the Egyptians*, 1:436.

52. Wilkinson, *The Ancient Egyptians*, 268.

53. Rosalie David, *The Ancient Egyptians: Religions, Beliefs and Practices* (London: Routledge & Kegan Paul, 1982), 125.

54. Margaret A. Murray, *Egyptian Religious Poetry* (London: John Murray Publishers, 1949), 96.

55. Irmgaard Woldering, *The Art of Egypt* (New York: Crown, 1963), 127.

56. Author's translation of Pyramid Text Utterance 269. See R. O. Faulkner, *The Ancient Egyptian Pyramid Texts* (Oxford: Clarendon Press, 1969).

57. Breasted, *Ancient Records of Egypt*, 2:318.

58. Ibid., 332.

59. Lawrence Durdin-Robertson, *The Year of the Goddess: A Perpetual Calendar of Festivals* (Wellingsborough, Northhamphire: Aquarian Press, 1990), 131.

60. Breasted, *Ancient Records of Egypt*, 2:359.

61. Ibid., 4:134-141.

62. Ibid., 141.

63. Budge, *The Gods of the Egyptians*, 2:30-31.

64. Alan W. Shorter, *The Egyptian Gods* (London: Routledge & Kegan Paul, 1937), 31.

65. Barbara Mertz, *Red Land, Black Land: Daily Life in Ancient Egypt* (New York: Dodd, Mead, and Company, 1978), 273.

66. Sauneron, *The Priests of Ancient Egypt*, 93.

67. Wainwright, *The Sky-Religion in Egypt*, 43.

68. Pyramid Text Utterance 220 translated by Margaret A. Murray. See Murray, *Egyptian Religious Poetry*, 96.

69. Veronica Ions, *Egyptian Mythology* (Middlesex: Hamlyn House, 1968), 72-78.

70. Wilkinson, *The Ancient Egyptians*, 301.

71. Ibid., 299.

72. Ibid., 300.

73. Ralph Blum, *The Book of Runes* (New York: St. Martin's Press, 1993), 51-52.

74. Parker, *The Calendars of Ancient Egypt*, 58.

75. Bleeker, *Hathor and Thoth*, 85.

76. Ibid., 75.

77. Ibid., 76.

78. Ibid., 78.

79. Quoting Johannes Duemichen's *Dendera* (Leipzig, 1865) in Gaston Maspero, *Dawn of Civilization*, trans. M. L. McClure, 4th rev. ed. (London: Society for Promoting Christian Knowledge, 1901), 322.

80. Bleeker, *Hathor and Thoth*, 82.

81. Ibid., 86.

82. James Teackle Dennis, *The Burden of Isis* (London: John Murray, 1918), 55-56. *Lady of Aset* means both "Lady of the Throne" and "Lady Isis." *Tait* is the name of Hathor in Busiris. *Suten-henen* is the city Herakleopolis. *Nebertcher* is the name of the god Osiris as Lord of the Universe.

83. For more precise locations of ancient place sites, see West, *The Traveler's Key to Ancient Egypt*. Most of the finest early coffins of ancient Egypt were made from imported Lebanon cedar in imitation of the tree that ensnared Osiris. Uncommon in ancient Egypt, trees were a high-priced commodity.

84. Dennis, *The Burden of Isis*, 15.

85. Merlin Stone, *When God Was a Woman* (New York: Dorsett Press, 1976), 144.

86. Dennis, *The Burden of Isis*, 16.

87. Sharon Kelly Heyob, *The Cult of Isis Among Women in the Graeco-Roman World* (Leiden, Netherlands: E. J. Brill, 1975), 64-65.

88. Ibid., 55-57.

89. Arthur Versluis, *The Egyptian Mysteries* (London: Arkana, 1988), 45.

90. Coffin Texts 44, 51, and 53 in Stephen Quirke and Werner Forman, *Hieroglyphs and the Afterlife* (Norman: University of Oklahoma Press, 1996), 87.

91. R. T. Rundle Clark, *Myth and Symbol in Ancient Egypt* (London: Thames and Hudson, 1959), 125-126.

92. Witt, *Isis in the Graeco-Roman World*, 33.

93. Robert Briffault, *The Mothers*, 3 vols. (New York: Macmillian Company, 1927), 2: 782.

94. Ozaneic, *Daughter of the Goddess*, 219.

95. Note 1,3 in R. O. Faulkner, "The Bremner-Rhind Papyrus," *Journal of Egyptian Archaeology* 22 (London: The Egyptian Exploration Society, 1936), 123.

96. Lines 3,1-3,20. Ibid., 123-124.

97. Naomi Ozaniec, *Daughter of the Goddess*, 219.

98. Erik Hornung, *Conceptions of God in Ancient Egypt* (Ithaca, N.Y.: Cornell University Press, 1982), 75.

99. Breasted, *Ancient Records of Egypt*, 2:387.

100. Ibid., 1:255.

101. Clark, *Myth and Symbol in Ancient Egypt*, 225.

102. Pinch, *Votive Offerings to Hathor*, 258.

103. Barbara G. Walker, *The Woman's Encyclopedia of Myths and*

Secrets (San Francisco: Harper & Row, 1983), 294.

104. Chapter 25 of The Egyptian Book of the Dead in E. A. Wallis Budge, *The Egyptian Book of the Dead: The Papyrus of Ani* (New York: Dover, 1967), 572-584.

105. Breasted, *Ancient Records of Egypt*, 3:74.

106. Clark, *Myth and Symbol in Ancient Egypt*, 61.

107. Author's translation of the Eighth Petition of "The Eloquent Peasant," a Middle Kingdom text. See Miriam Lichtheim, *Ancient Egyptian Literature: The Old and Middle Kingdoms*, 3 vols. (Berkeley, Calif.: University of California Press, 1973), 1:169-185.

108. Bob Brier, *Ancient Egyptian Magic* (New York: Quill, 1981), 233.

109. Wilkinson, *The Ancient Egyptians*, 299.

110. Bleeker, *Hathor and Thoth*, 99.

111. Parker, *The Calendars of Ancient Egypt*, 58.

112. Henri Frankfort, *Kingship and the Gods: A Study of Ancient Near Eastern Religion as the Integration of Society and Nature* (Chicago: University of Chicago Press, 1948), 356, note 19.

113. Walker, *Woman's Dictionary of Symbols and Sacred Objects*, 39-40.

114. Author's correspondence with Harold Moss, Church of the Eternal Source; March 6, 1997.

115. Geraldine Pinch, *Magic in Ancient Egypt* (Austin: University of Texas Press, 1995), 126.

116. Ibid., 122.

117. Author's personal communication with Richard Adams, December 15, 1996.

118. Author's conversation with Harold Moss, December 4, 1996, on the possible dates for the festival.

119. Ozaneic, *Daughter of the Goddess*, 183.

120. Bleeker, *Hathor and Thoth*, 88.

121. Lichtheim, *Ancient Egyptian Literature*, 1:41.

122. Ozaniec, *Daughter of the Goddess*, 81.

123. Troy, *Patterns of Queenship*, 85.

124. Bleeker, *Hathor and Thoth*, 89.

125. Piankoff, *The Pyramid of Unas*, 43.

126. Bleeker, *Egyptian Festivals*, 46.

127. The number 14 in ancient Egypt is a mystical number. Fourteen times Seth hacked the body of his brother, Osiris, with a knife and cut him into 14 pieces. Isis uttered 14 magical words to revive him. Fourteen magical words were spoken to restore the Eye of Horus, which Seth blinded in battle. Astrologically, the number 14 relates to the number of days that the moon wanes, as well as waxes. I thank Harold Moss of The Church of the Eternal Source for pointing out the use of 14 as related to the magical words.

128. Discrepancies abound in the names of the cities and the parts of the body found. Compare Budge, *The Gods of the Egyptians*, vol. 2 and George Hart, *A Dictionary of Egyptian Gods and Goddesses* (London: Routledge & Kegan Paul, 1986).

129. Lamy, *Egyptian Mysteries*, 87.

130. Cyril Aldred, *The Egyptians* (London: Thames and Hudson, 1961), 29.

131. Author's translation of Chapter 45 of The Egyptian Book of the Dead. See Budge, *The Egyptian Book of the Dead*, 105-106. See also Normandi Ellis, *Awakening Osiris* (Grand Rapids, Mich.: Phanes Press, 1988), 123.

132. Jean Houston, *The Passion of Isis and Osiris: A Union of Two Souls* (New York: Ballantine, 1995), 332.

133. Lichtheim, *Ancient Egyptian Literature*, 1:196-197.

134. Masters, *The Goddess Sekhmet*, 47.

135. Clark, *Myth and Symbol in Ancient Egypt*, 139.

136. Personal conversation with Jean Houston, June 26, 1994.

137. Budge, *The Gods of the Egyptians*, 2:129.

138. Lamy, *Egyptian Mysteries*, 87.

139. Ibid.

140. Briffault, *The Mothers*, 2:782.

141. Houston, *The Passion of Isis and Osiris*, 262.

142. Pierre Montet, *Everyday Life in Egypt* (Philadelphia: University of Pennsylvania Press, 1981), 295.

143. Walker, *Woman's Dictionary of Symbols and Sacred Objects*, 208.

144. Houston, *The Passion of Isis and Osiris*, 333.

145. Heyob, *The Cult of Isis Among Women*, 64-65.

146. Starhawk, *The Spiral Dance* (San Francisco: Harper & Row, 1979), 181.

Sowing Festivals

1. Coffin Texts, Spell 174, lines f-i. See R.O. Faulkner, *The Ancient Egyptian Coffin Texts Spells 1-354*, 3 vols. (Warminster, England: Aris & Phillips, 1978), 1:256.

2. Pinch, *Votive Offerings to Hathor*, 191-192.

3. Author's translation of Pyramid Text 77. Compare to Faulkner, *The Ancient Egyptian Pyramid Texts*, 18.

4. Bleeker, *Hathor and Thoth*, 46.

5. Ibid., 91.

6. Troy, *Patterns of Queenship*, 23.

7. Martin Bernal, *Black Athena: The Afroasiatic Roots of Classical Civilization*, 3 vols. (New Brunswick, N.J.: Rutgers University Press, 1987), 1:68.

8. Wilkinson, *The Ancient Egyptians*, 266.

9. Briffault, *The Mothers*, 1:594.

10. Patricia Monaghan, *The Book of Goddesses and Heroines* (St. Paul, Minn.: Llewellyn Publications, 1990), 49.

11. Translation by Margaret A. Murray from Chapter 164 of the Egyptian Book of the Dead. See Murray, *Egyptian Religious Poetry*, 103.

12. Internet communique with "The Admin," December 10, 1996.

13. Blackman, *The Fellahin of Upper Egypt*, 89.

14. Budge, *The Gods of the Egyptians*, 1:445.

15. Ibid.

16. Ibid.

17. Marilee Bigelow, "Bast," *Khepera* 2, no. 2 (March 1991), 12.

18. Budge, *The Gods of the Egyptians*, 1:449.

19. Herodotus, *The Histories*, 2:153.

20. M. Esther Harding, *Woman's Mysteries: Ancient and Modern.* (Boston: Shambhala, 1990), 188.

21. Wilkinson, *The Ancient Egyptians*, 301.

22. Emil Naumann, *History of Music*, trans. F. Praeger (London, 1882), 40. The Greek nature god Pan was related to Osiris in his fructifying form. *Panu* may be a mixture of the god Pan and the concept of the bennu bird, which was equated with the phoenix who returns to its nest, dies by fire, and is reborn from the ashes.

23. Wilkinson, *The Ancient Egyptians*, 297.

24. Erich Neumann, *The Great Mother*, trans. Ralph Manheim, Bollingen Series XLVII (Princeton, N.J.: Princeton University Press, 1972), 291.

25. Witt, *Isis in the Graeco-Roman World*, 92.

26. Based on the prayers of Lucius in *The Golden Ass* of Apuleius. See Robert Graves, *The Golden Ass* (New York: Farrar, Straus & Giroux, 1951), 282-283; and Jack Lindsay, *The Golden Ass* (Bloomington: Indiana University Press, 1960), 250-251.

27. Witt, *Isis in the Graeco-Roman World*, 110.

28. Lamy, *Egyptian Mysteries*, 23.

29. Lamy, *Egyptian Mysteries*, 20.

30. Communique of Iman Nossier in America Online news group Egypt.soc on World Wide Web, December, 1996.

31. Harding, *Woman's Mysteries*, 188.

32. Lamy, *Egyptian Mysteries*, 23.

33. Dennis, *The Burden of Isis*, 46.

34. Harding, *Woman's Mysteries*, 189.

35. Murray, *Egyptian Religious Poetry*, 73-74.

36. José A. Arguelles, *The Transformative Vision: Reflections on the Nature and History of Human Expression* (Boulder: Shambhala, 1975), 227.

37. Iamblicus, "On the Mysteries," Book III, paragraph 6, trans. Frederick C. Grant, as quoted in Mircea Eliade, *Essential Sacred Writings From Around the World* (San Francisco: Harper San Francisco, 1967), 492.

38. Jonathan Cott, *The Search for Omm Sety* (Garden City, N.J.: Doubleday, 1987), 156.

39. Walter Addison Jayne, *The Healing Gods of Ancient Civilization*, lst ed. (New Haven: Yale University Press, 1925), 30.

40. Pyramid Text of Pepi. See Lichtheim, *Ancient Egyptian Literature*, 1:46.

41. Spalinger, *Revolutions in Time*, 8.

42. Dennis, *The Burden of Isis*, 35.

43. Ibid., 24.

44. Witt, *Isis in the Graeco-Roman World*, 102-103.

45. Walter Berket, *Ancient Mystery Cults* (Cambridge: Harvard University Press, 1987), 8.

46. Blackman, *The Fellahin of Upper Egypt*, 107.

47. J. J. Bachofen, *Myth, Religion and Mother Right* (Princeton, N.J.: Princeton University Press, 1967), 191-192.

48. Blackman, *The Fellahin of Upper Egypt*, 78-80.

49. H. P. Blavatsky, *The Secret Doctrine*, 3 vols. (Wheaton, Ill: Theosophical Publishing House, 1978), 1:406.

50. J. E. Cirlot, *A Dictionary of Symbols* (New York: Dorsett Press, 1971), 347.

51. Wilkinson, *The Ancient Egyptians*, 288.

52. Budge, *The Gods of the Egyptians*, 2:191.

53. Bleeker, *Hathor and Thoth*, 91.

54. Hart, *A Dictionary of Egyptian Gods and Goddesses*, 79.

55. Pinch, *Magic in Ancient Egypt*, 37.

56. Ozaniec, *Daughter of the Goddess*, 83.

57. Lichtheim, *Ancient Egyptian Literature: The Late Period*, 3:56.

58. Ozaniec, *Daughter of the Goddess*, 85.

59. E. A. Wallis Budge, *Egyptian Magic* (New York: Dover, 1971), 165. Egypt's heaven and hell exist in the pattern of Egypt. There are islands ringed by water in heaven where the gods and goddesses live, and in the underworld exist islands of flame and lakes of fire.

60. Walker, *The Woman's Encyclopedia of Myths and Secrets*, 803-

804.

61. West, *Serpent in the Sky*, 62.

62. Murry Hope, *Practical Egyptian Magic* (New York: St. Martin's Press, 1984), 143.

63. Wilkinson, *The Ancient Egyptians*, 298.

64. Herodotus, *The Histories*, Book II, 62.

65. Ibid., 197.

66. Walker, *The Woman's Encyclopedia of Myths and Secrets*, 721.

67. Author's translation of Pyramid Text Utterance 317, lines 507-508. See Piankoff, *The Pyramid of Unas*, 18.

68. Monaghan, *The Book of Goddesses and Heroines*, 250.

69. Ozaniec, *Daughter of the Goddess*, 81.

70. Author's translation. See Budge, *The Gods of the Egyptians*, 1:459-460.

71. Monaghan, *The Book of Goddesses and Heroines*, 250.

72. Miriam Lichtheim, *Ancient Egyptian Literature: The New Kingdom*, 3 vols. (Berkeley, Calif.: University of California Press, 1976), 2: 217-218.

73. Piankoff, *The Pyramid of Unas*, 22. The Cool Region is the Milky Way, and the text refers to the appearance of Osiris as the constellation Orion beside the Milky Way.

74. Hancock, *Fingerprints of the Gods*, 407-409.

75. Rand Flem-Ath and Rose Flem-Ath, *When the Sky Fell: In Search of Atlantis* (New York: St. Martin's Press, 1995), xvii and 130.

76. Witt, *Isis in the Graeco-Roman World*, 20.

77. Breasted, *Ancient Records of Egypt*, 2:71.

78. Heyob, *The Cult of Isis Among Women*, 59.

79. Thanks to Harold Moss for this observation and clarification. Personal correspondence January 25, 1997.

80. Henry George Fischer, *Dendera in the Third Millennium B.C.* (Locust Valley, N.Y.: J. J. Augustin, 1968), 23.

81. Blackman, *The Fellahin of Upper Egypt*, 84.

82. Bleeker, *Hathor and Thoth*, 96.

83. Hart, *A Dictionary of Egyptian Gods and Goddesses*, 88-89.

84. Witt, *Isis in the Graeco-Roman World*, 63-64.

85. Hart, *A Dictionary of Egyptian Gods and Goddesses*, 98.

86. Parker, *The Calendars of Ancient Egypt*, 60.

87. Buffie Johnson, *Lady of the Beasts: Ancient Images of the Goddess and Her Sacred Animals* (San Francisco: Harper & Row, 1988), 320-321.

88. Clark, *Myth and Symbol in Ancient Egypt*, 88.

Harvest Festivals and Epagomenal Days

1. Hart, *A Dictionary of Egyptian Gods and Goddesses*, 107.

2. Pyramid Text Utterance 527. See Clark, *Myth and Symbol in Ancient Egypt*, 42.

3. Troy, *Patterns of Queenship*, 29.

4. Translation by John A. Wilson in Thorkild Jacobsen and John A. Wilson, trans. *Most Ancient Verse* (Chicago: University of Chicago Press, 1963), 49.

5. James, *Myths and Ritual in the Ancient Near East*, 115.

6. Ibid., 120.

7. Walker, *The Woman's Encyclopedia of Myths and Secrets*, 400.

8. Wainwright, *The Sky-Religion in Egypt*, 18.

9. Normandi Ellis, *Awakening Osiris* (Grand Rapids: Phanes Press, 1988), 180.

10. Bleeker, *Hathor and Thoth*, 44.

11. Lamy, *Egyptian Mysteries*, 84-85.

12. Margaret A. Murray, *The Splendor That Was Egypt* (New York: Philosophical Library, 1949), 138.

13. Lamy, *Egyptian Mysteries*, 82.

14. Briffault, *The Mothers*, 2:602.

15. Lamy, *Egyptian Mysteries*, 82.

16. Personal correspondence with Tamara Siuda, January 9, 1997.

17. Ellis, *Awakening Osiris*, 209.

18. Spalinger, *Revolutions in Time*, 8.

19. Etymologically, the connection between the Egyptian idea of Ra being both the sun and the pharaoh may find a similar resonance in the Indian word *raj*, meaning "king."

20. Spalinger, *Revolutions in Time*, 6.

21. John Foster, *Echoes of Egyptian Voices: An Anthology of Ancient Egyptian Poetry* (Norman, Okla.: University of Oklahoma Press, 1992), 7.

22. Lichtheim, *Ancient Egyptian Literature*, 1:220.

23. Ibid., 1:191.

24. Ibid., 3: 99.

25. Blackman, *The Fellahin of Upper Egypt*, 309-311.

26. Hart, *A Dictionary of Egyptian Gods and Goddesses*, 182-184.

27. Heyob, *The Cult of Isis Among Women*, 54.

28. Wilkinson, *The Ancient Egyptians*, 287.

29. Herodotus, *The Histories*, Book II, 171.

30. Aldred, *The Egyptians*, 53.

31. Murray, *The Splendor That Was Egypt*, 128.

32. Blackman, *The Fellahin of Upper Egypt*, 262.

33. Author's translation of the Harper's Song from the tomb of Intef. After Adolf Erman, *The Literature of the Ancient Egyptians*, trans. Aylward M. Blackman (New York: Benjamine Blom, 1971), 133; and William Kelly Simpson, R. O. Faulkner, and Edward F. Wente, Jr., trans. and eds., *The Literature of Ancient Egypt* (New Haven: Yale University Press, 1972), 306-307.

34. Wilkinson, *The Ancient Egyptians*, 296.

35. For the complete "Contendings of Horus and Seth," see Lichtheim, *Ancient Egyptian Literature*, 2:214-223.

36. Bleeker, *Hathor and Thoth*, 39.

37. Ibid.

38. Evelyn Wells, *Hatshepsut* (Garden City, N.Y.: Doubleday, 1969), 194-195.

39. Johnson, *Lady of the Beasts*, 276.

40. Briffault, *The Mothers*, 2:174.

41. Translated by Noel Stock in Ezra Pound and Noel Stock, trans., *Love Poems of Ancient Egypt* (Norfolk, Conn.: New Directions, 1962), 21.

42. Joseph Campbell, *The Masks of God: Occidental Mythology* (New York: Viking Press, 1958).

43. Layne Redmond, "Rhythm and the Frame Drum," *Woman of Power*, no. 15 (Fall/Winter 1990), 22.

44. Buffie Johnson, *Lady of the Beasts*, 274.

45. James Blades, *Percussion Instruments and Their History* (New York: Frederick A. Praeger Publishers, 1970), 156.

46. R. A. Schwaller de Lubicz, *Sacred Science: The King of Pharaonic Theocracy*, trans. André and Goldian VandenBroeck (Rochester, Vt.: Inner Traditions, 1982), 77.

47. Bleeker, *Hathor and Thoth*, 53-54.

48. Ibid., 84.

49. Hart, *A Dictionary of Egyptian Gods and Goddesses*, 15.

50. Troy, *Patterns of Queenship*, 17-18.

51. Author's translation after Lichtheim, *Ancient Egyptian Literature*, 1:201.

52. Ellis, *Awakening Osiris*, 222.

53. Author's translation, adapted from the "Hymn to Hathor" in Lamy, *Egyptian Mysteries*, 82.

54. Bleeker, *Hathor and Thoth*, 94.

55. Ibid., 93.

56. Lamy, *Egyptian Mysteries*, 80.

57. Ibid.

58. Ibid.

59. Bleeker, *Hathor and Thoth*, 94.

60. Ibid.

61. Lamy, *Egyptian Mysteries*, 81.

62. James, *Myths and Ritual in the Ancient Near East*, 119-120.

63. Ibid.

64. Bleeker, *Hathor and Thoth*, 94.

65. Author's translation after Lichtheim, *Ancient Egyptian Literature*, 1:107.

66. Bleeker, *Hathor and Thoth*, 99.

67. Ibid., 95.

68. Ibid., 99.

69. Ibid., 95.

70. Ibid., 99.

71. Ibid., 100.

72. Heyob, *The Cult of Isis Among Women*, 21.

73. Bleeker, *Hathor and Thoth*, 96.

74. Author's translation from the hieroglyphs. See also Lichtheim, *Ancient Egyptian Literature*, 1:44.

75. Bleeker, *Hathor and Thoth*, 98.

76. Troy, *Patterns of Queenship*, 100.

77. Ibid.

78. Personal communication with astrologer Richard Adams, December 15, 1996.

79. Amelia B. Edwards, *A Thousand Miles Up the Nile* (New York: A. L. Burt, 1888), 72.

80. Clark, *Myth and Symbol*, 228.

81. Murray, *The Splendor That Was Egypt*, xxi.

82. Bleeker, *Hathor and Thoth*, 73-74.

83. Clark, *Myth and Symbol*, 227.

84. Author's translation after Budge, *The Gods of the Egyptians*, 1:442-443.

85. Bleeker, *Hathor and Thoth*, 93.

86. Ibid., 38.

87. Masters, *The Goddess Sekhmet*, 45-46.

88. Durdin-Robertson, *The Year of the Goddess*, 31.

89. Lockyer, *The Dawn of Astronomy*, 237-239.

90. Breasted, *Ancient Records of Egypt*, 2:244-248.

91. Author's translation, Prayers for All Feasts Day. See Breasted, *Ancient Records of Egypt*, 4:177-182.

92. Olaf E. Kaper, "The Astronomical Ceiling of Deir El-Haggar in the Dakhleh Oasis," *Journal of Egyptian Archaeology* 81 (London: The Egypt Exploration Society, 1995), 180.

93. Ibid., 182-183.

94. Martin Bernal suggests another possibility—that Artemis may derive from the combined Egyptian solar gods Ra-Tem, which is light manifest as waning. See Bernal, *Black Athena*, 68.

95. Lichtheim, *Ancient Egyptian Literature*, 2:108.

96. Breasted, *Ancient Records of Egypt*, 2:123-124.

97. Budge, *The Gods of the Egyptians*, 1:517-518.

98. Author's translation from Chapter 164 of The Egyptian Book of the Dead, after Budge, *The Gods of the Egyptians*, 1:519.

99. Budge, *The Gods of the Egyptians*, 2:208-209.

100. Pinch, *Votive Offerings to Hathor*, 193.

101. Jeremy Naydler, *Temple of the Cosmos: The Ancient Egyptian Experience of the Sacred* (Rochester, Vt.: Inner Traditions, 1996), 66.

102. Bleeker, *Hathor and Thoth*, 27.

103. Ibid., 68.

104. Lockyer, *The Dawn of Astronomy*, 299. Lockyer suggests that the Hathor temple predates the Isis temple and that the star goddess (Sopdet) who heralded the coming flood as early as 5000 B.C.E. was Hathor as Deneb, not Isis as Sirius. He further notes that while the light of Sirius illumines the statue of Isis on New Year's Day (Thuthi 1), all the references to Sopdet appear in the larger, adjacent Temple of Hathor, which points northeast and would never receive any light from Sirius, a more southerly star. He goes on to suggest that perhaps the true origin of the Hathor temple is so ancient that the Pole Star was not the North Star of the constellation Ursa Minor as it is now. Neither was it Lyra or Draconis, as it was previously, but rather, Deneb.

105. Bleeker, *Hathor and Thoth*, 69.

106. Ozaniec, *Daughter of the Goddess*, 81.

107. Bleeker, *Hathor and Thoth*, 89.

108. Ibid.

109. Bleeker, *Hathor and Thoth*, 84.

110. All of the prayers and prognostications provided for the birthdays of the five great gods and goddesses derive from the Middle Kingdom text called the Cairo Calendar. See Brier, *Ancient Egyptian Magic*, 251.

111. Wilkinson, *The Ancient Egyptians*, 281.

112. Brier, *Ancient Egyptian Magic*, 251. The scribe has accidentally misplaced the last lines of this hymn. Rather than appearing on the day of Seth, the hymn appears in the Birthday of Isis. The reference to the child in the cradle, which is Isis, should appear on her day, rather than on the Birthday of Nephthys. I have changed the order of the hymns here, but the final hymn for Nephthys is missing.

113. Bleeker, *Hathor and Thoth*, 93.

114. Ibid.

115. Breasted, *Ancient Records of Egypt*, 4:318.

116. Lockyer, *The Dawn of Astronomy*, 194.

117. Witt, *Isis in the Graeco-Roman World*, 110.

118. Author's translation. See F. C. Grant, *Hellenistic Religions: The Age of Syncretism* (Indianapolis: Bobbs-Merrill, 1953), 131-133.

119. Budge, *The Gods of the Egyptians*, 2:256.

120. Pyramid Text 210. See Henri Frankfort, *Ancient Egyptian Religion: An Interpretation* (New York: Columbia University Press, 1948), 106.

121. Coffin Texts, Spell 35, b-d. See Troy, *Patterns of Queenship*, 39.

122. Pyramid Text Utterannce 616, a-d. Ibid.

123. Ibid.

124. Christine Downing, *Psyche's Sisters: ReImagining the Meaning of Sisterhood* (San Francisco: Harper & Row, 1988), 11.

125. Walker, *The Woman's Encyclopedia of Myths and Secrets*, 8.

126. Coffin Text, Spell 1240, d-g. See Troy, *Patterns of Queenship*, 39.

127. Lockyer, *The Dawn of Astronomy*, 246.

128. Author's translation of the Pyramid Text, Utterance 220. See Faulkner, *The Ancient Egyptian Pyramid Texts*.

129. After Plutarch's translation of an inscription found on a statue of Isis-Neith. See Johnson, *Lady of the Beasts*, 132.

BIBLIOGRAPHY

Aldred, Cyril. *The Egyptians*. Rev. ed. New York: Thames and Hudson, 1987.

Apuleius. *The Golden Ass*. Translated by Robert Graves. New York: Farrar, Straus and Giroux, 1961. See also the translation by Jack Lindsay. Bloomington: Indiana University Press, 1960.

Arguelles, Jose A. *The Transformative Vision: Reflections on the Nature and History of Human Expression*. Boulder: Shambhala, 1975.

Bachofen, J. J. *Myth, Religion and Mother Right*. Princeton, N. J.: Princeton University Press, 1967.

Bauval, Robert, and Adrian Gilbert. *The Orion Mystery*. New York: Crown, 1994.

Berket, Walter. *Ancient Mystery Cults*. Cambridge: Harvard University Press, 1987.

Bernal, Martin. *Black Athena*. Vol. 1, *The Afroasiatic Roots of Classical Civilization*. New Brunswick: Rutgers University Press, 1987.

Bigelow, Marilee. "Bast." *Khepera* 2, no. 2 (March 1991): 12.

Blackman, Winifred S. *The Fellahin of Upper Egypt*. London: George G. Harrap & Company, 1927.

Blades, James. *Percussion Instruments and Their History*. New York: Frederick A. Praeger Publishers, 1970.

Blavatsky, Helena Petrovna. *The Secret Doctrine*. London: Theosophical Society, 1988.

Bleeker, C. J. *Egyptian Festivals: Enactments of Religious Renewal*. London: E. J. Brill, 1967.

_____. *Hathor and Thoth: Two Key Figures of the Ancient Egyptian Religion*. Leiden, Netherlands: E. J. Brill, 1973.

Blum, Ralph. *The Book of Runes*. New York: St. Martin's Press, 1993.

Boylan, Patrick. *Thoth: The Hermes of Egypt*. 1979. Reprint. Chicago: Ares Publishers, 1987.

Breasted, James. *Ancient Records of Egypt*. 5 vols. Chicago: University of Chicago Press, 1906.

Brier, Bob. *Ancient Egyptian Magic*. New York: Quill, 1981.

Briffault, Robert. *The Mothers*. 3 vols. New York: Macmillan Company, 1927.

Budge, E. A. Wallis. *Dwellers of the Nile*. New York: Dover, 1977.

_____. *The Egyptian Book of the Dead: The Papyrus of Ani*. New York: Dover, 1967.

_____. *Egyptian Magic*. New York: Dover, 1971.

_____. *The Gods of the Egyptians*. 2 vols. New York: Dover, 1969.

Campbell, Joseph. *The Masks of God*. Vol. 3, *Occidental Mythology*. New York: Viking Press, 1958.

Cerny, Jaroslav. *Ancient Egyptian Religion*. London: Hutchinson's University Library, 1952.

Cirlot, J. E. *A Dictionary of Symbols*. New York: Dorsett Press, 1971.

Clark, R. T. Rundle. *Myth and Symbol in Ancient Egypt*. London: Thames and Hudson, 1959.

Cott, Jonathan. *The Search for Omm Sety*. Garden City, N. J.: Doubleday, 1987.

Cumont, Franz. *Astrology and Religion Among the Greeks and Romans*. New York: Dover, 1960.

David, Rosalie. *The Ancient Egyptians: Religious Beliefs and Practices*. London: Routledge & Kegan Paul, 1982.

Dennis, James Teackle. *The Burden of Isis*. London: John Murray, 1918.

Diodorus Siculus. *The Library of History*. Vol. 5. Loeb Classical Library, 1933.

Downing, Christine. *Psyche's Sisters: ReImagining the Meaning of Sisterhood*. San Francisco: Harper & Row, 1988.

Durdin-Robertson, Lawrence. *The Goddesses of Chaldaea, Syria and Egypt*. Clonegal, England, 1975.

_____. *The Year of the Goddess: A Perpetual Calendar of Festivals*. Wellingsborough, Northhampshire: Aquarian Press, 1990.

Edwards, Amelia B. *A Thousand Miles Up the Nile*. New York: A. L. Burt, 1888.

Eliade, Mircea. *Essential Sacred Writings from Around the World*. San Francisco: Harper San Francisco, 1967.

_____. *Myth and Reality*. New York: Harper & Row, 1963.

Ellis, Normandi. *Awakening Osiris*. Grand Rapids: Phanes Press, 1988.

Erman, Adolf. *The Literature of the Ancient Egyptians*. Translated by Aylward M. Blackman. New York: Benjamine Blom, 1971.

Faulkner, R. O. *The Ancient Egyptian Coffin Texts*. Vol. 1, Spells 1-354. Warminster, England: Aris & Phillips, 1978.

_____. *The Ancient Egyptian Pyramid Texts*. Oxford: Clarendon Press, 1969.

_____. "The Bremner-Rhind Papyrus." *Journal of Egyptian Archaeology* (London: The Egyptian Exploration Society) 22 (1936): 123.

Fischer, Henry George. *Dendera in the Third Millennium B.C.* Locust Valley, N. Y.: J. J. Augustin, 1968.

Flem-Ath, Rand, and Rose Flem-Ath. *When the Sky Fell: In Search of Atlantis*. New York: St. Martin's Press, 1995.

Foster, John. *Echoes of Egyptian Voices: An Anthology of Ancient Egyptian Poetry*. Norman, Okla.: University of Oklahoma Press, 1992.

Frankfort, Henri. *Ancient Egyptian Religion: An Interpretation*. New York: Columbia University Press, 1948.

_____. *Kingship and the Gods: A Study of Ancient Near Eastern Religion as the Integration of Society and Nature*. Chicago: University of Chicago Press, 1948.

Galvin, Marianne. "The Priestesses of Hathor in the Old Kingdom and the First Intermediate Period." Ph.D. diss., Brandeis University, 1981.

Gleadow, Rupert. *The Origin of the Zodiac*. New York: Atheneum, 1969.

Grant, F. C. *Hellenistic Religions: The Age of Syncretism*. Indianapolis: Bobbs-Merrill, 1953.

Griffith, F. L., and Herbert Thompson, eds. *The Leyden Papyrus: An Egyptian Magical Book*. New York: Dover, 1974.

Grimal, Nicolas. *A History of Ancient Egypt*. Translated by Ian Shaw. Oxford: Blackwell, 1992.

Hancock, Graham. *Fingerprints of the Gods*. New York: Crown, 1995.

Hancock, Graham, and Robert Bauval. *Message of the Sphinx*. New York: Crown, 1996.

Harding, M. Esther. *Woman's Mysteries: Ancient and Modern*. Boston: Shambhala, 1990.

Hart, George. *A Dictionary of Egyptian Gods and Goddesses*. London: Routledge & Kegan Paul, 1986.

Herodotus. *The Histories*. Book II. Translated by Aubrey dé Selincourt. Reprint. New York: Penguin, 1972.

Heyob, Sharon Kelly. *The Cult of Isis Among Women in the Graeco-Roman World*. Leiden, Netherlands: E. J. Brill, 1975.

Hoffman, Michael A. *Egypt Before the Pharaohs*. New York: Alfred A. Knopf, 1979.

Hope, Murry. *Practical Egyptian Magic*. New York: St. Martin's Press, 1984.

Hornung, Erik. *Conceptions of God in Ancient Egypt*. Ithaca, N. Y.: Cornell University Press, 1982.

Houston, Jean. *The Passion of Isis and Osiris: A Union of Two Souls*. New York: Ballantine, 1995.

Ions, Veronica. *Egyptian Mythology*. Middlesex: Hamlyn House, 1968.

Jacobsen, Thorkild, and John A. Wilson, eds. *Most Ancient Verse*. Chicago: University of Chicago Press, 1963.

James, E. O. *Myths and Ritual in the Ancient Near East*. New York: Praeger, 1965.

Jayne, Walter Addison. *The Healing Gods of Ancient Civilization*. New Haven: Yale University Press, 1925.

Johnson, Buffie. *Lady of the Beasts: Ancient Images of the Goddess and Her Sacred Animals*. San Francisco: Harper & Row, 1988.

Kaper, Olaf E. "The Astronomical Ceiling of Deir El-Haggar in the Dakhleh Oasis." *Journal of Egyptian Archaeology* (London: The Egypt Exploration Society) 81 (1995): 175-182.

Lamy, Lucie. *Egyptian Mysteries: New Light on Ancient Spiritual Knowledge*. New York: Crossroads, 1981.

Lauer, Jean-Phillipe. *Saqqara: The Royal Cemetary of Memphis*. New York: Charles Scribner's Sons, 1976.

Lichtheim, Miriam. *Ancient Egyptian Literature*. Vol. 1, *Old and Middle Kingdoms*; vol. 2, *New Kingdom*; vol. 3, *Late Period*. Berkeley: University of California Press, 1978-1980.

Lockyer, J. Norman. *The Dawn of Astronomy: A Study of the Temple Worship and Mythology of the Ancient Egyptians*. Cambridge, Mass.: MIT Press, 1964.

MacQuitty, William. *Island of Isis: Philae, Temple of the Nile*. New York: Charles Scribner's Sons, 1976.

Maspero, Gaston. *Dawn of Civilization: Egypt and Chaldea*. Translated by M. L. McClure. 4th rev. ed. London: Society for Promoting Christian Knowledge, 1901.

Masters, Robert. *The Goddess Sekhmet: The Way of the Five Bodies*. New York: Amity House, 1988.

Mertz, Barbara. *Red Land, Black Land: Daily Life in Ancient Egypt*. New York: Dodd, Mead & Company, 1978.

Michell, John. "The Ancient Temple and Modern Cosmology." Interview by David Fideler. *Gnosis* 15 (Spring 1990): 48.

Monaghan, Patricia. *The Book of Goddesses & Heroines*. St. Paul, Minn.: Llewellyn Publications, 1990.

Montet, Pierre. *Everyday Life in Egypt*. Philadelphia: University of Pennsylvania Press, 1981.

Murray, Margaret A. *Ancient Egyptian Legends*. London: John Murray Publishers, 1913.

_____. *Egyptian Religious Poetry*. London: John Murray Publishers, 1949.

_____. *The Splendour That Was Egypt*. New York: Philosophical Library, 1949.

Naumann, Emil. *History of Music*. Translated by F. Praeger. London: 1882.

Naydler, Jeremy. *Temple of the Cosmos: The Ancient Egyptian Experience of the Sacred*. Rochester, Vt.: Inner Traditions, 1996.

Neumann, Erich. *The Great Mother*. Translated by Ralph Manheim. Bollingen Series XLVII. Princeton: Princeton University Press, 1972.

Ozaniec, Naomi. *Daughter of the Goddess: The Sacred Priestess*. London: Aquarian Press, 1993.

Parker, Richard A. *The Calendars of the Ancient Egyptians*. Studies in Ancient Oriental Civilization, no. 26. Chicago: University of Chicago Press, 1950.

Pasachoff, Jay M., and Donald H. Menzel. *Peterson Field Guide: Stars and Planets*. Boston: Houghton Mifflin, 1992.

Piankoff, Alexandre. *The Pyramid of Unas*. Bollingen Series XL, no. 5. Princeton, N.J.: Princeton University Press, 1968.

_____. *The Shrines of Tut-Ankh-Amon*. Bollingen Series XL. New York: Harper Torchbooks, 1962.

Pinch, Geraldine. *Magic in Ancient Egypt*. Austin: University of Texas Press, 1995.

_____. *Votive Offerings to Hathor*. Oxford: Griffith Institute, 1993.

Porphyry. *On the Cave of Nymphs*. Translated by Robert Lamberton. Barry-town, N.Y.: Station Hill Press, 1983.

Pound, Ezra, and Noel Stock, trans. *Love Poems of Ancient Egypt*. Norfolk, Conn.: New Directions, 1962.

Quirke, Stephen, and Werner Forman. *Hieroglyphs and the Afterlife*. Norman: University of Oklahoma Press, 1996.

Redmond, Layne. "Rhythm and the Frame Drum." *Woman of Power* 15 (Fall/Winter 1990): 22.

Romer, John. *Valley of the Kings*. New York: Henry Holt & Company, 1981.

Sauneron, Serge. *The Priests of Ancient Egypt*. Translated by Ann Morrissett. New York: Grove Press, 1960.

Schwaller De Lubicz, R. A. *Sacred Science: The King of Pharaonic Theocracy*. Translated by André and Goldian VandenBroeck. Rochester, Vt.: Inner Traditions, 1982.

Shorter, Alan W. *The Egyptian Gods*. London: Routledge & Kegan Paul, 1937.

Simpson, William Kelly; R. O. Faulkner; and Edward F. Wente, Jr., trans. and eds. *The Literature of Ancient Egypt*. New Haven: Yale University Press, 1972.

Siuda-Legan, Tamara. The Neteru of Kemet. Chicago: Eschaton Productions, 1994.

Spalinger, Anthony J. *Revolutions in Time: Studies in Ancient Egyptian Calendrics*. San Antonio, Tex.: Van Siclen Books, 1994.

_____. *Three Studies on Egyptian Feasts and Their Chronological Implications*. Baltimore: Halgo, 1992.

Starhawk. *The Spiral Dance*. San Francisco: Harper & Row, 1979.

Stone, Merlin. *When God Was a Woman*. New York: Dorsett Press, 1976.

Troy, Lana. *Patterns of Queenship in Ancient Egyptian Myth and History*. Boreas Uppsala Studies in Ancient Mediterranean and Near Eastern Civilizations, 14. Stockholm, 1986.

Tyldesley, Joyce. *Daughters of Isis: Women of Ancient Egypt*. New York: Viking, 1994.

Versluis, Arthur. *The Egyptian Mysteries*. London: Arkana, 1988.

Von Franz, Marie-Louise. *A Psychological Interpretation of the Golden Ass of Apuleius*. Zurich: Spring Publications, 1970.

Wainwright, G. A. *The Sky-Religion in Egypt*. London: Cambridge University Press, 1938.

Walker, Barbara G. *The Woman's Dictionary of Symbols and Sacred Objects*. San Francisco: Harper & Row, 1988.

_____. *The Woman's Encyclopedia of Myths and Secrets*. San Francisco: Harper & Row, 1983.

Wells, Evelyn. *Hatshepsut*. Garden City, N.Y.: Doubleday, 1969.

West, John Anthony. "Ancient Egypt: The Meaning Behind the Magic." *The Quest* (Winter 1991): 80.

_____. *Serpent in the Sky: The High Wisdom of Ancient Egypt*. Wheaton, Ill.: Quest Books, 1993.

_____. *The Traveler's Key to Ancient Egypt*. Wheaton, Ill.: Quest Books, 1995.

Wilkinson, J. G. *The Ancient Egyptians: Their Life and Customs*. New York: Crescent Books, 1988.

Witt, R. E. *Isis in the Graeco-Roman World*. Ithaca, N.Y.: Cornell University Press, 1971.

Woldering, Irmgaard. *The Art of Egypt*. New York: Crown, 1963.

OTHER SUGGESTED READING

Albert, Susan Wittig. "Herbs of the Zodiac." In *Llewellyn's Organic Gardening Almanac*. St. Paul, Minn.: Llewellyn Publications, 1995.

Andrews, Ted. *Dream Alchemy: Shaping Our Dreams to Transform Our Lives*. St. Paul, Minn.: Llewellyn Publications, 1991.

Blair, Nancy. *Amulets of the Goddess*. Oakland, Calif.: Wingbow Press, 1993.

Breathnach, Sarah Ban. *Simple Abundance: A Daybook of Comfort and Joy*. New York: Warner Books, 1995.

Budapest, Zsuzsanna. *The Holy Book of Women's Mysteries*. Oakland, Calif.: Wingbow Press, 1989.

Csikszentmihalyi, Mihaly. *Creativity: Flow and the Psychology of Discovery and Invention*. New York: HarperCollins, 1996.

Cunningham, Scott. *Cunningham's Encyclopedia of Magical Herbs*. St. Paul, Minn.: Llewellyn Publications, 1996.

_____. *Magical Aromatherapy*. St. Paul, Minn.: Llewellyn Publications, 1995.

Dunwich, Gerina. *The Wicca Garden: A Modern Witch's Book of Magickal and Enchanted Herbs and Plants*. New York: Citadel Press, 1996.

Hand, Robert. *Planets in Transit*. Gloucester, Mass.: Para Research, 1976.

Hope, Murry. *The Way of Cartouche*. New York: St. Martin's Press, 1985.

McCoy, Edain. *In a Graveyard at Midnight: Folk Magick and Wisdom from the Heart of Appalachia*. St. Paul, Minn.: Llewellyn Publications, 1995.

Medici, Marina. *Good Magic*. New York: Simon & Schuster, 1992.

Monaghan, Patricia. *Magical Gardens: Myth, Mulch, and Marigolds*. St. Paul, Minn.: Llewellyn, 1997.

Mountainwater, Shekhinah. *Ariadne's Thread: A Workbook of Goddess Magic*. Freedom, Calif.: The Crossing Press, 1991.

Nahmad, Claire. *Dream Spells*. Philadelphia, Pa.: Running Press Books, 1994.

_____. *Earth Magic: A Wisewoman's Guide to Herbal, Astrological and Other Folk Wisdom*. Rochester, Vt.: Destiny Books, 1994.

Norris, Dorry Baird. *Sage Cottage Herb Garden Cookbook*. Old Saybrook, Conn.: The Globe Pequot Press, 1991.

Sheehy, Gail. *New Passages: Mapping Your Life Across Time*. New York: Random House, 1995.

Tanner, Wilda B. *The Mystical Magical Marvelous World of Dreams*. Tahlequah, Okla.: Sparrow Hawk Press, 1988.

INDEX

 Index

 Index

QUEST BOOKS
are published by
The Theosophical Society in America,
Wheaton, Illinois 60189-0270,
a branch of a world organization
dedicated to the promotion of the unity of
humanity and the encouragement of the study of
religion, philosophy, and science, to the end that
we may better understand ourselves and our place in
the universe. The Society stands for complete
freedom of individual search and belief.
For further information about its activities,
write, call 1-800-669-1571, or consult its Web page:
http://www.theosophical.org

The Theosophical Publishing House
is aided by the generous support of
THE KERN FOUNDATION,
a trust established by Herbert A. Kern
and dedicated to Theosophical education.